Painting in Spain 1650–1700

The Art Museum, Princeton University
April 18 – June 20, 1982

The Detroit Institute of Arts
July 18 – September 19, 1982

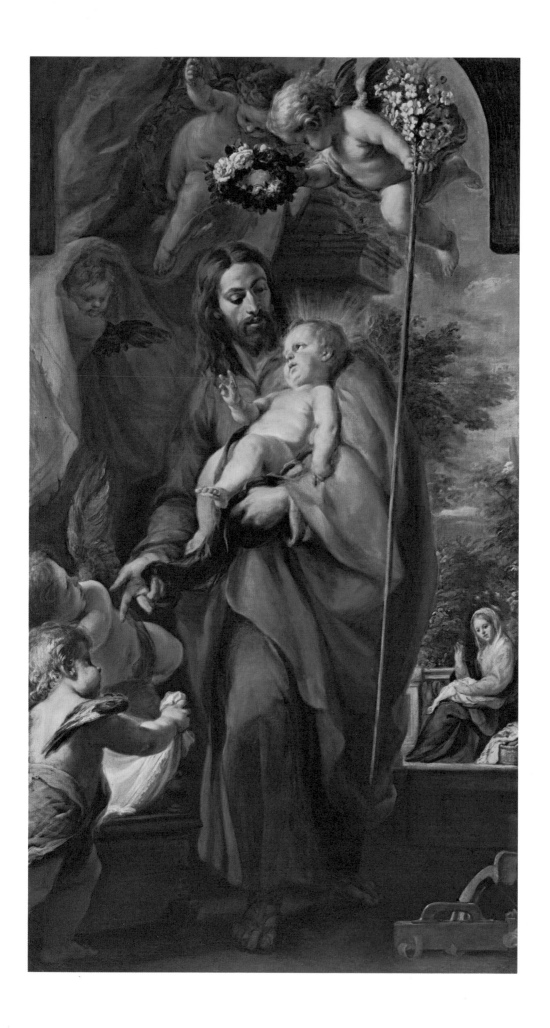

Painting in Spain 1650–1700

from North American Collections

Edward J. Sullivan
and
Nina A. Mallory
with an historical essay by J. H. Elliott

The Art Museum, Princeton University

Published in conjunction with the exhibition "Painting in Spain 1650–1700."
The Art Museum, Princeton University
The Detroit Institute of Arts

Designed by Quentin Fiore
Set in type by Columbia Publishing Company
Printed by Village Craftsmen

Cover/frontispiece: Claudio Coello, *St. Joseph and the Christ Child*
The Toledo Museum of Art, gift of Edward Drummond Libbey (Cat. no. 14, pl. 14)

Library of Congress Catalogue Card Number 81-47953

Published by The Art Museum, Princeton University, Princeton, New Jersey 08544.

This project is supported by the Dirección de Relaciones Culturales of the Ministry
of Foreign Affairs of Spain, and a grant from the National Endowment for the Arts,
a Federal agency.

Contents

Paintings in the Exhibition

N. B. Catalogue numbers 10 and 39 will be on exhibition in Princeton only.

Comparative Illustrations

N. B. Figure numbers 45 through 54 are to be found in the Desiderata.

Acknowledgements

We are most grateful to Edward J. Sullivan, Assistant Professor, Washington Square College, New York University, and Nina A. Mallory, Associate Professor, the State University of New York, Stony Brook, guest curators who have more than justified our initial enthusiasm and confidence when they first proposed this exhibition. We are also extremely happy that John H. Elliott has contributed an essay to the catalogue not only because of the distinction his contribution lends to the occasion, but also because it is yet another index of the close ties between the University and its good neighbor the Institute for Advanced Study.

We are fortunate that we have been joined in this endeavor by The Detroit Institute of Arts, and we are most grateful to Frederick J. Cummings, Director, and J. Patrice Marandel, Curator, Department of Early European Painting, for their interest and encouragement, and for the support of the exhibition by the Founders Society Detroit Institute of Arts.

Lenders to the exhibition have been most generous in parting with their treasures, and we must single out the following who have been especially helpful in making arrangements for the loans: Judith A. Barter, Curator of Collections, Mead Art Museum, Amherst College; Jean K. Cadogan, Curator, European Paintings, and Gregory Hedberg, Chief Curator, Wadsworth Atheneum, Hartford; Maria Heilbron, The Cintas Foundation; Myron Laskin, Curator of European Art, National Gallery of Canada; Scott Schafer, Curator, European Paintings, Los Angeles County Museum of Art; Thomas Sokolowski, Curator of European Paintings and Sculpture, and David W. Steadman, Director, Chrysler Museum at Norfolk.

In addition to members of the staff of The Art Museum mentioned by Professor Sullivan in his introduction, I would like to thank Robert Lafond, Registrar; Norman Muller, Conservator; Betsy Rosasco, Assistant Curator; and Toni Jones, Secretary to the Director, for their contributions to the successful realization of the exhibition. Quentin Fiore is the designer of this handsome publication, and Bernard Rabb and the staff of Columbia Publishing Company were remarkably conscientious and attentive typesetters.

Jonathan Brown, Institute of Fine Arts, New York University, has been unofficial Spanish godfather to The Art Museum ever since he curated the exhibition "Jusepe de Ribera: Prints and Drawings" in 1973, when he was a member of the Department of Art and Archaeology at Princeton. He has on this occasion again proved himself a good counselor and friend.

We are most appreciative of the support received from the Spanish Government and especially for the efforts of José Luis Roselló, Cultural Counselor. It is an honor to have the Spanish Government associated with this exhibition.

The generous support of this project by a grant from the National Endowment for the Arts, a Federal agency, is gratefully acknowledged.

Allen Rosenbaum
Director

Introduction

The second half of the seventeenth century in Spain may seem, to many people, a peculiar choice for a special exhibition. Velázquez was, of course, still painting until 1660; but aside from him, has any single figure retained a strong general popularity throughout the years? A mid-nineteenth-century audience would have responded immediately with the name of Murillo, whose prestige had hardly waned since his death in 1682. Yet his reputation began to decline after the 1850s and his critical fortunes have only recently begun to rise. Those with a slightly more specialized knowledge of seventeenth-century art might also mention Juan de Valdés Leal, who has continued to fascinate more modern audiences especially with his bizarre *memento mori* paintings featuring lugubrious assemblages of skeletons and corpses. Yet on the whole, the age of the late Baroque in Spain is one that is virtually unknown to all but scholars in the field. Research efforts have not done justice to the majority of artists who flourished at this time. Many of the principal figures still lack proper monographs and *catalogues raisonnés*. Francisco Rizi, Mateo Cerezo, Francisco Camilo, and Juan Carreño de Miranda, among others, are intensely interesting painters who worked in a variety of media. Complex issues of attribution and iconography of their art must still be resolved. We hope that by displaying a sampling of their work in the present exhibition, some of these artists may excite the curiosity of scholars and encourage them to tackle some of these problems.

For many years there has existed something of a void in our knowledge of all but the most outstanding painters of the Golden Age in Spain — El Greco, Ribera, Zurbarán, Cano, and Velázquez. Although many of the less well-known artists have been dealt with in the general histories of the period (see Aureliano de Beruete y Moret's *The School of Madrid*, 1909; August Mayer's *Die Sevillaner Malerschule*, 1911, and *Geschichte der spanischen Malerei*, 1913; George Kubler and Martin Soria's *Art and Architecture in Spain and Portugal and Their American Dominions 1500–1800*, 1959, in the Pelican History of Art series; and Diego Angulo Iñiguez's *Pintura del siglo XVII*, 1971, volume 15 of Ars Hispaniae), few of these masters have been accorded the rigorous scholarship they deserve. There are notable exceptions, however. In 1976, Jonathan Brown's *catalogue raisonné* of the drawings of Murillo was published in conjunction with an exhibition at Princeton and the Fogg Art Museum. The long-awaited monograph and complete catalogue of Murillo's paintings by Angulo appeared in 1981 and has proved to be a book that lays the groundwork for all further study of this great artist. Duncan Kinkead's dissertation (published in 1978) on Valdés Leal has also clarified our understanding of this painter's complex artistic personality.

An on-going series of catalogues by Angulo and Alfonso Pérez Sánchez is continuing the work of charting the history of Spanish painting begun by Chandler Rathfon Post. Thus far two volumes (covering Toledo in the first half, and Madrid in the first third, of the seventeenth century) have already appeared in Spain. Volumes dealing with the later part of the century are in preparation, as are corresponding catalogues by the same authors in a similar series on Spanish drawings published in England.

Exhibitions of Spanish art are suddenly proliferating. After decades of severely lim-

ited activity in this field, museums in both the United States and abroad are demonstrating a serious interest in Spanish painting of many different periods. Recent exhibitions in Germany, France, and England have presented splendid monographic and collective overviews of the work of Spanish painters from El Greco to Goya. Similar projects have been undertaken and still more are planned for the near future in the United States.

It is most appropriate that the present exhibition be organized by The Art Museum, Princeton University. Upon conceiving the idea for this show, I immediately remembered The Art Museum's history of presenting ground-breaking exhibitions of Spanish art over the last decade. Beginning with "Jusepe de Ribera: Prints and Drawings" and "Murillo and his Drawings," both organized by Jonathan Brown, and continuing with "Els Quatre Gats: Art in Barcelona around 1900," organized by Marilyn McCully, The Art Museum has done a great service to the development of the study of Hispanic culture in the United States by mounting exhibitions that combine serious scholarship with beautiful but little-known works of art to create unique aesthetic and intellectual experiences.

In choosing the works for this exhibition, Nina Mallory and I have relied strictly upon the collections in North America. Museums in the United States, Canada, and Puerto Rico are enormously rich in holdings of Spanish art. The perspicacity of the acquisitions policies of both private collectors and museum curators has resulted in the accumulation of a wide cross-section of works of art covering virtually all phases of the history of Spanish painting. Thus the paintings in the show represent in many cases some of the most outstanding works of the artists of this period. There are, unfortunately, a few gaps. Major examples of the work of such important painters as Francisco Rizi and José Antolínez are either not present in North America or were unavailable for the exhibition. In these cases we have attempted to explain their position in the development of late Baroque art in Spain in greater detail in the catalogue essays.

In this project we have been enormously aided at every step of the way by the kindness, encouragement, and generosity of Allen Rosenbaum, Director of The Art Museum, and David Nathans, Assistant Director. Our sincere gratitude is extended to them and to the large number of people on the staffs of both museums participating in this project; especially to Lauren Arnold, National Endowment for the Arts Intern at The Art Museum, and Jill Guthrie, Editor of Publications, who have done so much to assure the success of the catalogue and exhibition. I would also like to thank Irene Martín, Assistant Director of the Meadows Museum, Southern Methodist University, Dallas, for sharing her knowledge of the art of Juan de Arellano and Bartolomé Pérez in the catalogue entries for works by these painters.

We are especially indebted to the many lenders to our exhibition. It is their generosity, after all, which has been the key element in the realization of this project.

Edward J. Sullivan
New York
August 1981

Painting in Spain 1650–1700

J. H. Elliott

The Twilight of Hapsburg Spain

O n June 6, 1660, on a small island in the river Bidasoa dividing France from Spain, Philip IV of Spain came face to face for the first time with his young nephew, Louis XIV. The meeting was a poignant one. Since 1635 their countries had been at war, and the encounter of the two monarchs was intended to set the seal on the peace negotiations that had been agreed at the end of 1659. The setting and the ceremonial were worthy of the occasion. On the Spanish side the arrangements were made by Diego Veláz-quez, who had accompanied the king on his expedition to the frontier, and who had hung the conference chamber with splendid tapestries from the palace of the Alcázar in Madrid. A dividing line ran through the middle of the chamber, and Louis, advancing toward it, made as if to kneel to Philip, who prevented him from doing so and clasped him in his arms. Then Philip formally handed over to Louis his daughter, the Infanta María Teresa. Their marriage was to symbolize the reconciliation of the Crowns of France and Spain after the long years of enmity.

The ceremonial surrounding the Peace of the Pyrenees could not entirely conceal the ironies of that spectacular occasion. Philip, King of Spain and the Indies, was, in name at least, the most powerful king on earth, the heir to the Emperor Charles V and Philip II, the champion of the faith and the defender of the Hapsburg cause. Louis, himself half a Hapsburg, was the young ruler of a France that was now well on its way to wresting from Spain the primacy that it had enjoyed for more than a century. Within a generation France would possess European hegemony, and Louis would be casting covetous eyes on a Spanish monarchy and empire that gave every appearance of being in the last stages of decay.

But on the Island of Pheasants in 1660 the court of the rising Sun King was eclipsed in splendor by that of the Spanish Hapsburg, who himself had long ago, as the "Planet King," appropriated the image of the sun. The restrained dignity of Philip and the mea-sured ceremonial of his court bore eloquent witness to the exalted status of the King of Spain, who was not as other men. The pervasive influence of Spain's culture and manners reinforced the long-standing assertion of its claims to primacy. The lesson was not lost on the impressionable Louis XIV.

Yet for all the grave splendor of external appearance, it had long been obvious that the impressive façade was something of a sham. When Philip IV came to the throne in 1621 it was as a ruler determined to assert his supremacy in the arts of war and peace. A natu-ral aesthete and a devotee of the theater, he did indeed, under the guidance of his favorite and principal minister, the Count-Duke of Olivares, become a great patron of the arts. In the Alcázar, or at his pleasure palace of the Buen Retiro, built in the early 1630s on the outskirts of Madrid, he was at the center of a brilliant court. Velázquez was his official painter; the walls of his palaces were hung with the works of the great Italian masters and of contemporary artists like Rubens and Ribera; poets and men of letters, like Quevedo, produced their specially commissioned pieces for great court occasions; and the plays of contemporary dramatists, of Lope de Vega and Calderón, were mounted in spectacular productions at the court theater by the famous Italian scenographer Cosimo Lotti.

But in the arts of war, after some initial victories, the story was different. Philip and Olivares attempted to promote an ambitious foreign policy and to sustain a series of worldwide commitments on the basis of rapidly shrinking resources. Silver supplies from Mexico and Peru, which had done so much to keep the empire of Philip II afloat, were now reaching Seville in diminishing quantities, and the economy of Castile, in the grasp of inflation and heavily burdened by taxation, failed to generate new sources of wealth. After twenty years of continuous war, with the Dutch and then the French, the strains became intolerable, and in 1640 both Catalonia and Portugal revolted against the government in Madrid. A year later the British ambassador wrote: "I am induced to think that the greatness of this monarchy is near to an end." In 1643 Olivares was relieved of his duties, and Philip announced his intention of governing by himself.

This was an undertaking doomed from the start. Philip, oppressed with the sense of his own inadequacy, lacked both the self-confidence and the staying power needed to direct and control the massive bureaucratic apparatus which administered Spain and its empire. But with the help of ministers inherited from Olivares, he struggled with some success to limit the extent of the damage caused by the disasters of the 1640s. Although he never achieved his ambition of recovering Portugal, Catalonia returned to obedience in 1652. He also prolonged the war with France until he was in a position to achieve a peace settlement that would not be regarded as dishonorable to Spain; but the price paid by his subjects for an honorable settlement in 1659 might well be regarded as inordinately high.

The Spain bequeathed by Philip IV on his death in 1665 to his four-year-old son and heir, Charles, was visibly a Spain in decline—a defeated, demoralized, and war-weary country, in which extreme wealth and extreme poverty lived side by side. Castile, the heartland of the peninsula, which had borne the heaviest burdens of war, was in the midst of a long recession, its population stagnant, its currency disordered. But at the top of the social pyramid was a rich and influential elite—a powerful and restrictive church establishment, a well-entrenched and privileged bureaucracy, and a handful of grandees.

The existence of this elite goes a long way toward explaining the apparent paradox of the flourishing of the arts in an age of political and economic decline. At court, and in the major provincial cities like Seville, nobles, clerics, high officials, and members of the urban patriciate possessed the resources to indulge in conspicuous consumption, even though most of them were beset at one time or another by serious cash-flow problems. In such a status-conscious society conspicuous consumption was the order of the day, and in any event the state of the Castilian economy meant that there were few channels for productive investment. With the example of the king and the court before it, a parasitic *rentier* class was willing to devote some of its resources to artistic patronage, amassing collections of paintings and commissioning artists and craftsmen to decorate family chapels and the convents and churches in which it maintained a proprietary interest.

In the relatives and dependents of Olivares in particular, it is noticeable how great power, great wealth, and great patronage accompanied each other. The triumph of Olivares in 1621 meant the triumph of the three interconnected noble families of Guzmán,

Haro, and Zúñiga. These families survived the fall of Olivares in 1643 with their influence intact, and for a further generation dominated the political life of Spain, filling high ministerial posts at court and nominating their own members and dependents to episcopal sees and lucrative overseas offices, like the viceroyalty of Naples. They were also patrons and collectors on a splendid scale. Olivares himself, who loved the company of men of letters, built up one of the great libraries of the seventeenth century. His brother-in-law, the Count of Monterrey, and his son-in-law, the Duke of Medina de las Torres, were notable picture collectors. So, too, was his cousin, the Marquis of Leganés, whose son, Ambrosio Cardinal Spínola, Archbishop of Seville, commissioned work from Murillo. Olivares's nephew, Don Luis de Haro, who succeeded his uncle as the principal minister of Philip IV, was a collector of paintings in his own right, as well as being the heir to his uncle's paintings and library. Haro's eldest son, Don Gaspar de Haro, who died in 1687 as viceroy of Naples, was in turn an obsessive collector, whose collection (which included the *Rokeby Venus* of Velázquez) was the nearest rival to the splendid royal collection built up by Philip IV.

If these great nobles made an important contribution to the cultural life of seventeenth-century Spain, their contribution to its political life was less benign. Spain's governing class was faced by a massive challenge on the death of Philip IV in 1665. The overwhelming need of the moment was for institutional and economic reform, and for a serious attempt to tailor overextended commitments to shrunken resources. At a time of accelerating change over much of western Europe, Spain was increasingly assuming the appearance of a backward society, tenaciously clinging to traditional values and habits that tended to inhibit progress in an age of fierce economic competition and of major scientific and technological advance. An exaggerated notion of honor and a contempt for manual labor made it difficult for Castilian society to adapt to new challenges. A fervent Catholicism, which developed its own cherished dogmas, like the doctrine of the Immaculate Conception (a favorite theme of seventeenth-century Spanish artists), flourished behind the defenses erected by the Inquisition to shield the country from the contamination of new and heretical foreign ideas.

The choice facing Spain was either to dig in or adapt. During the later seventeenth century it opted to dig in. A program of reform and retrenchment would at the best of times have been difficult, but the circumstances of the new reign made it almost impossible. Charles, the new king and the only surviving son of Philip's two marriages, was a sickly and retarded infant, the culmination of a long period of Hapsburg inbreeding. It has been calculated that, over six generations, he had only 46 ancestors to the normal 126. His mother, Mariana of Austria, was his father's niece, and his prospects for survival seemed precarious from the start. During the minority of the child, Mariana acted as Regent, but even when the minority officially ended, Charles never really came of age. The last, degenerate sprig of the dynasty, he was subject to acute psychological disturbance and suffered from chronic ill-health. At the age of twenty-five he was described by the papal nuncio as being "unable to stand upright except when walking, unless he leans

against a wall, a table or somebody else. He is as weak in body as in mind. Now and then he gives signs of intelligence, memory and a certain liveliness, but not at present; usually he shows himself slow and indifferent, torpid and indolent, and seems to be stupefied."

Although Charles's death was confidently predicted from one year to the next, he was to reign for thirty-five years before his pallid life flickered out in 1700. But his incapacity for government made his reign a prolonged agony of political intrigue as rival court factions competed for power. With a vacuum at the center of political life, it was impossible for any single figure to obtain the consistent support that was needed to give the government a firm sense of direction. For all Mariana's attempts to uphold the rights of her son, the authority of the Crown was subject to constant erosion from the activities of the grandee oligarchy. A further element of political instability was provided by the thwarted ambitions of Don Juan José de Austria, the illegitimate son of Philip IV by an actress, whom Philip had taken care to exclude from the regency government. In 1667 Don Juan José, who had reforming aspirations and saw himself as a national savior, marched on Madrid with an army assembled in Aragon, and secured power in what was to be the first *coup d'état* in the history of modern Spain.

Don Juan José came to power at a time of famine, plague, and war with France. When he died in 1679 there was little to show for his two years of power. The Crown's debts remained a crushing burden on the economy, and the inflation in Castile had reached unprecedented heights. There followed a succession of weak ministries headed by grandees, with occasional abortive attempts at reform. But the domestic problems, grave as they were, were increasingly overshadowed by the looming problem of the succession.

The troubles of Charles's reign came not only from his incapacity to govern but also from his incapacity to generate an heir. His two marriages, first to Marie Louise of Orléans in 1679, and then, on her death ten years later, to Mariana of Neuberg, were both childless. There was much talk of the king having been bewitched, and in a court pullulating with priests, exorcism was attempted in the hope of effecting a cure. As it became increasingly clear that the king would remain childless and that his long-awaited death could not be far away, foreign ambassadors intrigued shamelessly in Madrid in support of the competing dynastic claims of Austria and France, and the Spanish succession became a major source of international conflict.

During the autumn of 1700, the last of the Spanish Hapsburgs was visibly dying. His long, sad reign had been a disaster for Spain, but it would be wrong to equate the life of the country with the living death of its last monarch of the House of Austria. Since the terrible plague of 1647 to 1652, which wiped out half the population of Spain's most prosperous city, Seville, and claimed half a million victims in a total population of some six million in the Crowns of Castile and Aragon, a modest demographic recovery had been under way. From around 1670 there were some encouraging signs of commercial and industrial growth in the maritime regions of the peninsula, especially the Basque provinces

and Catalonia; and even in Castile the worst seems to have been over after a drastic deflation and the stabilization of the currency between 1680 and 1686. Nor had the cultural life of the country been entirely blighted by the harsh economic conditions. Architectural achievement was modest, if only because building projects required the kind of consistent and heavy investment which problems of credit and currency did so much to deter. But other arts were less subject to the vagaries of the economy, and there are growing indications (of which this exhibition is one) that neither in painting nor in intellectual achievement was the Spain of Charles II the spiritual wasteland so commonly depicted.

Yet the fact remains that change and reform in Spain were long overdue. Since the fall of Olivares in 1643, the Crown had been in retreat, and the reign of Charles II saw the triumph of a self-serving oligarchy with little regard for the interests of the community at large. "Though this be a great monarchy," wrote the British minister Alexander Stanhope, in 1691, "yet it has at present much aristocracy in it, where every Grandee is a sort of prince." The dynasty and the grandees alike had each, in their own way, exposed the bankruptcy of the system, and now, in 1700, the dynasty was on the verge of extinction. On Sunday, October 3, the dying Charles II signed his will; he died a month later on November 1. By the terms of the will he bequeathed all his kingdoms and dominions to Philip of Anjou, the grandson of Louis XIV and of María Teresa, whom Louis had taken as his bride at the meeting on the Island of Pheasants forty years earlier. The inheritance for which Louis had schemed and planned had finally come his way. It was for the Bourbons to take up again where the last Hapsburgs had failed.

Edward J. Sullivan

Painting in Madrid 1650–1700

for Blanche Brown

*I*n 1650 Diego Velázquez, Spain's greatest painter of the seventeenth century, was in Italy. He had gone the previous year on his second trip to that country in order to buy works of art for the royal collections and to engage Italian artists to come to Spain to decorate the royal residences in and around the capital. Velázquez's journey, of almost two years' duration, was very successful. While in Rome (where he spent almost one year after visiting Genoa, Venice, and Naples) he produced some of his most important works, mostly portraits, which earned him not only further acclaim from his own countrymen but the esteem of Italian artists and cognoscenti as well.[1] The extraordinary representation of his servant and fellow painter Juan de Pareja, for example, executed in preparation for the portrait of Pope Innocent x caused a sensation among the Italian contemporaries of Velázquez, who had recently been named an honorary member of both the Accademia di San Luca and the Congregazione dei Virtuosi al Pantheon, a confraternity of artists under papal protection.[2]

Among the other works that Velázquez most likely painted during this Italian trip were the *Venus at her Mirror* (also known as the *Rokeby Venus*, in the National Gallery, London), a startlingly frank and sensuous representation of the nude female figure—so rarely painted by Spanish artists working under constant threat of sanction by the Inquisition—as well as the two small views of the Villa Medici, where the artist probably spent part of the summer of 1650 as he had spent that of 1630.[3]

In June of the following year, however, Velázquez was back in Madrid, at work again in his studio in the Alcázar. He would presumably have preferred to remain longer in Italy but was virtually forced to return to Spain by the repeated summonses of King Philip iv.[4] Thus Velázquez entered into the last decade of his life, one which was to be much less productive with regard to the number of paintings executed, but was, on the other hand, a time that witnessed the creation of some of his greatest masterpieces, including *The Maids of Honor* ["*Las Meninas*"] 1656, and *The Spinners* ["*Las Hilanderas*"] ca. 1655–60.[5] During the 1650s Diego Velázquez concentrated more of his efforts on his activities as courtier and architect. In the preceding decade he had already been awarded several titles carrying with them weighty responsibilities as a court official.[6] These were augmented when, in February of 1652, he was made *Aposentador de Palacio*, which entailed greater administrative duties and afforded him a liberal increase in salary. Velázquez's efforts were also strongly directed throughout the decade to gaining membership in the noble Order of Santiago, to which he was admitted on November 28, 1659, slightly more than ten months before his death on August 6, 1660.[7]

As for his increased architectural work, Velázquez had designed additions to the old royal palace (the Alcázar, destroyed by fire in 1734) in the 1640s and continued to serve as overseer of royal works in his capacity as Chamberlain of the Palace during the 1650s.[8] His last project was the preparation of the royal lodgings on the Island of Pheasants near Fuenterrabía in northern Spain, the site of the marriage of Princess María Teresa to King Louis xiv of France on June 7, 1660.

The preceding summary of the activities of Velázquez during the 1650s serves to em-

7

phasize his importance to both court and artistic life during that decade. Given his unquestioned prestige, it is paradoxical that this universally acknowledged master had few real followers. Although the impact of the art of Velázquez would be felt by many painters after his death (as in the portraits by Juan Carreño de Miranda and Claudio Coello, for example), less than a handful would continue his sober manner into the late seventeenth century. Despite the existence of a workshop that produced copies and variations of Velázquez's court portraits, often sent as gifts from the Spanish royal family to foreign monarchs or nobles, there were very few names or artistic personalities within it who distinguished themselves in their own right. This lack of a strong following is, of course, in marked contrast to the situation that prevailed around Velázquez's older contemporary and friend, Peter Paul Rubens. Rubens's assistants were numerous and his manner was perpetuated among Flemish painters for several generations by a number of competent and, at times, excellent masters who also developed their own easily recognizable styles. Xavier de Salas has recently characterized the personality of Velázquez as "grave and reflective" as opposed to the "brilliant and exuberant" Rubens.[9] Perhaps this introspection and sobriety can account, at least in part, for the lack of development of a true school around the Spanish painter.

Velázquez did, of course, have some followers, none of whom, however, matched his brilliance. Little-known names such as Benito Manuel Agüero or Francisco Palacios figure among the list of disciples as does the Aragonese painter Jusepe Leonardo.[10] Leonardo had participated in the decoration of the Hall of Realms of the newly erected pleasure palace known as the Buen Retiro in 1634, a project coordinated by Velázquez himself.[11] He executed two of the twelve battle scenes for the Hall (along with other famous painters of the day, including Vicente Carducho, Eugenio Cajés, Felix Castelo, Antonio de Pereda, Francisco de Zurbarán, and Juan Bautista Maino), works that can be favorably compared with the famous *Surrender of Breda* by Velázquez which also formed part of the cycle. A sensitive colorist and gifted draftsman, Leonardo had the potential for developing a satisfying style of his own had his career not been cut short by mental instability at a relatively early age, some years before his death in the early 1650s.

By far the closest follower of Velázquez was Juan Bautista Martínez del Mazo, who was in charge of the master's studio and ultimately married his mentor's daughter. Antonio Palomino highly praised Mazo for his ability to copy paintings by Tintoretto, Veronese, and Titian among others, works that he would have seen in the royal palace, where he served in several official capacities, including that of *Pintor de Cámara*, a post to which he was named after the death of Velázquez.[12] His copies certainly included works by his master, and in the literature on Velázquez there has often been confusion over attributions to the two painters. Yet Mazo was by no means a slavish imitator. He worked in various genres that were of less interest to his teacher. Palomino, for example, emphasized his expertise in painting equestrian scenes and cityscapes. The famous *View of Saragossa* in the Prado, often cited as a product of the collaboration between Veláz-

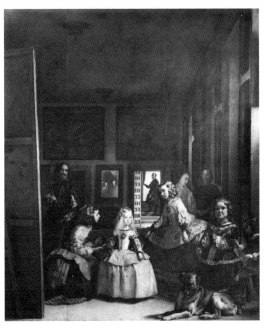

Figure 1. Juan Bautista Martínez del Mazo, *Family of the Artist*, oil on canvas. Vienna, Kunsthistorisches Museum.

Figure 2. Diego Velázquez, *The Maids of Honor ["Las Meninas"]*, oil on canvas. Madrid, Museo del Prado.

quez and Mazo, is very likely entirely the work of the latter. Equally interesting is Mazo's painting of the *Entrance of King Philip IV into Pamplona* (now lost, but an old copy exists in the Wellington Museum, London), which is another example of a subject—the panoramic view of a city or a town—rarely depicted by Spanish artists.[13] Sources for Mazo's themes and style can also be found in the work of non-Spanish artists, as Elizabeth Du Gué Trapier has pointed out.[14] Mazo spent several months in Naples and Rome between 1657 and 1658.[15] This Italian experience almost certainly reinforced the stimuli already received from paintings by Claude Lorraine and others in Spanish collections in creating the type of dreamy, vaporous landscapes which have been attributed to him, such as the beautiful *Arch of Titus, Rome*; *Landscape with a Classical Temple*; or the view of the *Large Lake at the Buen Retiro*; all of which are in the Prado.

Yet Mazo is undoubtedly best known for his group portrait, the *Family of the Artist* (ca. 1658 or 1664–5) now in the Kunsthistorisches Museum, Vienna (fig. 1) where a clear homage to *The Maids of Honor* is paid (fig. 2). Here we see, in the foreground, the painter's wife and his numerous children posing informally in the painter's studio in the Casa del Tesoro of the Alcázar.[16] In the middle ground there is a table, above which hangs a portrait of the elderly King Philip IV, similar to that by Velázquez now in the Prado, or the version attributed by López-Rey to Mazo himself in the National Gallery, London. In the background the space of the picture is extended—a device that had been

employed by Velázquez since his early years in Seville—offering us a view of an artist (Mazo? Velázquez?) at work on a royal portrait. The painting is signed in the upper left corner, not with the artist's name but with his escutcheon, comprised of an arm wielding a mace (a play on the painter's name—*mazo* in Spanish meaning "mace"). Although here, as in other instances, the brushwork imitates that of Velázquez (but lacking his "vital energy"),[17] and the painting is clearly dependent on his work, it is also very much the product of an artistic personality that managed to establish its own characteristics and distinct flavor.

What is more significant for the present context is the fact that a number of Velázquez's contemporaries were seemingly untouched by his style and, in the case of younger artists, created a new manner which resulted in the definitive transformation of late Baroque painting in Madrid. Few works are known by the hand of Juan de Pareja (who was not only Velázquez's servant but, on at least one famous occasion, his model),[18] yet they display an amazing lack of affinity with the art of the master. Despite statements by Palomino and Ceán Bermúdez that Pareja was not given lessons in painting or drawing by Velázquez, it is obviously with his art that he had the most contact.[19] Nonetheless, works such as the *Flight into Egypt* (Cat. no. 37) or even more ambitious paintings such as the *Vocation of St. Matthew* (1661) in the Prado (which includes the artist's self-portrait at the extreme left) or the *Baptism of Christ* (1667) in the Museo Provincial at Huesca, display characteristics of color and brushwork which are more easily relatable to the art of Rubens, Veronese, or even El Greco.[20]

The career of Antonio de Pereda, an artist from Valladolid who worked principally in Madrid, spans the years of Velázquez's ascendency at court.[21] His paintings, however, like those of Pareja and a number of others working in mid-century, depend very little on the manner of King Philip's favorite artist. As Alfonso Pérez Sánchez has recently suggested, Pereda's career might be divided into two distinct phases with the year 1635 serving as the dividing line.[22] Prior to that year the artist, under the patronage of Giovanni Battista Crescenzi, the Italian aristocrat and artist resident in Spain (designer of the Pantheon of the Escorial, among other projects), received official recognition from the court.[23] His most important commission was for a painting of the *Relief of Genoa*, a battle picture for the Hall of Realms in the Buen Retiro, part of the same program to which Jusepe Leonardo and others had contributed. After the death of his patron, Pereda was no longer employed by the royal family. The acrimonious relations between Crescenzi and the king's principal minister, the Count-Duke of Olivares, accounted for the artist's fall from favor. The rest of his lengthy career was mostly dedicated to painting religious subjects for the convents and monasteries of Madrid. His works often display a careful attention to detail in clothing and architectural rendering which is reminiscent of the art of earlier generations, calling to mind both Italian Mannerism (Bronzino, for example) or Flemish art of the sixteenth century. The use of brilliant reds and blues also suggests Pereda's affinity for Venetian Renaissance painting.

The most prolific period of Pereda's career encompasses the decades of the 1640s

and the 1650s. Typical of this phase is the *St. Joseph and the Christ Child*, signed and dated 1655 (fig. 3). While this painting still has characteristics akin to the art of Vicente Carducho,[24] one of Pereda's initial sources of inspiration, the fullness of the figures and the creamy white tones of the skin of the baby adumbrate the enormous impact that the style of Peter Paul Rubens would have on the painters of Madrid during the later phases of the Baroque period. This Flemish source, coupled with a newly awakened fascination with the Italian old masters and contemporary artists, provided the catalysts for the dramatic transformations that occurred in art at the court during the second half of the seventeenth century.

Late Baroque painting in Madrid is characterized by great exuberance and dynamism in composition, lightness of color, and a free, often sketchy technique. The first artist to assimilate most completely these "modern" aspects of painting was Francisco Rizi.[25] The impact that Rizi had on the last school of Madrid was realized by the neoclassic critic Ceán Bermúdez, who cited the artist as the chief contributor to what he saw as the deca-

Figure 3. Antonio de Pereda, *St. Joseph and the Christ Child*, oil on canvas. Dallas, Meadows Museum, Southern Methodist University.

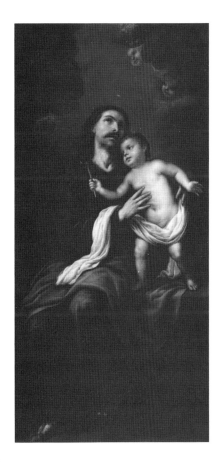

Figure 4. Francisco Rizi, *Virgin and Child Adored by Sts. Philip and Francis,* oil on canvas. El Pardo, Capuchin church.

dence of Spanish painting.[26] Rizi's work should now be estimated in a more positive light as having contributed to the new internationalization of Spanish art of this period. Unfortunately, Rizi is still an underrated artist for whom no complete monograph or *catalogue raisonné* exists.[27] He was born in Madrid, the son of a Spanish mother, Gabriela Chaves, and an Italian father, Antonio Ricci, a painter who had come to Spain to work on the decoration of the monastery of the Escorial. His older brother Juan also established his reputation as an artist whose paintings of monastic themes are stylistically related to the international Caraveggesque movement and were strongly influenced by the art of Francisco de Zurbarán.[28]

Francisco Rizi was trained by Vicente Carducho, whose impact can be observed in a number of his earliest known works such as the *Adoration of the Kings* (1645) in the cathedral of Toledo.[29] Rizi played an important role at court from the middle 1650s until the time of his death in 1685. In 1656 he was named *Pintor del Rey* and later, in 1677, given a further honorific title, *Ayuda de la Furriera*. He was also active as director of stage design for the Coliseo Theater of the Buen Retiro,[30] and was named official painter of the cathedral of Toledo. As the teacher of a large number of pupils Rizi was in part responsible for the quick acceptance of the new Baroque modes of painting which he had developed.

A key work in the creation of the late Baroque style in Spain is Rizi's altar painting

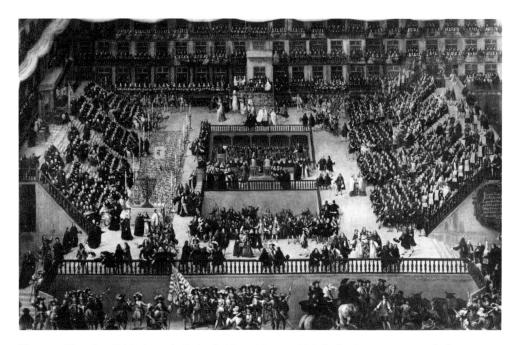

Figure 5. Francisco Rizi, *Auto de Fe in the Plaza Mayor of Madrid*, oil on canvas. Madrid, Museo del Prado.

depicting the *Virgin and Child Adored by Sts. Philip and Francis*, which he executed in 1650 for the Capuchin church at El Pardo and which is still *in situ* (fig. 4). In this large work (5.70 × 3.20 m.) the saints stand before an arch framing the celestial vision above; beyond the arch is a porch opening onto a landscape. There is an overt emotionality to the saints which is complemented by the warm, rich color of the scene. While these tones are not as light and pastel as the colors of Rizi's later work, they do indeed foreshadow the increasingly brighter palette of the artists of this generation.

The framing arch consists of an elaborate *grisaille* molding, with *grisaille* and "real" putti adorning it on either side. This architectural element echoes Rizi's theatrical interests and provides a model for the type of scenographic altarpiece that would become popular in the Spanish capital and elsewhere in the later decades of the century. Indeed, the theater and the "theatrical" nature of art was of vital importance for late Baroque painting in Madrid. Many of the artists of this time were often as well known in their day for their stage scenery as for their paintings.

The type of ornate stage décor of which many paintings of this time are reminiscent had actually been initiated much earlier in the century in Madrid by Italian scenographers imported to design the sets for plays by Lope de Vega, Calderón de la Barca, and many others. Among the earliest of the Italian theatrical artists were Giulio-Cesare Fontana and Cosimo Lotti, who worked for the court in the 1620s.[31] Lotti's successor, Baccio del

Bianco, developed the art of complex perspectival illusion in stage scenery to an advanced degree. His designs for the sets of *Andromeda y Perseo*, for example, a play attributed to Calderón (the drawings for which are preserved at the Houghton Library at Harvard University), offer a valuable record of the artistry of the Italian Baroque stage as transported to Spain.[32]

Theatrical entertainments of other sorts were also enormously important in the everyday life of Spanish people at this time. Parades and *tableaux* celebrating the feast days of saints, as well as Holy Week and Corpus Christi processions occasioned the creation of sculptures, floats, and other works of art.[33] Triumphal entries of the monarchs also provided artists with ample opportunity to create spectacular examples of ephemeral design in the form of triumphal arches (often decorated with numerous paintings), flags and banners to be hung from buildings, and other types of public adornment. The entry of Queen Marie Louise, first wife of Charles II, into Madrid on January 13, 1680, was one of the most spectacular of such events in the late seventeenth century. A veritable army of architects, painters, and sculptors was employed to create a splendidly adorned route for the royal retinue to travel on its way through the capital city.[34]

Another public event, no less exuberant than a triumphal entry but certainly more solemn, presented Francisco Rizi with the occasion to paint his most ambitious multifigured work (which was also one of the artist's few secular pictures). The *Auto de Fe in the Plaza Mayor of Madrid* (1683) is a large painting (2.77 × 4.38 m.) representing the first such large-scale manifestation of the Inquisition's authority that had taken place in more than fifty years (fig. 5). A detailed history of the five-day event describes the participants, including the royal family seen at the balcony at the upper center portion of the picture as they sat at perfect attention for the duration of the grueling ceremony in which a large number of accused heretics were questioned and sentenced to die at a site far from the city's center.[35]

In Rizi's more characteristic religious paintings, such as the *Annunciation* (ca. 1670), which is one of at least four examples of this composition, few figures appear, yet the canvas is enlivened by pictorial movement and light, as strong dramatic tensions are established not only through the confrontation of the participants but by the swirling masses of drapery and clouds executed in the lively and sketchy fashion typical of Rizi and other late Baroque masters (fig. 6).[36]

Similar dramatic emotions and vibrant movement are observed in a work which epitomizes the style and "feeling" of late Baroque painting in Madrid. The *Apotheosis of St. Hermengild* (fig. 7), painted by Francisco de Herrera the Younger, represents a sixth-century Christian governor of Seville who attempted to withstand the invasion of his city by Arian Visigothic troops led by his father Liuvigild.[37] Hermengild and his forces were defeated and he suffered imprisonment and, subsequently, martyrdom. In this painting the saint is shown as a soldier of Christian steadfastness, crowned with roses and presented with a martyr's palm branch by putti, as music-making angels and other celestial beings inhabit the rest of the space. Below, an Arian bishop and general

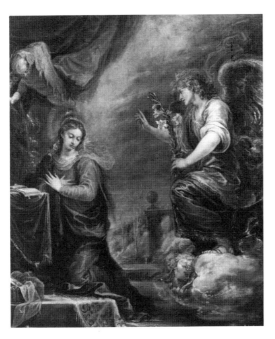

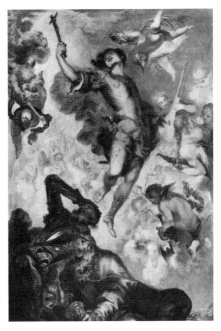

Figure 6. Francisco Rizi, *Annunciation*, oil on canvas. Madrid, Museo del Prado.

Figure 7. Francisco de Herrera the Younger, *Apotheosis of St. Hermengild*, oil on canvas. Madrid, Museo del Prado.

cower in fear. This painting, an obvious reference to the triumph of true belief over heresy, can also be understood as a symbol of the Spanish church upholding the faith at a time of constant menace from unorthodox practices, a theme developed in the work of many Spanish painters at the time. Herrera executed this picture in 1654 for the Church of the Unshod Carmelites in Madrid, where, as we are told by Palomino, he insisted that it be installed amidst a fanfare of horns and the clashing of cymbals.[38] This somewhat presumptuous stipulation gives us a hint of the artist's eccentricity and irascible character, traits which he undoubtedly inherited from his equally cantankerous father, who, according to tradition, had been the first teacher of Velázquez until his overbearing temper proved to be too distracting for the youthful pupil.[39]

Although he was born in Seville, in 1627, and received his early training there (presumably from his father), a number of his most important works were executed in Madrid, and he is rightly numbered among the painters who developed the characteristic late Baroque style of that city. He was expert in many fields, including architecture. His most noteworthy building design was the plan for the grandiose Church of El Pilar in Saragossa, which was ultimately executed, with numerous changes, by others. Herrera was appointed court painter by Philip IV, although his appointment was apparently not renewed by Philip's son Charles (possibly owing to Herrera's difficult personality). Nonetheless, he continued to do some work for the court theater. Herrera was undoubtedly one of the most successful royal stage designers, as a number of drawings for sets for Vélez

de Guevara's play *Los celos hacen estrellas* prove.[40] The production of this *zarzuela*, an entertainment with music performed at the theater of the Alcázar on December 22, 1672, as part of the birthday celebration for the Queen Mother Mariana, was the occasion for stage designs which show Herrera to have completely assimilated the contemporary manner of Italian perspectival scenery techniques.

One of Herrera's masterpieces is *The Dream of St. Joseph* (ca. 1670). A comparison between this painting (fig. 8 and Cat. no. 19) and a work with a similar subject, *The Dream of Jacob* (1639) by Jusepe de Ribera, will help to explain the new vigor in composition and excitement of color in paintings by artists working in Madrid in the later seventeenth century (fig. 9). In Ribera's picture the Old Testament figure reclines in a country setting as if taking an afternoon nap. His vision of the ladder of Heaven is simply suggested by a golden light in the clouds (in which several angels are faintly visible). The vision in the later work, however, becomes a highly palpable event. A youthful angel dramatically gestures to the tumbling, acrobatic putti holding symbols of the purity of the Virgin Mary. A dynamic arc is created that begins with the angel's outstretched finger and culminates in the toes of the recumbent saint. The chromatic harmonies evoked include bright, almost pastel shades of blue, red, pink, orange, and yellow.

Although Antonio Palomino stresses that many modern painters in Spain were able to perfect their art without making a voyage to Rome ("Velázquez," he says, "went to Rome not to learn but to teach"), still others did make the traditional pilgrimage to that artistic capital and studied the most up-to-date styles. Mazo and possibly Herrera had

Figure 8. Francisco de Herrera the Younger, *The Dream of St. Joseph*, oil on canvas. Norfolk, Virginia, The Chrysler Museum.

Figure 9. Jusepe de Ribera, *The Dream of Jacob*, oil on canvas. Madrid, Museo del Prado.

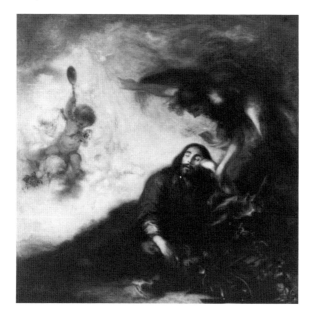

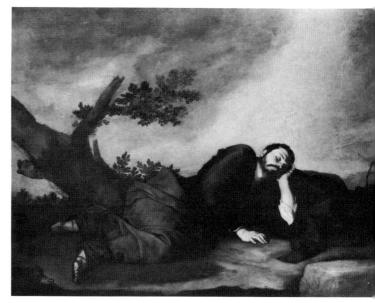

taken trips to Italy as did other less well-known figures such as José Jiménez Donoso and Sebastián Muñoz (who spent a number of years in the workshop of Carlo Maratta). On the whole, however, it was not so much the Italian works studied abroad but rather those that could be seen in Spanish collections that had such a significant impact on painters in late seventeenth-century Madrid and, together with the inspiration from Flemish art, caused a great change to be effected in painting in the Spanish capital after 1650. The presence of works by foreign artists in the royal palace in Madrid as well as in the great private collections of such patrons as the Marqués de Heliche and the Marqués del Carpio was by no means a recent phenomenon. Ever since the time of the "Catholic Kings" Ferdinand and Isabella, the taste in collecting at court had been eclectic, and works by foreigners were acquired with great alacrity. While the early Hapsburg monarchs Charles I and his son Philip II continued an already established interest in Flemish art, they also collected some of the greatest works of the Italian Renaissance masters, concentrating particularly on the Venetians. Titian's series of mythological works known as the *poesie* was created for his patron Philip II, who filled not only the palace at Madrid with masterpieces by Titian and others but also the grand monastery-palace complex which he had ordered built at the Escorial.

King Philip III continued to collect at a somewhat slower pace (although it was during his reign that Rubens made the first of two trips to Spain, in 1603), but acquisitive efforts increased enormously during the reign of Philip IV, who, as recent research has brought to light, should be recognized as one of Baroque Europe's most influential patrons.[41] During his reign the collections housed in the Alcázar were augmented, and splendid decorative ensembles were conceived and carried out for newly built royal residences. The decoration of the Buen Retiro has already been cited. That for the Torre de la Parada, the king's hunting lodge in the forest near Madrid, must also be pointed out, for it comprised a large series of pictures by Rubens and his workshop (as well as works by native artists such as Velázquez), which would have a fundamental impact upon the group of painters considered here.

While the coloristically rich and often flamboyant compositions of Rubens (of whom there were over sixty paintings in the Alcázar alone by 1682)[42] were of prime importance for the late Baroque painters of Madrid, there were other Flemish artists who greatly impressed their younger Spanish contemporaries. One of these, whose relationship to Spanish painters has been pointed out but not sufficiently studied, is Gaspar de Crayer.[43] The work of de Crayer, a disciple of Michael Coxie, was, like that of virtually all of his colleagues, closely inspired by Rubens. Along with Erasmus Quellinus, Cornelis de Vos, and Theodoor van Thulden, he had participated with Rubens in the decoration of the Torre de la Parada. In 1635 de Crayer entered the service of the Archduke of Flanders and was named *Pintor de Cámara* to the Cardinal Infante Ferdinand and later became *Pintor del Rey* to Philip IV. His numerous contacts with Spain have led some writers to suppose that he traveled there, but recent research on his life has disproven this hypothesis.[44]

Even more significant is the connection between the painters of the School of Madrid and Anthony Van Dyck. A strong dependence on the art of Van Dyck by Pereda, Juan Antonio Escalante, Claudio Coello, and others was pointed out by Trapier.[45] Although Van Dyck never came to Spain, his paintings were familiar to Spanish collectors and artists. Particularly instrumental in the introduction of Van Dyck's art into Spain was Diego Felipe de Guzmán, Marqués de Leganés, who was, for a time, Spanish ambassador in Genoa, where Van Dyck had lived and painted some of his finest pictures. Leganés (also a great collector of Rubens's work) was influential in obtaining numerous Spanish commissions for Van Dyck from such important patrons as the Condesa de Medellín and the Marqués del Carpio. It is also significant that works by Van Dyck which were admired by Spanish painters not only helped in transmitting to Spain the style of contemporary Flemish art, but carried with them a strong dose of Italian influence as well. As recently observed by Alan McNairn in his study of the artist's youthful career,

> By the time Anthony Van Dyck set out for Italy in the fall of 1621, he already possessed a considerable knowledge of Italian art. . . . In his youth he had developed a passion for the art of Titian . . . [who] appealed to the young Van Dyck as a kindred spirit because he was concerned not only with the perfection of pictorial design but also with the optical effects of paint. . . . For the sensitive Van Dyck, the study of Titian provided a counterpoise to his admiration of the solid, sculptural style of Rubens.[46]

Thus we see in the works of Van Dyck, so many of which were in Spain, an amalgam of the most predominant elements, Italian and Flemish, which account for the "new look" of late Baroque painting in Madrid.

The question of "delayed influence" must be taken into account in explaining the artistic changes in painting after 1650. Since the lifetimes of Titian, Tintoretto, Veronese, and other old masters, their works were collected by the Spanish monarchs. Paintings by Rubens and other Flemings were present in Spain for artists to admire and copy from the first decade of the seventeenth century. Why, then, was it only after 1650 (and, on a wider scale, after 1660) that painters in Madrid (and elsewhere in Spain, as in Andalusia) responded eagerly to the styles that would result in a true high Baroque mode in Spanish painting?[47] One of the major factors that inhibited the rise of a truly international Baroque style before the 1650s was the tenacity of the naturalistic manner, which had found great favor in Spain in the early part of the century. Since approximately the first decade, when the Mannerism of painters like El Greco fell out of favor, artists such as Pedro Orrente and Juan Sánchez Cotán in Toledo, Vicente Carducho and Eugenio Cajés in Madrid, Francisco Pacheco, and later, Diego Velázquez and Francisco de Zurbarán in Seville established a taste for realism that was to experience far greater longevity in Spain than it had in any other center of western European painting with the exception of Holland.[48]

Although the art of Velázquez developed away from the scenes of quotidian reality, which he had portrayed in his early career, he never fully embraced either a "High" or "Classical" Baroque mode (to use the terminology often employed in discussions of Ital-

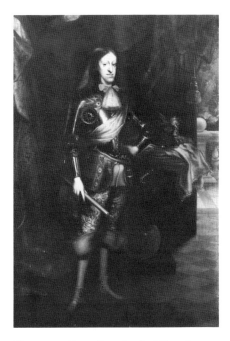

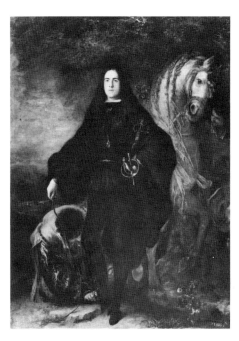

Figure 10. Juan Carreño de Miranda, *Portrait of King Charles II*, oil on canvas. New York, The Hispanic Society of America.

Figure 11. Juan Carreño de Miranda, *Portrait of the Duke of Pastrana*, oil on canvas. Madrid, Museo del Prado.

ian *seicento* painting). While not an "artistic dictator" like his Roman counterpart Bernini, Velázquez's reputation and his sober, straightforward style came to dominate art at mid-century, especially at the court. Until his death, artists in Madrid were reluctant to effect a change in completely new directions with the same enthusiasm that they seemed to have for embracing international styles afterward. Nonetheless, Velázquez's impact continued to be felt even long after 1660 in the works (especially the portraits) of a number of artists who were otherwise in the forefront of the avant-garde.

One of the most notable figures who played an important role in the development of the new style while remaining sensitive to the heritage of Velázquez was Juan Carreño de Miranda.[49] Velázquez and Carreño were, in fact, close friends and colleagues for over thirty years, and it was the older master's intervention that accounted for Carreño's receiving a number of private commissions as well as his posts at the court, where he later rose from *Pintor del Rey* (1669) to *Pintor de Cámara* (1671). He is perhaps best remembered for his numerous portraits of King Charles II, his mother Mariana of Austria, and his first wife Marie Louise of Orléans. Carreño's portrait of Charles is a perfect fusion of the idealized yet sober renditions of Philip IV by Velázquez (such as the so-called *Silver Philip* in the National Gallery, London, or the *Philip IV in Army Dress* in the Frick Collection, New York), with the additions of elegant drapery and classicizing architectural elements behind the king (fig. 10). The royal portraits by Carreño and other

official painters were always flattering to Charles, who had inherited the most unattractive of the Hapsburgs' physical traits.[50]

Carreño's debt to the art of Van Dyck has often been cited, and perhaps nowhere is it clearer than in the splendid image of the Duke of Pastrana (ca. 1666). This imposing portrait of the nobleman in black attended by two servants and standing before his splendidly bedecked steed is the essence of prideful *hidalguía* (fig. 11). Carreño establishes a feeling of nonchalant elegance very close to that evoked by Van Dyck in his portraits of Charles I of England, such as the famous *Charles at the Hunt* (ca. 1635) in the Louvre. Even more direct "quotes" from Flemish art are found in Carreño's religious paintings. Three of his most impressive canvases, *St. James Battling the Moors* (1660),[51] *The Martyrdom of St. Andrew* (ca. 1682),[52] and *The Assumption of the Virgin* (ca. 1646–48),[53] have been described by Pérez Sánchez as "glosses" on well-known compositions by Peter Paul Rubens, which, in at least one case, would have been known to the Spanish artist through a print by Bolswert.[54]

Carreño was also important as a fresco painter. Velázquez was instrumental in gaining for him the commission to paint mythological scenes in the Salón de Espejos in the Alcázar, which he executed in 1659. Much of his work in fresco was done in collaboration with Francisco Rizi, with whom he executed the ceiling painting of San Antonio de los Portugueses (1660), the *camarín* of the Dominican Chapel of Nuestra Señora de Atocha (1664), both in Madrid, and the vault of the octagonally shaped reliquary chapel (*ochavo*) in the cathedral of Toledo (1665). Of these projects, only that in San Antonio remains.[55] It is a lamentable fact that a great number of Baroque churches of Madrid, many of which were sumptuously decorated in fresco, were destroyed in the urban expansions of the nineteenth century and during the Spanish Civil War.

The fresco work of Carreño represents a significant chapter in the history of his career and, indeed, in the development of late Baroque painting in Madrid, for it was only at this time that the art of large-scale painting on walls achieved popularity in Spain. Unlike their counterparts in Italy, Spanish painters of the Renaissance and earlier phases of the Baroque period concentrated their efforts almost exclusively on easel painting. Although there are some examples of fresco by native masters prior to 1650, they are rare exceptions.[56] Velázquez himself is known to have had great interest and respect for the art but declined to practice it.[57] One of the reasons for his second trip to Italy was to attempt to engage the most prestigious decorator of the day, Pietro da Cortona, to come to Madrid to paint in the royal palace. Cortona refused the invitation but two of his colleagues, Agostino Mitelli and Michelangelo Colonna, were invited to Spain. These painters arrived in Madrid in 1658.[58] Mitelli was expert in the art of *quadratura*, a "particular Bolognese form of decorative surround used to enframe ceiling and wall fresco,"[59] while Colonna was a figure painter who executed the scenes surrounded by the fictive architecture.[60] They painted in several rooms of the royal palace and executed the decorations for the hermitage church of San Pablo on the grounds of the Buen Retiro as well as other projects. The intervention of Velázquez in the design of the programs for their

paintings was important, and it is almost certain that he recommended the subjects for the decorations in the Salón de Espejos in the Alcázar.[61]

The impact of these two Italian artists on the history of late Baroque decorative painting in Spain was enormous. Numbered among their pupils were the most prestigious painters of the day including Rizi, Carreño, Claudio Coello, Jiménez Donoso, and Herrera.[62] These artists not only assimilated the Bolognese manner in their own frescos, but applied the lessons they had learned from Colonna and Mitelli to their easel paintings, in which complex architectural settings are often found. The essentially north Italian fresco style survived well into the eighteenth century in the work of Antonio Palomino (in the charterhouses of Granada and El Paular and several churches in Valencia), Giacomo Bonavia (in the Palace of La Granja) and others, being replaced completely only in the 1760s by the Rococo style of Tiepolo.

The subject matter of late Baroque painting in Madrid (and all of Spain for that matter) was predominantly religious, as had traditionally been the case earlier. Certain themes were favored above others and Marian imagery was of enormous importance, with special emphasis given to depictions of the Immaculate Conception. The concept which this theme represents, that of the Virgin Mary as the only mortal person after Adam and Eve to have been born without the stain of original sin on her soul, was not yet official church dogma, and would not be proclaimed so until the nineteenth century. It was the cause of lively debate and discussion in Spain, with some ecclesiastical factions violently opposed to the idea, while the vast majority of others firmly believed in this miraculous aspect of the mother of Christ. Artists and theoreticians had devised certain formulae for the representation of the Virgin Immaculate which evolved through the years.[63] By the late seventeenth century the most typical images of the Immaculate Conception portrayed the Virgin as a mature woman, standing or floating amidst clouds, wearing voluminous (usually blue) drapery, accompanied by putti holding symbols of her purity (lilies, a mirror) and, at times, a serpent grasping an apple in its jaws.[64]

Murillo is usually considered the outstanding artist of this theme in late Baroque Spain. For many artists in Madrid, however, this was also a favorite subject. The painter who cultivated the image of Mary Immaculate with greater enthusiasm than any other artist of his generation was José Antolínez. Antolínez, born in Madrid in 1635, was one of the few major artists of his generation who did not work for the court.[65] His early training took place with Francisco Rizi, who introduced him to the flamboyant style of late Baroque painting in the Spanish capital. Like his contemporary Francisco de Herrera, Antolínez was noted for his bad manners and irascible temper. No hints of his impetuosity are to be found in his painting, however, for his work radiates sweetness, gentleness, and pious devotion. With an unbounding enthusiasm for Marian iconography, Antolínez painted over twenty-five versions of the Immaculate Conception (fig. 12). Most of them date after the mid-1660s and virtually pulsate with the energy of acrobatic cherubs and agitated drapery, all of which is offset by the reverent attitude of the Virgin herself.[66] As in other versions of this theme by Antolínez, there is a definite reliance upon the models of

his teacher Francisco Rizi, who also painted the Immaculate Conception with great zest. Also similar to Rizi's portrayals (while remaining perfectly recognizable in their own right) are Antolínez's three known versions of the Annunciation, in which the Virgin, like his other representations of female figures, displays distinctive anatomical features, including a small mouth, large almond-shaped eyes, and attenuated fingers.[67]

Among Antolínez's most excited and "Baroque" compositions are those of the transport of the Magdalen. Scenes of visions and ecstasy are as essential to Spanish Baroque art as they are to Italian, and a mood of heightened religiosity is created by Antolínez in his version of the theme (fig. 13), which is reminiscent of the most emotionally high-pitched works of artists such as Giovanni Lanfranco, Cortona, or Bernini. This painting represents a story from *The Golden Legend*, which relates that after the death of Christ, Mary Magdalen retreated to a desert spot for contemplation. Each day she would be visited by angels who would carry her to Heaven to enjoy celestial music and the presence of the saints. Thus she had no need of earthly sustenance. This theme was not treated exclusively by Antolínez, for the subject, as well as aspects of the style of this painting, are anticipated by the famous version by Ribera now in the Academia de San Fernando in Madrid, painted in 1636.

Among other female saints whose popularity with painters of the late Baroque in Madrid was strong was St. Catherine of Alexandria, the early Christian martyr who,

Figure 12. José Antolínez, *The Immaculate Conception*, oil on canvas. Barnard Castle, County Durham, England, The Bowes Museum.

Figure 13. José Antolínez, *Ecstasy of Mary Magdalen*, oil on canvas. Madrid, Museo del Prado.

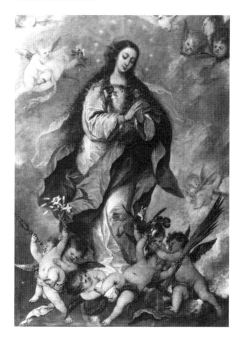

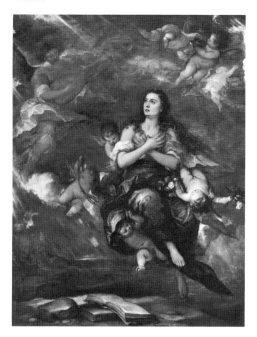

under orders of Emperor Maxentius, was tortured on a spiked wheel for refusing to submit her Christianity to pagan beliefs. The seventeenth century in Spain witnessed the creation of a number of paintings of Catherine standing triumphantly with her attribute, the broken wheel, above the recumbent Roman emperor (for example, by Claudio Coello, Cat. no. 13, and by Escalante in the Church of Sts. Justus and Pastor, Madrid). She is also shown frequently in the more pietistically serene activity of her mystic marriage to the Christ Child, as in a work by Mateo Cerezo (ca. 1660).[68] In this splendid painting, careful attention to detail is apparent in the embroidery of the saint's robes and in the still-life elements on the steps below the group (fig. 14). This meticulousness is contrasted to the free brushwork of the background. The painting, with obvious Rubensian inspiration, was done by an artist who was one of the many pupils of Carreño and worked in the royal palace, studying and copying the masterpieces of the collection. Like others of his generation he died young, at the age of forty, unable to fulfill the precocious promise of his youth. This *Mystic Marriage* (of which there is another version in the cathedral of Pamplona)[69] served as a prototype for several *sacre conversazioni* by the painter who is recognized as the greatest master of his age in Madrid, an artist who was a worthy heir to the reputation of Velázquez, Claudio Coello.[70]

Coello's painting of the *Holy Family Adored by St. Louis of France and other Saints* (fig. 15) is one of two such works, both in the Prado and both from ca. 1665–68. While

Figure 14. Mateo Cerezo, *Mystic Marriage of St. Catherine*, oil on canvas. Madrid, Museo del Prado.

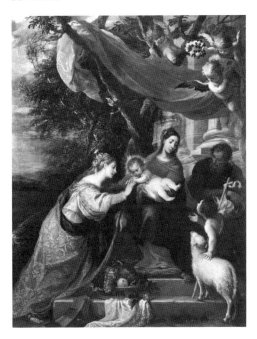

Figure 15. Claudio Coello, *Holy Family Adored by St. Louis of France and other Saints*, oil on canvas. Madrid, Museo del Prado.

Figure 16. Claudio Coello, *Triumph of St. Augustine*, oil on canvas. Madrid, Museo del Prado.

Cerezo's *Mystic Marriage* may have served as the immediate precedent, the ultimate source of this and other paintings by Coello must be sought in the art of Rubens. The Flemish master's great *Virgin and Child Adored by Saints* (1628) in the Church of St. Augustine, Antwerp, with the Holy Family posed before draped classical columns approached by saints bearing their attributes, is the primary image which gave rise to a number of Spanish depictions of sacred groups. In the case of Coello the connection to Rubens is somewhat more direct than in that of other painters in the period under consideration here. As Julius Held has recently shown, the Spanish artist's early large-scale commission for the altarpiece of the Benedictine Church of San Plácido in Madrid was derived from a sketch made by Rubens during his second visit to Spain.[71] The *Incarnation as Fulfillment of All Prophecies* (1668) was a rare subject for seventeenth-century painters. It is a theme whose great iconographic complexity was fully developed by Rubens in his sketch for an unexecuted project which later served the twenty-six-year-old Coello in his monumental painting for San Plácido.[72]

 Coello, like others of his generation, gained his knowledge of the art of the past from the royal collections. Although there have been attempts to prove that he made a journey to Italy, it is almost certain that Coello never traveled abroad.[73] Born in Madrid in 1642 of Portuguese parents, he studied painting, drawing, and, most likely, stage design with Francisco Rizi who, as court painter, allowed his pupil access to the king's galleries. By

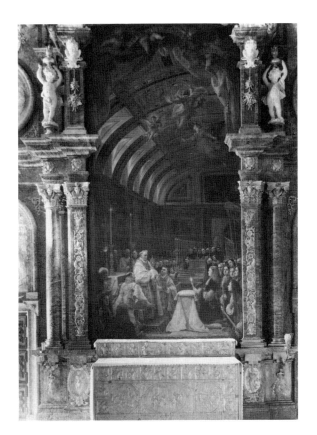

Figure 17. Claudio Coello, *Sagrada Forma*, oil on canvas. El Escorial, Monastery of San Lorenzo.

1666 Coello was already being given independent commissions such as that for the high altar in the Church of Santa Cruz, Madrid,[74] and a *Triumph of St. Augustine* for the Convent of the Agustinos Recoletos in Alcalá de Henares (fig. 16). The *St. Augustine*, with its upward, "corkscrew" movement, emotional excitement, and light, almost pastel colors, perfectly embodies the style of Claudio Coello. While calling to mind certain paintings by Coello's Spanish contemporaries such as the *St. Hermengild* by Herrera the Younger, it is equally close to works by late Baroque painters in Italy such as Giovanni Battista Gaulli and Andrea Pozzo.

Coello was also heir to the manner of Italianate fresco painting introduced into Madrid by Colonna and Mitelli. His career as a muralist began in the early 1670s with the decoration of the vestry of the cathedral of Toledo, in collaboration with José Jiménez Donoso (completed in 1674). The vast majority of his many works in this medium has been destroyed although a few (such as the decorations in La Mantería, Saragossa, and the Casa Panadería in the Plaza Mayor of Madrid) remain and serve to give us a hint of his excellence in fresco painting.

Claudio Coello's position as one of the most important artists in the capital had been secured by the early 1680s. He executed his first work for the Crown in 1680, when he designed a series of arches for the *joyeuse entrée* of Queen Marie Louise into Madrid, and in 1683 he was named *Pintor del Rey*. Three years later he received the more prestigious post of *Pintor de Cámara*. As official court artist he was obliged to execute a number of portraits of the royal family. The *Sagrada Forma* or *King Charles II and His Court Adoring the Eucharist* (fig. 17) is the most significant group portrait painted by Coello and marks a watershed in Spanish Baroque art. It is the painter's largest work on canvas (measuring approximately five meters in height and three in width) and is in its original position above the altar in the sacristy of the Escorial. The *Sagrada Forma*, often cited as the last major painting of the seventeenth century in Spain, is a work of enormous visual richness and iconographic complexity. The principal theme is that of the triumph of the Eucharist and the steadfastness of the Spanish church under the guidance of the Hapsburg monarch. The Host, which the prior of the monastery, Fray Francisco de los Santos, holds in an elaborate gold monstrance, is a sacred relic that had formerly belonged to a church in the Netherlands, where it was desecrated by Protestant heretics in the sixteenth century. When the nails of the heretic's boot pierced the wafer, blood miraculously issued forth from three holes. The Eucharist was preserved by local ecclesiastical authorities and eventually given as a gift to King Philip II, who donated it in turn to the Escorial where it is still preserved.[75]

Coello's painting, while a highly original image, has a number of visual precedents in the treatment of space (Velázquez's *The Maids of Honor*) and general theme (Pedro Ruíz González's *King Charles II Before the Sacrament*, Cat. no. 41).[76] This huge composition, which records an historic event (the transference of the Host from the main altar of the church to that of the sacristy), virtually mirrors the very room in which it is placed, for the architecture of the sacristy has been repeated exactly in the painting.[77] Here, the sacred drama enacted by the king and members of his court becomes itself the subject of the picture. The adoration of the wafer takes place behind parted curtains, as both heavenly and earthly spectators witness the proceedings. Yet the *Sagrada Forma* is more than a recreation of a dramatic event. The picture itself serves as a stage curtain and an integral element in a eucharistic drama which occurs twice a year. The painting is not a stationary, but a moveable object, having been painted on a canvas attached to a pulley so that it can be lowered into the floor below twice a year, on the feast of St. Michael the Archangel and on that of Sts. Simon and Jude, revealing in a gold monstrance the same Host which in the painting is adored by the king and his retinue. Thus art, religion, and sacred theater play inextricably connected roles in creating a highly intellectual *Gesamtkunstwerk*. The *Sagrada Forma* may stand, then, both as a principal monument of seventeenth-century Spanish art and as a paradigm of the highly sophisticated interrelationship of painting and theater that is at the heart of so many examples of late Baroque art in Madrid.

Although Claudio Coello often included beautiful still-life passages in his figure

compositions, there is no independent still life recorded as by his hand. This is not surprising, however, since still life was considered a genre of secondary importance in the Golden Age. Francisco Pacheco in his *Arte de la pintura* (published in Seville in 1649)[78] stated that the painting of flowers (and fruits) "can be very entertaining.... But painters should try to put greater care in painting living things, such as figures and animals which are more highly thought of."[79] This is not to say that there were not excellent still-life painters in Spain at this time. Among the artists who had flourished in this genre in Pacheco's day were Juan Sánchez Cotán, Juan van der Hamen, and Antonio Mohedano. In the later seventeenth century a number of painters throughout Spain carried on this tradition.[80] In Madrid, flower painting claimed a particularly important position in the work of such artists as Juan de Arellano, Bartolomé Pérez, and Gabriel de la Corte. Like others, these painters created both wreaths of flowers surrounding religious subjects (*guirnaldas*) or simply vases and baskets of flowers of many different types. While the former category has obvious religious significance, it is known that commissions were also given to still-life painters by churches for *floreros* to be hung in sanctuaries along with religious figure paintings. Since antiquity, flowers have had iconographic significance, and it seems likely that many of the flower paintings by Spanish artists retained at least a covert symbolic meaning.[81]

It has often been stated that the early seventeenth-century tradition of still life in Spain derives primarily from Dutch and Flemish sources.[82] Recently, however, Eric Young has made a case for the early development of still life to have sprung from an indigenous source before 1600.[83] But as far as later seventeenth-century flower painting in Spain is concerned, foreign inspiration cannot be doubted. Arellano's abundantly varied floral arrangements can be easily related both to similar compositions by Flemish masters such as Daniel Seghers and to the work of such Italian still-life painters as Mario Nuzzi. The latter was a Roman master whose spontaneous exuberant style earned him significant commissions from the Spanish crown to paint flower pictures for the Buen Retiro and other palaces. His work was very popular in Madrid and was emulated with great enthusiasm by Arellano, Pérez, and their contemporaries.[84]

The depiction of *vanitas* themes was another important category of still life developed by seventeenth-century Spanish masters. One of the most remarkable practitioners of this genre was Antonio de Pereda. His *Knight's Dream* (ca. 1660) presents a plethora of worldly objects including playing cards, jewels, musical manuscripts, armor, coins, and books as reminders of the swift passage of earthly life (fig. 18). The skulls, clock, flowers, and extinguished candle remind the viewer, as does the message on the banderole held by the angel (AETERNE PVNGT — CITO VOLAT ET OCCIDIT, "It pierces perpetually — flies quickly through the air and kills") that life is but a dream, a moment in eternal time. In many *memento mori* images painted in seventeenth-century Spain, the concepts present in painting and contemporary literature experience a closer convergence than in any other instance. The theme of *desengaño* or disillusion with temporal life is a leitmotif found constantly in the works of both major and minor writers of the time. From Cervantes's

Don Quijote to Calderón de la Barca's *La vida es sueno*, authors stress the importance of looking beyond the fallacious appearances of the present to the more certain world of the next life. Such works as Pereda's *vanitas* pictures, as well as those by Valdés Leal in Seville, have often been connected to the concepts inherent in the Calderonian world view.[85]

In the various histories of Spanish art Claudio Coello is cited as the last in line of Golden Age painters. In 1692 Luca Giordano arrived in Madrid, summoned by Charles II to execute fresco projects in the Buen Retiro and the Escorial. Giordano undoubtedly presented Coello with his greatest competition, and the supposed rivalry between the two gave rise to Palomino's assertion that Coello died of a broken heart after refusing to paint any longer for the court. While this story is probably exaggerated—Coello did paint an impressive *Martyrdom of St. Stephen* for the Church of San Esteban in Salamanca, a work much admired by Giordano himself—it can be said with relative certainty that Giordano's "new style" (especially in fresco painting, in which airy compositions with even brighter colors than before was the rule) represented a harbinger of things to come in the eighteenth century, which, in Spain, was dominated by foreign artists. Nonetheless, the late Baroque style as developed by Rizi, Carreño, Cerezo, and others did not abruptly cease in 1693, when Claudio Coello died in Madrid. It was continued in both easel and fresco painting by many artists. The majority of these, including Coello's followers Sebastián Muñoz, Vicente Berdusán (or Verdusán),[86] and Isidoro Arredondo[87] were de-

Figure 18. Antonio de Pereda, *Knight's Dream*, oil on canvas. Madrid, Real Academia de Bellas Artes de San Fernando.

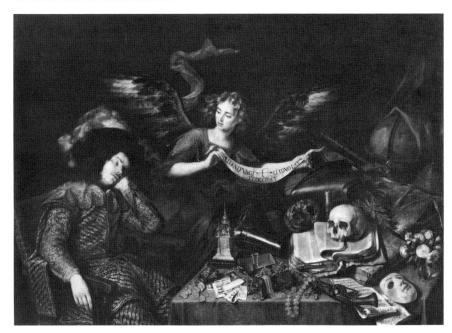

cidedly minor figures. One distinguished painter who carried this style well into the eighteenth century was Palomino. Born in Bujalance in the province of Córdoba, Palomino was a peripatetic figure who painted in many parts of the Iberian Peninsula. In 1688 he was named *Pintor del Rey*, having already executed a number of works for the Crown, including a series of frescos in the Alcázar in collaboration with his friend and teacher Claudio Coello. Throughout the rest of his life he proudly signed his works *Regis Pictor*. Palomino is, nonetheless, much better remembered for his theoretical and practical treatise and biographies of famous Spanish artists, published between 1715 and 1724 with the title *Museo pictórico y escala óptica*.

Palomino's book is enormously useful and informative and is referred to in virtually every study of Spanish Renaissance and Baroque art for its information on the lives of the most eminent painters, sculptors, and architects. The sections containing practical and theoretical advice to artists, however, are hardly as well known and have often been denigrated by scholars of art theory. The opinion that aesthetic treatises written by Spanish authors during the Baroque period were derived almost exclusively from Italian theory is a fallacious notion which has existed for many years.[88] Only recently, with the studies of Julián Gállego, Fernando Calvo Serraller and others, is there a growth of interest in Spanish art theory of the seventeenth century and a recognition of its intrinsic merits.[89] Among the theoretical works that have been accorded renewed attention is José García Hidalgo's *Principios para estudiar el nobilísimo arte de la pintura*, published in 1693.[90]

García Hidalgo, a painter in the orbit of Coello, is one of the shadowy transitional figures who worked in Madrid at the turn of the eighteenth century.[91] Born around 1642, he arrived in the capital some time before 1674, having spent several years studying in Rome with Cortona, Maratta, Giacinto Brandi, and Salvator Rosa (according to Ceán Bermúdez). After further training in Madrid with both Carreño and Rizi, he began his own career with a series of paintings for the Church of San Felipe el Real. Although distinguished as a painter (he was made *Pintor de Cámara ad honorem* by Philip V in 1703), he is equally interesting both for his lengthy treatise and for the academy which he established in his studio. We have very little precise information on this academy, but its mere existence is an important fact. Spain, unlike France or Italy, did not have any officially recognized artistic institution until the mid-eighteenth century. Small private instructional academies (such as the drawing academy co-founded by Murillo and Herrera the Younger in Seville) were in existence, however, in the seventeenth century. A print accompanying the text of García Hidalgo's book shows a scene in his school (fig. 19). Artists are drawing a nude male model from life, while plaster casts rest on a shelf at the back of the studio, showing us that Spanish artists of this period shared the same concern for anatomical study as did their counterparts in other countries. This print gives us insight into the academic practices that would be codified in Spain only many years later with the establishment in Madrid of the Academia de San Fernando (and similar academies in other cities) under the impulse of Anton Rafael Mengs. In the following century these concerns with drawing from the model and from casts of antique

Figure 19. José García Hidalgo, *Drawing Academy*, engraving. From *Principios para estudiar el nobilísimo arte de la pintura*.

sculpture would become universal and form the basis of training for all artists, including the next native-born genius to achieve international fame, Francisco de Goya.

The late Baroque period in Madrid witnessed the flowering of many talented artists. Although none of them reached the level of genius of Velázquez, figures such as Carreño, Rizi, and Coello were extremely accomplished and contributed enormously to the continued development and the internationalization of Spanish Golden Age painting. Overshadowed by the towering artistic personalities of Velázquez and Goya, the critical fortunes of these masters have also suffered for belonging to a period whose social history was rife with decay. The era of Charles II, while perhaps not as decadent as generally believed, was nonetheless a time of serious economic decline for Spain. Monetary difficulties prohibited the large-scale art patronage of earlier times on the parts of both the Crown and private individuals. Although impressive decorative projects were undertaken in the Alcázar and elsewhere, nothing as splendid as the creation of a new royal palace (such as the Buen Retiro built in Philip IV's time, for example) was commenced. Our knowledge of the art of this period has also been severely hampered by the loss of so many of the great works of fresco decoration, in which this generation excelled. Yet with the aid of the few cycles that remain, and through a careful study of the artists' splendid easel paintings as well as their drawings, we can reconstruct this rich and aesthetically fulfilling chapter in the history of Spanish art.

Notes

1. On Velázquez and Italy, see Enriqueta Harris, "Velázquez en Roma," *Archivo Español de Arte*, 31 (1958), pp. 185–192 and "La misión de Velázquez en Italia," ibid., 33 (1960), pp. 109–136.

2. The documents admitting Velázquez to the Congregazione dei Virtuosi al Pantheon are dated Feb. 13 and 27, 1650. They are transcribed in part in *Velázquez. Homenaje en al tercer centenario de su muerte* (Madrid, 1960), pp. 272–273. It should be noted that Velázquez was admitted to these organizations before doing the portrait of Pareja (which is now in the Metropolitan Museum of Art, New York; the portrait of Innocent x is in the Galleria Doria-Pamphili, Rome).

3. These landscapes have also been dated to the artist's second Italian trip. For the most recent discussion and summary of the opinions regarding the dating of these pictures see Harris, "Velázquez and the Villa Medici," *Burlington Magazine*, 123 (1981), pp. 537–541. Both paintings are in the Prado.

4. A letter from King Philip to the Spanish ambassador in Rome; the *Duque del Infantado* is reproduced in *Velázquez. Homenaje*, p. 273.

5. José López-Rey, in *Velázquez' Work and World* (London, 1968), p. 125, dates *The Spinners* (also known as the *Fable of Arachne*) at 1648, prior to the artist's second Italian journey. Judging by the extreme looseness of technique, however, a later dating seems more likely. Both paintings are in the Prado.

6. Velázquez was made *Ayuda de Cámara* in 1643, and in 1646 was granted the title *Ayuda de Cámara con Oficio de Entrada*.

7. See Jonathan Brown, *Images and Ideas in Seventeenth-Century Spanish Painting* (Princeton, 1978), pp. 103–110, for a discussion of Velázquez's efforts to gain admission to the Order of Santiago.

8. On Velázquez as architect, see Antonio Bonet Correa, "Velázquez, arquitecto y decorador," *Archivo Español de Arte*, 33 (1960), pp. 215–249.

9. Xavier de Salas, "Rubens y Velázquez," *Museo del Prado, Studia Rubenniana* (Madrid, 1977), vol. 2, n. pag.

10. On Leonardo, see María Angeles Mazón de la Torre, *Jusepe Leonardo y su tiempo* (Saragossa, 1977).

11. See J. Brown and J. H. Elliott, *A Palace for a King: The Buen Retiro and the Court of Philip IV* (New Haven, 1980).

12. Acisclo Antonio Palomino de Castro y Velasco, *Museo pictórico y escala óptica* (Madrid, 1724; facsimile ed., Madrid, 1947), p. 962.

13. For a discussion of the cityscape in Spain, see Richard J. Wattenmaker, *The Dutch Cityscape in the 17th Century and its Sources* (Amsterdam and Toronto, 1977), pp. 23–24 and Brown, "El Greco's 'View of Toledo,'" *Portfolio* (Jan.-Feb., 1981), pp. 34–38.

14. Elizabeth Du Gué Trapier, "Martínez del Mazo as a Landscapist," *Gazette des Beaux Arts*, 56 (1963), pp. 293–310.

15. Documents relating to this journey were first published by María Luisa Caturla, "Sobre un viaje de Mazo a Italia hasta ahora ignorado," *Archivo Español de Arte*, 28 (1955), pp. 73–75.

16. For extensive documentation concerning the marriage of Velázquez's daughter Francisca to Mazo, see José López Navío, "El matrimonio de Mazo," *Archivo Español de Arte*, 33 (1960), pp. 387–419. This painting may have been done after Francisca's death, in which case Mazo's second wife Francisca de la Vega is depicted.

A recent discussion of this work in the catalogue for the exhibition, *Pintura española de los siglos XVI al XVIII en colecciones centroeuropeos* (Madrid, 1981–82), pp. 76–77, proposes that the older woman in the picture is indeed Mazo's second wife, identifies the children, and states that the later date is the most plausible one.

17. George Kubler and Martin Soria, *Art and Architecture in Spain and Portugal and Their American Dominions 1500–1800*, Pelican History of Art (Harmondsworth and Baltimore, 1959), p. 286.

18. It has traditionally been stated that Pareja was the slave of Velázquez. This is refuted by Juan Antonio Gaya Nuño, "Revisiones sexcentistas, Juan de Pareja," *Archivo Español de Arte*, 30 (1957), pp. 273–274.

19. Palomino, *Museo pictórico*, p. 960; Juan Agustín Ceán Bermúdez, *Diccionario histórico de los más ilustres profesores de las bellas artes en España* (Madrid, 1800; modern ed., Madrid, 1965), vol. 4, p. 50.

20. At the end of his biography of Pareja, Palomino, *Museo pictórico*, p. 961, mentions that the artist was especially gifted as a portraitist. Only one portrait has been attributed to him, that of the artist José Ratés (in a private collection in Loja, Granada, illustrated in Gaya Nuño, "Revisiones," pl. v), If this is indeed a work by Pareja, it would seem as if he had absorbed some of the lessons of his master in this genre.

21. On Pereda see Elías Tormo y Monzó, *Un gran pintor vallisoletano: Antonio de Pereda* (Valladolid, 1916) and Alfonso E. Pérez Sánchez, *Don Antonio de Pereda (1611–1678) y la pintura madrileña de su tiempo*, exh. cat. (Madrid, 1978–79).

22. Pérez Sánchez, *Don Antonio de Pereda*, n. pag.

23. On Crescenzi and his relationship to Pereda and other contemporary artists, see René Taylor, "Juan Bautista Crescencio y la arquitectura cortesana española," *Academia*, 48 (1979), pp. 63–126.

24. Carducho (1576–1638) was a key figure in the development of naturalism in early seventeenth century Spain and a teacher of numerous disciples. See Angulo and Pérez Sánchez, *Historia de la pintura española, pintura madrileña, primer tercio del siglo XVII* (Madrid, 1969), pp. 86–189 and Mary Crawford Volk, *Vicencio Carducho and Seventeenth Century Castilian Painting* (New York, 1977).

25. On Rizi, see Angulo, "Francisco Rizi. Su vida. Cuadros religiosos fechados anteriores a 1670," *Archivo Español de Arte*, 31 (1958), pp. 89–115; "Francisco Rizi. Cuadros religiosos posteriores a 1670 y sin fechar," *Archivo Español de Arte*, 35 (1962), pp. 95–122; "Francisco Rizi. Cuadros de tema profano," *Archivo Español de Arte*, 44 (1971), pp. 357–387 and "Francisco Rizi. Pinturas murales," *Archivo Español de Arte*, 47 (1974), pp. 361–382.

26. Quoted in Angulo, *Pintura del siglo XVII*, Ars Hispaniae (Madrid, 1971), vol. 15, p. 233.

27. The four articles by Angulo (see note 25) form the basis for a monograph and most of the works are listed there. More work needs to be done, however, on Rizi's influence and his disciples. On Rizi see also Jesús Urrea Fernández, "Una nueva obra de Francisco Rizi," *Boletín del Seminario de Estudios de Arte y Arqueología*, 44 (1978), pp. 500–502.

28. See Tormo and Enrique Lafuente Ferrari, *Fray Juan Ricci* (Madrid, 1930).

29. Illustrated in Angulo, *Pintura del siglo XVII*, p. 232, fig. 221.

30. Palomino, *Museo pictórico*, p. 1018.

31. On stage design at the Spanish court in the seventeenth century see Angel Valbuena Prat, "La escenografía de una comedia de Calderón de la Barca," *Archivo Español de Arte*, 6 (1930), pp. 1–16 and N. D. Shergold, *A History of the Spanish Stage from Medieval Times until the End of the Seventeenth Century* (Oxford, 1967), pp. 264–330.

32. See Phyllis Dearborn Massar, "Scenes from a Calderón Play by Baccio del Bianco," *Master Drawings*, 15 (1977), pp. 365–375.

33. For an excellent discussion of Corpus Christi festivals and the works of art created for them see Vicente Lleó Cañal, *Arte y espectáculo. La fiesta del Corpus Christi en Sevilla en los siglos XVI y XVII* (Seville, 1975).

34. A description of this event was published in an anonymous pamphlet, *Descripción verdadera y puntual de la real majestuosa y pública entrada que hizo la Reyna nuestra señora doña María Luisa de Borbón desde el Real Sitio del Retiro hasta su real palacio el sábado 13 de enero de 1680 con la explicación de los arcos y demás adornos de su memorable triunfo* (Madrid, 1680). See also Conde de Polentinos, "Arcos para la entrada en Madrid de la reina Da. María Luisa de Borbón, primera mujer de Carlos II," *Boletín de la Sociedad Española de Excursiones*, 28 (1930), p. 101.

35. *Relación del Auto General de la Fe que se celebró en Madrid en presencia de sus majestades el día 30 de junio de 1680 dedicado al Rey Nuestro Señor Carlos Segundo* (Madrid, 1680), quoted in Angulo, "Francisco Rizi. Cuadros de tema profano," pp. 359–369.

36. See Santiago Alcolea, *Pinturas de la Universidad de Barcelona. Catálogo* (Barcelona, 1980), pp. 106–107.

37. On Herrera see Brown, "Herrera the Younger: Baroque Artist and Personality," *Apollo* (July 1966), pp. 34–43.

38. Documents proving the date of execution of the *St. Hermengild* were published by Caturla, "La verdadera fecha del retablo madrileño de San Hermenegildo," *Actas del XXIII Congreso Internacional de Historia del Arte*, 3 (Granada, 1978), pp. 49–55.

39. Velázquez's apprenticeship with Herrera has never been proven, although it is stated in Palomino's biography of the artist.

40. Juan Vélez de Guevara, *Los celos hacen estrellas*, ed. J. E. Varey and N. D. Shergold (London, 1970). The drawings, now mostly in the Oesterreichisches Nationalbibliothek, Vienna, are discussed in the Introduction, p. XXXVII–XLIII.

41. See Brown and Elliott, *A Palace for a King*, for information on royal patronage. Brown is currently preparing a study on Philip IV as patron and Marcus Burke is preparing a study on private patronage in Spain during the Baroque period.

42. Yves Bottineau, "L'Alcazar de Madrid et l'inventaire de 1686. Aspects de la cour d'Espagne au XVII siècle," *Bulletin Hispanique*, 58 (1956), p. 437.

43. See Hans Vlieghe, *Gaspar de Crayer, sa vie et ses Oeuvres* (Brussels, 1972).

44. According to Matías Díaz Padrón, *Museo del Prado, Catálogo de pinturas. I. Escuela flamenca, siglo XVII* (Madrid, 1975), p. 86, no concrete proof exists to substantiate a Spanish trip for de Crayer.

45. Trapier, "The School of Madrid and Van Dyck," *Burlington Magazine*, 99 (1957), pp. 265–273.

46. Alan McNairn, "Van Dyck and Italian Art," in *The Young Van Dyck*, exh. cat. (Ottawa, 1980), pp. 18–20.

47. The assertion that Spanish artists became interested in Venetian Renaissance and Italian and Flemish Baroque art only after 1650 is perhaps a generalization. We do perceive in some of the paintings of Velázquez (especially in his religious compositions such as the *Sts. Anthony and Paul* or the *Coronation of the Virgin*) a response to Rubensian color and figure types without, however, the overt emotionalism of Rubens. In his portraiture there is also a debt to Rubens, one of the most obvious points of contact being Velázquez's equestrian portraits of Baltasar Carlos, Olivares, or Philip himself. Velázquez executed a now-lost equestrian portrait of the king which was closely modeled after a Rubens composition of 1628–29.

Among the numerous Italian sources in Velázquez one may cite the inspiration of Titian's reclining Venuses for the London *Venus at her Mirror*, the Guercinesque figure types in *Joseph's Bloody Coat* in the Escorial as well as the quotes from famous compositions by Veronese, Michelangelo, and others cited by Angulo in *Velázquez cómo compuso sus cuadros principales* (Seville, 1947). There are also instances of such borrowings in the art of Alonso Cano and others, although in general, it is fair to say that a true international Baroque style based on a more general assimilation of these sources did not occur until later in the century.

48. In Rome, for example, Caravaggesque realism was no longer practiced by native artists after ca. 1620 although it continued to be a mode of expression popular among foreign artists both there and in provincial centers such as Naples. In France, realist styles also flourished into mid-century and beyond, although not in Paris where classicism developed under the influence of Vouet and, later, Poussin.

49. On Carreño see Rosemary Anne Marzolf, "The Life and Work of Juan Carreño de Miranda (1614–1685)," Ph.D. diss., University of Michigan, 1961) and Jesús Barettini Fernández, *Juan Carreño, pintor de cámara de Carlos II* (Madrid, 1972).

50. Although both Velázquez and Carreño idealized the king, neither was adverse to portraying deformed individuals with no attempt at beautification as in, for example, the famous series of court dwarf portraits by Velázquez, and Carreño's well-known depictions of the grotesquely obese child Eugenia Martínez Vallejo clothed and nude, both in the Prado. Such images as these are part of a long tradition of Spanish portrayals of grotesque figures in art. See Erika Tietze-Conrat, *Dwarfs and Jesters in Art* (London, 1957), and J. Moreno Villa, *Locos, enanos, negros y niños palaciegos* (Mexico, 1939).

51. Illustrated in Marianne Haraszti-Takács, *Spanish Masters* (Budapest, 1966), no. 27; in the Szépmúvézeti Múzeum, Budapest.

52. Illustrated in Pérez Sánchez, "Rubens y la pintura barroca española," *Goya* (Sept.-Dec. 1977), p. 105; in the Carmelite convent, Alcalá de Henares.

53. Ibid., p. 104; in the Wielkopolski Muzeum, Poznan, Poland.

54. Ibid., p. 107. Carreño's *St. James* is based on Rubens's *St. George and the Dragon* which was acquired for the Spanish royal collection during the lifetime of Philip IV. The *Martyrdom of St. Andrew* is based on a composition of the same subject by Rubens which, in 1639, was installed in the Hospital de los Flamencos in Madrid and which had an enormous impact on contemporary painters. Carreño would not have seen any of Rubens's versions of the Assumption but would have relied on Bolswert's print which is closest to the version in the cathedral of Antwerp.

55. The original designs for the San Antonio frescos were by Michelangelo Colonna and Agostino Mitelli. The discussion of these frescos in Marzolf, "Carreño," pp. 44–49, stresses the poor technique used by Carreño (and Rizi) which has caused the paintings to severely deteriorate. The precarious state of the paintings might have been realized even in the late seventeenth century by Luca Giordano, who retouched them and added scenes of his own.

56. In the earlier sixteenth century fresco decorations in Spain were executed by artists who had studied in Italy such as Juan de Borgoña who was in the workshop of Ghirlandaio in Florence and painted in the Sala Capitular in the cathedral of

Toledo between 1509 and 1511; and Gaspar Becerra, a pupil of Michelangelo who worked in the Alcázar of Madrid and in the palace of El Pardo, painting scenes of the Perseus legend.

Between 1567 and 1594 a number of Italian artists were called to Spain to decorate the Escorial. See Eusebio Julián Zarco Cuevas, *Los pintores italianos en San Lorenzo El Real de El Escorial* (Madrid, 1932). Their Tuscan late Mannerist style of mural painting was continued by Jerónimo de Cabrera in El Pardo and by Carducho and Eugenio Cajés in the cathedral of Toledo.

57. Ebria Feinblatt, in *Agostino Mitelli Drawings: Loan Exhibition from the Kunstbibliothek, Berlin* (Los Angeles, 1965), n.pag., refers to Jusepe Martínez's assertion that "Velázquez…was…'inimical' to fresco painting because of its inherent difficulties and demands."

58. On Colonna and Mitelli in Spain see Karl Justi, *Velázquez y su siglo* (Madrid, 1953), pp. 595–604; also see Harris, "Angelo Michele Colonna y la decoración de San Antonio de los Portugueses," *Archivo Español de Arte,* 34 (1961), pp. 101–105, and Feinblatt, "A 'Boceto' by Colonna-Mitelli in the Prado," *Burlington Magazine,* 107 (1965), pp. 349–357.

59. Feinblatt, *Agostino Mitelli,* n.pag.

60. Colonna also participated in the painting of *quadratura.*

61. No fully accepted project by Colonna and Mitelli survives in Spain. The grand staircase in the Convent of the Descalzas Reales in Madrid has been attributed alternately to the Italians and to anonymous Spanish painters. See Feinblatt, "A 'Boceto,'" p. 357, and Jesús Juan Garcés, *El museo madrileño de las Descalzas Reales* (Madrid, 1969), p. 21.

62. These artists worked primarily for religious and royal institutions in Madrid yet the major surviving examples of their work exist outside the capital with the exceptions of the paintings in the Descalzas, San Antonio, and a series by Rizi in San Plácido. See, for example, the frescoed ceilings by Rizi, Carreño, and Coello in the cathedral of Toledo and the decoration of the Church of San Roque ("La Mantería") in Saragossa by Coello and Sebastián Muñoz, discussed by Manuel Chamoso Lamas in his "Las pinturas de las bóvedas de la Mantería de Zaragoza, obra de Claudio Coello y de Sebastián Muñóz," *Archivo Español de Arte,* 17 (1944), pp. 370–384.

63. See the forthcoming doctoral dissertation (New York University, Institute of Fine Arts) by Suzanne Stratton on the iconography of the Immaculate Conception in Spanish painting from the Middle Ages to 1700.

64. For a repertory of Immaculate Conception images see Manuel Trens, *María, iconografía de la Virgen en el arte español* (Madrid, 1947).

65. See Angulo, *José Antolínez* (Madrid, 1957), for a discussion of the artist's career and further bibliography.

66. Many of the Immaculate Conception paintings by late Baroque artists were anticipated by Ribera's great version of 1636 in the Church of the Augustinians in Salamanca with its lively color and the animated attitudes of the figures.

67. Rosario (Argentina), private collection; Madrid, Museo Cerralbo; and Saragossa, Church of El Pilar.

68. See Tormo, "Mateo Cerezo," *Archivo Español de Arte y Arqueología,* 3 (1927), pp. 113–128 and 245–274; José Rogelio Buendía, "Mateo Cerezo en su tercer centenario (1626–1666)," *Goya* (Nov.-Dec. 1966), pp. 278–291.

69. Buendía, ibid., p. 281.

70. On Coello see Gaya Nuño, *Claudio Coello* (Madrid, 1957); Eric Young, "Claudio Coello and the Immaculate Conception in the School of Madrid," *Burlington Magazine,* 116 (1974), pp. 509–513 and Edward J. Sullivan, *Claudio Coello and Late Baroque Painting in Madrid* (forthcoming).

71. Julius Held, *The Oil Sketches of Peter Paul Rubens* (Princeton, 1980), vol. 1, Cat. no. 319.

72. The sketch by Rubens is in the Barnes Foundation, Merion, Pa.

73. The evidence given by Gaya Nuño and others for Coello's supposed trip is a small drawing in the Albertina, Vienna, of the Casa di Rienzi, Rome, signed "C. Coellos." It has nothing to do with the artist's graphic style. Palomino notes that Coello was able to achieve fame without traveling to Italy to perfect his art, a statement which should be carefully considered since Palomino was a good friend and student of Coello.

74. On this commission see Caturla, "Iglesias madrileñas desaparecidas. El retablo mayor de la antigua parroquia de Sta. Cruz," *Arte Español,* 18 (1950), pp. 3–9.

75. For the history of the relic and the event depicted in Coello's painting see Tormo, *El cuadro de la Santa Forma de Claudio Coello, su obra maestra* (Madrid, 1942).

76. The *Founding of the Trinitarian Order* by Carreño, in the Louvre, is another likely visual source for Coello's *Sagrada Forma.*

77. In the painting, however, the room appears as if turned at a thirty-degree angle.

78. A modern edition, with an introductory study by Francisco Javier Sánchez Cantón, was published in Madrid in 1956.

79. Pacheco, *Arte de la pintura*, vol. 2, pp. 125–126.

80. On still-life painting see Julio Cavestany, *Floreros y bodegones en la pintura española. Catálogo ilustrado de la exposición,* exh. cat. (Madrid, 1936–40); Ingvar Bergström, *Maestros españoles de bodegones y floreros del siglo XVII* (Madrid, 1970); and Ramón Torres Martín, *La naturaleza muerta en la pintura española* (Barcelona, 1971).

81. The survival of flower symbolism in late seventeenth-century Spanish still-life paintings is discussed in an unpublished master's thesis by Irene Martín, "Juan de Arellano and Flower Painting in Madrid," (Southern Methodist University, 1980), vol. 1, pp. 2–14.

82. See, for example, Bergström, *Maestros españoles*, pp. 48–51.

83. Eric Young, "New Perspectives on Spanish Still-life Painting of the Golden Age," *Burlington Magazine*, 118 (1976), pp. 203–213.

84. See Pérez Sánchez, *Pintura italiana del siglo XVII* (Madrid, 1970), pp. 407–411.

85. For a discussion of the symbolism in the *vanitas* pictures of Pereda and Valdés Leal see Julián Gállego, *Visión y símbolo en la pintura española del siglo de oro* (Madrid, 1972), pp. 245–251.

86. Esteban Casado Alcalde, "Berdusán," *Príncipe de Viana*, 152–153 (1978), pp. 507–546.

87. Pérez Sánchez, "Un lienzo de Arredondo para el Prado," *Boletín del Museo del Prado*, 1 (1980), pp. 17–22.

88. See, for example, Marcelino Menéndez Pelayo, *Historia de las ideas estéticas en España* (Madrid, 1940), vol. 2, p. 387.

89. Gállego, in his *Visión y símbolo* and Francisco Calvo Serraller, in his *Teoría de la pintura del siglo de oro* (Madrid, 1981), have made important contributions in the reevaluation of Spanish art theory.

90. A modern edition of this treatise was published in Madrid in 1965.

91. On García Hidalgo see Urrea Fernández, "El pintor José García Hidalgo," *Archivo Español de Arte*, 49 (1975), pp. 97–117.

Nina A. Mallory

Painting in Seville 1650–1700

*A*fter the discovery of America, Seville soon became the economic metropolis of the new dominions, and through the sixteenth century it was the richest, most populous, and most commercially active city in Spain. Its river port, thanks to its monopoly on trade with the American colonies, became one of the most important ones in all of Europe. Seville's position as a major trade center, as Antwerp was then in the north, made it the most cosmopolitan city in Spain, culturally and artistically. Spain itself during the sixteenth century was the dominant political power in Europe, reaching its apogee during the reign of Emperor Charles v. The seventeenth century, however, saw a reverse in the fortunes of both the city and the whole country. Although the crisis of the seventeenth century had its roots in conditions that had developed during the reign of Philip II (1556–98), it was only at his death that it began to manifest itself overtly. The political, economic, and social decadence of the Spanish monarchy and its empire begins with the reign of Philip III (1598–1621), and in the course of the next hundred years, until the death of the last of the Hapsburgs, Charles II, Spain was to decline little by little to the level of a minor power. The fate of Seville was tied to that of the country, but there were specific factors that conditioned its own particular decline as well.

During the first quarter of the seventeenth century, Seville was still a bustling civic center due to the intense trade with the Indies carried on from its shores, but by the second quarter it was no longer the "great Seville" that Cervantes's sonnet praises, and its demographic and commercial decline became clearly evident by the mid-century. In 1640 the weakening Spanish monarchy began to go through one of its more severe crises. That year both Catalonia and Portugal rebelled, followed in 1647 by Sicily and Naples. The crown had to declare bankruptcy in 1647 and again in 1653. In 1657 the treasure fleet, which brought silver from the Indies, was captured by the English, and no further silver arrived for the following two years. Although the Catalonian uprising and the revolt of the Kingdom of the Two Sicilies were suppressed, the Portuguese rebellion ended in 1668 with the granting of independence to that country. Seville had shouldered the greatest burden of the war effort in the struggle with Portugal (in 1645 the city was asked to supply 200,000 ducats to the Crown), and its local economy and human resources were drained by the end of the conflict.

At mid-century the population of Seville, in spite of the already ongoing economic decline which drove its men to emigrate, particularly to the colonies, was not much below the 130,000 inhabitants it had reached at its peak. Then, in the spring of 1648, a major episode of bubonic plague began to decimate Spain's southeastern coast, breaking out first in Alicante and Málaga, and reaching Seville by year's end. In five months of 1649 (May and June being the worst) it is estimated that between 50,000 and 60,000 lives were lost, the population shrinking to 65,000 inhabitants, approximately half of what it had been prior to the outbreak of the plague. Seville's population did not rise again to 80,000 inhabitants until the eighteenth century. In 1651, partially as a result of post-plague conditions, the city was afflicted by famine, and in 1652 the shortage of food (principally bread) was so severe that there was a popular outburst of violence in the Barrio de la Feria, which had to be put down forcibly.

On other quarters the economic decline of Seville was hastened by the shift of the trade with the Indies to Cádiz, a process that had begun in 1648 and was intensified in 1659. The resultant growth of Cádiz was to the detriment and impoverishment of Seville.

Later in the century Seville would experience another series of shocks. The years of 1678 and 1679 were ones of extreme penury, as the city was struck again by a lesser episode of the plague and subsequent famine. In 1680 there was an earthquake that ruined no less than 200 buildings, and although the plague had disappeared by 1682, it was followed almost immediately by another epidemic (perhaps typhus), which lasted until 1685. There was also a food crisis during those years, as a long, continuous drought, broken only in 1684, desolated the land.

Concurrently, with the process of political and economic decadence that Spain underwent through this period, Spanish intellectual life was choked by the designs of the Counter-Reformation, with its strict control of thought, a control exercised by the Church and the State in unison to achieve the goal of religious unity. This policy manifested itself in the inquisitorial scrutiny of all intellectual activity, and in the general prohibition of studying abroad and importing books to which Spaniards were subjected. The outcome of this policy was that the enormous mental energies repressed by it were channeled away from scientific and philosophical investigations, which had become too dangerous to engage in, toward the fields of artistic and literary creation. This may explain why this period of decadence and stagnation in so many quarters should be the "Golden Age" of Spanish letters and art, the richest in literary and artistic works that Spain would ever have.

Throughout this period of political, economic, and intellectual discomfort, a general attitude of evasion would develop vis-à-vis the bitter realities of an impoverished and oppressive daily life. Individual evasion took the form of seeking refuge internally in asceticism and mysticism, as well as in the reversal of values that is reflected in the picaresque novel. Collective evasion was channeled toward mass spectacles: religious ceremonies, processions, the *pasos* of Holy Week, *autos sacramentales*, and theatrical productions. The popularity of the theater during this period was so enormous that the plays of the most famous authors can be counted by the thousands, and technical and scenographic developments took place at an extraordinarily rapid pace. The combined policy of Church and State to promote a traditionalist, orthodox, and conformist attitude in the people is a very decisive factor in the direction taken by this popular and influential sector of literary activity, Spanish Golden Age drama. Not only were all plays written within the general framework of this policy, but a great many were geared specifically to serve it. This is clear from the great output of religious plays, whose purpose was to explain the dogmas of the Church, passages of Scripture or moral issues, or those which had an edifying content aimed at stimulating popular devotion.

During this age sculpture was exclusively dedicated to the service of religion, an unparalleled phenomenon unique to Spain in this century. Painting also was, to a singular degree in relation to contemporary Europe, focused on the production of religious images. Throughout this period of decline the Catholic Church had been the one institu-

tion to remain economically powerful, and even though its somewhat more straitened circumstances determined the halt in the foundation of new monasteries after the first third of the century, it became, apart from the royal court in Madrid, the only important source of patronage for Spanish artists. In Seville, where religion and its external manifestations (processions, *pasos*, feasts) held a particularly important place in the life of the city, and where the Church was almost the sole patron of the arts, religious art completely dominates the scene. There is an almost total absence of secular subject matter in Sevillian art of the period, most particularly in the second half of the century. In the realm of sculpture there is hardly a work produced that is not religious in purpose, and in the field of painting, apart from moralizing allegories of obvious religious significance, only portraiture stands out as a substantially significant form and, on a very modest scale, genre, still-life, and landscape painting.

The artistic community of Seville in the first half of the seventeenth century was made up of such disparate and independent figures that it is difficult to speak of a Sevillian school.

The oldest of the first generation of Baroque painters in Seville, and one of the most outstanding artists of the city in the first quarter of the century, was Juan de las Roelas (ca. 1558/60–1625). His artistic personality was in part shaped by his intermittent but extensive stays at the court throughout his career, which may account for the Venetian colorism and painterliness of his style. Although dead long before Murillo began his apprenticeship, Roelas played a major role in the formation of the young artist's style by dint of the artistic vigor of his work, in contrast to the more timid style of Murillo's own master, Juan del Castillo. His art is also recognizably the local point of departure for the late Baroque flamboyance of Valdés Leal's painting.

The long-lived Francisco Pacheco (1564–1644), although well regarded in his day, was a conservative artist, whose style to the end remained a survival of the late Mannerism of the end of the previous century. His academy, however, was of great importance as a focus of artistic and intellectual life in Seville, and his treatise *Arte de la pintura* (1649) is one of the most valuable sources for the history of Spanish art.

Francisco de Herrera the Elder (ca. 1590–1656), one of the most talented artists working in Seville in the third and fourth decades of the century, would leave his native city in 1640 to go to Madrid, where he remained until his death. An artist with an intractable character, he did not keep students for long, but his influence on younger artists through his works was substantial. The degree of impact he may have had on the young Velázquez is debatable, as the younger artist had developed by ca. 1617 a style and technique that were comparable in their novelty to Herrera's in the 1620s. The relationship of Zurbarán's work to Herrera's in the late 1620s, on the other hand, is more apparent, although not in the area of technique. The series of canvases painted by Herrera on the life of St. Bonaventure for the collegiate church of San Buenaventura (1628) clearly influenced Zurbarán's compositions for the same series, painted around 1629, in the treatment of figures in space and in the strongly characterized portraits and imagined types that fill the various epi-

sodes. Herrera's *Triumph of St. Hermengild* (ca. 1624) in San Hermenegildo in Seville also served as a model for Zurbarán's *Apotheosis of St. Thomas Aquinas* (1631) in the Museo Provincial de Bellas Artes, Seville, in its compositional structure. Technically, however, Herrera's lively and bold brushwork had no effect on Zurbarán's smooth and meticulous execution. It is again Murillo in his early work for the Franciscans of Seville who would profit from his observation of both the individualization of the types and the painterly facture of Herrera's St. Bonaventure series. Much later in his career, while painting the cycle for the Hospital de la Caridad (1667–70), Murillo would again draw on the work of Herrera in fashioning the composition of the *Miracle of the Loaves and the Fishes* (1647) after Herrera's picture of the same subject, painted in Madrid for the Archbishop's Palace. Herrera's large painting of *St. Basil* (1639), in the Museo Provincial de Bellas Artes, Seville, has a formal and emotive exuberance that can be regarded as presaging the art of Valdés Leal. The dark yet rich colors and the application of pigment with freedom and even violence also laid the groundwork for Valdés Leal's style in the 1650s.

Juan del Castillo (1584–1640) is a weaker artist than Roelas and Herrera but, as the teacher of Murillo and head of a major workshop, he needs to be mentioned as part of the artistic background of the painters who worked in Seville in the second half of the century. One of his most important works, the *Assumption of the Virgin* now in the Museo Provincial de Bellas Artes, Seville, would serve Valdés Leal as one point of departure for his own version of the Assumption (Cat. no. 43).

The artistic significance for Sevillian painting of the period that concerns us here of the works of the greatest of Spanish seventeenth-century artists, Velázquez, is certainly not commensurate with his importance for the history of world art. This statement applies even more emphatically with respect to his Sevillian works. Velázquez (1599–1660) may have been briefly in Herrera's workshop, as Palomino reports, but he received his training under Francisco Pacheco. He was apprenticed to him at the age of twelve, and stayed with his master from 1611 to 1617. Shortly after, he would renew his bond to Pacheco by marrying his daughter. During the short years of his residence in Seville as a master (1617–23, with an absence of seven months spent in Madrid in 1622), Velázquez painted a number of religious and genre works that would inspire some aspects of Murillo's early paintings, but it was the work carried out in Madrid that had the greater effect on the younger master. The solid naturalism, plasticity, and strong chiaroscuro of Velázquez's Sevillian works could not speak persuasively to the generation of Murillo and Valdés Leal, whose artistic tendencies, like those of their contemporaries in the school of Madrid, were toward a Venetian-based colorism and painterliness.

The second major painter working in Seville of the generation born at the turn of the century was Francisco de Zurbarán (1598–1664). Although apprenticed in Seville until 1617, Zurbarán returned to his native Extremadura at the conclusion of his training, and it was only around 1626 that he began to receive commissions from the various religious communities and churches in Seville. In 1629 he moved his residence there at

the invitation of the city council, and for the following ten years (interrupted by a brief stay at the court in Madrid in 1634) he executed paintings for the monastic orders that covered a wide range of religious subjects, from didactic images and narrative series to portraits of the members of the religious communities that employed him. This was undoubtedly his most productive and successful decade as an artist.

The work done for the Carthusians of Jerez de la Frontera and for the Hieronymite monastery of Guadalupe best exemplifies Zurbarán's art as the ideal transmitter of monastic attitudes and interpreter of the monastic spirit. His work during this period is characterized by extreme chiaroscuro contrasts, sharply illuminated volumes picked out from a dark, airless space, emphasis on plastic form, an intense realism in the description of human beings and objects, minimal movement, and a restrained and austere expression of affects.

After 1639, due in part to the general economic situation in Seville, Zurbarán's commissions began to decrease, and from then on he was forced to turn to producing pictures for export to the American colonies. Even so, from 1650 onward the state of his finances became progressively strained. This change in the demand for his work, however, was not only a factor of the general economic circumstances, since the young Murillo began to thrive at this time, but of a decline in the taste for his art. In 1658 Zurbarán left the city whose patronage had turned away from him to go to Madrid, but his situation did not improve markedly there and he died neglected and poor.

The works produced during the last decade of Zurbarán's life present changes in the selection of subject matter and in their expressive content that reflect his response and attunement to the general shift in the religious attitudes of the period. This altered conception of religious art is manifested in Zurbarán's late works in the clear appeal they make to the emotions of tenderness and loving devotion of the pious viewer. During these years devotional pictures are frequent in his oeuvre, and the emotional tone of the works is gentler and more tender. His style correspondingly exhibits a softer, less severe mode than that of his maturity, a change that had begun to appear in his painting shortly before 1650. Although Zurbarán still renders the objects depicted with the customary insistence on tactile values that typifies his work, he modifies the consistent crispness of outline of his earlier manner and the starkness of the light and dark contrasts so that the transitions from the solid forms to the enveloping space are less sharp, the contours blurred, and the shadows softer, hazier, less opaque. This softening of his technique is accompanied by a mellowing of the color as well. The sharp tones, often enamel-like in their brilliance, of the paintings of the 1630s are replaced by a less saturated palette, and abrupt transitions between color areas are avoided.

A work such as the *Virgin and Child with St. John the Baptist* (1658) is an excellent example of this final stage in the art of Zurbarán (fig. 20). The intimacy of the theme and the tenderness of feeling that the characters express in this painting are a far cry from the ascetic spirit and the austerity that characterize his earlier work. The appeal of this warm, softly lighted scene is enhanced by the more sensuous beauty of the Virgin and Child, dif-

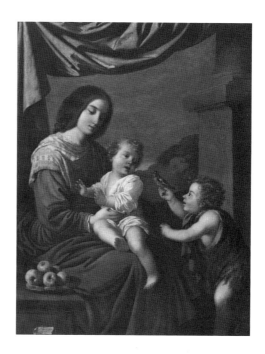

Figure 20. Francisco Zurbarán, *Virgin and Child with St. John the Baptist*, oil on canvas. San Diego, California, San Diego Museum of Art.

ferent in type from similar figures in earlier work. It was Murillo who carried the ideals of Catholic art of the second half of the century to their ultimate conclusion in his sensual, idealized, and tenderly emotive work, but even an artist like Zurbarán, whose style was deeply committed to an essentially different mode, naturalistic and stark, was responsive to the change in religious outlook and expressed the new spirit—albeit in a more sober fashion—in his last works.

The third great figure of Velázquez's and Zurbarán's generation trained and active for some time in Seville is Alonso Cano (1601–67). Although he was born in Granada and spent two-thirds of his career in his native city and in Madrid, he was a resident of Seville from the age of thirteen and it is there that he received his training as an artist, both in painting and in sculpture. Like Velázquez, Cano was apprenticed to Francisco Pacheco, and he coincided with the slightly older artist in this workshop for a few months. There is no documentation or tradition to tell us by whom he was taught the art of sculpture, but his style in that medium strongly suggests that he must have worked in the studio of Martínez Montañés by the early 1620s.

Cano's earliest known painting in Seville, the *St. Francis Borgia* (1624), in the Museo Provincial de Bellas Artes, is done in a tenebrist, realist style of strongly modeled forms painted with a fairly smooth technique, features it has in common with Velázquez's work of the Seville years and with that of the early works of Zurbarán. A strong element of

idealization, however, is already present in Cano's early Sevillian paintings. The *St. Francis Borgia* is exceptional in this respect, as is understandable in a likeness. Even before leaving Seville in 1638 to settle in Madrid, Cano's work had begun to move toward a lighter coloration, a looser facture, and ever more elegant, idealized figure types. His work in Seville had been primarily in the field of sculpture, but his carved images of Virgins and saints, all of them members of an ideal world of perfection and grace, set a standard of beauty, refinement, and delicacy of expression, not just for the younger generation of sculptors, but also for a painter of similar sensibility, such as Murillo.

In Madrid (1638–52), under the combined influence of Velázquez's style of the 1630s and 1640s and the massive exposure to the Venetian paintings, the Venetian-inspired works of Van Dyck, and the Correggios in the royal collection, Cano's tendencies toward a painterly technique, a luminous palette, and an idealizing figure style developed apace. The style and technique developed in Madrid were carried further along the same lines in the works produced in Granada and elsewhere during the last fifteen years of his life.

Cano's paintings, like those of his fellow Andalusians, Velázquez and Murillo, show a greater reticence in the expression of emotion (broad theatrical gestures are absent from his work), more sober and classical compositions, and a lower coloristic key than the exuberant works of the Madrid school of the second half of the century. The active, dramatic compositions and vivid colors of the paintings of Francisco Rizi, Herrera the Younger, Carreño, and Antolínez are in striking contrast not only to the art of the older Velázquez and Cano but also to that of Murillo, who was their contemporary. Among the artists trained in Seville, only Valdés Leal parallels with his exuberant style and the bravura of his execution the flamboyant late Baroque manner of the Madrid painters.

The naturalism of Spanish religious art of the first half of the seventeenth century, of which Zurbarán was the principal exponent in Seville, aimed at instructing and edifying the viewer by reaching him through strong, almost tangibly real images of the divinity and saints that made the religious message as vividly actual as possible. In many of these works the ascetic ideal was held up for imitation and reverence, and the importance of an intense, firm, and simple faith as the path to salvation was emphasized. In the second half of the century the dominant mood of religious art shifted to a softer, less austere temper given form in a more sensuously appealing, elegant, and idealizing mode. A gentler and more sentimental outlook on religious themes pervades the work of this phase, which is given its quintessential expression in Seville by Bartolomé Esteban Murillo (1617–82).

As Velázquez dominated painting at court in the first half of the seventeenth century, Murillo was the preeminent painter of the late Baroque in Seville. Although he was acknowledged as the most important Spanish artist of the second half of the century during his lifetime and for almost two centuries after his death, his critical fortunes underwent a drastic change in the late nineteenth century, and it is only recently that an assessment of his position as an artist of the first rank has begun to reemerge.

Murillo was primarily a painter of religious images, and his work embodies in splendid fashion the aims of religious art in the second half of the seventeenth century, both

in his native Seville and beyond. The majority of his work was commissioned by the monastic orders and churches of Seville and other Andalusian cities, and it reflects the particular form of piety and the themes that were prevalent and popular among this public. The image of the Virgin, both as mother and as the Immaculate, is one of the most frequently repeated subjects in his oeuvre. Visionary states are favored over narrative scenes in the lives of the saints he depicts, scenes of martyrdom are rare, and so are the episodes of the Passion of Christ. The representation of Christ that he paints most often is the *Ecce Homo* (fig. 21), as a devotional image divested of a narrative context meant to arouse in the viewer a loving, emotive response.

Surveying the religious works of Murillo, we soon realize that the themes he deals with are almost always undramatic and that high tragedy is seldom depicted. Time and time again, instead, we meet with scenes of spiritual beatitude—joyful, radiant, and sensuously appealing. Their contemplation seduces us into sharing the blissful experience he portrays; the tenderness of feeling his holy personages radiate convinces us of their love for the believer and of the joys to be reached through devotion and faith. To persuade the viewer of the truth of the mysteries and beliefs of the Church is the prime objective that animates these works, and Murillo is a master of this sort of pictorial religious propaganda. The tender emotions and the more sentimental faith conveyed by such works are no less genuine and sincere as expressions of belief than Zurbarán's sterner

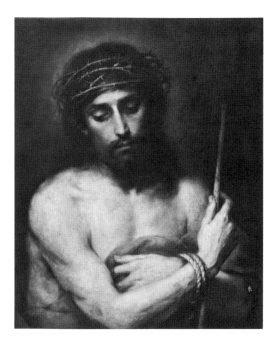

Figure 21. Bartolomé Esteban Murillo, *Ecce Homo*, oil on canvas. Richmond, England, the Cook Collection.

images of saintliness, they simply respond to a changed religious temper and to different expectations in the viewer to which they are addressed. Murillo's temperament leads him to explore and develop the more accessible roads to religious persuasion that are opened by physical beauty, tender feelings, and the sensuous appeal of the work as a whole. In this he both formulates and follows the taste of his period, which favors grace, a lighter emotional tone, and an aestheticism in religious art, characteristics that are far removed from the severe and naturalistic representations of an earlier moment. His paintings show an inspired blend of idealization and realism in the portrayal of the physical types and the spiritual content of the characters, both human and divine (figs. 22–24). The ideal nature of the holy persons is evident, but the essential reality of their human existence is also persuasively suggested. The heightening of their outward beauty and inner spirituality beyond ordinary experience predisposes the faithful to veneration, but Murillo's power to convince us that they also belong to a recognizable humanity makes them accessible on a more intimate and direct level. Can one wonder that commissions from the Church were so plentiful?

Next to religious subjects, the most important and popular facet of Murillo's work was genre paintings in which children are the sole or principal protagonists of the action. Although in absolute terms Murillo's production of children's genre may have been small, its weight in establishing his artistic reputation outside the confines of Seville, in his own time and later, was considerable. Representations of children in secular scenes had been fairly rare in the first half of the seventeenth century, but Murillo's paintings established a pattern that would be much imitated in Spain and abroad in the late part of that century and the following one.

Murillo's genre pictures belong mostly to the latter part of his career, to the 1670s, although he had made some early essays in this field in the late 1640s and early 1650s: *The Lice Chase*, in the Louvre, and *The Grape and Melon Eaters*, in the Alte Pinakothek, Munich. Most of his late works depict beggars or at least very poor children, but nonetheless they are conceived in a light spirit, and the potential charm inherent in the portrayal of their various activities is fully exploited (figs. 25, 26). Whether eating, playing, or counting money Murillo's urchins exude an irrepressible vitality, and although occasionally there is a hint of the pain of poverty or of the less benign aspects of children's behavior, they appear to enjoy thoroughly whatever life has to offer them. In some instances one can detect a moralizing intention in the subject, but it is always the charm and liveliness of the characterizations, the anecdotal interest of the scene, and the pictorial appeal of the work that primarily engage us.

The development of Murillo's style and technique from his beginnings as an independent master in 1639 to his death in 1682 follows a clear course that culminates in the extreme painterliness of his "vaporous" later manner. His earliest known works, *The Vision of Fray Lauterio* in the Fitzwilliam Museum, Cambridge, and *The Virgin of the Rosary with St. Dominic* in the Archbishop's Palace, Seville, still artistically immature and provincial in style, reflect primarily the influence of Juan de las Roelas and, to a

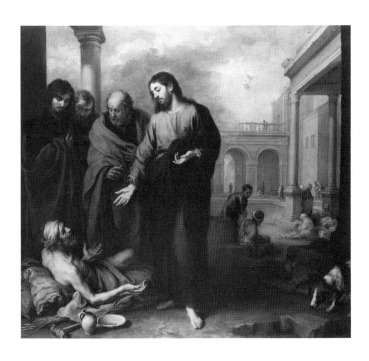

Figure 22. Bartolomé Esteban Murillo, *Christ Healing the Paralytic at the Pool of Bethesda*, oil on canvas. London, The National Gallery. Reproduced by courtesy of the Trustees, The National Gallery, London.

Figure 24. Bartolomé Esteban Murillo, *St. Thomas of Villanueva Distributing Alms*, oil on canvas. Seville, Museo Provincial de Bellas Artes.

Figure 23. Bartolomé Esteban Murillo, *Vision of St. Francis*, oil on canvas. Seville, Museo Provincial de Bellas Artes.

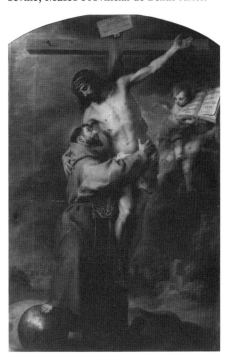

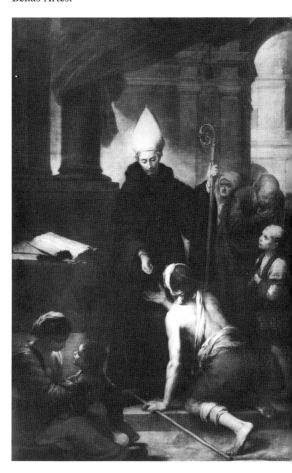

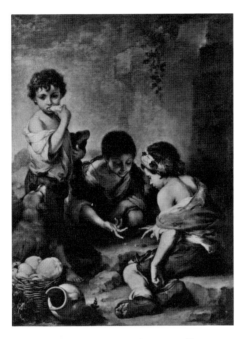

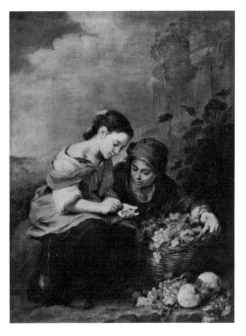

Figure 25. Bartolomé Esteban Murillo, *Boys Playing Dice*, oil on canvas. Munich, Alte Pinakothek.

Figure 26. Bartolomé Esteban Murillo, *The Little Fruit Vendors*, oil on canvas. Munich, Alte Pinakothek.

lesser degree, that of Zurbarán. In them, Roelas's types and fluid brushwork are juxtaposed to a hard, sculpturesque definition of form that stems from Zurbarán. In the cycle for the Claustro Chico of San Francisco (fig. 27), ca. 1645–47, other local influences are apparent, such as those of Herrera the Elder and of the Sevillian paintings of Velázquez, but there are also echoes of works that fell outside of his Sevillian background. It is likely that Murillo had a brief sojourn in Madrid around 1643, and this first-hand exposure to the large numbers of Italian and Flemish works housed in the royal collection did not fail to have an effect on some of the figure types and in the facture of the Claustro Chico paintings. Beyond the recognizable influences that can be picked out in these canvases, Murillo's own individual manner also begins to emerge more clearly.

Murillo's work of the first half of the 1650s (see fig. 28 and Cat. no. 25) still retains the solidity of form and the dense chiaroscuro that characterize the Claustro Chico series, but by the second half of the decade these begin to give way to a looser technique, a more transparent chiaroscuro, and richer effects of light, as can be seen in the *Vision of St. Anthony of Padua* (1656), in the cathedral of Seville. Murillo's documented stay at court during part of 1658, which brought him in contact again with the work of the mature Velázquez and with Venetian and Flemish painting at a point when he was particularly receptive to such impressions, must have given further impetus to his own evolution toward a freer brushwork, greater luminosity, and a more delicate and lighter palette. The paintings executed from the mid-1660s through the time of his death consistently

Figure 27. Bartolomé Esteban Murillo, *La Cuisine des Anges [The Angels' Kitchen]*, oil on canvas. Paris, Musée du Louvre.

Figure 28. Bartolomé Esteban Murillo, *Holy Family with the Bird*, oil on canvas. Madrid, Museo del Prado.

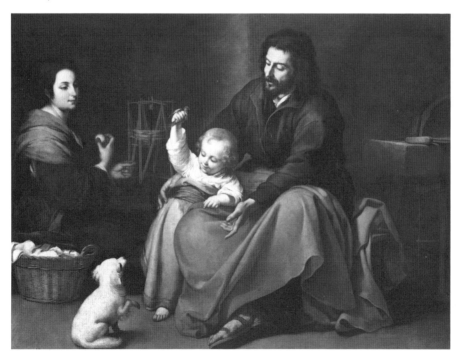

develop this trend. They are characterized by a spontaneous, lively touch, more or less impressionistic depending on the intended location of the work, and a treatment of chiaroscuro, whenever it is employed, that is extraordinarily rich and inventive in its luminary effects (figs. 24, 25, and 29). Broken colors, undefined contours, and the dissolution of solid forms in the surrounding atmosphere are features of Murillo's mature technique that he shares with other painters of his generation, both in Seville and in Madrid, but his technical bravura is always more controlled, and his approach to color more muted and mellower than that of most of his contemporaries.

The very late *Martyrdom of St. Andrew* is a good example of the character and vitality of Murillo's painting in his final years (fig. 30). The delicate, loose, summary brushwork defines the nearer forms softly and imprecisely, and gives a ghostly indistinctness to the more distant ones, endowing the finished work with all the spontaneity of a first sketch. The whole scene, painted in light, pastel colors, reverberates with a brilliant light that partially dissolves the solid forms without undermining their power to convince us of their substantial reality. Works like the *Martyrdom* point up most vividly the triumph of Venetian colorism and painterliness that marks all Spanish painting of the second half of the century.

The followers or imitators of Murillo in Seville must have been numerous, if one is to judge by the quantities of inferior Murillesque paintings executed in the late seventeenth century and well into the eighteenth, but he had no pupils of great distinction. The artist whose work is closest to Murillo's and who stands out as the most competent of

Figure 29. Bartolomé Esteban Murillo, *The Patrician Relating his Dream to Pope Liberius*, oil on canvas. Madrid, Museo del Prado.

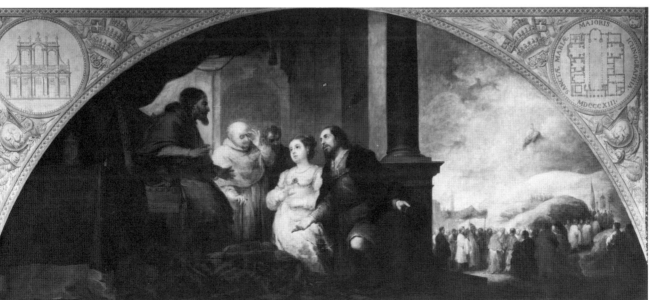

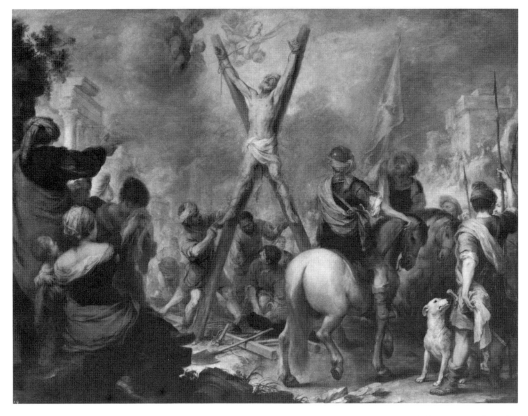

Figure 30. Bartolomé Esteban Murillo, *Martyrdom of St. Andrew*, oil on canvas. Madrid, Museo del Prado.

his followers is the Sevillian Francisco Meneses Osorio (ca. 1630–ca. 1705). His style and technique reflect Murillo's work of the late 1660s quite closely, but he does not attain either the brilliant handling of the paint or the subtlety and richness of expression of the older master (see Cat. no. 22).

Pedro Nuñez Villavicencio (1640–ca. 1698), always numbered among Murillo's disciples, takes up the children's genre created and popularized by Murillo, but his style and technique derive from different sources and are unrelated to the late manner of the great Sevillian painter (see Cat. nos. 33 and 34).

The most outstanding painter of the second half of the century in Seville, next to Murillo, was Juan de Valdés Leal (1622–90). In spite of their being almost exact contemporaries and sharing a similar artistic background, they embody completely different approaches to religious imagery, and antithetical sensibilities. Valdés's passionate, dramatic work is far removed from the composure and gentleness of Murillo's painting, as is the morbid intensity of his interpretation of the subject matter remote from the serene and joyous faith expressed by Murillo. Valdés's disregard for correctness of drawing and

Figure 31. Juan de Valdés Leal, *In Ictu Oculi [Hieroglyphs of Death and Salvation]*, oil on canvas. Seville, Hospital de la Caridad.

conventional beauty, always sacrificed for the sake of expressiveness, is also in marked contrast to Murillo's stress on refinement of form, grace, and physical beauty as the external manifestations of an ideal spiritual content.

The colorism and painterliness of Valdés Leal's work align him in general terms with his contemporaries in the two major artistic centers in Spain, Seville and Madrid, but his individual interpretation of these two aspects of painting, color and brushwork, is distinctive and original. His vivid colors are combined in unexpected ways, sometimes producing clashing contrasts, and they are bathed by a light that makes them shimmer, often with an eerie effect. His brushwork is rapid, bold, and nervous, at times violently energetic, and is particularly well suited to the suggestion of motion, always important in his work. The explosive energy and passionate agitation of his images are due in part to his technique and handling of light, but also to the twisting motions and emphatic gestures of his figures, to their swirling draperies, and to the animation with which he endows even inanimate objects.

Valdés Leal represents the more infrequent darker side of religious sentiment in this period. The morbidity and tension of his approach to the depiction of conventional religious subject matter give a good indication that he was temperamentally suited to give to the *vanitas* theme one of its most memorable renderings. The *Hieroglyphs of Death and Salvation* in the Hospital de la Caridad present one of the most shocking and

terrifying versions of the theme in Baroque art, perhaps the grimmest reminder of our mortality ever painted (fig. 31).

Although Valdés Leal's work was in great demand through the late 1650s and early 1660s, its high emotional pitch and agitated style were soon to be superseded by Murillo's calm, warm interpretation of religious themes. From around 1665 onward Murillo's position as the dominant figure in Sevillian painting was clearly established, and Valdés Leal never regained his former hold on artistic patronage. His manner would not find any followers, either, as it was too eccentric and personal to be imitable, and it was the more temperate expression of his Sevillian rival that influenced the lesser painters of Andalusia.

It is not possible to speak of a Sevillian school of the second half of the seventeenth century as one can of the school of Madrid, where a sizable number of gifted artists worked for the court and the Church along very similar stylistic lines. The homogeneity of style in the painting of Francisco Rizi, Herrera the Younger, Carreño, Antolínez, Cerezo, and even the more Italianate Coello is a phenomenon that has no parallel in Seville, nor is there a comparable concentration of artistic talent in the southern metropolis. There are only two really outstanding artistic personalities working in Seville during this period, Valdés Leal and Murillo, and their work is strikingly different in almost every respect. The common denominator that binds them together is their adoption of the heritage of Venetian painting—an impressionistic technique and stress on color—which they also share with the painters of the Madrid school. With Murillo's death in 1682 and Valdés Leal's decline in the early 1680s, the second great burst of artistic activity in Seville during the seventeenth century came to an end.

Catalogue of the Exhibition

NOTE: *The catalogue is arranged in alphabetical order according to the artist's Spanish surname. Exhibition entries include medium, measurements, provenance when known, and literature references. These references are in short form—consisting of author, date, page or plate number—and full reference information can be found in the Selected Bibliography.*

Contributors to the catalogue:

N.A.M. Nina A. Mallory
I.M. Irene Martín
E.J.S. Edward J. Sullivan

ANONYMOUS
1. *The Annunciation*

Oil on canvas; 135 × 178 cm. (53 × 70 in.)

Provenance Don Gaspar de Remisa y Miarons (Marqués de Remisa), Madrid (by 1885); Baron von Stumm-Holzhausen (before 1914); heirs of Baron von Stumm-Holzhausen (until 1953); F. Kleinberger and Co., New York.

Literature Faison, 1954, pp. 204–205; Faison, 1958, p. 178, fig. 3; Gaya Nuño, 1958, p. 99, no. 167; Indianapolis, 1963, no. 15; Muller, 1963, p. 103; Kinkead, 1978, p. 506, no. X62; Faison, 1979, no. 23.

Williams College Museum of Art, Williamstown, Massachusetts, gift of Mr. George Alfred Cluett (54.1).

The Virgin kneels at a *prie-dieu* set on a pedestal between parted curtains at the right of the scene. A sewing basket rests on the floor and a vase of roses and lilies is at the Virgin's feet. A youthful angel, wearing voluminous drapery, announces to Mary that she will be the Mother of God. At the upper left is God the Father, holding the Christ Child on his lap. The dove of the Holy Spirit approaches the Virgin. The presence of the Holy Trinity at the upper left indicates that this scene represents the moment just prior to the Incarnation.

There has been a great deal of discussion concerning the attribution of this beautiful painting. Many artists have been suggested as its authors, including Francisco Rizi, Juan Carreño de Miranda, Claudio Coello, Francisco de Herrera the Younger, and even the Italian painter Valerio Castello. In the von Stumm collection it was given to Valdés Leal and retains this attribution in the Williams College Museum of Art handbook.

While the painting does indeed resemble in one way or another the work of virtually all of these artists, it is sufficiently different (especially in the figure types) to render doubtful an attribution to any of them. It is here proposed that the Williams College *Annunciation* may be by José Moreno. The face of the Virgin and the angel are particularly close to similar figures in paintings and drawings by this little-known artist. One may compare this painting, for example, with the two known versions of the *Flight into Egypt* (in Minneapolis Cat. no. 23, and Madrid) where the full, rounded faces are not unlike those in the *Annunciation*.[1] The color scheme, however, differs from the Minneapolis and Madrid pictures in its use of deeper shades of green, brown, and other tones. Until further paintings by Moreno are brought to light, it may be impossible to prove the attribution suggested here. E. J. S.

NOTE

1. Illustrated in Angulo, "José Moreno," *Archivo Español de Arte*, 19 (1956), pl. II.

JUAN DE ARELLANO
Santorcaz 1614–1676 Madrid

The foremost exponent of flower painting in Spain in the seventeenth century was Juan de Arellano, who was born on August 3, 1614, in the village of Santorcaz, near the university town of Alcalá de Henares. At approximately the time that Velázquez moved to the court at Madrid, eight-year-old Juan was apprenticed to an unknown artist in Alcalá by his recently widowed mother. His general education began in this artist's studio, where he remained until he was at least sixteen. He then went to work for Juan de Solís in Madrid.

Juan de Arellano was married twice. His first wife, María Banela, bore him a son whose name was also Juan and who was taught the art of painting by his father. He died at the age of eighteen. His second marriage in 1643 was to María de Corcuera, a niece of Juan de Solís's wife. By her, Arellano had four children: Juana, who married Bartolomé Pérez, the most prominent follower and student of Arellano; Joseph, who was also trained as an artist by his father; and Manuel and Julián.

By 1646 Arellano had established enough of a reputation as an artist to have his own workshop and apprentices. Two paintings signed and dated 1652 in the Prado attest to the fact that he was indeed accomplished and talented, and within a decade Arellano enjoyed a great reputation as a flower painter. In 1664 a Madrid poet, Pedro Alvarez de Lugo y Uso de Mar, published a book titled *Vigilias del sueño*, in which a poem was dedicated "to Juan de Arellano, famous painter of Madrid, having painted with all perfection some flowers." Antonio Palomino praised Arellano's ability as a flower painter no less than Alvarez saying, "after studying

flowers in nature, he came to make them so excellently that none of the Spaniards exceeded him in the eminence of this ability." Arellano's much-admired flower paintings decorated private houses, palaces, and churches. Palomino cites specifically the excellent works in the collection of the Conde de Oñate and four in the Chapel of Nuestra Señora del Buen Consejo in San Isidro el Real.

Prior to the emergence of Arellano as a flower painter, there were no painters in Spain who specialized in this genre. A few artists such as Juan van der Hamen and Juan Fernández, "El Labrador," painted flower pieces as part of their oeuvre, but they were primarily still-life painters. Arellano drew inspiration from these artists' works, but he also had access to those by contemporary Flemish and Italian artists for study. The two most notable foreign artists whose works were of major influence on Arellano were Daniel Seghers and Mario Nuzzi. Arellano was able to absorb and to translate Seghers's style and composition, and to adopt the painterly and effervescent quality of Nuzzi's pictures to create his own unique style of painting and compositional variations in flower pieces.

The inventory of Arellano's estate at the time of his death also established him as a painter of other subjects. The inventory listed paintings of fruit, landscapes, birds, portraits, and cityscapes, among others. Two of his religious paintings, *St. Joseph and the Christ Child* and *St. Christopher and the Christ Child*, were executed in 1667 for the parish church of Santorcaz, and are still *in situ*.

Arellano died in his home on October 13, 1676, and was buried in the Convent of San Felipe across the street from his home and workshop where, appropriately, some of his paintings hung. I. M.

2. *A Basket of Flowers*

Oil on canvas; 81.7 × 102 cm. (33 × 41¼ in.)

Signed bottom right: *Juan, de Arellano*

Provenance Waldhausen family, Austria, end of the eighteenth to the twentieth century; Newhouse Galleries, New York; Kimbell bequest to Kimbell Art Museum, Fort Worth, Texas.

Literature Fort Worth, 1972, pp. 74–76; Fort Worth, 1981, p. 155.

Kimbell Art Museum, Fort Worth, Texas (ACF 65.5).

One of the most common types of flower paintings by Arellano is the bouquet in a basket. This work is typical of the artist and is also one of the most beautiful of his extant paintings. In the composition Arellano has placed a wide, open-weave basket filled with a variety of flowers on a stone plinth, and made the height of the basket and the height of the bouquet above almost equal. This device enabled him to paint a large arrangement without giving the composition an overly weighty appearance.

Strong light comes from the left, casting the flowers at the right into shadow. The left background is dark, creating a contrast with the bright flowers, while the background at the right highlights the silhouette of the shadowy flowers and foliage. This technique creates a three-dimensional space: the bright flowers come forward and the dark outlines recede. The brilliance is brought out even further by the placement of the bouquet against a plain background.

Most of the flowers, of which there are at least eight varieties, are in full bloom or at the apex of their short lives. There is seemingly little attention paid to placement. Those scattered on the plinth appear to have just fallen from the bouquet, which is cluttered and wild, yet soft and airy. The effect is that of an untamed garden. The flying and crawling creatures add to the effect of the natural setting. I. M.

FRANCISCO CAMILO
Madrid ca. 1615–1671 Madrid

Camilo's first teacher was Pedro de las Cuevas, who was also the master of Antonio de Pereda and other notable artists of Madrid. At the age of eighteen he received his first important commission for a painting of *St. Francis Xavier* for the Jesuits' Profess House in Madrid. He is also recorded as having decorated the Salón Grande de Comedias in the Alcázar at the age of twenty-five. Unfortunately these works are no longer extant and most of the paintings that survive by his hand are

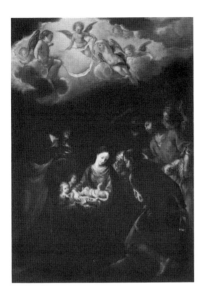

Figure 32. Francisco Camilo, *Adoration of the Shepherds*, oil on canvas. Madison, Wisconsin, Elvehjem Museum of Art.

from a much later period in his development. Judging from a signed and dated *Adoration of the Shepherds* (1649), Caravaggesque naturalism was still practiced by Camilo at a time when many of his colleagues were beginning to brighten their palettes (fig. 32). Given the style of this picture, with its tenebrist light and shadow, it is particularly interesting to speculate on the effects of a series of ceiling paintings done by Camilo in oil in the Alcázar of Madrid. This cycle, which was assessed in 1643 by Alonso Cano, depicted fourteen scenes from Ovid's *Metamorphoses*. These must have appeared quite different from the type of mural painting done in the capital after the arrival of Colonna and Mitelli in 1658. Palomino states that Camilo's sweet and devout temperament made him unfit to depict this type of subject matter. He further relates that King Philip IV was displeased with the artist's work, remarking that Camilo had made Jupiter look like Jesus Christ and Juno like the Virgin Mary.

Camilo was apparently much more successful with religious subjects, for he had many patrons not only in Madrid but in surrounding towns such as Getafe and in the larger cities of Toledo and Segovia. Many of his paintings treat themes of charming intimacy between members of the Holy Family, as in the well-known works of *Christ and St. Joseph* in the Museo Provincial at Huesca and in the Hospital of Cardinal Tavera in

Toledo. Nonetheless, more sober images representing the triumph of Christian steadfastness over death were also cultivated by Camilo as seen in the two paintings in the present exhibition.

By the 1650s the typical Baroque dynamism and light color which characterize the late school of Madrid appear in such works of his as the *Ascension of Christ* (1651) in the Museo de Arte de Cataluña, Barcelona, or his altarpieces in the parish church at Santorcaz, Madrid (1656), and Fuenciscla, Segovia (1662). At a later moment in his career Camilo's art demonstrates the scenographic mode as employed by such artists as Francisco Rizi in works like the *St. Torcuato Consecrated by St. Peter* (ca. 1666–70) in Toledo. Camilo died in August of 1670. Palomino states that he had many disciples although he names only one, Francisco Ignacio Ruíz de la Iglesia.　　　　E. J. S.

3. *The Infant Jesus as Victor over Sin and Death*

Oil on canvas; 105.7 × 81.8 cm. (40 × 27¾ in.)

Provenance　J. Spier, Auldes, Muthill, Perthshire, Scotland.

Literature　Angulo, 1965, p. 59, pl. 1; Held, 1965, p. 180; Kinkead, 1978, p. 508, no. 5r.

Museo de Arte de Ponce, Puerto Rico (62.02.42).

The Christ Child, clad only in a blue sash, is shown in an agitated sky, holding the Cross. At his feet are heads of putti, a skull, and a serpent.

The iconography of this theme has been discussed by both Hernández Perera and Gállego.[1] Representations of the Infant Christ bearing the instruments of the Passion held great favor in Spain, Portugal, and Ibero-America. There are numerous examples of what Gállego calls the "Hieroglyph of the Redemption" in seventeenth-century Spanish painting.[2] Two versions by Antonio de Pereda (in the Church of Las Maravillas, Madrid, and the parish church of Arc-Senans, France) depict the Infant Christ above a globe, numerous skulls, flowers, and an entire complement of nails, a crown of thorns, a scourge, and other such implements. Valdés Leal, to whom this painting was formerly attributed, executed several versions of this theme: portraying the Christ Child as the dominant

element of the picture (private collection, Madrid); or accompanied by saints, as in the *Jesuit Allegory of the Holy Sacrament with Sts. Ignatius and Francis Borgia* (ca. 1675) in the Museo Provincial de Bellas Artes, Seville. In Portugal, Josefa de Ayala painted several curious variations of this motif around 1660, in which the Christ Child appears walking in a landscape, dressed as a pilgrim with the instruments of the Passion adorning his clothing.[3]

In Spanish Baroque sculpture this subject is also portrayed, yet in a slightly different way. In polychromed wood images, it is more often the *Niño Jesús de la Pasión* or the *Christ Child Carrying the Cross* on the way to Calvary that is favored by sculptors such as Alonso Cano (in the Cofradía de los Navarros, Madrid).[4] In other works the Infant is shown upright on the heads of cherubs, holding the Cross with his left hand while the right is in a pose of blessing (as in the work by Francisco Dionisio of ca. 1644 in the Church of San Juan de la Palma, Seville).

The victory of the Christ Child over sin (represented by the snake) and death (the skull) manifests the theme of the triumph of the immortal soul over earthly existence. This subject takes many forms in Spanish Baroque art. The other work by Camilo in this exhibition (*Mors Imperator*, Cat. no. 4) also expresses this concept.

Camilo's painting can be comprehended furthermore as representing the triumph of the faith and the Catholic Church, and, as such, is a quintessential Counter-Reformation image, similar in ideological content to Claudio Coello's *St. Catherine of Alexandria Dominating the Emperor Maxentius* (Cat. no. 13). E.J.S.

NOTES

1. Jesús Hernández Perera, "Iconografía española. El Cristo de los Dolores," *Archivo Español de Arte*, 27 (1954), pp. 59–61; Gállego, *Visión y símbolo* (Madrid, 1972), p. 246.
2. Ibid.
3. See Edward J. Sullivan, "Josefa de Ayala," *Journal of the Walters Art Gallery*, 37 (1978), pp. 31–33.
4. Murillo, in a drawing in the Courtauld Institute Galleries, London, also depicted this theme. See Brown, *Murillo and His Drawings*, exh. cat. (Princeton, 1976), no. 81.

4. *Mors Imperator (St. Louis of France Contemplating a Skull)*

Oil on canvas; 102.2 × 70.5 cm. (40¼ × 27¾ in.)

Signed and dated at lower left corner: *F . . . C . . . L*
FAᵗ Aº 1651

Provenance Geheimrat Josef Cremer, Dortmund; Dr. Gisela Marx-Cremer, Wieslich; Jacques Seligman and Co., New York; sold at Christie's, London, March 18, 1960 (as Juan de Valdés Leal).

Literature Voss, 1914, p. 51, no. 241, pl. 53; Gestoso, 1916, pp. 207, 211–212, pl. 58; Guichot y Sierra, 1930, p. 17; Lafuente and Friedländer, 1935, p. 139; López Martínez, 1922, pl. 5; Trapier, 1956, pp. 16–17, fig. 9; Angulo, "Francisco Camilo," 1959, pp. 98–99, pl. VII; Trapier, 1960, p. 77, note 129; Harris, 1962, p. 330, pl. I; Kinkead, 1978, p. 508, no. 6r.

John and Mable Ringling Museum of Art, Sarasota, Florida (State number 711).

The saint wears a blue robe adorned with a yellow fleur-de-lis pattern. Around his shoulders hangs the chain of the Order of the Holy Spirit and at his waist is the knotted cord of the Third Order of St. Francis. With one hand, St. Louis holds his scepter, and with the other, places his crown upon the skull which rests on the table along with a vase of purple irises.

The obvious theme of the picture is the triumph of death over worldly things. This was a subject depicted on several occasions by Valdés Leal, and until the signature was recognized as Camilo's and a preliminary drawing published, the painting was attributed to the Sevillian artist.[1]

The iconography of this painting is unusual. The thirteenth-century St. Louis was the subject of great veneration in Spain and was portrayed many times by El Greco, Luís Tristán, Claudio Coello, and other artists. He was famous for his charity and his staunch defense of the faith, qualities which were greatly admired in Counter-Reformation Spain. St. Louis was also partly Spanish; his mother was Queen Blanche of Castille. Camilo seems to have been the only artist to portray Louis in a *memento mori* context.

The theme of the triumph of death is a pervasive motif in seventeenth-century Spanish art and literature. Angulo reminds us of several important treatises on this subject which have affinities with Camilo's paint-

ing.[2] Among them are Father Nieremberg's *Diferencia entre lo temporal y lo eterno* (published with the complete works of this author in the same year as Camilo painted this picture) as well as Quevedo's *La cuna y la sepultura* (1649). The latter was a book that obviously enjoyed great popularity. It even appears as a still-life element in the *Vanitas* by Juan Francisco Carrión in the present exhibition (Cat. no. 10). The *Hieroglyphs of Death and Salvation* (fig. 31) by Valdés Leal in the Hospital de la Caridad, Seville, and the *vanitas* still lifes of Antonio de Pereda are perhaps the most famous of the scores of such works done by Spanish Baroque painters denoting the swift and inexorable passage of earthly time.

This is one of Camilo's earliest paintings. The circumstances of its creation are not known, but it may have been executed for a small private oratory, given its modest size. It is also a *trompe l'oeil* image, with the saint's right foot projecting out from the ledge into the space of the viewer. The technique is somewhat sketchy and rapid, and the face displays the gentleness that characterizes many figures of male saints by Camilo. E.J.S.

NOTES

1. Harris, "Francisco Camilo: Un dibujo atribuido a Cano para un cuadro que se atribuyó a Valdés Leal," *Archivo Español de Arte*, 34 (1962), p. 330. This drawing is in the Ecole des Beaux-Arts in Paris.

2. Angulo, "Francisco Camilo," *Archivo Español de Arte*, 32 (1959), pp. 98–99.

ALONSO CANO
Granada 1601–1667 Granada

Alonso Cano, painter, sculptor, and architect, was born in Granada and baptized in the Church of San Ildefonso on March 19, 1601. He was the son of the architect and retable-maker Miguel Cano, who moved with his family to Seville in 1614. Cano thus received his artistic training in that city, where he was apprenticed to Francisco Pacheco in 1616. He entered this important workshop while Velázquez, two years his senior, was still studying under his future father-in-law, and spent perhaps as many as five years there, overlapping Velázquez's stay by four months. Early

sources (Palomino) state that he was also apprenticed to Juan del Castillo, Murillo's teacher, but this is an assumption that is probably only based on the known collaboration of this painter with Miguel and Alonso Cano on several projects in the 1630s. It is very likely, on the other hand, that from around 1620 to 1625 Cano may have worked in the studio of Juan Martínez Montañés (1568–1649), the greatest Sevillian sculptor of the century, and clearly the major influence in Cano's development as a sculptor.

In 1626 Cano passed the examinations to enter the guild of painters, but the works that occupied his youthful years and established his reputation as an artist were in the field of sculpture. His most important commission of the Seville years was the design of the architecture and the execution of the polychromed figures of the large retable of Santa María de la Oliva in Lebrija (1629–31).

Notwithstanding the prominence he gained as an artist during the 1630s, Cano was put in debtors prison in 1636, an indication of the mismanagement of his private affairs that kept surfacing again in later years. In 1638 the Count-Duke Olivares appointed him as his painter and *Ayudante de Cámara*, and Cano went with his second wife to the court in Madrid, never to return to Seville.

At court, Cano came into contact with Velázquez again, and with the contents of the royal collection, rich in Venetian sixteenth-century works; both would play an important role in the development of his mature painting style. The task of restoration of the works that survived the 1640 fire which destroyed and damaged scores of paintings in the Buen Retiro was probably also influential in promoting the change that is visible in Cano's style after 1645. His earliest works in Seville had been painted in a tenebrist style, with a strong plastic modeling of the forms and a generally smooth facture. Some of the later works of that period (*Vision of St. John the Evangelist*, 1635–37, in the Wallace Collection, London) begin to move away from this pronounced chiaroscuro toward a more luminous palette and more elegant, idealized types. After 1645, Cano's modeling became noticeably less sculpturesque, and his definition of contour less linear; his brushwork became softer and more painterly, and the lighting more diffuse.

In 1644 Cano's wife was murdered, stabbed fifteen times in her bed, and he was accused of being respon-

sible for the deed and put to torture. He was soon declared innocent and released, but he left for Valencia shortly thereafter, returning to Madrid only after a little over a year's absence.

The years spent in Madrid between 1645 and 1652 were Cano's most productive as a painter, while no sculptural works can be assigned to that period. To this phase belong the extraordinary *Miracle of the Well* (ca. 1646–48), the *Immaculate Conception* (ca. 1650–52), and our own *Christ in Limbo* (figs. 33, 34, and Cat. no. 6).

In 1651 Cano had applied for a position of prebendary in the cathedral of Granada, and he was appointed to it early in 1652. He left Madrid then for his native city, where he would remain for the following five years. From the start, his relations with the canons of the cathedral were strained (his dilatoriness in taking holy orders being the main point of contention), and in 1656 his position was declared vacant after he was judged deficient in his Latin exams. In 1657 Cano left Granada to protest in Madrid his ejection from the cathedral post, and by the following year he had received holy orders and been reinstated in his office as prebendary. He returned to Granada in 1660 and, with the exception of an extended stay in Málaga in 1665–66, remained there until his death on September 3, 1667.

The last fifteen years of his life were rich in works of painting and sculpture, and also include a major work of architecture, the 1664 design for the façade of the cathedral of Granada, whose official architect he became shortly before his death in 1667. Among the most important paintings of this period are the seven canvases of the *Life of the Virgin*, in the cathedral of Granada; the *Holy Family*, in the Convent of the Angel Custodio, Granada; the *Immaculate Conception*, in the oratory of the cathedral, Granada; the *Vision of St. Bernard*, in the Prado; and the *Virgin of the Rosary*, in the cathedral of Málaga.

In spite of his great talent and productivity in all artistic fields, unique among the Spanish masters of the Golden Age, and of the high repute in which he was held during his lifetime, Cano died in poverty, leaving numerous debts behind. N. A. M.

5. *Christ the Redeemer*

Oil on panel; 95.0 × 43.8 cm. (36⅞ × 16⅔ in.)

Provenance Private collection, New York; Prentis Cobb Hale, Jr., San Francisco.

Literature Winnipeg, 1955, no. 8A; Wethey, 1955; *Art Quarterly*, 1957, p. 123; Gaya Nuño, 1958; San Diego, 1960,

Figure 33. Alonso Cano, *Miracle of the Well*, oil on canvas. Madrid, Museo del Prado.

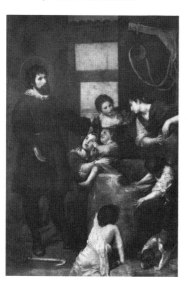

Figure 34. Alonso Cano, *The Immaculate Conception*, oil on canvas. Vitoria, Museo Provincial de Alava.

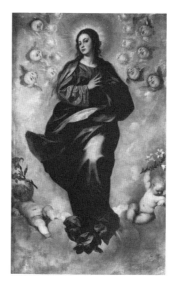

60

p. 93; San Diego, 1962, no. 4; Indianapolis, 1963, no. 8; Petersen, 1968.

San Diego Museum of Art, gift of Mr. Prentis Cobb Hale, Jr., 1957 (57:53).

The full-length Christ stands in a strong contrapposto stance, holding a chalice with his left hand and the Host above it with his right. The subject matter and the rare use of panel as a support indicate that the painting was probably intended as the door of a tabernacle for the Host. Its iconography is like that of Cano's lost tabernacle door for a retable at Getafe, and of the tabernacle door with a half-length *Christ Holding the Chalice and Host* in the Olóriz Collection in Granada, both also on panel.[1] The larger size of the present painting may be due to its being a door for the monstrance tabernacle in the body of a retable, rather than for the smaller enclosure for the Host itself in the predella.

The style of both figure and drapery, and the character of the pose, suggest that *Christ the Redeemer* was painted in the last years of Cano's stay in Madrid (ca. 1650–52) or shortly after his return to Granada (ca. 1653). The figure is most closely related formally to one of Cano's greatest masterpieces, the *Immaculate Conception* (ca. 1650–52) at Vitoria (fig. 34). The delicate and sensuous facial type of Christ, with large, dark eyes and full lips, is very similar to that of the *Immaculate*; the very pronounced contrapposto, full of movement for a standing figure, and the simple, broad treatment of the drapery folds are also closer to the Vitoria Virgin than to any other figure of Cano's.

The *Redeemer* is most characteristic of the sensitivity, elegance, and composure of Cano's religious images, whether in painting or in sculpture. N. A. M.

NOTE

1. Harold Wethey, *Alonso Cano. Painter, Sculptor and Architect* (Princeton, 1955), p. 201. Wethey points out that Cano used wood as a support in only four known paintings; the two mentioned above, another lost tabernacle door, with just the Chalice and Host, and a predella panel.

6. *Christ in Limbo*

Oil on canvas; 167.6 × 120.6 cm. (66 × 47½ in.)

Signed with Cano's monogram: *A̶ CN̶ . F*

Provenance Manuel Martínez Verdexo, Granada, ca. 1800; C. J. Tabor Collection; Bates, 1928; Frank T. Sabin, 1944; Welker, 1944; Julius Weitzner Gallery, New York.

Literature Cruz y Bahamonde, 1812, vol. 12, pp. 313–314; Graves, 1970, vol. 1, p. 149, no. 3; Valentiner, 1948, pp. 16–19; Valentiner, 1950, p. 37; Wescher, 1954, no. 78; Wethey, 1955, pp. 59, 152; Wethey, 1958, pp. 21–22, 34; Wethey, 1963, pp. 207–208.

Los Angeles County Museum of Art, gift of Miss Bella Mabury (M.48.5.1).

There is no scriptural basis for the creed of the Harrowing of Hell—Christ's descent into Limbo after his death and burial to liberate the souls of the Old Testament forefathers—but it became an article of faith in the fourth century and a popular subject for illustration from the Middle Ages on. The scene usually represents Christ holding the banner of the Resurrection and entering through a gateway whose doors have been broken off their hinges and lie trampled under his feet. As demons flee, Christ pulls by the hand a man from the approaching throng, Adam, who has Eve by his side. John the Baptist is usually near, as is often the penitent thief, holding the Cross; other Old Testament figures are identifiable by their attributes. The illustration of this Christian tenet remained frequent throughout the sixteenth century, but it is not common afterward, so the present painting is rare in this respect. Cano's painting is also unusual in setting the scene in a solid, if simple, architectural interior rather than in the more frequently depicted ruins or cave. Adam, Eve, and Seth, as well as a shadowy figure in the doorway (perhaps Abel), and the good thief with the Cross have already been pulled up from Hell. Christ is hoisting a man up by the hand (his appearance suggests John the Baptist), and one final figure, a bearded, balding old man, is seen emerging from the ground by his side.

The *Christ in Limbo*, in spite of its less than good condition, is one of the most striking and memorable works of Alonso Cano. Perhaps, as has been suggested, the painting was never finished, and the weaknesses of the drawing can be attributed to the participation of a studio assistant in its execution, but the canvas's present state seems more the result of its having been subjected to very rough cleanings and improper retouchings at various times. The losses in Christ's head and extremities, the crude appearance of the dark, barely roughed-in figures on the left and extreme right, and

the generally poor condition of the surface of the red-dish brown Cross and architectural background against which the actors are set, present us with unfortunate impediments to the full appreciation of a really extra-ordinary piece of painting, but the quality of the prin-cipal nudes, Christ, Eve, and the child Seth, is so high that it carries the painting through.

The treatment of the male nude is not infrequent in Cano's work, as it appears in other representations of Christ (on the Cross, in the Flagellation, dead and sup-ported by an angel), and in figures such as *St. John the Baptist* (Cat. no. 7) and Adam (*First Labor of Adam*, in the Glasgow Art Gallery), and here it is particularly brilliant. The very naturalistic rendering of Christ's body structure and still supple flesh is achieved with a light and sensitive handling of color and brushwork that also gives a soft glow to the skin. The lessons learned from Velázquez are clearly demonstrated here.

Beautiful surface effects are also given to the sturdy young body of Seth. Cano had devised this pose, which presents a near profile view of the subject, for a little angel holding a staff in a drawing now in the Prado, but transformed it here by adapting it to a realistic image of an older child, taller and less chubby. Seth stands in a cross-armed attitude, watching Christ intently and al-most defiantly, a perfect image of childish assurance.

The figure of Eve is one of the most beautiful (and rare) female nudes in Spanish seventeenth-century painting. Like Velázquez's *Venus* in London, also seen discreetly from the back, she is a memorably sensuous image of feminine flesh. Eve seems to have been painted from a specific model (unlike Velázquez's ideal form, with its reference to the Hellenistic "Hermaphrodite"), and her appeal derives at least in part from the speci-ficity of her beauty and its very imperfection. Her pose, like Seth's, is also wonderfully expressive, her slouch a reminder of the shame of original sin.

The composition of *Christ in Limbo* has been criti-cized for its lack of unity and the excessive emptiness of its upper section. However, the hiatus between Christ and the first parents (exaggerated in any case by the vagueness of the damaged surroundings) seems appro-priate to the action, and the general organization of the elements follows a clear rising diagonal pattern that one can find in many versions of this theme, from Dürer's woodcut (in the *Large Passion*) to those by Beccafumi and by Sebastiano del Piombo.[1] Among the most familiar renderings of the theme, only Sebasti-

ano's is more sparsely populated than Cano's, although even there the space is concurrently more restricted, so that by comparison with other versions, Cano's appears unusually empty. It certainly lacks the compactness of grouping, the crowds of expectant souls, and the com-plexity of the physical surroundings that are common to scenes of Christ's descent into Limbo. Although the large open space in the upper portion of Cano's *Christ in Limbo* is indeed rare for compositions of this sub-ject, it is not altogether unusual in his own late works. It can be seen again most clearly in the *Vision of St. Bernard* (ca. 1658–60) in the Prado, where one also finds an unusually sparse environment with a great amount of space above the main figure.

The *Christ in Limbo* has been dated ca. 1646–52 on the basis of its stylistic and technical similarity to the *Miracle of the Well* (ca. 1646–48) in the Prado (fig. 33) and the *Noli Me Tangere* (ca. 1646–52) in Budapest. Although it fits well among the works assignable to this phase of Cano's residence in Madrid, it is also equally comfortable in the period 1652–60, which Cano spent partly in Granada and partly at the court. A precise dating of the work seems quite beyond what is possi-ble without the benefit of supporting documentation, but a date in the 1650s recommends itself as most likely. The fact that the painting was in a private collection in Granada around 1800 militates for its having been executed there between 1652 and 1657, rather than in Madrid. N.A.M

NOTE

1. This last painting had been placed by Velázquez in the sacristy of the royal palace of the Escorial before 1657. Bec-cafumi's *Christ in Limbo* is in the Pinacoteca, Siena, and Se-bastiano's is in the Prado.

7. *St. John the Baptist*

Oil on canvas; 185.2 × 113 cm. (72⅞ × 44½ in.)

Signed at lower left with the monogram: *A CA FA*

Provenance Baron Gaspard Gourgand, France; Prince Napoleon Gourgand, France; Julius Böhler, Munich, 1957; private collection, Germany, by 1958; H. Sperling, New York, 1960; F. Kleinberger and Co., Frederick Mont, New York, by 1964.

Literature Wethey, 1958; Cincinnati, 1968, pp. 1–36; Adams, 1971, pp. 268–279; Rogers, 1978, pp. 9–10.

Cincinnati Art Museum, Fanny Bryce Lehmer Endowment (1964.69).

St. John the Baptist is depicted as a very young man, seated on a rocky outcrop in a landscape. A tree branch is spread overhead, and an opening with a view of distant hills is to the left. In his right hand St. John holds a reed staff with a banderole inscribed: ECCE AGNVS DEI (John 1:29, 36), and with his left he points at the lamb before him.

The image of the Baptist as the prophet of Christ, meditating in the wilderness, is one of the most common representations of this saint in the sixteenth and seventeenth centuries.

Cincinnati's *St. John the Baptist* is a very characteristic example of Cano's late manner, painted with a very loose technique and soft edges that fuse the solid forms with their surroundings. The light tonality of the whole work, the pearly, luminous skin tones, and the silvery light that bathes both figures and distant bluish landscape point to Cano's admiration for and understanding of Velázquez's work. Even the dark pink cloth and the warmer foreground of browns and greens echoes Velázquez's coloration, and throughout the work, the character of the brushwork also brings to mind Velázquez's technique.

The composition may be very loosely inspired by a Ribera print of *St. Jerome* (1621) particularly in the strong diagonal of the saint's pose, but the elegant contrapposto twist is peculiar to the *St. John*. A lost Cano painting depicting *St. John the Evangelist at Patmos*, known through two copies (in Budapest and Málaga), seems an intermediary between the Ribera *St. Jerome* and Cano's *Baptist*, although the figure is clad in voluminous robes.

The spiritual content of the image is brought out in a way that is typical of Cano's sensibility. St. John's expression is quietly restrained (the melancholy look at the beholder and the mild pointing gesture downward toward the lamb are both subtly understated), and yet it is profoundly evocative of a special state of mind. A thoughtful, gentle sorrow emanates from St. John's face and from his body as he rouses himself from his meditation to point to us the *Agnus Dei*, the sacrificial lamb of which he is the prophet. The lassitude of the upper portion of his body and the wisp of hair falling over one eye contribute as much as the facial expression to create the mood of melancholic reverie that St. John projects.

A similar depth of feeling, tender and serene, can be seen in contemporary works such as the *San Bernardino and San Juan Capistrano* (ca. 1653–57) in the Museo Provincial, Granada, and in his polychromed sculptures of this period, like the *San Diego de Alcalá* and the *St. Joseph and the Infant Christ* (1653–57) in the Museo del Palacio de Carlos V, Granada.

Although the Cincinnati *St. John* has been dated between 1645 and 1650, on the basis of style it seems to fit better a somewhat later moment in Cano's career, the period spent in Granada between 1652 and 1657. In physical type and technique, it is closest to the *Immaculate Conception* (Conde de las Infantas, Granada) that was probably painted ca. 1653–57 for an altar in San Antonio y San Diego, the church for which the aforementioned predella with *San Bernardino and San Juan Capistrano* was also painted. The *St. John* is also close to one of Cano's most ravishing pictures, the *Holy Family*, done between 1653 and 1657 for the Convent of the Angel Custodio in Granada. Cano painted fourteen works for these Franciscan nuns during those years, but unfortunately all but the *Holy Family* seem to have disappeared. One of the works by Cano mentioned by an early source as in the Convent of the Angel Custodio was a *St. John the Baptist in the Desert*.[1] The Cincinnati picture may be this lost work, the only St. John mentioned in the literature that would fit the present painting. N. A. M

NOTE

1. See Fray Tomás de Montalvo, *Vida…de Sor Beatriz María de Jesús* (Granada, 1719), pp. 425–426.

JUAN CARREÑO DE MIRANDA
Avilés (Asturias) 1614–1685 Madrid

Juan Carreño de Miranda was one of the few Spanish painters of his generation to be born into a noble family. His ancestors had served the Crown since at least the thirteenth century. Carreño first came to Madrid with his father around 1624 and remained there to study art in the studio of Pedro de las Cuevas. Carreño's second teacher was Bartolomé Román, through whom he was introduced to the art of Vicente Carducho, which became influential in his own early works. Román was also most likely instrumental in Carreño's re-

ceiving his first commission to paint scenes of the life of St. Augustine (now lost) to decorate the cloister of the Colegio de Doña María de Aragón in Madrid, an important religious institution for which El Greco had worked some thirty years before.

In the 1640s and 1650s the artist painted for a number of churches in and near Madrid. His first surviving work, *St. Anthony Preaching to the Fishes*, was one of several paintings done for the Church of the Caballero de Gracia in Madrid in 1646. It is now in the Museo Balaguer in Vilanova i la Geltrú.

By 1650 Carreño had begun his long career as a teacher. One of his first pupils was Mateo Cerezo, who later became one of the leading artists of late Baroque Madrid. Others included Francisco Ruíz de la Iglesia, Pedro Ruíz González, and José García Hidalgo. Meanwhile, Diego Velázquez, who had known Carreño as a youth, hired him to take part in the fresco decoration of the royal palace. Carreño painted in the Salón de Espejos beginning in 1659. In this (now lost) and other fresco projects, such as that in the Church of San Antonio de los Portugueses, Madrid (1660, in collaboration with Francisco Rizi), and the paintings in the *ochavo* of the cathedral of Toledo (1665), the Italianate style of mural decoration that had been brought to Spain by Colonna and Mitelli was a guiding force.

In 1667 Carreño petitioned the king to be named *Pintor de Cámara*, but it was not until two years later that he was given the lower position of *Pintor del Rey* (the former post was assigned to him in 1671). Besides the numerous portraits of the royal family, Carreño also depicted important visitors to the court of Madrid including the Russian ambassador Peter Iwanowitz Potemkin (1682), whose portrait is in the Prado.

Carreño's activities as a religious painter did not cease with his court appointments, for he continued to work for many churches, convents, and monasteries. The large canvas representing the *Founding of the Trinitarian Order* (1666), painted for the Trinitarian convent in Pamplona, is one of the most ambitious and beautiful altarpieces by any painter of the time.[1] Among other large religious works done late in Carreño's career is the faithful copy of Raphael's *Way to Calvary* ["Lo Spasimo"], 1674, which was then in the Spanish royal collection and is now in the Prado. Carreño's copy, made for the Descalzas Reales, is in the Academia de San Fernando. During the last years of his life, the artist continued to create numerous religious works and

portraits for private patrons, undertook further projects in the royal palace, and served as keeper of the royal collections. E. J. S.

NOTE

1. This altarpiece is also called *The Miraculous Vision of St. John Matha*, and is in the Louvre.

8. *Flaying of St. Bartholomew*

Oil on canvas; 250.8 × 186.7 cm. (98¾ × 73½ in.)

Signed and dated at bottom right of center: *Juan Carreño Fat. Año 1666*

Provenance Convento del Rosario, Madrid; Infante Sebastián de Borbón, Pau (purchased by the Infante in the nineteenth century); Infanta María Cristina de Borbón, Madrid; Manuel González, Madrid.

Literature Palomino, 1724 (1947 ed.), p. 1030; Pau, 1876, p. 66, no. 586; Madrid, 1902, no. 8; Marzolf, 1961, p. 152; Pérez Sánchez, review of Marzolf, 1966, pp. 98–99; Baticle, 1964, pp. 140–153; Madrid, 1966, no. 116; Barettini Fernández, 1972, p. 42; Jordan, 1974, pp. 34, 97, checklist no. 7.

Meadows Museum, Southern Methodist University, Dallas, Texas (68.01).

Figure 35. Jusepe de Ribera, *Martyrdom of St. Bartholomew*, etching. Dallas, Meadows Museum, Southern Methodist University.

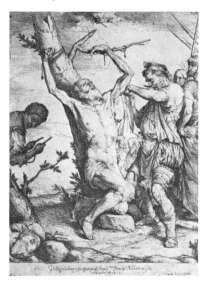

The saint, depicted as an old man, is tied to a tree. As one man binds his left foot and another his left hand, a third begins the hideous torture of flaying. At the lower center there is a broken head of a statue, and at the right, soldiers on horseback point to the scene of Bartholomew's suffering.

St. Bartholomew was one of Christ's twelve apostles. After the death of Jesus, Bartholomew spread the Gospel to many corners of the world, including Lycaonia in Asia Minor, India, and Armenia. Carreño sets the scene in a Roman province, however, for the banner of the soldiers at the right is inscribed sp(QR).

The best-known portrayals of this horrific event are several paintings by Jusepe de Ribera (in the Palazzo Pitti, Florence; the Museo de Arte de Cataluña, Barcelona; the Nationalmuseum, Stockholm). Yet Ribera's interpretation first appeared as a print in 1624 (fig. 35).[1] This etching served as Carreño's point of departure.[2] There are a number of similarities to Ribera's work, including the fallen head of the idol on the ground. This sculptural fragment refers to a story related by Jacobus de Voragine in *The Golden Legend*, who states that in India, Bartholomew succeeded in converting King Polemius and in curing his daughter of insanity. After this, Polemius ordered the pagan idols destroyed. The priests of the cult, on hearing this, reported the events to the king's brother, Astrages, monarch of a neighboring region, who confronted Bartholomew and accused him of leading Polemius away from the worship of their idols. He ordered the apostle to worship a statue of the god Baldach which, at that moment, was miraculously destroyed. Astrages, infuriated, ordered Bartholomew to be killed by flaying.[3]

Such scenes of martyrdom are not unusual in Spanish Baroque art. As William Jordan explains:

> In a century riddled with religious wars that drained the Spanish coffers, every day men were being required by law or social pressures to take up arms in defense of the nation's religious-political position. Belief in the necessity of willingness to sacrifice one's life for his faith was, therefore, related to the early heroes of the Church, whose examples were seen as a source of inspiration in the overcoming of fear.[4]

The *Flaying* was a famous work in its own day. Palomino accords it special praise, calling it a painting "of excellent taste" (*cosa de superior gusto*).[5] It is the perfect embodiment of the inspiration received by Carreño from the art of the Venetians in the blue, gray, and pink tones of the sky. The freedom of the brushwork also indicates a study of Titian's techniques. While the *Flaying of St. Bartholomew* portrays one of the most painful episodes from the lives of the saints, it does not concentrate on the purely bloody and grotesque nature of the event as Ribera had done earlier. As is often the case in such portrayals in the art of the masters of the late Baroque in Spain, the most unpleasant aspects of the scene are mitigated by soft colors and gentle contours.

E. J. S

NOTES

1. See Brown, *Jusepe de Ribera: Prints and Drawings*, exh. cat. (Princeton, 1973), p. 28, for a discussion of Ribera's print of *St. Bartholomew*.

2. This observation was made by William Jordan, *The Meadows Museum. A Visitor's Guide to the Collection* (Dallas, 1974), p. 34.

3. See the French ed. of *The Golden Legend*. Jacobus de Voragine, *La Légend dorée* (Paris, 1843), vol. 1, pp. 248–252.

4. Jordan, *The Meadows Museum*, p. 34.

5. Palomino, *Museo pictórico*, p. 1030.

9. *Portrait of Doña Mariana de Austria, Queen of Spain*

Oil on canvas; 173.7 × 101 cm. (69⅜ × 39¾ in.)

Signed on base of table at lower left: *J. Carreño p.*

Provenance Stokes Collection, New York; John and Mable Ringling, Sarasota, Florida.

Literature Suida, 1949, p. 279, no. 338, reproduced p. 278; Austin, 1950, p. 21; Gaya Nuño, 1958, p. 129, no. 533; Hernández Perera, 1958, pp. 63–64, 144, pl. XXV; Marzolf, 1961, p. 167; Coley, 1963, p. 63; Indianapolis, 1963, no. 11; Birmingham, 1971, p. 10, 14.

John and Mable Ringling Museum of Art, Sarasota, Florida (State number 338).

The Queen, wearing widow's weeds, sits before a desk. A black and brown oriental carpet is on the floor. Behind Mariana's chair is a partially hidden table supported by a bronze lion with a large globe below its

left paw. On the table to the immediate right of the Queen is an antique clock. The room in which she sits is identified by two mirrors with eagles above them as the Hall of Mirrors in the Alcázar of Madrid.[1]

The first wife of King Philip IV, Elizabeth of Bourbon, died in 1649. Philip then married Mariana, the daughter of his sister the Empress Maria, wife of the Holy Roman Emperor Ferdinand III. Mariana was only fourteen at the time of the marriage. She bore Philip five children, only two of whom survived, a daughter Margarita, and a son Charles, who became the last Hapsburg monarch of Spain. Mariana was widowed in 1665. She reigned as Queen Regent until her son came of age in 1675.

Diego Velázquez's full-length portrait of the Queen (1652–53) in the Prado shows the monarch in an elegant black dress and elaborate coiffure. She stands before a table on which is placed the same clock that Carreño includes in his representation.[2] After the death of Philip, Mariana assumed the habit of a nun, common dress for a widow of the time. She was so portrayed by a number of painters of the later seventeenth century. A portrait by Mazo in the National Gallery, London, shows Mariana seated in the Octagonal Room of the Alcázar. There are versions of Carreño's painting in the Prado, the Museo de Bellas Artes in Bilbao, the Harrach Collection in Rohrau, Austria, and the Academia de San Fernando in Madrid. There is a detailed drawing of the seated Mariana in the British Museum, also by Carreño. Among the most beautiful paintings of this subject by other artists is the example by Claudio Coello in the Alte Pinakothek, Munich.

Carreño's Sarasota version is successful in its description of the pale skin of the woman. Her hauntingly melancholic, pensive appearance could convincingly be read as an embodiment of the malaise of the age in which she lived.

In 1669 Carreño was named *Pintor del Rey* and would then have begun to execute a series of royal portraits. By 1670 Mariana was forty years of age. The figure in the Sarasota painting does not appear to be much older than that, and we may therefore suggest a dating for the picture of approximately 1670. E.J.S.

NOTES

1. Carreño also portrayed the young King Charles II in this room, standing before similar (or the same) mirrors in a portrait of 1673, now in the Prado.

2. Hernández Perera, in *La pintura española y el reloj* (Madrid, 1958), p. 63, states that a clock made by Hans de Evalo and presented to King Philip II (now in the Escorial) may be identified with the one included in Carreño's portrait of Mariana.

JUAN FRANCISCO CARRION

No documentation exists regarding this painter, and the *Vanitas* still life in the present exhibition is the only known work by his hand. Angulo suggests that he may be the same artist who signed a *Still Life* in a private collection in Madrid inscribed *Carrión fecit.*[1] He further states that the presence of the cardoon in the Indiana University painting relates it to still lifes which include the same element by Juan Sánchez Cotán (1560–1627), who worked in both Toledo and Granada. E.J.S

NOTE

1. See Angulo, "Un 'Memento Mori' de Juan Francisco Carrión," *Archivo Español de Arte*, 32 (1959), p. 261.

10. *Vanitas*

Oil on canvas; 120 × 85 cm. (41 × 33 in.)

Signed and dated on the cartellino beneath the skull: *JUAN FRANCO CARRIO f*; inscribed on the paper at lower left: *Cario F. 1672.*

Provenance Sidney Hill, New York.

Literature Angulo, "Un 'Memento Mori,'" 1959, pp. 260–262, pl. 2; E.C.B., 1965, pp. 37 and 56; Newark, 1964, no. 12; Torres Martín, 1971, p. 143, pl. 43.

Indiana University Art Museum, gift of Henry D. and Sidney Hill (59.46).

This somber painting depicts a table below two shelves on which are placed bound sheets of paper, open and closed books, a bottle, hour glass, skull, ink well, and two quill pens. On the middle shelf, beneath the skull, is a piece of paper on which is inscribed a poem:

O tu que me estas mirādo O you who look at me
mira bien i vivas bien Look well and live well

que no cabes como o cuãdo	You know not how nor when
te veras asi tanvien	You will also look like me
mira vien con atencion	Look well and with attention
este retrato o figura	At this portrait or figure
todo para en cepultura	All things end at the grave

Juan franᶜᵒ Carrio f

Below the three books on the table there is another paper on which there is an illegible inscription.

Angulo has identified some of the books. The only one inscribed with an author's name on the spine is the book next to the skull. It reads: "Pestes de Quevedo," thus identifying it as the *Virtud militante contra los cuatro pestes del mundo: Invidia, Ingratitud, Soberbia, Avaricia* by Francisco Gómez de Quevedo y Villegas. Beneath the skull is another book on whose spine is written the work *Lacun.* This may be another volume by Quevedo: *La cuna y la sepultura para el conocimiento propio y desengaño de las cosas ajenas*, a popular work in its time. At the lower right is *La corte santa* by Nicolás Causino, originally written in French and translated into Spanish by Francisco Antonio Cruzada y Aragón. It was published in Spain in various editions between 1670 and 1677.[1]

The still-life tradition of placing objects on shelves can be traced at least as far back as the first century A.D. There are several Pompeiian *trompe l'oeil* paintings with this motif. Charles Sterling published fifteenth- and sixteenth-century German and Flemish examples of objects on shelves. These lack, however, the obvious *vanitas* connotations that this subject was to assume later.[2] Perhaps the closest comparisons with non-Spanish paintings may be with several examples by the seventeenth-century French artist Sebastien Stoskopf of books and other objects, including a skull, on shelves.[3] Torres Martín published a work by a "follower of Murillo" portraying four shelves of books, scissors, a clock, and flowers, which is in a private collection in Madrid.[4] The theme flourished well into the eighteenth century, although the symbolic content seems to have diminished. Giuseppe Maria Crespi's *Shelves in a Library* (ca. 1710–15) presents the viewer with simulated book shelves painted to conceal the doors of a real library in the Conservatory of Music in Bologna, where the painting is still found.[5]

The style of this interesting work is somewhat *retardataire* for the 1670s. Its dark colors and clearly defined, isolated objects remind us more of Spanish still lifes of the earlier part of the century. Carrión is here keeping alive the tradition of early Zurbarán, Sánchez Cotán, Juan van der Hamen, Blas de Ledesma, and others. E.J.S

NOTES

1. Angulo, "Un 'Memento Mori,'" pp. 261–262.
2. Charles Sterling, *Still Life Painting From Antiquity to the Present Time* (Paris, 1959), pls. 10, 14.
3. Michel Faré, *La Nature Morte en France* (Geneva, 1962), pls. 111, 112.
4. Torres Martín, *La naturaleza muerta*, p. 46.
5. Sterling, *Still Life Painting*, p. 86, pl. 70.

MATEO CEREZO
Burgos 1626–1666 Madrid

Cerezo's father was a painter, well known for his many versions of the so-called "Cristo de Burgos." His impact on his son was not as strong, however, as that of the young artist's first teacher in Madrid, Juan Carreño de Miranda, with whom he began to study in ca. 1641. Carreño must have impressed on his young pupil, as he did on many other students, the importance of studying the old master and significant modern works in the royal collections, for there are abundant evidences of the impact of Titian, Rubens, and Van Dyck on Cerezo's extant paintings. Buendía cites a copy of Titian's *Burial of Christ* in a private collection in Pamplona and a copy of Rubens's *Adoration of the Magi* both by Cerezo as having been in the Standish Collection.[1]

By 1646 Cerezo was an independent master. Judging from Palomino's life of the artist, he was prolific, yet not one of the works listed by Palomino survives today. Three of the paintings registered in the biography were known in modern times (and photographs document their appearance). These were the *Visitation*, *St. Thomas of Villanueva Distributing Alms*, and *St. Nicholas of Tolentino Saving Souls from Purgatory*, executed ca. 1666 for the Church of Santa Isabel in Madrid. They were destroyed in the Spanish Civil War.

Most of Cerezo's career developed in Madrid, although between 1656 and ca. 1659 he was again in Burgos and Valladolid, where he executed many paintings for the religious institutions of those cities. Ce-

rezo was particularly fond of ecstatic and penitential subjects. Most outstanding of these are several versions of *Mary Magdalen* as a voluptuous young woman with partially exposed breasts (see, for example, the version in the Rijksmuseum, Amsterdam). Such sensuous representations of the female figure were particularly rare in Baroque Spain. The renditions of the ecstasy and visions of St. Francis are also significant (e.g. *St. Francis Receiving the Stigmata*, Cat. no. 11, and the splendid *Virgin and Christ Child Appearing to St. Francis* in the Museo Lázaro Galdiano, Madrid).

Cerezo also practiced the art of fresco painting. He is recorded as having assisted Francisco de Herrera the Younger in the decoration of the Church of Nuestra Señora de Atocha. None of his mural paintings survives. Cerezo's talent was significant and most likely would have been developed to a much greater extent had his life not ended at the early age of forty.

<div align="right">E. J. S.</div>

NOTE

1. Buendía, "Mateo Cerezo," p. 280.

11. *St. Francis Receiving the Stigmata*

Oil on canvas; 205 × 123 cm. (81 × 48½ in.)

Signed and dated at lower left: *Mateo Cerezo 1663*

Provenance W. J. Hales, Bristol, England; sold at Sotheby's, London, 1971.

Literature Buendía, 1966, p. 286; Bantel and Burke, 1979, pp. 72–73, no. 7.

Elvehjem Museum of Art, University of Wisconsin, Madison, Class of 1945 Gift Fund Purchase (71.4).

Although this painting has been damaged by abrasion, it holds an important place in the oeuvre of Cerezo. The saint, clothed in brown robes, kneels in ecstasy with outstretched arms to receive the stigmata (the marks of the Crucifixion) from a seraph at the upper right. His chest is pierced by a miraculous ray emitted from the figure of the angel. Before the saint, on the ground, are an open book and skull, symbols of his contemplation and penitence.

Francis of Assisi is one of the most revered and often portrayed saints in Christendom. His lengthy biography

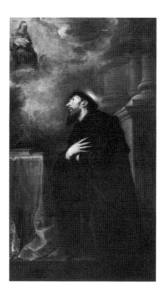

Figure 36. Mateo Cerezo, *St. Augustine*, oil on canvas. Madrid, Museo del Prado.

by St. Bonaventure relates that even before the time he consecrated himself to God at the age of twenty-four, he was a virtuous and generous man. After a vision, he gave up his worldly riches and dedicated himself to rebuilding the monastery of San Damiano in Assisi. He later oversaw the repairing of the abandoned Benedictine chapel of the Portiuncula, which became the mother house of the Franciscan order, where the rules of chastity, humility, obedience, and strict poverty were followed. Francis's kindness and compassion for all mankind and beasts alike were legendary even in his own time. He traveled throughout Europe and the Near East making converts to Christianity. Toward the end of his life he retired to a desert spot for forty days of fasting, penitence, and contemplation on the Holy Scriptures. At the climax of this retreat he experienced the mystical reception of the wounds of Christ from a six-winged angel. These marks remained with him until his death two years later in the Church of St. Mary of the Portiuncula. He was canonized in 1228 by Pope Gregory IX.

The St. Francis theme was one of Mateo Cerezo's favorite subjects. A *St. Francis Receiving the Stigmata* is listed by Palomino as having been painted for the Convent of Jesus and Mary in Valladolid as a companion to a *St. Anthony of Padua*. Ceán Bermúdez mentions a *St. Francis* along with a *St. Augustine* in the

Convent of the Unshod Carmelites in Madrid. The latter is now in the Prado (fig. 36).[1] There was a version of this theme in the cathedral of Valencia which was destroyed during the Spanish Civil War. Buendía records another in the Hospital of the Venerable Orden Tercera in Madrid.[2]

There are also several paintings in which St. Francis worships the Virgin and Child, the most famous of which is in the Museo Lázaro Galdiano, Madrid. The popularity of Cerezo's paintings with Franciscan subjects is attested to by the copies of his *St. Francis in Ecstasy* by José García Hidalgo and José Moreno, versions which are very similar to the Madison painting.

The Stigmatization of St. Francis was an archetypal Counter-Reformation theme and, as such, was taken up in the seventeenth century by scores of artists in many parts of Europe. It evoked dramatic emotions and also depicted the type of intimate, personal communication with the Lord that was stressed in the post-Tridentine church. Among the foremost representations of this subject in Spain, aside from those by Cerezo, were the versions painted by El Greco and Valdés Leal.

Cerezo, in contrast to these and other painters of the scene, simplified it considerably. The angel in this painting bears no crucifix; Brother Leo, St. Francis's companion, is absent, and, with the exception of the book and skull, there are no details to give the viewer any more than the basic facts of the story. This reduction of narrative elements is significant, for it serves to heighten the emotional impact of the saint's confrontation with the seraphic presence before him.

Despite the serious abrasion (especially in the background) Cerezo's rapid brush-technique can nonetheless be observed. The paint is thinly applied, allowing the weave of the canvas to show through. E. J. S.

NOTES

1. Marcus Burke points out that the Prado's *St. Augustine* (no. 2244) is of nearly equal size and bears a similar signature to the Madison picture (see fig. 36). He plausibly concludes that these two paintings are those referred to by Ceán Bermúdez. See Bantel and Burke, *Spain and New Spain. Mexican Colonial Arts in Their European Context* (Corpus Christi, 1979), p. 73.

2. See Buendía, "Mateo Cerezo," p. 288.

CLAUDIO COELLO
Madrid 1642–1693 Madrid

Coello was the fourth child of Portuguese parents who had emigrated to Spain. His father, Faustino, was a craftsman who fashioned bronze objects. Wishing to have his son assist him in his work, he sent the child to the studio of Francisco Rizi in ca. 1654–55 to study drawing. Rizi, realizing the boy's talent, persuaded the elder Coello to allow his son to begin a full apprenticeship with him. Coello also assisted his master in his capacity as theatrical designer for the Coliseo Theater of the Buen Retiro.

Coello's first dated work is *Christ at the Door of the Temple* (1660) in the Prado. Six years later he was given his first large-scale commission for which there is documentation. The retable for the high altar of the Church of Santa Cruz, Madrid, no longer exists, but three altar paintings executed for the Benedictine convent of San Plácido, his second significant commission, are still *in situ*. The work for this Benedictine institution led him to be awarded the commission for two retables for the Benedictine convent in Corella (Navarre), which he painted (probably in his studio in Madrid) ca. 1682. The subjects are a *Martyrdom of St. Placid* and the *Mystic Marriage of St. Gertrude*.

Coello's work as a frescoist began in the early 1670s. In collaboration with José Jiménez Donoso he painted the ceiling of the vestry in the *sagrario* of the cathedral of Toledo (1671–73). Shortly thereafter, Coello and Donoso were again contracted together to paint three ceilings in the Casa Panadería in the Plaza Mayor of Madrid. Coello also painted the portraits of famous men on the façade. During the 1670s and 1680s Coello was very active in painting series of fresco decorations as well as easel paintings for the churches of Madrid, including San Andrés, San Isidro, San Ginés, San Nicolás, and San Martín, among others. In addition, he worked for churches outside Madrid. Important altarpieces are still *in situ* in San Juan Evangelista, Torrejón de Ardoz, and in the Church of Santa María Magdalena, Ciempozuelos. The most complete surviving fresco cycle is that which Coello executed together with Sebastián Muñoz in the Church of San Roque ("La Mantería") in Saragossa (1683).

Coello was introduced to court circles by his teacher Rizi and also by Carreño (who, Palomino states, allowed him access to the royal picture collections). Coello

first worked for the court, designing arches for the triumphal entry of Queen Marie Louise into Madrid in 1680. He was appointed *Pintor del Rey* in March 1683 and *Pintor de Cámara* in 1686. Coello painted mythological scenes in the Galería del Cierzo in the royal palace (these were finished by Palomino). In 1685 he was asked to come to the Escorial to work on a painting which Rizi had begun but left unfinished at the time of his death that year. Coello discarded Rizi's plans for the *Sagrada Forma* and began work on a new design for the grandiose group portrait of King Charles II and his court adoring the Eucharist. It was his last major court commission and he continued work on the picture until 1690. In 1692 Luca Giordano arrived at court and, according to Palomino, there was bitter rivalry between the two artists. Although this enmity might have been exaggerated by Palomino, Coello nonetheless painted little else for the royal family, working principally for religious institutions outside the capital (the cathedral of Toledo, the Carmelitas de Abajo and San Esteban in Salamanca). He died in Madrid on April 20, 1693, and was buried in the Church of San Andrés. E. J. S.

12. *The Christ Child Appearing to St. Anthony*

Oil on canvas; 218 × 192 cm. (67 × 50½ in.)

Signed and dated in lower left corner: *CLAUDIO FA 63*

Provenance Royal collections, Madrid; Louis-Philippe Collection, Paris; Galerie Espagnole (1838–1848); Newhouse Galleries, New York; Walter P. Chrysler, Jr., New York.

Literature Paris, 1838, no. 22; Paris, 1853, no. 398; Winnipeg, 1955, no. 16, fig. 15; Portland, 1956, no. 16; Angulo, "Claudio Coello," 1958, 339, pl. 2; Indianapolis, 1963, no. 15; Muller, 1963, p. 103; Norfolk, 1973; Baticle and Marinas, 1981, p. 63.

The Chrysler Museum, Norfolk, Virginia, gift of Walter P. Chrysler, Jr. (71.542).

Before a background of columns and arches, St. Anthony of Padua kneels before a vision of the Christ Child, who sits on a globe amidst clouds and heads of putti. Below this heavenly group there is a table draped with a brilliant red cloth. At the lower left is a gold ewer with lilies. Two angels stand in the background holding a book, while two cherubs bearing roses fly above the saint's head.

Anthony of Padua, who was born in Portugal, was a favorite saint among Spanish artists, and Claudio Coello, like many others, often painted his likeness. The Norfolk picture is the first representation of this Franciscan saint in Coello's oeuvre.

According to legend, one day when Anthony was explaining the mystery of the Incarnation to a group of people, the Christ Child suddenly appeared, took the Bible held by the saint and stood upon it.[1] In this painting, however, the Infant does not stand on the book but sits on a globe while the book is held by two conversing angels in the background. The painting was erroneously known as the *Vision of St. Francis* when it was exhibited in the Galerie Espagnole in the Louvre.[2]

The *Christ Child Appearing to St. Anthony* (which may have been originally set into a frame with an arched upper portion) is one of the first known works by Coello. Its signature is similar to that of his earliest signed painting, *Christ at the Door of the Temple*, in the Prado. In both, the letters and date appear to be "carved" into the stone — in this case that of the platform on which the altar rests. The bulkiness and extreme sculptural quality of the figures also point to an early date before Coello developed his characteristic slender and elegant types (cf. Cat. nos. 13 and 14). The figure of St. Anthony may be related to Carreño's depiction of this saint in a *Vision* painted in 1656 and now in a private collection in Valladolid.[3] There is an autograph replica of this painting in a private collection in Madrid. E. J. S.

NOTES

1. Mrs. Anna Jameson, *Legends of the Madonna as Represented in the Fine Arts* (New York, 1899), p. 282.

2. Baticle and Marinas, *La Galerie Espagnole de Louis-Philippe au Louvre 1838–1848* (Paris, 1981), p. 63.

3. See Urrea Fernández, "Una pintura de Carreño y otra de Van de Pere en Valladolid," *Boletín del Seminario de Estudios de Arte y Arqueología*, 48 (1977), p. 489, fig. 1.

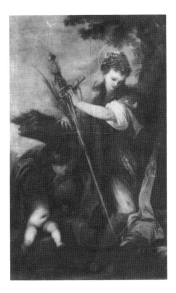

Figure 37. Juan Antonio Escalante, *St. Catherine of Alexandria*, oil on canvas. Madrid, Church of Las Maravillas.

13. *St. Catharine of Alexandria Dominating the Emperor Maxentius*

Oil on canvas; 218 × 155 cm. (86⅛ × 60¹⁵⁄₁₆ in.)

Provenance Duque de Montemayor d'Almeida; Robert Millington Holden, Nuthall Temple, Nottinghamshire, England; Milton Hebald, Rome; Constantini, Rome; Manuel González, Geneva.

Literature "Acquisitions," 1977, p. 251; González, 1978, p. 185 (see also Portuguese ed.).

Meadows Museum, Southern Methodist University, Dallas, Texas (76.01).

St. Catherine, shown here as a mature woman, clad in richly brocaded robes and adorned with jewels at her breast and in her hair, stands over the almost diabolical-looking Roman Emperor. She holds her attributes: the broken wheel, sword, and martyr's palm.

Catherine was a popular figure in the visual arts from the Middle Ages onward. There are literally hundreds of portrayals of her mystic marriage to the Christ Child as well as other scenes in which she is shown with the spiked wheel. This saint, who lived in Alexandria in the third century, converted to Christianity after she experienced visions of the Infant Jesus. At this time Em-

peror Maxentius established his capital at Alexandria. He summoned Catherine, known for her beauty, to his court and offered to marry her. Refusing to give up her Christianity as well as her virginity, she was imprisoned. Although the Emperor attempted to starve her into submission she was fed daily by a dove who came to her cell. Enraged at her steadfastness, Maxentius had her bound between four wheels rimmed with spikes. Before the spikes could tear her flesh, however, the wheels miraculously broke apart. She was later beheaded.

There is a sixteenth-century Spanish precedent for a scene of Catherine trampling the head of the Emperor by Alonso Sánchez Coello in the Escorial.[1] Coello's composition is closer, however, to the *St. Catherine* by Escalante in the Church of Las Maravillas (also known as the Church of Sts. Justus and Pastor) in Madrid (fig. 37). Coello's painting approximates in subject matter and style his *Triumph of St. Augustine* in the Prado (fig. 16). Both are images of the triumph of faith over paganism and, like the *St. Michael the Archangel* (Cat. no. 15), can be read as symbols of the perseverance of Spanish Catholicism. The date of this work is approximately 1665.

Coello returned to this subject later in his career. In the Wellington Museum, London, there is a three-quarter length *St. Catherine* dressed in a similar costume, holding her attributes. E.J.S.

NOTE

1. The painting also includes the figure of St. Inez with her attribute, the lamb. See Zarco Cuevas, *Pintores españoles*, p. 155, no. 3.

14. *St. Joseph and the Christ Child*

Oil on canvas; 184.2 × 103 cm. (72½ × 40½ in.)

Signed and date at lower left: *Claudio Coello 1666*

Provenance Private collection, Madrid; Matthiesen Fine Art, Ltd., London.

The Toledo Museum of Art, gift of Edward Drummond Libbey (81.44).

St. Joseph, wearing a brown cape over a mauve tunic, holds the Infant Christ in his arms as he motions to a cradle at the lower left. Two putti hold a white cloth

over the cradle as another lifts up a curtain. Two other cherubs hover above the heads of the holy pair holding a crown of roses and Joseph's flowering staff. On a porch beyond a large column that separates the two spaces of the picture, sits the Virgin, engaged in sewing. Beyond her a wooded landscape is seen.

Devotion to St. Joseph, the earthly spouse of the Virgin Mary, became very popular in the seventeenth century. The feast of St. Joseph was instituted by the Council of Trent, declaring Joseph *nutritoris domini*. It was made obligatory for the entire Church by a decree of Pope Gregory XIV in 1621.[1] In Spain the veneration of the saint was intense. It is known that St. Theresa of Avila had a deeper devotion to Joseph than to any other saint, and founded a number of churches dedicated to him.[2] Her spiritual advisor, St. Peter of Alcántara, was equally instrumental in promoting the cult of the saint. Ignatius Loyola, founder of the Jesuits, had previously fostered reverence for Joseph in his *Spiritual Exercises,* in which he describes him as a model of parental authority and the Christ Child as a paragon of filial obedience.

The popularity of St. Joseph is reflected in Spanish Baroque art. Perhaps the earliest well-known image of the saint's paternal care and tenderness is El Greco's *St. Joseph and the Christ Child in a Landscape* (ca. 1597–99) painted for the Capilla de San José in Toledo. Later in the seventeenth century Murillo did several versions of this theme, also in an outdoor setting (in the Museo Provincial de Bellas Artes, Seville, and the Hermitage, Leningrad). Vicente Berdusán, a follower of Claudio Coello, executed a painting of St. Joseph (in the Museo de Bellas Artes, Saragossa) in which the figures of God the Father and the dove of the Holy Spirit appear, forming the Holy Trinity. Francisco Camilo's *Sleeping Christ Child in the Arms of St. Joseph* (Museo Provincial, Huesca) is one of the few depictions of this theme in an indoor setting.

Coello's version is unusual. It is set within the carpenter's shop and includes the Virgin, not as an active participant, but as an observer in the background. Nonetheless, her sewing accentuates the intimacy of the scene, while the action taking place in the foreground has a more ecstatic and miraculous feeling. Coello creates a unique coalescence of the quotidian and the divine. The composition may have a precedent in popular art. In the Museo de Arte de Cataluña, Barcelona, there is an eighteenth-century plaque

with a similar configuration, possibly reflecting earlier prototypes in prints and ceramics.[3]

This beautiful painting is published here for the first time and nothing is known about its early provenance. It was apparently made for an arched frame and its large size indicates that it would have most likely been executed for a church rather than a private oratory. It is dated 1666, placing it in the first decade of Coello's artistic activity. In that year the artist was twenty-four years of age and had already received the first large-scale commission for which there is documentation, that of the altarpiece for the Church of Santa Cruz. Palomino mentions that Coello painted a *San José* for the charterhouse of El Paular, but it is difficult, if not impossible, to prove that Coello's biographer was referring to this painting. It may also be that this painting was executed for a Jesuit church, since Coello later undertook several commissions for the Jesuits in Madrid and Valdemoro.[4]

The bright, almost Venetian colors of the painting point to the young artist's avid study of the Italian old master pictures in the royal collections. While incorporating the sketchy, rapid manner of execution of his master Rizi, Coello's careful drawing in the figures creates perfectly believable individuals who embody the quintessence of both spirituality and human tenderness.

E.J.S.

NOTES

1. Sheila Schwartz, "The Iconography of the Rest on the Flight into Egypt," (Ph.D. diss., New York University, 1975), p. 151.
2. Emile Mâle, *L'Art religieux de la fin du XVIe siècle, du XVIIe siècle et du XVIIIe siècle* (Paris, 1951), pp. 314–315.
3. Illustrated in *San José en el arte español*, exh. cat. (Madrid, 1972), p. 193, no. 139.
4. See Sullivan, "Two Paintings by Claudio Coello," in *Homenaje a Humberto Piñera* (Madrid, 1979).

15. *St. Michael the Archangel*

Oil on canvas; 182.8 × 116.7 cm. (72 × 46 in.)

Provenance Sir William Hervey, Langley Park, Slough, Berkshire, England; Colnaghi's, London; Spencer Samuels and Co., New York.

The Sarah Campbell Blaffer Foundation, Houston, Texas.

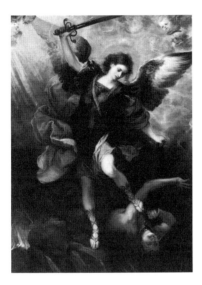

Figure 38. Attributed to José Antolínez, *St. Michael the Archangel*, oil on canvas. Greenville, South Carolina, Bob Jones University Collection.

The bold figure of the archangel, dressed in armor, boots, and a red cape which is tossed about by the wind, stands triumphantly above the figure of Satan. Michael holds aloft a sword and a Cross. The devil covers the wound he has just received from the heavenly warrior with a cloven hand. The sparks and fires of Hell are depicted in the lower part of the painting, while a celestial light streams down from the upper left.

This previously unpublished work is one of Coello's most dramatic and coloristically rich images. The Archangel Michael (whose name means "like unto God" and is often shown, as here, as a handsome young man) was the Captain-General of the heavenly hosts of angels who did battle with the legions of Satan. He is Protector of the Church Militant and, as such, was a popular figure in the iconography of Spanish art of the Baroque period, serving as a representation of the triumph of the Church over heresy, and, by extension, as a paradigm of the militancy of Spanish Catholicism.

Other striking representations of this saint by Spanish painters of the late seventeenth century include the version by Palomino (Cat. no. 35), several examples by Juan de Valdés Leal, and a little known but beautiful version here attributed to José Antolínez, in the Bob Jones University Collection (fig. 38).[1] All of these images are variants of Raphael's *St. Michael*, in the Louvre, which was known through prints such as that by Gilles Rousselet. Another popular version of the theme by Guido Reni (1635) in Santa Maria della Concezione, Rome, also provided a model for later depictions of the saint.

The early provenance of this painting is not known. There are, however, several references to paintings of St. Michael in the royal inventories. In a record of the paintings in the Casa Real del Campo made in 1701 there are two works of equal size listed as numbers 7747 and 7748: "*dos pinturas yguales* [sic], *de a dos varas en cuadro, la una el angel San Miguel y la otra el Angel San Gabriel, de mano de Claudio Coello.*"[2] These were in a room described as the "*pieza oscura que sale a la Escalera*" ("the dark room which gives onto the staircase"). A St. Michael "*de dos varas y quarta de ancho y dos de alto*" was among the paintings saved from the fire at the Alcázar in 1734. The inventory of paintings taken from the royal palace to the residence of the archbishop in 1747 lists a "*San Miguel de dos varas y quarta original de Claudio Coello*" and put its value at 300 *reales*. Finally, a "*San Miguel con el diablo a los pies y la Santisima Trinidad, seis quartas de ancho y dos varas de alto de Claudio maltratado*" was in the "*Pieza de la librería*" of the Buen Retiro according to the 1772 inventory. Given the well-known imprecision of the royal inventories, it cannot be said for certain which, if any, of these descriptions could apply to the Blaffer Foundation's painting.

It is also known that ca. 1680 Coello executed all the paintings for the retable of the high altar of the Church of the Caballero de Gracia in Madrid, including a *St. Michael*. These are thought to be lost. The Blaffer picture probably does not correspond to that painted for the Caballero de Gracia, however, because the style of the work relates it to Coello's paintings done in the 1660s.

Here, as in the case of the *St. Catherine of Alexandria* (Cat. no. 13), the most cogent point of comparison is with the Prado *Triumph of St. Augustine* (fig. 16). The dynamic movements, precisely defined facial features, hands and feet, and the over-all theatricality of the scene are typical of Coello's works at that time. Although the color is dark in many areas, the creamy white tones of the saint's skin and the bright blues of his shoulder and of the sky at the upper left might also be compared with the colors of the *St. Joseph and the Christ Child* (Cat. no. 14). E. J. S.

NOTES

1. This painting is attributed to Juan de Valdés Leal by the museum. Other examples of St. Michael by Valdés Leal are in the Prado, the Shod Carmelite Church, Córdoba, and the Church of La Magdalena, Seville.

2. These inventories are in the Archivo de Palacio, Madrid.

16. *Susannah and the Elders*

Oil on canvas; 125 × 145 cm. (49 × 57 in.)

Signed and dated at lower left: *Clau(dio) Coe(llo) fat. 1664(?)*; On the back of the canvas there is the entire signature *Claudio Coello*, which was covered when the painting was relined.

Provenance Private collection, Austria; sold at the Dorotheum, Vienna, March 17, 1964.

Literature Held, 1965, pp. 39–40, 302; Taylor, 1965, pp. 61–62; Pérez Sánchez, 1976, p. 159, fig. 29.

Museo de Arte de Ponce, Puerto Rico (64.0470).

Susannah, trying hastily to gather her white robe to cover her naked breasts, faces away from the two old men who have surprised her at her bath. To the right is seen a portion of a fountain sculpture including a leg (of a putto?) and a stylized sea creature from whose mouth issues water.

The story of Susannah and the Elders appears only in the Book of Daniel in the Apocrypha. Susannah was the daughter of Chelsias of Babylon and was falsely accused of infidelity to her husband Joachim by two men who themselves had lusted after the woman.

Coello's painting, along with Velázquez's *Venus at her Mirror*, are remarkable exceptions to the rarity of the nude female figure in Spanish Baroque painting. It is the only such nude done by Coello and his only painting depicting an Old Testament subject.

Taylor theorizes that the picture may have been commissioned by a private (possibly non-Spanish) patron, thus avoiding censorship by the Inquisition, which disapproved of such subject matter.[1]

Both Flemish and Venetian influence have been pointed out in explaining the style of this work. Taylor relates it to a painting of the same theme by Rubens in the Academia de San Fernando, Madrid.[2] There are also certain similarities (in the faces of the old men) to

Van Dyck's *Susannah* in Munich. Pérez Sánchez has stated his belief that Coello's picture shows a strong debt to Titian.[3] In general, the work seems to be an amalgam of the most potent sources of inspiration for the young painter, which also included the art of Coello's Italian contemporaries. Perhaps the best-known version of this theme by an Italian Baroque master is Guercino's *Susannah* now in the Prado, but which was at the Escorial during Coello's lifetime. E.J.S.

NOTES

1. Taylor, "Un Claudio Coello inédito," *Archivo Español de Arte*, 38 (1965), pp. 61–62.

2. Ibid.

3. Pérez Sánchez, "Presencia del Tiziano en la España del siglo de oro," *Goya*, 135 (1976), p. 159.

JUAN ANTONIO ESCALANTE
Córdoba 1633–1670 Madrid

In about 1645 Juan Antonio de Frías y Escalante went to Madrid from his native Córdoba. Palomino tells us that he had already begun his career in Andalusia, but he gives no information regarding his teachers. Buendía has hypothesized that he may have studied with Antonio del Castillo, the most important artist working in Córdoba in the later seventeenth century.[1] He bases this supposition on an examination of a *St. Anthony of Padua* (1659) in a private collection in Madrid, which displays reminiscences of Castillo's brand of tenebrism. Unfortunately, Escalante's first recorded painting for a religious institution in Madrid, a *St. Gerard*, which was placed in the cloister of the Religiosos Calzados de Nuestra Señora del Carmen, is lost.

Escalante's teacher in Madrid was Francisco Rizi, whose sketchy style strongly influenced the young artist, as can be seen in almost all the works from his mature phase. Although Escalante was, like his contemporaries, primarily a religious painter, there are a few mythological paintings by his hand, such as the *Andromeda and Perseus* in the Prado (attributed by the museum to Giordano). In 1660 Escalante painted a *St. Catherine of Alexandria* for the Church of San Miguel (now in the Church of Las Maravillas), Madrid (fig. 37). This is a key picture in his development, for

it shows, as Palomino (who states that the painting "parece de Tintoretto") points out, that the artist had thoroughly assimilated the Venetian influence that would mark the remainder of his work. This painting is also significant in that it strongly influenced Claudio Coello's version of the St. Catherine theme (Cat. no. 13).

In 1666 Escalante painted an *Immaculate Conception* for the Benedictine convent in Corella, for which Coello and José Jiménez Donoso were later to work. The painting is cited in Palomino's biography and is probably the same picture now in the Benedictine convent in Lumbier.

Between 1667 and 1668 Escalante executed a series of seventeen paintings, with Old Testament subjects prefiguring the institution of the Eucharist, for the Church of the Merced Calzada in Madrid. The series has been dispersed and some of the pictures are lost. Surviving, among others, are *Abraham and Melchizedek* in the Church of San José, Madrid, *Elias in the Desert* in the Prado, and *Abraham and the Three Angels* in a private collection, Madrid. One of Escalante's last projects (ca. 1668–70) was to execute two canvases depicting Benedictine saints for San Plácido, Madrid. These pictures, still *in situ*, have been cited as displaying the influence of Van Dyck, but they may also attest to the impact of the style of Coello, who, in 1668, had finished three monumental altarpieces in the church that display figures of similar solid proportions and dynamic movements as those of Escalante.[2]

Palomino also mentions Escalante's assistance in the creation of a new eucharistic repository (*monumento*) to be used by the cathedral of Toledo during Holy Week. The commission had been granted in June of 1668 to Francisco Rizi, who was also aided by Carreño and Dionisio Mantuano. The *monumento* does not survive. Like Mateo Cerezo, Escalante died in Madrid at the age of thirty-seven. E. J. S.

NOTES

1. Buendía, "Sobre Escalante," *Archivo Español de Arte*, 43 (1970), p. 35.
2. Ibid., p. 45.

17. *The Baptism of Christ*

Oil on canvas; 163.2 × 119.2 cm. (64 × 47 in.)

Provenance George Dudley-Wallace, London; Julius H. Weitzner, New York.

Literature Greenville, 1962, no. 211; Buendía, "Sobre Escalante," 1970, p. 39, pl III.

Bob Jones University Collection, Greenville, South Carolina (P.59.195).

A description of the event portrayed by Escalante is found in Matthew (3:13–17):

> Then cometh Jesus from Galilee to Jordan unto John, to be baptized by him. But John forbad him saying, "I have need to be baptized of thee, and comest Thou to me?" And Jesus answering said unto him, "Suffer it to be so for now: for thus it becometh us to fulfill all righteousness."... And Jesus, when He was baptized, went up straightaway out of the water: and, lo, the heavens were opened unto Him, and He saw the Spirit of God descending like a dove, and lighting upon Him: and lo a voice from heaven saying "This is My beloved Son in Whom I am well pleased."

This painting was formerly attributed to Alonso Cano, and indeed, the figure of Christ might be convincingly compared with analogous types in Cano's paintings of ca. 1650, such as the *Noli Me Tangere* in Budapest or the *Dead Christ Supported by an Angel* in the Prado. An attribution to Escalante was suggested in correspondence to the Bob Jones University Collection by both Harold Wethey (in 1959) and Martin Soria (in 1959 and 1960).

Palomino stresses the strong impact of the artists of the Venetian Renaissance upon Escalante. Both the figure types and use of a diffused golden glow in the area surrounding the dove suggest the influence of Tintoretto. Buendía, who cautiously accepts the attribution to Escalante, has also noted the influence of the artist's contemporaries, Rizi and Carreño, while pointing out the strong resemblance in the elongated figure and expressive face of St. John to that of Escalante's early *St. Anthony* (1659), discussed above in the biography of the artist.[1] With this similarity in mind, we might date this painting ca. 1660. E. J. S.

NOTE

1. Buendía, "Sobre Escalante," p. 39.

Luca Giordano
Naples 1634–1705 Naples

Giordano's links with Spain began early in his career. As a young artist he was an important figure in the workshop of Jusepe de Ribera, the great expatriate who spent most of his artistic career in Naples, a city under Spanish political domination. Many of Giordano's early paintings were done in the Riberesque style. He was an artist who assimilated and, at times, imitated (although never copied) the work of such diverse masters as Rembrandt, Veronese, Raphael, and Rubens, as well as Ribera. He worked in many cities in Italy: Rome, Florence, Bergamo, and Venice, as well as Naples. Giordano was aptly described by Rudolf Wittkower as "The prototype of the itinerant artist... perhaps the first *virtuoso* of the eighteenth century... although most of his work belongs to the seventeenth century."[1]

By the 1660s Giordano had become a major force in fresco painting in Italy, having assimilated the coloristically rich manner of Pietro da Cortona and others. Among the most splendid examples of his work in fresco are the ceilings executed in Florence in the 1680s for the Church of Santa Maria del Carmine and the Palazzo Medici-Riccardi.

His virtuosity as well as his fabled swiftness of execution, which earned him the nickname *fa presto*, brought him to the attention of the Spanish court, and he was called to Madrid to execute fresco decorations in 1692. He arrived in May of that year, accompanied by his son, son-in-law, and two assistants. His first project was to paint the enormous ceiling above the grand staircase in the monastery of the Escorial, as well as ten vaults in the church. The theme of the staircase fresco is the worship of the Holy Trinity by a heavenly glory of saints (including Lawrence, patron of the monastery) and King Charles I. Also included are the likenesses of Giordano's patron Charles II, his mother Mariana, and his second wife, Mariana of Neuburg. The iconographic program was devised by the monastery's prior, Francisco de los Santos. Both Old and New Testament subjects are depicted in the frescos in the church.

Among the other large-scale fresco projects undertaken by Giordano in Spain was the ceiling of the sacristy of the cathedral of Toledo as well as that for the great hall of the Casón del Buen Retiro in Madrid. In San Antonio de los Portugueses, Madrid, Giordano retouched the frescos that had been painted in the early 1660s by Rizi and Carreño and added his own paintings on the side walls. He also executed decorative fresco paintings in the Alcázar and in Nuestra Señora de Atocha, projects which do not survive.

Giordano prepared an important cycle of easel paintings for the Monastery of Nuestra Señora de Guadalupe in Extremadura (western Spain). These nine paintings represent scenes from the life of the Virgin and are placed in the *camarín*, where the miraculous image to which the monastery is dedicated is housed. In addition, he executed many single paintings and tapestry designs while in Spain. His work was much admired by the two monarchs under whose reigns he worked.

Giordano left Spain on May 1, 1702, returning to Naples, where he continued to produce prodigious examples of fresco such as the *Triumph of Judith* in the Cappella del Tesoro in the Certosa di San Martino. The artistic legacy of Giordano remained alive in the work of many painters, including another Neapolitan whose work in Spain was of considerable importance in the eighteenth century, Corrado Giaquinto.

E. J. S.

NOTE

1. Rudolf Wittkower, *Art and Architecture in Italy 1600–1700*, Pelican History of Art (Harmondsworth, 1958), p. 305.

18. *The Dream of St. Joseph*

Oil on canvas; 118.5 × 138 cm. (46⅝ × 54¼ in.)

Provenance Private collection, England; Walter P. Chrysler, Jr., New York; Thomas Agnew and Sons, Ltd., London.

Literature Bertina Manning, 1962, no. 28; Robert Manning, 1962, no. 28; Milkovitch, 1964, p. 38; Ferrari and Scavizzi, 1966, vol. 2, p. 132, 246, vol. 3, pl. 432; London, 1971, no. 13; Janson and Fraser, 1980, pp. 80–81; Janson and Fraser, 1981, n. pag.

Indianapolis Museum of Art, Martha Delzell Memorial Fund (77.52).

At the right of this two-part composition, the sleeping St. Joseph rests his head on a table in his carpenter shop surrounded by tools. An angel approaches to tell

him: "Fear not to take unto thee Mary as thy wife, for that which is conceived in her is of the Holy Ghost" (Matthew 1:18–25). At the left the Virgin kneels in prayer as a vision of God the Father and the Holy Spirit appears above, representing (with the implied presence in the womb of Mary) the Holy Trinity and the Incarnation. The depiction of Joseph's dream and the Incarnation side by side is an iconographic novelty.

This painting, done around 1700, was formerly thought to have been executed as a cartoon for the Real Fábrica de Tapices in Madrid. No tapestry, however, is known to exist of this composition. There are several variations of this painting, including workshop replicas in the Valenciano Collection, Barcelona, the Infantado Collection, Madrid, and the cathedral of Toledo. Another version of this theme is in the Landesmuseum at Graz, showing only the sleeping saint.

Perhaps the *Dream of St. Joseph* was painted as part of a series depicting scenes from the life of the Virgin. Although there is no documentary evidence to support this hypothesis, we might remember that Giordano had executed such a series in Spain for the monastery at Guadalupe, and at least one other, of which two paintings in the Louvre (a *Marriage of the Virgin* and an *Adoration of the Shepherds*) are parts. It is known that the Infantado Collection copy of the Indianapolis painting had a (now lost) pendant, *The Education of the Virgin*, but it is not certain that such a companion picture existed for the painting under discussion here.

The virtual flood of pale, golden light and the use of pastel tones are hallmarks of Giordano's mature art and exerted a strong influence on painting in Spain, preparing the way for the development of a true Rococo style. E. J. S.

FRANCISCO DE HERRERA THE YOUNGER
Seville 1627–1685 Madrid

Herrera was baptized on June 28, 1627, in the Church of San Andrés in Seville. He was the son of María de Hinestrosa and Francisco de Herrera the Elder who may have been the first teacher of Diego Velázquez. According to tradition, Velázquez was unable to suffer the elder Herrera's bad temper and left his studio. A similar strident personality seems to have been passed from father to son, for Palomino, in his biography of the painter, insists on his vanity and irrascibility.

Palomino also tells us that Herrera first studied with his father and later went to Rome. Although this information is repeated by Ceán Bermúdez, who states that he went there to copy the works of Raphael and other old masters as well as the principal monuments of antique art, there is no documentary evidence to prove his stay in that city (a journey to Italy is plausible nonetheless), nor do there exist any paintings which attest to his mastery of still life (for which, Palomino states, he was given the nickname of *il Spagnole degli pesci*).

Herrera was in Madrid by 1654 when he was commissioned to paint his famous *Apotheosis of St. Hermengild* (fig. 7) for the Church of the Unshod Carmelites. This splendid picture is one of the earliest examples of a fully developed high Baroque style in Spain. It probably predates other well-known paintings by his hand also demonstrate the artist's obvious knowledge and incorporation of Italian and Flemish Baroque styles, such as the *Holy Sacrament Adored by Fathers of the Church* and the *Apotheosis of St. Francis*, both in the cathedral of Seville.

In 1660 he was co-president of a drawing academy in Seville with Bartolomé Esteban Murillo. He remained in this post for only a few months, however, after which he most likely left for Madrid. There he won the favor of the Crown and was appointed painter to King Philip IV. Philip died in 1665 yet Herrera was not re-appointed to this post by Charles II until 1672.

In Madrid Herrera also worked for a number of churches executing fresco paintings (all of which, unfortunately, are lost). Among the most prominent buildings decorated by him in this medium were San Felipe el Real and Nuestra Señora de Atocha. Herrera often received commissions for easel paintings as well as frescos from these churches. In the Museo Lázaro Galdiano in Madrid are two impressive canvases, an *Ecce Homo* and a *Way to Calvary* which originally formed part of the ensemble of paintings for the chapel of Nuestra Señora de los Siete Dolores in the Church of Santo Tomás, Madrid.

In 1671 Herrera contributed two prints—an allegorical portrait of Charles II and a frontispiece—to the festival book compiled by Francisco de la Torre Farfán to honor St. Ferdinand, patron of Seville, who was canonized at that time. The following year Herrera

designed the stage sets for Juan Vélez de Guevara's zarzuela *Los celos hacen estrellas*. Drawings done after the performance of the play are found in the collections of the Uffizi in Florence and the Öesterreichische Nationalbibliothek in Vienna.

Herrera may have been as well known in his own time for his architecture as for his painting, for Palomino lists him as *Arquitecto y pintor de su majestad*. In 1673–74 his architectural expertise assumed greater importance; it was in this year that he designed a retable which was executed by José Ratés and José de Churriguera. He became Royal Architect and Assistant Keeper of the Palace Keys in 1677. Three years later he arrived in Saragossa to oversee the construction of the Church of Nuestra Señora del Pilar, which he had designed. His plans were later radically changed, however, and the church retains virtually nothing of his original ideas.

Herrera died in Madrid on August 25, 1685. E. J. S.

19. *The Dream of St. Joseph*

Oil on canvas; 208 × 196 cm. (82 × 77 in.)

Provenance Colegio de Santo Tomás, Madrid; the Gentile family, Genoa; a member of the Gentile family, Paris; Legenhooch, Paris, 1953; Newhouse Galleries, New York, 1954.

Literature Palomino, 1724 (1947 ed.), p. 1021; Portland, 1956, p. 23, illus., p. 9 (as Valdés Leal); Kubler and Soria, 1959, p. 288, pl. 153A (as Escalante); Buendía, "Sobre Escalante," 1970, p. 44 (as Escalante); Norfolk, 1973 (as Valdés Leal); Helburn, 1974; Amaya and Zafran, 1977, no. 13.

The Chrysler Museum, Norfolk, Virginia, on loan from the collection of Walter P. Chrysler, Jr. (L77.365).

St. Joseph reclines in an open landscape with his carpenter tools at his side. At the right, an angel approaches him and points to putti holding symbols of the Virgin Mary's purity: lilies and a mirror; the same attributes which often appear in paintings of the Immaculate Conception.

This painting illustrates a scene described in Matthew (1:18–25):

> Now the birth of Jesus Christ was on this wise: When as his mother Mary was espoused to Joseph, before they came together, she was found with child of the Holy Ghost. Then Joseph her husband,

> being a just man, and not willing to make her a public example, was minded to put her away privily. But while he thought on these things, the angel of the Lord appeared unto him in a dream, saying, Joseph, thou son of David, fear not to take unto thee Mary thy wife: for that which is conceived in her is of the Holy Ghost. And she shall bring forth a son and thou shalt call his name Jesus....

Although Matthew's Gospel is the only one which refers to this event, it was also described in the apocryphal literature such as the *Protoevangelium of James*.[1] It became a popular theme in medieval art; the earliest representation of it may be that on a Carolingian ivory relief of the ninth century from Werden Abbey and now in the Victoria and Albert Museum, London.[2] The seventeenth century witnessed a revival of this subject as a consequence of the increased devotion to St. Joseph (see the discussion of this phenomenon in the essays for Coello's *St. Joseph and the Christ Child* and Murillo's *Flight into Egypt*). Among Spanish painters who painted the *Dream* were Vicente Carducho, Juan Montero de Rojas, and Mateo Gilarte.

Although formerly attributed to Valdés Leal and Escalante, Jonathan Brown (in correspondence with the Chrysler Museum) correctly pointed out that this is the painting referred to by Palomino in his description of the decoration of the chapel dedicated to St. Joseph in the Church of Santo Tomás, Madrid: "*un peregrino cuadro del Sueño de San José... en el remate del retablo, que aseguro que es de lo más regalado, y de buen gusto, que he visto suyo*" ("a beautiful painting of the Dream of St. Joseph in the upper area of the altar piece, which, I assure you, is one of the most delicate and tasteful works that I have ever seen by him"). The painting originally had a curved top in accordance with its placement in the upper part of the retable. A copy is in the Silva Collection, Madrid.

Although the precise date of this picture is not known, the warm tonalities and soft lighting relate it to the later years of the artist's work in Madrid (1670s). Herrera had also painted scenes of the Passion of Christ for the Church of Santo Tomás. In the two surviving examples (*Ecce Homo* and the *Road to Calvary* in the Museo Lázaro Galdiano, Madrid), a much greater emphasis on light and dark contrasts is employed whereas in the Chrysler picture, the *sfumato* effects suggest a gentler mood. E. J. S.

NOTES

1. Gertrude Schiller, *Iconography of Christian Art* (Greenwich, 1971), vol. 1, p. 56.

2. In medieval art the Dream of Joseph is often combined with other episodes of the Nativity, such as the Birth of Christ or the Journey to Bethlehem.

JOSE JIMENEZ DONOSO
Consuegra (Toledo) 1628–1690 Madrid

There is no modern study of the work of José Jiménez Donoso. The most lengthy biography is that by Ceán Bermúdez, who tells us that the artist's first lessons were given to him by his father, also a painter, and that he later came to Madrid to study with Francisco Fernández, in whose shop he remained until the age of approximately eighteen. He then went to Rome, where he spent at least seven years studying painting and architecture. Palomino, in his life of Donoso, pays special attention to his study (in Italy) of architectural perspective, which was to benefit him later in Spain where he executed a number of projects in fresco with Claudio Coello and other major artists of the day.

After returning from Rome he studied, like so many others of his generation, with Carreño de Miranda. It is not known exactly how long he spent with Carreño, but Palomino states that upon leaving his shop he began to work with Coello. Possibly the earliest collaborative effort of the two artists was for fresco decorations of the presbitery in the Church of Santa Cruz (ca. 1667–68). These paintings are lost and their subjects are not recorded. Also from this time are two major easel paintings now in the Museo Provincial de Bellas Artes at Valencia, the *Founding of St. John Lateran* and the *Mercedarians before the Pope*.

Around 1673 Donoso and Coello executed their most ambitious joint project, the frescos of the Capilla de San Ignacio and the sacristy of the Colegio Imperial (now San Isidro) in Madrid. Palomino gives a lengthy description of these paintings with allegories of the Company of Jesus and scenes from the life of St. Ignatius. Unfortunately, this cycle was destroyed during the Spanish Civil War. Other works executed at this time with his collaborator were the ceiling of the vestry in the cathedral of Toledo and three ceilings in the Casa Panadería in the Plaza Mayor, Madrid. These

paintings survive (in part), and although the styles of the two artists are very similar, it is most likely that Coello executed the greater share of the work.

As an architect, Donoso was important as a designer of retables for churches in and around Madrid. Most of his architectural work has also been destroyed, such as the high altar of the Convento de la Victoria in Madrid. A drawing of the altarpiece's central image, *Our Lady of Victory*, is in the collection of the Biblioteca Nacional, Madrid. Also from this convent comes one of Donoso's most important extant paintings, the *Vision of St. Francis of Paola*, now in the Prado.

Although Palomino names Donoso as the architect for a number of building projects in Madrid, the recent research of Virginia Tovar Martín has found no documentation to substantiate any of these claims.[1]

While the artist's bad temper probably prevented the king from naming him to an official royal post, he was much in demand in other quarters. Among his last works was the fresco painting for the chapel of Don Diego Ignacio de Córdoba in Madrid. Palomino states that Donoso had written a book on *cortes de cantería* and another on architecture, neither of which, unfortunately, survives. E.J.S.

NOTE

1. Virginia Tovar Martín, *Arquitectos madrileños de la segunda mitad del siglo XVII* (Madrid, 1975), p. 13.

20. *The Immaculate Conception*

Oil on canvas; 81.3 × 61 cm. (32 × 24 in.)

Provenance Bought in Madrid in 1842. Bequest of T. W. C. Moore, 1872.

Literature New York, 1915, no. 222; Marzolf, 1961, p. 147.

The New-York Historical Society, New York (1872.14).

The Virgin stands on a globe. Her arms are outstretched and she looks up to Heaven as her blue mantle billows out to the right. Below, putti hold a mirror, a crown of roses, lilies, and a palm, while above, other cherubs hold a gold crown.

This painting is presently catalogued as an *Assumption* in the collection of the New-York Historical Society, yet the presence of the typical attributes of the

Immaculate Conception identify the work as representing this subject, one of the most frequent in Baroque Spain.

This picture is surely not by Carreño de Miranda, to whom it has traditionally been ascribed. The youthful Virgin is unlike Carreño's more robust types. It should be identified with a large painting in the Museo de Bellas Artes in Salamanca by Donoso,[1] of which the New York picture is a reduced version.[2] It cannot be described as a sketch (as has been done) because of its finished qualities. E.J.S.

NOTES

1. See Amelia Gallego de Miguel, *El Museo de Bellas Artes de Salamanca* (Salamanca, 1975), p. 27, pl. 9. The Salamanca painting measures 2.30 × 1.60 m.

2. Marzolf, in "Carreño," p. 147, states that this is "probably a sketch for a lost painting." She mentions the Salamanca painting, without citing Donoso as the artist.

JUAN BAUTISTA MARTINEZ DEL MAZO
Province of Cuenca ca. 1610/15–1667 Madrid

Mazo's father was Hernando Martínez from the town of Alarcón, and his mother was Lucia Bueno from Beteta in the province of Cuenca. This documentation, published by Zarco Cuevas, has led Gaya Nuño to suppose that the artist was born around 1612, although Neil McLaren has proposed that he may have been born as late as 1616.[1] No further documentation has been found to account for the artist's training or whereabouts before 1633, when he was married to Francisca Velázquez, daughter of Diego. He had probably entered Velázquez's studio before the marriage. On March 23, 1634, he was named Usher to the Royal Antechamber (*Ujier de Cámara*), his first official court post, which had formerly belonged to his father-in-law. From 1643 to 1646 he was drawing master to the young Prince Baltasar Carlos. Mazo's first wife died in ca. 1654, but he was married twice again: at an unknown date (probably between 1656 and 1657) to Francisca de la Vega; and at her death (1665), to Ana de la Vega (Francisca's sister?), who survived him.

In 1657 Mazo was named *Ayuda de la Furriera*, and in 1660, *Pintor de Cámara* upon the death of Velázquez. Mazo's only known trip abroad was to Italy in 1657, possibly to accompany a shipment of art destined for the royal palace in Madrid.[2] He was survived by four children, none of whom became painters, although his son Gaspar was named *Ujier* in 1658.

We do not know who gave Mazo his early artistic training, although it is likely that he entered Velázquez's studio at an early age since there exists no work by him that does not bear the strong imprint of his protector and father-in-law. Palomino lauds Mazo's ability to copy paintings by the Italian old masters (Veronese, Tintoretto, and Titian). Many portraits formerly ascribed to Velázquez are now given to Mazo, often without reason. Nonetheless, the relatively few signed portraits by him attest to his faithfulness to the style of his teacher. The signed *View of Saragossa* in the Prado points to Mazo's excellence in landscape and a number of similar paintings have been attributed to him. E.J.S.

NOTES

1. Gaya Nuño, "Juan Bautista del Mazo, gran discípulo de Velázquez," *Varia Velázqueña* (Madrid, 1960), vol. 1, p. 472; and Neil McLaren, *The Spanish School*, National Gallery Catalogues (London, 1972), p. 51.

2. Caturla, "Sobre un viaje de Mazo a Italia hasta ahora ignorado," *Archivo Español de Arte*, 28 (1955), pp. 73–75.

21. *A Child in Ecclesiastical Dress*

Oil on canvas; 167.3 × 121.9 cm. (65⅞ × 48 in.)

Provenance Harrach Collection, Vienna, late seventeenth century–1950; Frederick Mont, New York.

Literature Waagen, 1866, no. 338 (as Velázquez); Curtis, 1883, no. 150 (as Velázquez); Lefort, 1888, p. 146 (as Velázquez); Justi, 1903 (2nd ed.), vol. 2, p. 260, and (4th ed.), 1933, pp. 683–685, 753, illus. p. 655 (as Mazo); Baldry, 1905, p. XXIX (as Velázquez); Beruete, 1909, pp. 119–121 (as Mazo); Glück, 1923, no. 13 (as Mazo); Mayer, 1936, no. 437, pl. 112 (as probably Mazo); Gaya Nuño, 1958, no. 1724 (as Velázquez); Kubler and Soria, 1959, pp. 264, 284 (as Mazo); López-Rey, 1963, no. 481, pl. 309 (as perhaps Mazo); Camón Aznar, 1964, vol. 2, pp. 978–979 (as Carreño); Rogers, 1967, pp. 35–36; Barettini Fernández, 1972, pp. 50–51, 129 (as Carreño); Toledo, 1976, pp. 110–111, pl. 59.

The Toledo Museum of Art, gift of Edward Drummond Libbey (51.364).

In this beautiful portrait a young child stands next to a table on which there is a vase of flowers. Through an open doorway is a view of the suburban landscape of Madrid. The Jardín del Moro, adjacent to the Royal Palace, and the Manzanares River are seen. Beyond the river is the Royal Park and the Casa de Campo.[1]

While formerly attributed to both Velázquez and Carreño, this painting is more convincingly ascribed to Mazo. López-Rey compares it to his portrait of the Queen Mother Mariana of Austria in the National Gallery, London.[2] The technique is, nonetheless, still very close to that of Mazo's teacher. In the landscape detail, Velázquez's evocative views of the Sierra del Guadarrama in the backgrounds of the equestrian and hunting portraits of the royal family are brought to mind. In the figure of the child we also see the impact of Velázquez's affectionate depictions of the young Prince Baltasar Carlos.

The identity of the child has puzzled many writers and no totally convincing suggestion has been put forth. It is certain, however, that the subject was an important individual in order to have been portrayed in what appears to be the robes of a cardinal.

The painting has been dated ca. 1666 based on the similarities to the London portrait of Mariana.[3]

E. J. S.

NOTES

1. Identified as such in the museum catalogue. See The Toledo Museum of Art, *European Paintings* (Toledo, 1976), p. 110.

2. López-Rey, *Velázquez: A Catalogue Raisonné of His Oeuvre* (London, 1963), p. 287.

3. Ibid., p. 287. López-Rey also states, however, that the painting resembles the *View of Saragossa* in the landscape elements. This picture was done twenty years earlier than the portrait of Mariana. The dating of the Toledo picture is therefore elusive.

FRANCISCO MENESES OSORIO
Seville ca. 1630–ca. 1705 Seville

The investigation of the school and late followers of Murillo is still in a rudimentary stage, and it is most difficult to discern clear artistic personalities among the many works done in a Murillesque style in the late seventeenth and early eighteenth centuries, let alone attach these works to known artists' names.

Meneses's work is somewhat better documented than most due to his participation in Murillo's last known commission, the retable for the Capuchin Church of Santa Catalina in Cádiz, whose central painting is a *Mystic Marriage of St. Catherine*.[1] However, little else is known about this artist other than that he finished painting this retable after Murillo's death in 1682, following the designs of the master. Between 1666 and 1673 he was a member of the Sevillian academy of drawing, founded in 1660 by Murillo and other artists, serving as *mayordomo* during the presidency of Llanos y Valdés, in 1668–69. At this time he donated to the academy an *Immaculate Conception* by his hand, now lost.[2]

The paintings of Meneses, the closest of Murillo's followers, survive principally in Cádiz, and they include, besides the finished surface of the *Mystic Marriage of St. Catherine*, which could have reached only its most preliminary stages at Murillo's death, the rest of the paintings in the high altar retable. These are the lunette above the *St. Catherine*, with *God the Father in a Glory of Angels*, a *St. Michael*, a *Guardian Angel*, a *St. Joseph with the Christ Child*, and a *St. Francis of Assisi*, the last signed by Meneses.

A tentative list of his works can be compiled from the biographies of Meneses in Ceán Bermúdez's *Diccionario* and in the still useful catalogue by Charles Curtis of Velázquez and Murillo. This list would have to be tested by the standards of the Capuchin paintings and a few other signed works, such as the *St. Cyril of Alexandria at the Council of Ephesus* (1701) in the Museo Provincial de Bellas Artes, Seville, and a *Mater Dolorosa* (1703) in the church of La Encarnación at Osuna.[3]

N. A. M.

NOTES

1. Angulo, *Murillo* (Madrid, 1981), vol. 3, Cat. no. 88.
2. Ibid., vol. 1, p. 65.
3. Angulo, *Pintura del siglo XVII*, also mentions two

other signed paintings, a *St. Joseph* (1684) and a *Virgin and Child*, until recently in the art market (1971), but whose present whereabouts are unknown to me.

22. *The Savior of the World*

Oil on canvas; 78.7 × 65.7 cm. (31 × 25⅞ in.)

Provenance Hammer, 1952.

Literature Greenville, 1954, p. 134; Gaya Nuño, 1958, no. 1791; Greenville, 1962, vol. 2, p. 356.

Bob Jones University Collection, Greenville, South Carolina (P.55.83).

Christ, as in most representations of this subject, is shown in half-length, holding the orb in his left hand and raising his right in a gesture that here seems more one of surprised concern than a traditional benediction. His eyes are cast down, as he looks intently at the globe.

This *Salvator Mundi* was tentatively attributed to Meneses by Soria in 1954, and appears as by him in Gaya Nuño's *La pintura española fuera de España*. The Bob Jones painting, although not mentioned by Ceán Bermúdez or Curtis, closely fits Meneses's very Murillesque style, and its attribution to this artist seems totally sound.

The *Salvator Mundi* reflects Murillo's style of the late 1660s, although it was probably painted considerably later. The facial type of Christ is closely reminiscent of that of the Christs in Murillo's *Porciuncula*, in the Wallraf-Richartz Museum, Cologne, part of the series done for the Capuchins of Seville between 1665 and 1670, and in his *Miracle of the Bread and the Fishes*, from the series for the Hospital de la Caridad in Seville, painted between 1667 and 1670.

The theme, as far as we know, had not been treated by Murillo, so the only images by the older artist comparable to the *Salvator Mundi* are those of various half-length *Ecce Homo*s, which of course have a different spiritual tone and deal with a partially undraped figure.

Although Meneses's technique here is very Murillesque, with a soft definition of the edges, transparent shadows, and a painterly touch throughout, and though its coloration of soft red, lavender, and grays is also close to Murillo's, the painting shows a distinctive style that separates it from that artist's work. The facial fea-

tures have their own characteristic cast, and they are less finely modeled, less sensitive in contour, and differ in details such as the shape of the eyebrows (arched rather than straight) and the pouting lower lip. The comparison of the face of the *Salvator Mundi* with the Cook Collection's *Ecce Homo* by Murillo points up these differences very clearly (fig. 21).

The blander, less fine facial type of Meneses is also spiritually less animated than its counterparts in Murillo's work. The expressive richness of the latter's characterizations is not reached here; there is a more muted quality to the whole image, which does not convey the pathos and conviction of Murillo's.

The deficiencies pointed out here with respect to the works that inspired Meneses are inevitably brought out when comparisons between a great artist and his followers are drawn, but they need not blind us to the very high quality and intrinsic merit of the work at hand. N.A.M.

JOSE MORENO
Burgos 1642–1674 Burgos

Moreno is one of a number of gifted painters of the school of Madrid about whom we know far too little. Palomino, in his very brief biography, states that Moreno began his studies in his native city and, later, was a pupil of Francisco de Solís in Madrid. Palomino cites only three works by Moreno's hand: a *Flight into Egypt*, a *St. Catherine Martyr*, and a *St. Anthony Abbot*. Ceán Bermúdez repeats this same information with no additions, although the Conde de la Viñaza in the third volume of his *Adiciones al diccionario histórico* gives more precise locations for the works of Moreno. According to Viñaza, the artist executed four paintings for the Church of the Convent of San Pablo in Burgos: a *Saint Saying Mass* (with souls in Purgatory and Christ above), an *Immaculate Conception*, a *St. Michael Saving Souls from Purgatory*, and a *St. John the Evangelist*. These paintings were no longer in the church, however, when Viñaza was writing; it had been converted into a military barracks. Their whereabouts is unknown. Viñaza and later Angulo cite two works in the museum at Saragossa, a half-length *St. Francis* (signed *José Moreno 166...*) and its

companion piece, a *St. John the Baptist*.[1] A *Visitation* (1662) is in the Prado. A *Flight into Egypt* was recorded by Viñaza as in the Ministerio de Fomento in Madrid and is now in the Prado (although it is not listed in the 1972 catalogue of the museum).

Viñaza also mentions a Juan Moreno, who signed and dated an *Adoration of the Magi* in 1635, and suggests that he may be the father of José Moreno. The surname is a very common one, however, and other references to painters with it have recently been published by Mercedes Agulló y Cobo. Therefore such a supposition can only remain conjectural.[2] E. J. S.

NOTES

1. Angulo, "José Moreno," p. 69.
2. Mercedes Agulló y Cobo, *Noticias sobre pintores madrileños de los siglos XVI y XVII. Documentos inéditos para la historia del arte* (Madrid, 1978), vol. 1, pp. 105–107.

23. *The Flight into Egypt*

Oil on canvas; 165 × 249 cm. (65 × 98 in.)

Signed and dated on the rock at lower right: *Joseph Moreno F 16(62)*

Provenance Julius H. Weitzner, New York.

Literature Minneapolis, 1970, pp. 68, 71; "La Chronique," 1971, p. 77, no. 361.

The Minneapolis Institute of Arts, the Putnam Dana McMillan Fund (70.22).

An angel holds the reins of a donkey carrying the Virgin and Child. The Infant looks up towards two putti who approach him from the heavens as St. Joseph also observes a celestial vision beyond the space of the picture. At the right side Roman soldiers converse with two men in a wheat field.

According to Matthew (2:13–23), after the birth of Jesus, the Infant was adored by shepherds and Magi from the East. When they had gone, an angel of the Lord appeared to Joseph in a dream and said: "Arise, and take the young Child and His mother, and flee into Egypt, and be thou there until I bring thee word: for Herod will seek the young Child to destroy Him." To insure the death of the newborn Messiah, Herod or-

dered the massacre of all male children under the age of two years.

Moreno's painting depicts two episodes of the *Flight*. While the Holy Family forms the principal focus of the picture, one of the many medieval legends concerning the event is shown at the right. Herod, discovering that Mary and Joseph had left Bethlehem, sent soldiers after them. During the course of their journey the Holy Family came upon a field where a man was sowing wheat. The Virgin said to the sower: "If anyone asks you whether we have come this way, you will say 'The wayfarers passed when I was sowing this wheat.'" To delude the pursuers, God caused a miracle to occur and the wheat grew in a single night. The next morning, the soldiers confronted the workers with the question that Mary had anticipated. When hearing that the Family had passed through at the time of sowing, the soldiers gave up their chase.[1]

Although the two groups are in close proximity, the artist has created a strong sense of distance between them by employing a deliberately sketchy style for the soldiers and sowers, while giving the Holy Family and the angel greater solidity.

The delicate blending of blue, pink, mauve, red, and yellow in this painting is masterful, as is the free brushwork, especially in the group at the right. The passage of the soldiers and field workers resembles similar figures in the *Flaying of St. Bartholomew* by Carreño (Cat. no. 8), a painting done at approximately the same time as Moreno's *Flight into Egypt*. Moreno would certainly have come into contact with Carreño's work while in Madrid, although there is no documentary evidence to prove this.

It is unclear whether the Minneapolis painting is the same *Flight into Egypt* mentioned by Palomino. In 1865 Gregorio Cruzada Villaamil catalogued a *Flight into Egypt* by Moreno in the Museo de la Trinidad.[2] This is presumably the same picture recorded by Viñaza in 1899 as in the Ministerio de Fomento,[3] and cited again by Tormo as belonging to the Painting Gallery of the Palacio de Justicia in Madrid.[4] When the Palace burned, Moreno's painting was saved and passed into the collection of the Prado.[5] It depicts a similar Holy Family and angel group to those in the Minneapolis picture but does not include the soldiers and field workers. The painting in Madrid also lacks the dramatic effect of the "language of gestures" present in the version shown here, where the energetic pose of the

angel with uplifted arm and the vigorous pointing gesture of St. Joseph add strong horizontal and vertical accents to the scene. E. J. S.

NOTES

1. The story is recorded by Jameson, *Legends*, p. 232.
2. Cruzada Villaamil, *Catálogo provisional, historial y razonado del Museo Nacional de Pintura* (Madrid, 1865), p. 76.
3. Conde de la Viñaza, *Adiciones al diccionario histórico de los más ilustres profesores de las bellas artes en España de D. Juan Agustín Ceán Bermúdez* (Madrid, 1889), vol. 3, pl. 110.
4. Tormo, "La galería de cuadros del incendiado Palacio de Justicia," *Boletín de la Sociedad Española de Excursiones*, 23 (1915), pp. 175–176.
5. Reproduced in Angulo, "José Moreno," pl. II, and in *San José en el arte español*, p. 112, no. 68.

BARTOLOME ESTEBAN MURILLO
Seville 1617–1682 Seville

Bartolomé Esteban Murillo, born in Seville during the last days of 1617, was baptized in the Church of the Magdalena on January 1, 1618. Although his father's surname was Esteban and his mother's Pérez, Murillo would later adopt his maternal grandmother's surname, under which he became known.

In 1627 Murillo's father died and six months later, his mother, so the ten-year-old orphan was placed under the care of his brother-in-law.

We have no record of the year in which Murillo started his apprenticeship as a painter, but in all likelihood it was around 1633, when he was fifteen. That year he had signed a document declaring his intention to emigrate to the New World, but this did not come to pass and he probably entered the workshop of his kinsman, the Sevillian painter Juan del Castillo (1584–1640), soon after. He would remain there until 1638, when Castillo left Seville permanently for Granada and Cádiz.

Although Castillo is a figure of the second rank among the Sevillian painters of the first half of the seventeenth century, he appears to have had some merit as head of a workshop and he provided Murillo with the necessary technical instruction. Alonso Cano was Castillo's distinguished collaborator during the years of Murillo's apprenticeship, but although his presence around the studio may have stimulated the young artist, his work during those years was in the field of sculpture, not painting. It is only in general terms that Murillo may be said to have absorbed the lessons of Cano's art, as both artists placed a comparable stress on ideal beauty and refined, serene, spiritual qualities.

The earliest works of Murillo, painted between 1639 and 1646, do not show a direct relationship to Castillo's weak style, but rather to those of the more talented painters who had worked in Seville in the first four decades of the century: Juan de las Roelas, Francisco Herrera the Elder, Francisco de Zurbarán, and the young Velázquez. The paintings that signal the end of this early phase of Murillo's development are those of the cycle painted for the cloister of the Convent of San Francisco el Grande, of 1645–46 (Cat. no. 24 and fig. 27), his first major commission. In at least some of the paintings of this series, influences from beyond the Sevillian sphere can be detected, the result perhaps of an almost certain brief stay by Murillo at the court in Madrid, some time between 1642 and 1644.

In 1645 Murillo, aged twenty-seven and starting on a brilliant career with this important commission for the Franciscans, married Beatriz Cabrera, who was to bear him nine children before she died in 1663. The artist, aged forty-five at the time of her death, would never remarry. During his eighteen years of matrimonial life Murillo made a documented visit to Madrid in 1658, helped found a drawing academy in 1660, and executed several works for the cathedral of Seville and a good number of isolated religious and secular paintings. The first essays in genre painting belong to the late 1640s and early 1650s and include the superb *Lice Chase* in the Louvre. Scenes of the early life of Christ, treated with the naturalism and homeliness of his genre paintings (Cat. no. 25 and fig. 28) alternate with more idealized images of the Virgin and Child and an occasional visionary scene. The major work of this period is the large *Vision of St. Anthony of Padua* (1656) painted for the baptistry of the cathedral. Here the solidity of Murillo's early style begins to give way to a looser technique and convincing effects of miraculous illumination.

The second half of the 1660s, after the death of his wife, must have been Murillo's most prolific period. In those years he received three major commissions: from the Church of Santa María la Blanca, from the

Capuchins of Seville, and from the Hospital de la Caridad. By 1665 he had finished four large paintings for Santa María la Blanca (fig. 29), which show a considerable change in their manner of execution from that of the *Vision of St. Anthony*. Murillo's evolution toward an increasingly painterly style and a more delicate and lighter palette, undoubtedly furthered by his stay at court in 1658, had reached by this time a very advanced stage. The handling of the paint is completely impressionistic, with broken colors, undefined edges, and forms (even in the foreground) that seem to dissolve in the surrounding atmosphere. Even though in these works he employs a strong chiaroscuro, the general effect they produce is of luminosity: the darks are not as opaque and the lights are more brilliant than in earlier paintings, saturating both solids and spaces as never before.

The commission Murillo received from the Capuchins in 1665 took him until 1670 to complete, with one interruption in 1667. It engaged him in producing twenty-one canvases and some small crucifixes and represents a staggering performance for their sustained level of quality (figs. 23 and 24). The paintings for the Caridad, done between 1667 and 1670, also involved a good number of large works of various formats, and include some of his most impressive pictures (fig. 22).

To these years also belong a number of his best-known treatments of a favorite subject, the *Immaculate Conception* (fig. 41), and the majority of his portraits, done in the decade between 1665 and 1675.

The first half of the 1670s saw a continuation of Murillo's artistic success and extraordinary creative vigor. This was the period in which his second series of genre paintings dealing with children was produced, as well as numerous religious pictures treating a great variety of subject matter. These paintings were executed in a manner that has been described as the "vaporous" style since Ceán Bermúdez coined the term in 1800. This last phase of Murillo's painting style continued the tendencies already well established in the 1660s: the brushwork is feathery and the pigment thinner, the illumination more generalized and brighter (rather than chiaroscuristic), and the coloration cooler and lighter.

The paintings of the final years of his life (ca. 1675–82) are less numerous but of an unflagging quality and vitality, both in their expressive power to convey emotion and in technique.

The last important commission undertaken by Murillo was for the church of the Capuchins of Cádiz in 1681, but he is not responsible for the actual painting of the high altar retable, which was finished by studio assistants when death overtook him. According to Palomino's report (he was in Madrid at the time of Murillo's death), the artist died as a result of a fall from the scaffolding set up to paint this altarpiece, but it is impossible to determine whether the death followed shortly after the fall or whether Murillo lived on for some time afterward, in ill health but able to conduct his affairs and paint. In any case, when death came on April 3, 1682, it was rather sudden, as he was unable to finish dictating his will, started *in extremis*. This will makes clear that despite the enormous success he had enjoyed during all of his career, and of how prolific an artist he was to the end, he had not accumulated the wealth one might think consonant with so much well-remunerated activity. If he did not die as poor as Palomino suggests, he certainly did not leave the world as a rich man.

Murillo was buried on April 4 in the now destroyed Church of Santa Cruz, after a massively attended funeral. N. A. M.

24. *Two Franciscan Monks*

Oil on canvas; 156.7 × 106.7 cm. (61¾ × 42 in.)

Provenance San Francisco el Grande, Seville; Alcázar, Seville, 1810; Julián Williams, 1831; Richard Ford, by 1836; Francis Clare Ford, 1883; Captain Richard Ford, by 1913; T. Harris, 1929.

Literature Wilenski, 1930, p. 476; Hubbard, 1956; Winnepeg, 1955, no. 11; Angulo, 1961, pp. 1–24; Kubler, 1970, pp. 11–31; Angulo, 1981, vol. 1, pp. 262–263 and vol. 2, pp. 3–5 and Cat. no. 9.

The National Gallery of Canada, Ottawa (4088).

In 1645, Murillo was given his first major commission by a religious order, the Franciscans of Seville. It consisted of thirteen large paintings that were to line the four walls of the Claustro Chico in the Convent of San Francisco. Of the thirteen, according to early sources, two were perhaps of smaller dimensions and of inferior quality, a painting of the crests of the Franciscan order and an *Immaculate Conception* (both now lost).

The remainder were eleven narrative scenes designed to illustrate miraculous episodes in the lives of Franciscan friars and saints, some of them Spanish. The idea of painting an extensive cycle of historic episodes concerning a religious order became very popular in Spain in the seventeenth century (the first of these cycles was done by Francisco Pacheco for the cloister of the Mercedarians of Seville in 1600–03), and some of them consisted of more than fifty paintings. The series for the Claustro Chico was the first of several large commissions that Murillo would receive from religious orders and confraternities in Seville, but the only one with this particular narrative structure. The cycle was preserved intact and *in situ*, if not in good condition, until the Napoleonic invasion of Spain, when the French military forces removed most of it from Seville and sent it to France between 1810 and 1812. The various works are now dispersed among different collections in Europe and America, except for one (a *San Diego*), which is lost.

One of the paintings in the series bears the date 1646, but since Murillo must have taken no less than one year and perhaps two to paint the whole cycle, and some of the works are more developed stylistically than others, it is likely that their execution ranges from 1645 to 1646–47.

All the paintings for San Francisco deal with scenes of charity or exaltation (through apparitions, visions, levitation) of various members of the order. At one point they all included inscriptions in verse at the bottom of each work commenting (rather cryptically) on the event illustrated. A number of them, including the one in the present exhibition, no longer preserve these inscriptions to aid us, however inadequately, in identifying the story portrayed.

The subject of this particular painting is one that is still in dispute, although the most likely identification is a deed of San Diego de Alcalá.

Two monks, in Franciscan habits of different colors, are seen out of doors, next to a tree and some shrubbery, beyond which, to the left, rises a modest house (or houses). The younger monk is seated on the ground in a collapsed posture, eyes closed, and deadly pale; the older monk bends over him, laying his hands on his head and looking up to Heaven, as if imploring for miraculous aid from above.

San Diego, who is also the subject of three of the other narrative scenes (Academia de San Fernando, Madrid; Musée des Augustins, Toulouse; and the lost work), was a humble lay brother from Seville who lived and died in the Franciscan convent at Alcalá in the first half of the fifteenth century, and was canonized in 1589. The episode of his life represented may be his healing the sick of plague in the orchard of the convent of Aracoeli during his trip to Rome, or his caring for his companion who fell ill on their way back to Spain. Although Angulo does not think the standing monk looks like the San Diego in the other stories, the differences in his physiognomy from the two others are not notable, and certainly are not greater than those between the two securely identified San Diegos. An alternate identification of the subject as Fray Juan de la Cruz tending the plague-stricken in his convent, proposed tentatively by Angulo, seems unlikely on the basis of the apparent age of the friar in the painting. Fray Juan de la Cruz died at the age of thirty-three, and Murillo's figure seems too old to represent a man in his twenties or, at most, very early thirties.

The vertical format of the painting is unique among the surviving works of the cycle (the lost *Immaculate* may have been of similar proportions), and was designed to complement one of the two long horizontal canvases on the south wall of the cloister, the Louvre's *La Cuisine des Anges* (fig. 27). As is the case in the rest of the series, the standing figure occupies practically all of the available height of the painting, but here the two figures fill the surface of the canvas almost to capacity. The painting seems to have been cut down, apart from the removal of the bottom strip with the inscription, to judge by the dimensions of other relevant paintings in the series. This adds to the already striking effect of massiveness and monumentality of the group.

The *Two Franciscan Monks*, like other paintings in the Claustro Chico cycle, reflects Murillo's artistic formation in Seville under the influence of the early works of Velázquez and the mature works of Zurbarán. The naturalism of the types, the plasticity of the forms, the dense application of paint, with a thick impasto in the highlights, and the handling of the habits of the friars with simple folds of heavy drapery point to his indebtedness to the two older masters. The tonality of the painting, in which light tones of blue, gray, and green predominate, points instead to a knowledge of Velázquez's works in Madrid of the 1630s, and signals Murillo's own movement away from the tenebrism that distinguishes some of the other paintings of this period.

N. A. M.

25. *The Flight into Egypt*

Oil on canvas; 209.6 × 166.3 cm. (82½ × 65½ in.)
Signed on rock in foreground: *B^me Murillo f.*

Provenance James Mendez, Esq., Mitcham, Surrey; Sir Samson Gideon, Belvedere, Kent, 1756; Lord Saye and Sele; Sir Culling Eardley; Mrs. Culling Hanbury; Sir Francis Fremantle, 1938; James Fremantle; Maurice Harris, 1945; French & Co., New York.

Literature "Detroit Given a Murillo," 1948, pp. 47–48; Richardson, 1948, pp. 363–367; Braham, 1965, pp. 445–451; Detroit, 1971, p. 112.

The Detroit Institute of Arts, gift of Mr. and Mrs. K. T. Keller, Mr. and Mrs. Leslie H. Green, Mr. and Mrs. Robert N. Green (48.96).

Probably painted around 1650, the Detroit *Flight into Egypt* is a later and superior version of the similar painting of this subject in the Palazzo Bianco, Genoa. The earlier painting, as a number of works throughout Murillo's career, was inspired by a print, in this case an engraving after Marten de Vos.

According to Matthew (2:13–15), Joseph was warned by an angel in a dream to flee into Egypt with the Virgin and Child because King Herod would seek the child to destroy him. They departed the following night and remained in Egypt until Herod's death, thus escaping the Massacre of the Innocents (Matthew 2:16). The Holy Family is shown on its way through a wooded, hilly landscape, St. Joseph leading the ass and carrying his carpenter tools in a straw bag on his back and the Virgin riding sidesaddle with the sleeping child in her arms and a large tied bundle behind her.

Although the figures are set in a landscape, they take up most of the picture's surface and press close to the picture plane, a compositional structure common to a great many of Murillo's early works. The figures of the Holy Family and donkey are solidly modeled, but handled with a painterly touch in parts; the landscape is painted very softly altogether, and in a rather sketchy manner.

Murillo portrays the Virgin looking down lovingly at the Child in her arms, with a hint of sadness that contrasts with the beatific peace of the sleeping Infant. St. Joseph is depicted striding forward purposefully, leading the animal and its charges with a firm rein but looking to the side with an expression of concern, determined but also preoccupied by the uncertainty of their fate.

The interpretation of the husband of Mary as a still youthful and virile man, and the importance accorded him altogether in the context of the infancy of Christ, are characteristic of Murillo in particular and of Spanish seventeenth-century religious art in general. The image of St. Joseph had already undergone a change in fifteenth-century art with respect to the late Middle Ages. From an object of condescension or even mild ridicule, he became a dignified figure, shown at his trade as the breadwinner or in his role as the protector of the Christ Child. In Spain, the special devotion for St. Joseph grew in the sixteenth century, when St. Theresa of Avila, St. Peter of Alcántara, and the Jesuit order promoted it vigorously. By the seventeenth century it had become firmly established, and in 1621 Pope Gregory XV decreed the official celebration of the feast of St. Joseph on March 19. With the special devotion to the saint grew a controversy as to how to represent him, young or old, with several important doctors of theology proposing a youthful image, of a man from thirty to forty years old. This new conception, which departed from the traditional representation of Joseph as old, or even extremely aged, caught hold most strongly in Spain. Murillo, more consistently than any other artist, is the painter of St. Joseph in the fullness of physical vigor and as an exemplar of moral nobility and paternal devotion. Here he represents him as an energetic and handsome man of around forty, as in the contemporary *Holy Family with the Bird* (fig. 28).

The characters in this painting are naturalistically portrayed as humble people in their dress, but they have the ideal innate grace and elegance that are a consistent trait of Murillo's figures from the late 1640s on.

N. A. M.

26. *The Adoration of the Magi*

Oil on canvas; 190.7 × 146 cm. (75⅛ × 57½ in.)

Provenance William Stanhope, 1729; Dukes of Rutland, Belvoir Castle, ca. 1760; Count Contini-Bonacossi, Florence, 1926; Anonymous owner, to 1972; Wildenstein, New York.

Literature Rome, 1930, no. 49; Mayer, 1930, p. 207; Suida, 1930, p. 144; Toledo, 1976; Brown, *Murillo*, 1976, p. 68; Gaya Nuño, 1978, no. 49; Angulo, 1981, vol. 2, no. 227.

The Toledo Museum of Art, gift of Edward Drummond Libbey (75.84).

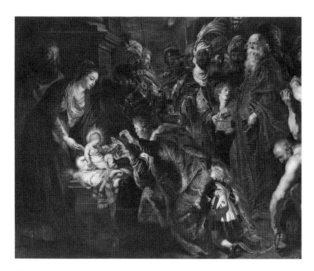

Figure 39. Peter Paul Rubens, *Adoration of the Magi* (detail), oil on canvas. Madrid, Museo del Prado.

Although Murillo painted a number of Adorations of the Shepherds throughout his career, the Toledo painting is the only version we have of his treatment of the related theme (Matthew 2:11).

The Virgin is shown standing behind a tall wooden bench, on which she rests the Child, presenting him to the veneration of the three Magi. St. Joseph stands behind her, and beyond the whole group rises a ruinous arched masonry and timber structure. Caspar kneels in the foreground in front of the Child in an attitude of devotion, with the gift of gold in a casket by his side, and Melchior and Balthazar stand further back, bearing their gifts of frankincense and myrrh in golden vessels. Two small pages, one of them holding up Caspar's train, and three men form the remainder of the visible portion of the retinue; a couple of lances behind them suggest the rest. The star of Bethlehem shines in the small area of open sky at the left.

Our painting is formally related to Zurbarán's *Adoration of the Magi* (1638–39) for the Cartuja de Nuestra Señora de la Defensión in Jerez de la Frontera (now in the Musée de Peinture et de Sculpture, Grenoble) and to a Rubens *Adoration of the Magi* of 1617–19,[1] as engraved by Lucas Vosterman in 1620. The Zurbarán composition is, in turn, similar to Adorations by Luis Tristán (1616), Vicente Carducho (1618 and 1619),[2] and Giacomo Cavedoni (1614), so it conforms to an obviously very popular format for this subject in the early seventeenth century.[3] Murillo refers to both the

Zurbarán *Adoration* and the Vosterman engraving, maintaining the sparser composition and foreground placement of Caspar of the Zurbarán, but going back to Rubens for the poses and placement of many of the figures and for the organization of the space. He also adopts from Rubens the two children bearing the train of the kneeling Magus. As in the prototype, the child farthest back looks out into our space, but while Rubens uses the device of establishing eye contact between the child and the viewer to draw us into the world of the painting, Murillo avoids this direct communication; his child, distracted from his duties, daydreams with an abstracted and unfocused gaze.

Some details, such as the type and arrangement of the turban worn by the black Magus, can be traced to the Vosterman engraving, but the head of the old man in the retinue refers directly to Zurbarán's painting, and the head of the helmeted guard and the pose and headgear of the Virgin seem closely inspired by still another Rubens *Adoration*, the large work of 1609, then in the collection of the Spanish king (fig. 39). What seems thoroughly original is the back view of the old Magus, which obscures his face almost completely and allows only the tips of the fingers of his clasped hands to show, but draws us most effectively into the scene.[4]

Although the date of this work has been placed most recently at ca. 1660–65,[5] its style indicates a date of ca. 1653–55. A preparatory drawing (in a private collection, Paris) for the Toledo composition has been dated ca. 1650–56, which would agree with the date proposed here.[6]

N.A.M.

NOTES

1. This *Adoration* is the center of a triptych painted by Rubens for the Church of St. Jean at Malines, where it remains. The Vosterman engraving reverses the composition.

2. Brown, *Francisco de Zurbarán* (New York, 1973), p. 118. Tristán's *Adoration* is in the Church of Yepes, Toledo. Vicente Carducho's paintings are in Guadalupe (1618) and the parish church at Algete (1619).

3. In my opinion, ultimately descended from Venetian prototypes of the sixteenth century, such as Veronese's *Adoration* (1573) in the National Gallery, London.

4. One must mention, however, that Rubens's *St. Ildefonso Altarpiece*, in the Kunsthistorisches Museum, Vienna, has the title saint in a very similar position.

5. Angulo, *Murillo*, vol. 2, Cat. no. 227, p. 206.

6. Brown, *Murillo and His Drawings*, Cat. no. 7, p. 68.

27, 28. *Saint Justa* and *Saint Rufina*

Oil on canvas; each 93.4 × 66.4 cm. (36¾ × 26½ in.)

Provenance Marqués de Villamanrique, Seville; Conde de Altamira, Seville and London; Marquis of Stafford, London, 1827; Duke of Sutherland, London, by 1858; Böler Gallery, Munich, 1913; *St. Rufina:* Bernart Back, Szeged, Hungary, 1917; private collection, France; Schickman Gallery, New York, 1972.

Literature Jordan, 1974, pp. 47–49 and 102; Gaya Nuño, 1978, nos. 278 and 279; Haraszti-Takács, 1978, no. 28; Angulo, 1981, vol. 2, nos. 346–347.

Meadows Museum, Southern Methodist University, Dallas, Texas (72.04 and 72.05).

This pair of paintings shows the patron saints of Seville in half-length images set against an open ground. St. Justa faces right, her head almost in profile and slightly tilted upward, and her eyes cast to Heaven. St. Rufina faces her sister, with a slight turn of the body to the left but with the head almost frontal, her eyes engaging the viewer's directly. Each carries in her hands earthenware pots and a palm leaf, attributes of their profession and their martyrdom.

The two young women were the daughters of a poor potter, and members of the clandestine Christian community in Seville during the third century. Refusing to sell their wares for use in idolatrous ceremonies, they quarreled with the pagan worshippers who harassed them, and destroyed an image of a false deity. Denounced as Christians, they confessed their creed and underwent torture and death for their refusal to sacrifice at a pagan altar.

Murillo represented these popular saints on at least three occasions, his major rendering of the subject being the large canvas for the Capuchins of Seville (1665–66), where the saints are shown together in full length.[1] The present paintings appear to be earlier in date, perhaps shortly before 1660, and are conceived in an intimate rather than a monumental vein.

The two young women, particularly St. Rufina, have a beauty of such concrete type that they are almost portrait-like; they look indeed very much like a pair of lovely Sevillian girls. Thus, although they are ideal creatures from a remote past, the specificity of their beauty and type endows them with a quality of actuality. Their physical loveliness, the bloom of their

youth, and the sweetness of their demeanor are all powerful inducements for the beholder to experience affection for them. It is hard indeed to remain unmoved in front of these young martyrs.

The Meadows paintings epitomize Murillo's qualities as an intepreter of religious subjects for his age. The gentleness of his approach to the theme, his blend of naturalism and idealization in the presentation of the characters, and his capacity to awaken emotion in the pious viewer by provoking sensuous and aesthetic responses to the painted image are characteristic of his religious work and explain the appeal it had for his contemporaries. N. A. M.

NOTE

1. There is an interesting precedent for the half-length format and poses of Murillo's Sts. Justa and Rufina in the painting by Hernando Sturm of the two saints in the Chapel of the Evangelists in the cathedral of Seville (1555), a painting Murillo would have known well. This work shows both saints together in the same canvas, but the arrangement of the bodies, hands, and heads is quite similar to the one Murillo would adopt. St. Justa looks down instead of up, but otherwise the poses and character of the figures are quite similar.

29. *Portrait of a Cavalier*

Oil on canvas; 88.5 × 62.5 cm. (35 × 24½ in.)

Provenance Prince Eugène de Beauharnais, 1806; Duke George de Leuchtenberg Collection; M. Knoedler and Co., 1906; Sir William van Horne Collection, Montreal.

Literature Loga, 1913, pp. 103–104; Mayer, 1922, p. 345; Kubler and Soria, 1969, p. 277; Gaya Nuño, 1978, no. 213.

The National Gallery of Canada, Ottawa (23411).

Portraiture does not play a very large role in Murillo's oeuvre—the number of likenesses by his hand that have survived is quite small, in fact—but among his few portraits there are some that demonstrate his great capabilities in this difficult field.

Considering the emphasis on expression and on description of emotion that we find in Murillo's genre and religious works, it comes as something of a surprise to find that in his portraits he stays away almost completely from the portrayal of personality. The full-length portraits that make up the majority of his work

in this field present their subjects with a severe countenance and a formal, almost rigid bearing which keep the viewer at a respectful distance. They are unusually uncommunicative by the standards of Baroque portraiture, their subjects withdrawn behind an almost icy reserve. This detachment and reticence is also found in some of Murillo's portraits in a smaller, half-length format, like the *Nicolás Omazur* (1672) in Madrid (fig. 40), and even his own *Self-Portrait* (ca. 1670–72) in the National Gallery, London. There are a few portraits, however, and the Ottawa *Cavalier* is one of them, in which the sitters appear to us revealed both in their essential humanity and in their own specific spiritual identities. They exist for us as human beings with the same vividness that their originals must have had for their acquaintances. In works like the *Cavalier*, the full-length hunting portrait of Don Antonio Hurtado de Salcedo (ca. 1660–64) in a private collection, Vitoria, and the fragmentary *Portrait of a Man* (ca. 1660) in St. Louis, Murillo attains as high a level of description and interpretation of his subjects as Van Dyck.

The present portrait presents the half-length figure within a painted oval frame through which one sees it as through a window. The man stands outdoors, against a distant view of hills, with architectural elements to

Figure 40. Bartolomé Esteban Murillo, *Portrait of Nicolás Omazur*, oil on canvas. Madrid, Museo del Prado.

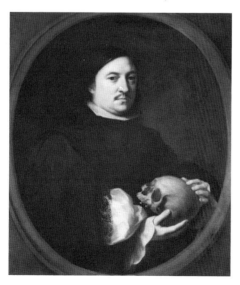

the right and left that suggest a terrace. His apparel is rich but sober, and it includes a sword, a sign of social distinction. His body is turned at a three-quarter angle to the picture plane, but the head confronts us more frontally.[1] His right hand is raised to his heart, in a gesture that connotes devotion, and he looks out toward the viewer with a glance that is both soft and intense. The degree of emotional engagement which this figure establishes with the viewer makes one wonder whether the portrait was not destined as a token of commitment to a future bride or to a present wife.

Both the use of the feigned stone oval frame and the suggestion of a terrace setting are common features in Murillo's portraits. The latter is frequent in the full-length portraits; the former appears in various forms in his half-length portraits, from the earliest ones of ca. 1649 to the late *Nicolás Omazur*, which is the one that resembles our picture most in this framing device. The Ottawa portrait combines both elements.

Although the traditional attribution of this portrait to Murillo has been upheld by Mayer, Gaya Nuño, Soria, and, most recently, by Brown in a personal communication,[2] it has been rejected by Angulo, who suggests an alternate attribution to a member of the Madrid school, perhaps Claudio Coello.[3] The attribution to Murillo seems to the present author uncontestably solid. The technique of the entire painting is very much in keeping with Murillo's autograph works of the 1660s. The treatment and form of the right hand and sleeve are thoroughly Murillesque and can be closely matched to any number of his works, including the St. Rufina in the present exhibition (Cat. no. 28). The softly painted, expressive eyes are also quintessentially Murillo's in execution and feeling. Neither the technique nor the coloration of this work seem possible for a painting of the Madrid school, and its extraordinary over-all quality does not allow one to think of it as either a copy, a school piece, or as anything but an original work of the 1660s by Murillo's own hand.

N. A. M.

NOTES

1. This view of the face is favored by Murillo over a strict three-quarter angle, and occasionally he gives his sitter's head a completely frontal position.

2. Letter of Dec. 26, 1979 (on file at The National Gallery of Canada).

3. Angulo, *Murillo*, vol. 2, Cat. no. 2901, pp. 586–587.

30. *The Immaculate Conception*

Oil on canvas; 135 × 117 cm. (54¾ × 46 in.)

Provenance Capuchins, Genoa, 1674; W. Buchanan, London, 1803–06; Walsh Porter; M. M. Zachary, England, 1838; Marquis of Lansdowne, 1859; Frank T. Sabin, London, 1930; H. W. Parsons, 1930.

Literature Waagen, 1854, vol. 2, p. 152; Tormo, 1914, p. 55; Kansas City, 1941; Kansas City, 1973, p. 131; Angulo, 1981, vol. 1, p. 409 and vol. 2, no. 107.

William Rockhill Nelson Gallery — Atkins Museum, Kansas City, Missouri (30-32).

The Virgin, dressed in a white robe and blue mantle, stands on a crescent moon amidst clouds and cherubs. Both hands are pressed to her breast, her head is inclined, and her eyes are cast down. A hint of a smile plays about her features.

Although the dogma of the Immaculate Conception was only established in 1854, the representation of the Virgin Immaculate in paintings and sculptures was among the most popular subjects in Spanish Baroque art. Spain would play a large role throughout the seventeenth century in promoting the proclamation of the dogma of the exemption of Mary from original sin, exerting pressure to extract decrees from Paul V in 1617 and Gregory XV in 1622 to protect the doctrine from attack, and the bull *Sollicitudo* from Alexander VII, in 1661, to clarify its dogmatic definition. In 1664 another papal bull established the feast of the Immaculate Conception, and in Seville, where her cult was particularly fervent, a lavish procession was organized to celebrate it.

Murillo is associated more than any other artist with the Baroque image of the Immaculate Conception, so many and so perfect in their portrayal of the Virgin are the paintings of this subject that came from his hand. His interpretation of its iconography, however, departs in one important respect from the Spanish tradition established by sixteenth-century devotional images (i.e. by Juan de Juanes) and reaffirmed by Pacheco in his treatise and by example in the seventeenth. The Virgin is no longer surrounded by the symbols of the Marian litanies — well, rose bush, fountain, gate, etc. — that play an important part in earlier Spanish Immaculates (including those by Velázquez,

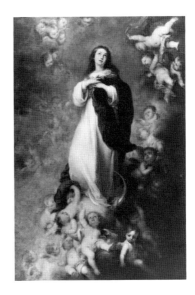

Figure 41. Bartolomé Esteban Murillo, *The Immaculate Conception*, oil on canvas. Madrid, Museo del Prado.

Zurbarán, and Ribera), but rather embodies in her own person the doctrine of innocence from original sin. The emblems of purity — lilies and mirror — which together with other Marian symbols such as palm fronds and roses are occasionally held by the cherubs in Murillo's paintings, are only a discreet elaboration of what the Virgin herself conveys by her appearance and gestures: the spotlessness of her body and soul.

Murillo painted this theme in numerous versions throughout his career, from the monumental *Immaculate of the Franciscans* ["*La Grande*"] of 1652 in the Museo Provincial de Bellas Artes, Seville, to the glorious *Immaculate of the Venerables* of ca. 1678 (fig. 41).[1] It is in the atmosphere of exaltation of the doctrine promoted by the papal bulls of 1661 and 1664 that the most significant examples of the subject by Murillo, painted in that decade and the next, were produced. The Nelson Gallery *Immaculate*, also known as the "*Little Conception*," belongs to that group.

In his recurrent treatments of the image during these decades Murillo created a whole array of wonderfully varied physical and spiritual characterizations of the Virgin and of formal arrangements for her and the attendant cherubs. The Kansas City example partakes of features that are found in other Immaculates of the period, but combined so that an individualized image is

brought into being. In physical type and pose, hand position and arrangement of the drapery she is closest to the *Concepción del Padre Eterno* (1668), painted for the Capuchins of Seville, but the lowered head and glance relate her instead to the Immaculates of Santa María la Blanca (1665) and of the chapter hall of the cathedral of Seville (1667–68), both works meant to be seen from below.[2] The general arrangement of all the figures in the painting, and the light and dark pattern are — on a more modest scale — similar to the *Concepción de los Venerables* mentioned above. Although it shares these various elements with other works, the *"Little Conception"* has its own distinct character. The Virgin, one of the most youthful of the Immaculates and less ostensibly beautiful than many, expresses more than most a gentleness and a shy modesty that make her a particularly touching figure.

The small size and intimate character of the Kansas City *Immaculate* suggest that it was destined perhaps for either domestic use or for placement in a private chapel. We can be quite certain that it was one of the six paintings by Murillo owned by a Genoese resident of Cádiz, who bequeathed them to the Capuchin convent of Genoa in 1674. Given the disparity of their sizes and subject matter — the largest ones are the *Adoration of the Shepherds* and *Joseph and His Brethren* (both in the Wallace Collection, London), the medium ones are the *Rest on the Flight to Egypt* (in the Earl of Stratford's Collection, Wrotham Park) and the *Charity of St. Thomas of Villanueva* (in the Wallace Collection, London), and the small ones are the *Immaculate Conception* (in the present exhibition) and the *Penitent Magdalen* (in the Wallraf-Richartz Museum, Cologne) — it is clear that they were not conceived as a group. What their original purpose and destination were, unfortunately, may never be discovered. N. A. M.

NOTES

1. This painting, also known as the *Immaculate Conception of Maréchal Soult*, attained the somewhat dubious distinction of fetching the highest price ever paid for a work of art at auction until the recent explosion of the art market in our own century. It was sold for 615,300 francs in 1852.

2. The *Concepción del Padre Eterno* is in the Museo Provincial de Bellas Artes, Seville; the *Immaculate* of Santa María la Blanca is now in the Louvre. The other Murillo *Immaculate* with lowered head and downward glance, besides the two already mentioned, was *"La Grande,"* which was also destined for a high location in the Franciscan church, over the triumphal arch.

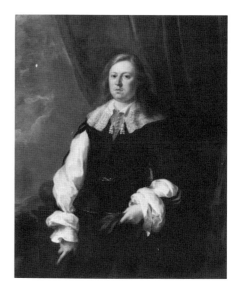

Figure 42. Bartolomé Esteban Murillo, *Portrait of Joshua Van Belle*, oil on canvas. Dublin, National Gallery of Ireland.

31. *Portrait of a Man*

Oil on canvas; 203 × 114 cm. (80 × 45 in.)

Provenance W. G. Rawinson, London, 1893; Eugene Boross, New York, 1923; A. L. Nicholson, London, 1927; F. Kleinberger, New York, 1929; Oscar Cintas, 1929.

Literature Brown, *Murillo*, 1976, pp. 174–175; Angulo, 1981, vol. 1, p. 465 and vol. 2, no. 423.

Cummer Gallery of Art, Jacksonville, Florida, on loan from The Cintas Foundation, Inc., New York.

Most of Murillo's full-length, life-size portraits stay, in their general outlines, within the tradition for courtly portraiture established in Spain by Antonis Mor in the sixteenth century, and continued in the seventeenth by Velázquez. In his depictions of Sevillian noblemen, Murillo emphasized further the formality and reticence of the sitters by the almost frontal pose he favored, the stiff-backed stance of the figures, and the severe, impassive expressions on their faces.

As in the aristocratic portraits, the unknown *Man* stands very rigidly and looks out at the viewer with a sober and neutral expression. The painting also conforms to the compositional pattern for figure and setting of most of Murillo's other full-length portraits:

the subject, holding hat and gloves, stands in an open terrace overlooking a landscape, with a balustrade, a pier or column, and a piece of drapery gathered behind him as the standard props. In general terms this is the scheme that Rubens launched so successfully in Genoa in the first decade of the century, and that Van Dyck developed in multiple variations from the 1620s on. Murillo's work parallels the arrangements that can be found in a number of Van Dyck likenesses,[1] but it reflects quite closely a specific work of Rubens which is more relevant than the former as a possible source of inspiration, a lost portrait of *Philip IV*, much replicated in its day.[2]

Although the format of our painting and the depiction of the sitter refer to courtly precedents, the subject of the Cintas picture was most probably a member of the wealthy merchant colony harbored temporarily by Seville, still an important commercial center. In the early 1670s Murillo had in fact painted the portraits of two merchants and amateur collectors from the Netherlands: the Dutchman *Joshua Van Belle* in 1670, now in Dublin (fig. 42); and in 1672 the Fleming *Nicolás Omazur* (fig. 40). The Cintas portrait, very similar to the Van Belle in many respects,[3] and also datable in the early 1670s, records a physiognomy that can very well be that of a Netherlander. The garments of our *Man* also follow very much the same fashion in overall cut and detail, with similar wide and soft lace collar with tassels, slightly opened at the neck, rather than the more characteristically Spanish stiff *golilla*.

Most of the figure and its setting are painted with the verve that one expects from Murillo's brushes, but the face of the Cintas *Man* appears to have been retouched at a later time, and has a hardness of outlines that does not match the rest of the painting's execution.

<div style="text-align: right">N.A.M.</div>

NOTES

1. The closest are the *Portrait of an Italian Nobleman* (ca. 1623) in the Wallace Collection, London, the *Portrait of a Man* (ca. 1630) in the Alte Pinakothek, Munich, and the *Portrait of Joos de Hertoghe* (ca. 1635) in the Gemäldegalerie, Kassel.

2. The painting is known to us through several copies. The figure's pose is very close to the copy in Stratfield, Duke of Wellington Collection, and both figure and background correspond to that in the Galleria Durazzo Pallavicini, Genoa. The placement of the legs, which differs from that of other Murillo standing portraits in their being set less wide apart, is like that of the Rubens *Philip*.

3. It was probably even closer at one point, because the Van Belle portrait appears to have been cut at the level of mid-thigh from an original full-length format. The Dublin picture has an inscription on the relined back copied from the front of the canvas as it stood originally. It reads: "Josua van Belle / BARTO^{ME} = MURI / LLO / en Sevilla an^o do 1670." The existence of this copied inscription adds support to the visual evidence that the painting was cut down in height.

32. *Christ After the Flagellation*

Oil on canvas; 125.5 × 146 cm. (50⅛ × 57½ in.)

Provenance Frank Hall Standish; Louis-Philippe Collection, Paris, 1842; Lord Carew, Castleton, Kildare, 1853; Wildenstein, New York, 1957; Mrs. Herman C. Krannert.

Literature Indianapolis, 1963, Cat. no. 54; Wethey, 1963, pp. 207–208; Gaya Nuño, 1978, no. 161; Angulo, 1981, vol. 1, pp. 427–428 and vol. 2, no. 246.

Krannert Art Museum, University of Illinois, Champaign, Illinois, gift of Mrs. Herman C. Krannert (60-4-1).

Christ, on his knees and dressed only in a loincloth, picks up his robes from the ground. Behind him, to the right and at a distance, is the short column of the Flagellation (the one at Santa Prassede, Rome, favored in seventeenth-century representations) with a trailing rope hanging from it and, below, the flail and a bundle of birch branches.

Figure 43. Bartolomé Esteban Murillo, *Christ after the Flagellation*, oil on canvas. Boston, Museum of Fine Arts.

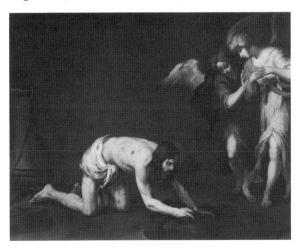

The subject represented here, Christ reaching for his garments after the Flagellation, is a rather unusual one among the themes of the Passion of Christ, but there exist two versions of it by Murillo, both of them now in America. Our version (ca. 1670) is somewhat later than that in Boston (fig. 43), and it differs from it most obviously in that it represents Christ facing in the opposite direction, on a larger scale, and alone, without the accompanying sorrowing angels. The theme is one of those elaborations of the scenes of the Passion that, in the wake of the Counter-Reformation and of St. Ignatius's aids to devotion, the *Spiritual Exercises*, became paintable subjects for the artists of the seventeenth century. Earlier in the century Velázquez had painted his *Christ after the Flagellation Contemplated by the Christian Soul* (ca. 1626–28) in the National Gallery, London, giving concrete form to the visualization by the pious Christian of the sufferings of Christ at the column. There, Christ is shown sitting on the ground and still tied to the column, presented to the devotion of the Christian soul by its guardian angel. The Dutch painter Gerard Seghers (1591–1651) painted one of the earliest representations of this subject, the moment after Christ has been unbound from the pillar and is on his knees, picking up his garments, as visualized by the Toletan mystic Alvarez de Paz in his *Meditations*, written in the early years of the seventeenth century.

The pertinent passage in Alvarez de Paz reads: "Untied from the column, you fell to the ground because of your weakness. You were so exhausted by the loss of blood that you could not stay on your feet. The pious souls contemplate you dragging yourself on the ground, sweeping your blood with your body, looking here and there for your garments."[1]

Zurbarán had rendered this scene in 1661 (for Nuestra Señora del Carmen, Jadraque, Guadalupe) but presented Christ as already on his feet, straightening up as he holds his robes, and looking out toward the beholder. Murillo, instead, presents in the Boston painting a very close visual transcription of the text, stressing, like Paz, the exhaustion of Christ after his brutal punishment. The pathetic weariness of Christ is vividly brought out by the gracelessness of his posture (contrasted by the elegant movement of the angels). Not only is he on his knees, but his back is bent and the head brought very low, as he barely supports his weight on his left arm. He has just managed to reach his garments, and one can very well sense the

arduousness of his displacement, crawling "on all fours" from the column directly behind him to the spot nearby where his clothes lie. The emphasis on Christ's crawling on hands and knees, on the physical humiliation of his condition, is modified in the Krannert version. Here Christ's posture is more erect as he pulls up his garments toward himself, and a different, softened pathos is attained. The facial expression, meditative and sorrowful, plays a greater role in dictating the emotional response of the beholder. Together with the kneeling pose and bearing of Christ, more composed and less helpless than in the Boston picture, it suggests humility, resignation, and infinite sadness, rather than a physical yielding to the weakness of the flesh. The response that Murillo tried to evoke from the pious viewer here is of respect for the forbearance and endurance of the tortured God-made-flesh, rather than of outrage at the indignity of his human fate.

The style of this beautiful work is very representative of the final phase in the development of Murillo's art. As in all his autograph works, the brushwork and the handling of the lights and darks make every inch of the painted surface live. Against the dark gray-brown of the background and the delicate grays and violets of the robes, the brilliant flesh tones and whites touched with blood-red of the figure of Christ himself make it seem to radiate a spiritual light. N. A. M

NOTE

1. Alvarez de Paz, *Meditaciones* (1620 ed.), p. 251, quoted by Mâle, *L'Art religieux après le Concile de Trente* (Paris, 1932), p. 265.

PEDRO NUÑEZ DE VILLAVICENCIO
Seville 1640–ca. 1698 Seville

Pedro Nuñez de Villavicencio, known primarily as a genre painter, was born in Seville into an aristocratic military family. His father was an admiral, and he himself entered the military order of San Juan de Jerusalén — the Knights of Malta — in 1661.[1] Villavicencio is believed to have studied in 1659 under Mattia Preti in Malta, where the Calabrese artist and fellow Knight was staying temporarily, prior to his settling there definitively in 1661. According to Palomino, Villavicencio

copied many works by Crespi, among them the *Magdalen* (1657).

Our artist is known to have been in Rome in 1673, and to have spent some time in Italy before, but the exact dates and duration of his stays there are uncertain. In 1664 he joined the brotherhood of the Santa Caridad in Seville, which Murillo was to join the following year.[2] The two artists became good friends, and Murillo named him, on his deathbed, joint executor of his will with Don Justino de Neve and his own son Gaspar Esteban Murillo.[3] Villavicencio died in Seville some time before 1698, the year in which he is mentioned as already deceased.[4]

Villavicencio is traditionally numbered among Murillo's followers, but this is mostly on the basis of his known close relationship with the older artist during the last years of Murillo's life, and on his choice of children's genre subjects of a similar sort to those first explored by Murillo. His technique, style, and physical types in those paintings, however, are thoroughly unlike Murillo's. Neither his brushwork, coloration, nor handling of the light can be connected to Murillo's, and his children are portrayed with a naturalism that does not recoil at ugliness. Their faces are sometimes distorted by the expressions they wear, and their body movements and poses are often graceless or awkward, something that can never be said about Murillo's figures.

His best known work is the *Boys Playing Dice* in the Prado, which was in the *Obrador* of the court painters in the Alcázar by 1686, presented by the artist to Charles II as a gift. This work is signed as Knight-Commander of Bodonal, to which he had title as a member of the prestigious order of Santiago.[5]

A catalogue of his oeuvre has been undertaken only recently by Marianne Haraszti-Takács, and is still in its tentative stages. The greatest part of his preserved and recognized work belongs to the category of genre, although Curtis, in his list of works by this artist, mentions religious paintings exclusively. He is also known to have painted portraits, but no certain work of his remains in this field.

Among the children's genre, apart from the autograph Prado painting, there are two more works signed with his initials: a *Boy Feeding a Blessed Companion* and *Two Boys Gambling*, both in the Leicester Museum and Art Galleries. A number of other examples seem sufficiently consistent in style to be grouped with rea-

sonable assurance under his name. Among these are the two paintings in this exhibition (particularly Cat. no. 34, previously unpublished). The other works to be included in this list are: the *Water Carrier* in the Casa Murillo, Seville; *The Little Beggar* in the Galleria Pallavicini, Rome; *The Mussel Eaters* in the Louvre; and the *Two Boys with Pots* in the Musée Vivenel, Compiègne.

One religious painting has recently been acquired by the Prado, a *Pietà with the Magdalen*, signed and dated *168*. N. A. M.

NOTES

1. *Museo del Prado. Adquisiciones de 1978 a 1981*, exh. cat. (Madrid, 1981), no. 14.
2. Angulo, *Murillo*, vol. 1, p. 81.
3. Ibid., pp. 161–163, Murillo's will.
4. *Museo del Prado. Adquisiciones de 1978 a 1981*, no. 14.
5. *Museo del Prado. Catálogo de las pinturas* (Madrid, 1972), no. 1235.

33. *Two Boys with Pumpkins*

Oil on canvas; 147.6 × 104.1 cm. (59 × 45⅜ in.)

Remnants of a signature at lower left: *dro ... nez* (?)

Provenance E. Zimmermann, Berlin; Herman Ferré, Puerto Rico.

Literature Lozoya, 1965, p. 277; Gaya Nuño, 1962; Indianapolis, 1963, Cat. no. 55; Held, 1965, p. 127; Haraszti-Takács, 1977, pp. 129–155.

Museo de Arte de Ponce, Puerto Rico, gift of Herman Ferré (59.0083).

In this painting of two ragged boys with pumpkins, Villavicencio comes closest to Murillo's late genre scenes of little urchins. Villavicencio also portrays the boys with lively, expressive gestures that animate a simple scene. The play of bodily and facial expressions here, however, does not convey the subtly differentiated but always clear messages that we can read in Murillo's works. The gesture of the raised left hand of the boy at the left is almost identical to that of one of the children in his *Boys Playing Dice*, in the Prado, and their facial expressions are similar. The closedfisted gesture of the other boy's hands appears in Murillo's painting of *Boys Playing Dice* (fig. 25), where it clearly informs us

that some coins are being tightly held. The right hand of the first boy is set in a rather distinct fashion, palm upward as if asking for or expecting something (in this instance, money, one may assume) to be placed in it, but with the thumb curiously and awkwardly overlapping half the palm. The boy on the right looks up at the beholder as if challenging him, with an expression of almost jaded amusement on his smiling face, while the boy on the left gestures and talks in the direction of an unseen third party to the right, whom he seems to be persuading. The boy might be bargaining for the price of the two pumpkins that lie on the ground in front of him, but his hand gestures as well as those of his friend can also be related to gambling. The ambiguity of the action in this work, as well as the conspicuous absence of the person or persons being addressed, suggest that we may be dealing with a fragment of a larger composition, of which the present painting formed the left half. This suggestion had been made earlier by David G. Carter on the basis of the gesture of address without a recipient, and other observations confirm this supposition.[1] In its present format the painting follows that of Murillo's genre subjects of this type, but the cut-off point for the composition on the right leaves an uncomfortably tight space for the figure of the boy facing us, and the placement of the two figures with respect to the over-all height of the canvas also leaves relatively little space above their heads. These features are not to be found either in Villavicencio's own paintings nor in the Murillo two- and three-figure works that it resembles.

In its general composition Villavicencio's painting follows closely the pattern set by Murillo in his genre scenes of the 1660s. The children are seen at close range and full length, with the feet and still-life elements coming close to the bottom edge of the canvas, while a more generous area of background is left above their heads. They are outdoors, seated on some rocky ground, and behind them, to one side, is a ruinous piece of masonry (a structure in ruins in Murillo, perhaps a sarcophagus in the Villavicencio). Some distant ground can be seen on the opposite side, and a piece of sky above. The background is rendered in all cases rather indistinctly, with the concentration of light and detail reserved for the foreground figures.

The Villavicencio is a much darker picture than any of Murillo's counterparts, and with the exception of the latter's early genre pieces, such as the *Lice Chase*

in the Louvre, it is much more intense in its chiaroscuro contrasts. The technique of the younger artist is quite free, with a creamy impasto and the brushstroke much in evidence in parts, but it is unrelated to the painterliness of Murillo's style in the 1660s and later. Instead of the softly contoured forms that blend into the surrounding space and the transparent shadows and complex reflected light effects of Murillo, we find here more sculpturesque and solid figures that are sharply and simply lighted.

The attribution of the Ponce painting to Villavicencio was made by Mayer in 1928 on the basis of its similarity to the Louvre's *The Mussel Eaters* and to a work dated 1682 in the art market in Switzerland in 1926. This attribution has been sustained by Carter and Held, but it has been questioned by Lozoya, who suggested the painting might be by an Italian imitator of Murillo.[2]

There are remnants of a signature in the lower right-hand corner which can be read as the last two syllables of the artist's two first names, *dro . . . nez*, but the evidence is not conclusive. The stylistic similarity of our painting to the autograph *Boys Playing Dice* in the Prado is not strong enough by itself to make for a watertight case of attribution, but the Ponce painting, on the other hand, is very close in the children's physical types and in its execution and handling of the light to the *Two Boys Gambling* in Leicester, which is a signed work (with the initials *PNV f.*). N. A. M.

NOTES

1. John Herron Museum of Art, and Museum of Art, Rhode Island School of Design, *El Greco to Goya*, exh. cat. (Indianapolis, 1963), no. 55.

2. Ibid. See also Julius Held, *Museo de Arte de Ponce. Catalogue I. Paintings of the European and American Schools* (Ponce, 1965) and the Marqués de Lozoya, "Pintura española en el Museo de la Fundación Luis A. Ferré en Ponce," *Goya*, 35 (1960), pp. 274–277.

34. *Two Peasant Children in a Landscape*

Oil on canvas; 150 × 115 cm. (59 × 45¼ in.)

Provenance Private collection, Switzerland.

Private collection, New York.

A boy and a girl, dressed in ragged peasant's garb, sit in a landscape by the wayside, looking out toward the viewer with expressions that border on the pathetic. The boy's smile, more than the girl's serious mien, suggests a condition far from the buoyant spirits of carefree childhood. Their position by a road, their attitudes of expectation, and the earthenware pots they hold in their hands indicate that they sell water to the passersby. This is a subject that Villavicencio treated in at least two other works that can be regarded as authentic, the *Water-Carrier* in Seville and the *Two Boys with Pots* in Compiègne.

The girl's face is painted with a similar technique to that used in the Prado picture of *Boys Playing Dice*, relatively smoothly. The boy's has livelier brushwork and greater sparkle.

The boy in this painting is a typical example of Villavicencio's naturalistic types, and very different from Murillo's children (fig. 25). His face has the coarseness of a peasant's, without a single feature that can be called pretty, and the oversized hat sitting low on his forehead adds another element of awkwardness to his looks. His pose and the configuration of his body—short neck, narrow shoulders, fleshy trunk, large, ungainly feet—are also designed to stress that the child is of peasant stock. The girl is prettier and more graceful, but the pair are a very different breed from the beautiful boys and girls in Murillo's genre paintings (fig. 26). Villavicencio's approach to genre types is more in line with that of the *bamboccianti* in Rome than with Murillo's idealized vision of poor children.

N.A.M.

ANTONIO PALOMINO
Bujalance (Córdoba) 1655–1726 Madrid

Acisclo Antonio Palomino de Castro y Velasco was baptized on December 1, 1655. As a child in Córdoba he was trained in theology and took minor orders. An encounter with the painter Juan de Valdés Leal in Córdoba in 1672 proved important for the young artist. According to Palomino himself, Valdés Leal not only instructed him in painting but also gave him some (now lost) "documents to govern [my art] which I esteemed and appreciated [as] being from an erudite man [who was] practiced in his field." Another of Palomino's teachers in Córdoba was Juan de Alfaro.

Palomino arrived at the court of Madrid in 1676.

There he not only painted but studied geometry at the Jesuit Colegio Imperial, the knowledge of which served him well in his later practical and theoretical writing and in his own painting. In Madrid, Palomino soon made the acquaintance of Claudio Coello, who was instrumental in gaining for the younger artist his first court commission. In the Galería del Cierzo of the Alcázar, Palomino painted scenes of the Cupid and Psyche legend. With this and other works for the Crown, Palomino pleased Charles II, who named him *Pintor del Rey* in 1688. Among other royal projects was the decoration of the Plaza de la Villa in 1690, when the second wife of Charles II, Mariana of Neuberg, made her triumphal entry into the capital.

There are a number of important fresco projects by Palomino which survive. In Madrid he adorned the chapel of the town hall (*ayuntamiento*) with eucharistic subjects. Between 1699 and 1700 he decorated the interior of San Juan del Mercado in Valencia, beginning a long association with religious institutions in that city. His other major decorative effort in Valencia was the execution (in 1701) of the frescos in Nuestra Señora de los Desamparados. For the Church of San Esteban in Salamanca, Palomino painted a large *Triumph of the Church* in the choir, a fresco based on Rubens's design for one of the tapestries in the Descalzas Reales, Madrid. In 1712 Palomino was in Granada, where he executed frescos in the *Cartuja*; the following year he did the paintings for the main altar of the cathedral of Córdoba. Palomino's last decorative fresco cycle was for the charterhouse of El Paular near Segovia.

By 1715 he had published the *Teórica de la pintura*, the first volume of his famous treatise, the *Museo pictórico y escala óptica*. The second volume, *Práctica de la pintura*, and third, *Parnaso español pintoresco laureado* were published in 1724. These volumes were very successful in their day and were reprinted in their totality in Spain in 1795–97. Summaries were published in English in 1739 and in French in 1749 and 1762.

In both his fresco and easel paintings (see, for example, the versions of the *Immaculate Conception*, in the Prado and Cat. no. 36) Palomino continued the high Baroque style of the Madrid school into the following century. He was enormously influenced by Coello, to whom he dedicated a long and laudatory biography in the *Museo pictórico*. At the death of his wife Catalina Bárbara Pérez, in April of 1725, Palomino was ordained a priest only a few months before his own death on August 12, 1726.

E.J.S.

Catalogue

35. *The Archangel Michael Casting Satan into Hell*

Oil on canvas; 125.7 × 90.5 cm. (49½ × 35⅝ in.)

Signed on reverse at bottom: *Reg. pict. Antᵒ Palomᵒ f*

Provenance Schaeffer Galleries, New York.

Literature "Accessions," 1958, p. 322, illus. p. 324; Bologna, 1958, p. 300; Kubler and Soria, 1959, p. 290; Pérez Sánchez, 1972, pp. 262–263, pl. VIII; Stokstad, 1972, p. 34, pl. 10; Bantel and Burke, 1979, pp. 74–75, no. 8.

William Rockhill Nelson Gallery—Atkins Museum, Kansas City, Missouri, gift of Mr. and Mrs. Milton McGreevy through the Westport Fund (F.58.35).

This version of the victorious angel is similar to that by Palomino's teacher and friend, Claudio Coello, in the present exhibition (Cat. no. 15). Here, however, the saint wears a helmet and holds the horned figure of Satan (who lies to the right of Michael) with a chain. He subdues him with a thunderbolt instead of with the sword and Cross that Coello's figure wields. Nonetheless, there is an analogous vigor of composition and dramatic evocation of the fires of Hell in the image by Palomino.

Palomino did at least one other version of the St. Michael theme, now in the Lassala Collection in Valencia.[1] The Kansas City picture, however, is more successful in conveying a mood of heavenly triumph.

Ceán Bermúdez, in his biography of the artist, mentions a canvas of this subject in a side altar in the Church of La Victoria in Madrid.[2] Although Pérez Sánchez doubts that we can identify the Kansas City picture with the painting mentioned by Ceán Bermúdez it is not wholly impossible, especially if our *St. Michael* was painted as one of several components of a retable.[3]

Bologna,[4] Pérez Sánchez,[5] and Burke[6] have suggested that the rapid brushwork and type of composition are due to Palomino's contact with the art of Francesco Solimena and Luca Giordano. While the color can be compared with that of the Neapolitan artists, the *St. Michael* is sufficiently close in theme and treatment to other works of the masters of the late Baroque in Spain that foreign inspiration need not necessarily explain the total effect of the picture. Soria has also suggested that the work's dynamism is, in part, due to the artist's

having developed an expertise in the art of fresco painting.[7]

As for the date, Palomino signed the work *Regis pictor*, providing us with a *terminus ante quem* of 1688, the date he received the title of *Pintor del Rey*. Although few of the artist's easel paintings are dated, we might safely assign this work to the period of ca. 1700.

Pál Kelemen has noted that this representation of St. Michael the Archangel became very popular in Mexico, Peru, and elsewhere in the New World.[8] "In Spanish America it was customary for every town to select a guardian saint who was then featured in its seal. Besides Our Lady—patroness of all the Americas—Michael was perhaps the most popular figure."[9] It was precisely this type of triumphant standing figure with a thunderbolt or sword that was constantly depicted in paintings and sculptures in the seventeenth and, especially, eighteenth centuries. E.J.S.

NOTES

1. Illustrated in Emilio Aparicio Olmos, *Palomino: Su arte y su tiempo* (Valencia, 1966), pl. 9.
2. Ceán Bermúdez, *Diccionario*, vol. 4, p. 39.
3. Pérez Sánchez, "Notas sobre Palomino, pintor," *Archivo Español de Arte*, 45 (1972), p. 263, n. 30.
4. Ferdinando Bologna, *Francesco Solimena* (Naples, 1958), p. 300.
5. Pérez Sánchez, "Notas sobre Palomino, pintor," pp. 262–263.
6. Bantel and Burke, *Spain and New Spain*, p. 75.
7. Kubler and Soria, *Art and Architecture*, p. 290.
8. Letter to the Schaeffer Galleries, New York, May 21, 1958.
9. Pál Kelemen, *Peruvian Colonial Painting*, exh. cat. (New York, 1971), no. 44. See also Kelemen, *Baroque and Rococo in Latin America* (New York, 1951), p. 214.

36. *The Immaculate Conception*

Oil on canvas; 188 × 125.7 cm. (74 × 49½ in.)

Provenance Private collection, Dresden; private collection, U.S.A.; sold at auction 1970; Nelson Shanks, Chelwood, Andalusia, Pennsylvania.

Meadows Museum, Southern Methodist University, Dallas, Texas (80.01).

The Virgin, dressed in a blue cloak and white tunic tied at the waist with a red sash, looks heavenward. Her arms are outspread and she is surrounded by seraphim and cherubim at the upper and lower portions of the picture. Those below the Virgin hold irises, roses, and a palm branch, symbols of her purity. The dove of the Holy Spirit appears above her head, which is crowned with twelve stars.

The Immaculate Conception was as important an image for the painters of Madrid as for those of Seville, and Palomino painted this subject at least eight times.[1] In all but one version Mary's eyes are raised to Heaven and her hands are folded in prayer. Palomino depicts the Virgin as a mature woman with a fleshy face. The Dallas *Immaculate Conception* is closest in figure type to the Virgins painted by Carreño (see, for example, the *Immaculate Conception* in the cathedral of Vitoria or the *Assumption* in Poznan).

There is an inscription on the reverse of the canvas which reads *Palomin*. Prior to 1980 there was another inscription on the lower right of the painting itself: *A.P.f. 1716*. Since this was considered to be a later addition, and not by the artist, it was removed when the picture underwent conservation.

It is likely that the date of the painting is indeed earlier than 1716. The figure of the Virgin is very close to those of Carreño, as mentioned, as well as to the *Inmaculadas* of Claudio Coello. The soft contours of the Virgin's face are also unlike the hard outlines in Palomino's late works. A date of ca. 1695–1700 may therefore be suggested for this heretofore unpublished work. E.J.S.

NOTE

1. See Pérez Sánchez, "Notas sobre Palomino, pintor," p. 265 and pls. XI, XII, and Aparicio Olmos, *Palomino*, pl. 12.

JUAN DE PAREJA
Seville ca. 1604-07–ca. 1670 Madrid

At least one of Pareja's parents was of Moorish or African origin. Nothing is known of his early training, but in a letter he wrote from Seville on May 12, 1630, he stated that he was a painter and asked permission of the procurator of his native city to go to the capital to further his studies in the studio of his own brother Jusepe. In Madrid he was introduced to Diego Veláz-

quez, probably through a mutual Sevillian acquaintance, as Gaya Nuño supposed, and began work as his shop assistant.[1] Many writers, including Palomino, Ceán Bermúdez, and others have cited Pareja as the "slave" of Velázquez, yet the aforementioned letter, published by Rodríguez de Rivas, is significant in the refutation of this idea.[2] As Trapier explains, no slave would have been a painter in Seville or elsewhere in Spain.[3] We cannot discount everything in Palomino's biography, however, for it does seem likely that his statement that Velázquez refused to give Pareja artistic training can be borne out considering the dissimilarity of this painter's style from that of his master.

Among the few indisputable biographical facts concerning Pareja is that of his having accompanied Velázquez on his second trip to Italy in 1649–51. The most eloquent testimony to that voyage is, of course, Velázquez's masterful *Portrait of Juan de Pareja* (fig. 44).

There is only a small corpus of signed and dated works by which we might chart the artistic progress of Pareja. The first is the *Flight into Egypt* (1658) in the Ringling Museum, Sarasota (Cat. no. 37), followed by the *Calling of St. Matthew* (1661) in the Prado, the *Baptism of Christ* (1667) in the Museo Provincial at Huesca, and the *Mystic Marriage of St. Catherine*

Figure 44. Diego Velázquez, *Portrait of Juan de Pareja*, oil on canvas. New York, The Metropolitan Museum of Art, Isaac D. Fletcher Fund, Jacob S. Rogers Fund & Bequest of Adelaide Milton De Groot (1876–1967), Bequest of Joseph H. Durkee, By Exchange, Supplemented by Gifts from Friends of the Museum, 1971.

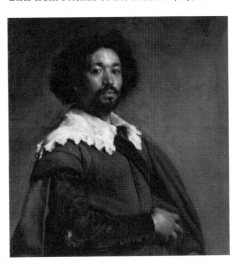

(1669) in the parish church of Santa Olaja de Eslonza, in the province of León.

Palomino also states that, after the death of Velázquez, Pareja entered the service of his daughter Francisca. Gaya Nuño points out that this would have been impossible because Doña Francisca died in 1654.[4]

No documents have been found recording his death, which probably took place when, as Palomino tells us, Pareja was slightly less than sixty years of age. E. J. S.

NOTES

1. Gaya Nuño, "Revisiones," p. 274.
2. Mariano Rodríguez de Rivas, "Autógrafos de artistas españoles," *Revista Española de Arte*, 1 (1932–33), p. 233.
3. Trapier, *Velázquez* (New York, 1948), p. 295.
4. Gaya Nuño, "Revisiones," p. 276.

37. *The Flight into Egypt*

Oil on canvas; 168 × 125 cm. (66½ × 49⅜ in.)
Signed and dated at lower left: *Pareja 1658*

Literature Suida, 1949, pp. 279, 280, no. 339; Gaya Nuño, "Revisiones," 1957, pp. 276–277; Gaya Nuño, 1958, p. 265, no. 2139, fig. 176; Coley, 1963, p. 65; Indianapolis, 1963, no. 58; Angulo, 1971, p. 213; Fahy, 1971, pp. 469–472.

John and Mable Ringling Museum of Art, Sarasota, Florida (State no. 339).

The Virgin, wearing a blue mantle, red dress, and brown hat holds the Christ Child in her arms. They ride on a donkey led by an angel with St. Joseph behind them. At the left a palm tree bends toward the group, and in the sky a glory of putti appears in a golden light holding palm branches and what appears to be an apple or a globe. In the background at right there is a circular temple, reminiscent of classical sanctuaries, with niches in which statues are placed. In the middle ground there is a very sketchy scene of Roman soldiers engaged in the Massacre of the Innocents.

Although most representations of the Flight simply depict the Virgin, the Christ Child, and St. Joseph, there are several Spanish versions (including a painting attributed to Francisco de Solís, in the Royal Palace, Madrid, and the two *Flights* in the present exhibition, by Pareja and José Moreno), which show the angel with the Holy Family. Poussin also provided

heavenly accompaniment for the Family in several paintings of this theme.[1]

The bent palm tree at the left of the painting refers to two apocryphal stories concerning the Flight. According to one of these legends, the branches of all the trees of the forest through which the Holy Family passed bent in respect to the sacred group. In another of these stories the Christ Child ordered the branches of the date palm to bend to give shade to his mother.[2]

Although this is the first dated painting by Pareja, it is a sufficiently accomplished work to make us believe that there must have been others before it. Nonetheless, there is a charming, naïve quality here. The angel who guides the Holy Family in their travels wears a green dress with very precise, minute embroidery, revealing a love of detail akin to that of the many painters of such angels in Latin America. A similar interest in detailed embroidery was taken by Zurbarán, with whose work Pareja almost certainly would have been familiar.

We must also remember that this painting was done after the artist's return from Italy, where he accompanied Velázquez. Such elements as the classical temple in the background, as well as the group of putti in the upper portion of the scene (vaguely reminiscent of Correggio's angels in the Parma frescos) may be seen as products of his experience abroad. E. J. S.

NOTES

1. See Jacques Thuillier, *Tout l'oeuvre peint de Poussin* (Paris, 1974), no. 207, B37.
2. Jameson, *Legends*, pp. 234–235.

ANTONIO DE PEREDA
Valladolid 1611–1678 Madrid

Pereda's parents were Antonio de Pereda Tribilla, a painter of modest talents, and María Salgado, who was born in Flanders of a Spanish father and a Flemish mother. He received his first lessons in drawing and painting from his father, as did his brothers José and Mateo. Sometime after the death of the elder Pereda in 1622, Antonio went to Madrid. His teacher there was Pedro de las Cuevas. In Cuevas's workshop he made the acquaintance of Francisco Tejada, an important collector and patron, in whose home (as Palomino tells

us) Pereda was able to study and copy many significant works of art. A more influential figure for Pereda's early career, however, was the Italian statesman, painter, and architect Giovanni Battista Crescenzi, who had arrived in Spain in 1617. Through the good offices of Crescenzi, Pereda was introduced into the artistic world of the court. His most important royal commission was for a large battle painting, the *Relief of Genoa* (1634), part of the cycle of twelve such paintings by various artists to decorate the Hall of Realms of the newly built Buen Retiro. In 1635, however, Crescenzi died and Pereda's association with the court abruptly ended. Pérez Sánchez has recently noted that even forty years later, in 1678, Pereda still affectionately referred to Crescenzi in his will as *"el Marqués, mi señor."*[1]

In the later 1630s Pereda began to execute a large number of religious paintings for convents in Madrid and surrounding towns such as Alcalá de Henares, as well as in his native city of Valladolid.

By the 1650s he had begun to cultivate another genre of painting for which he became famous—the still life. Among the most important examples are those in the Museo Nacional de Arte Antiga, Lisbon; the Hermitage in Leningrad; and the Pushkin Museum in Moscow. Pereda was married twice, the first time in 1634 to Mariana Bautrés, and again, at the age of 63, to Mariana Pérez, who outlived her husband by more than twenty years. From the last decade of the artist's life there are many records of his activities as an appraiser of private collections. In 1677 he took part in a lawsuit brought by a number of painters of Madrid to have the art of painting recognized as a noble activity rather than a craft. This dispute on the nobility of art was a vehemently contested issue in the seventeenth century in which many painters of renown, from El Greco to Velázquez, took part.[2]

Pereda drew up his will in January 1611, and was buried in the Church of San Francisco in Madrid.[3]

E. J. S.

NOTES

1. Pérez Sánchez, *Don Antonio de Pereda*, n. pag.
2. Gállego, *El pintor de artesano a artista* (Granada, 1976).
3. See the transcription by Viñaza, *Adiciones al diccionario*, pp. 237–247.

38. *The Sacrifice of Isaac*

Oil on canvas; 218 × 170 cm. (85⅛ × 67¼ in.)

Provenance Manuel Ortíz de Zavallos, Paris and Lima; Ortíz de Zavallos Collection, Lima; Clarence Hoblitzelle, St. Louis, Missouri.

Literature Jeckel, 1873, p. 14, 1899 ed. (anon. author), p. 57, no. 74; Pérez Sánchez, 1978, no. 34.

The Hoblitzelle Foundation, Dallas, Texas, on loan to the Dallas Museum of Fine Arts (96.1937).

Abraham, wearing a mauve tunic with red sash, holds the forearm of his son Isaac and points heavenward. The boy, kneeling on a small pyre of firewood, looks at his father with a fearful glance. Unlike most other representations of this event described in Genesis (22: 1–19), this painting depicts the moment before the arrival of the angel of the Lord. Abraham appears to be explaining to his son the necessity of the sacrifice.

The sacrifice of Isaac was traditionally considered a prefiguration of the sacrifice of Christ to redeem mankind. It also may have had an additional meaning in seventeenth-century Spain. Just as Carreño's *Flaying of St. Bartholomew* could be seen as symbolic of the need to sacrifice one's life, if necessary, for the faith, so could this subject be looked upon as paradigmatic of the virtues of moral steadfastness, no matter what the consequences.

When first published, this painting was considered to be by Titian. It was next given to the Dutch school of the later seventeenth century and then, at the suggestion of Sterling (in an unpublished note in the files of the Dallas Museum of Fine Arts), to an anonymous Spanish painter of the middle of the seventeenth century. It was first published as a work of Pereda by Pérez Sánchez in 1978. He remarked on the similarity of modeling in the figure of Abraham to that in Eliah and Elijah in two paintings from the Church of the Shod Carmelites in Madrid. These paintings were done in 1659 and thus Pérez Sánchez tentatively dated the Dallas picture to that time. He also noted, however, that there are additional similarities to Pereda's *St. Peter* and *St. James* in the Prado, works of 1645.

Ceán Bermúdez mentions a *Sacrifice of Isaac* as in the Church of the Unshod Carmelites in Madrid, along with a *St. James*, a *St. Bartholomew*, and a *Frat-*

ricide of *Cain*. The *Sacrifice* as well as the other paintings (now lost?) may have left Spain at the time of the secularization of the country's religious institutions during the 1830s.[1]

As Pérez Sánchez points out, the painting of the nude (or even partially nude) figure is relatively rare in Spanish Baroque art, but Pereda seems to have studied the nude form assiduously.[2] His study of the art of Ribera, who painted numerous similar types, was beneficial for Pereda's modeling of the figures (especially that of the old man) in *The Sacrifice of Isaac*.

The few landscape elements in the picture appear to be well painted, although there has been considerable abrasion in the upper area which obscures the details in that part of the painting. E. J. S.

NOTES

1. Opinion of William B. Jordan (in the museum's files).
2. The seemingly clumsy anatomy of the boy's left shoulder and upper arm is probably due to damage by abrasion.

BARTOLOME PEREZ
Madrid 1634–1693 Madrid

Bartolomé Pérez, born in Madrid in 1634, first studied painting with Juan de Arellano and may well have been one of his first apprentices. While still an assistant, according to Palomino, Pérez collaborated with his teacher in painting figural subjects in the center of garland paintings. He later married Arellano's only daughter, Juana.

By 1665 Pérez had become an independent master. His skill as a painter was not limited to flower pieces. Ceán Bermúdez refers to a signed painting of *St. Rose of Lima*, which was of such high quality that after seeing it he considered Pérez one of the finest artists of the seventeenth century.

Pérez often painted stage curtains for the Coliseo Theater of the Buen Retiro. In 1689 he was named *Pintor del Rey*. In 1693, while painting a ceiling in the palace of the Duke of Monteleón, he fell from a scaffold, and died from his injuries. He was buried in the Church of San Ildefonso, in Madrid. I. M.

39. *A Vase of Flowers on a Pedestal*

Oil on canvas; 64.8 × 47 cm. (25½ × 18½ in.)

Provenance Heirs of Santiago Pierrad, Madrid; Newhouse Galleries, New York.

Literature Cavestany, 1936–40, p. 162, no. 92, pl. XLIX; Valentiner, 1956, p. 85, no. 216; Gaya Nuño, 1958, p. 270, no. 2201.

North Carolina Museum of Art, Raleigh, Phifer Funds (G.52.9.227).

On a fragment of a classical base is a glass vase with lilies, roses, carnations, and other flowers. A lily rests on the base next to the vase.

The style of Pérez is very closely allied to that of his teacher and father-in-law, Arellano. In this painting the light comes from the left as it does in Arellano's *Basket of Flowers* (Cat. no. 2). On the vase is a subtle reflection of a window in the artist's studio. The shape of the vase itself is fairly distinctive. Whereas Arellano tends to use a round-stemmed vessel, Pérez often paints a slightly elongated one. The date of Pérez's paintings is difficult. Apparently, he reached his maturity in the later 1660s, judging from several dated works published by Cavestany and Mitchell.[1]

A companion painting to this work is also in the collection of the North Carolina Museum of Art. E. J. S.

NOTE

1. Cavestany, *Floreros y bodegones*, p. 157, no. 51, pl. XLV (this painting is signed and dated 1665); and Peter Mitchell, *Great Flower Painters: Four Centuries of Floral Art* (Woodstock, N.Y., 1973), fig. 282 (signed and dated 1666).

40. *Still Life: Flowers and Fruit*

Oil on canvas; 62.2 × 48 cm. (19½ × 24½ in.)

Provenance Carlebach Gallery, New York.

Literature Gaya Nuño, 1958, p. 270, no. 2204; Park and Mayhew, 1960, p. 53; Indianapolis, 1963, no. 61; Newark, 1965, p. 26, no. 23.

Lyman Allyn Museum, New London, Connecticut, gift of N. J. Leigh (1956.32).

The vase on a shelf contains foxglove, carnations, irises, roses, and other flowers. Peaches are at the right side. This painting does not conform to Pérez's more common use of a strong light from the left (see Cat. no. 39) yet the treatment of the flowers is sufficiently similar to that in other paintings by this artist to accept the attribution to him.

Although the symbolic references in such seemingly straightforward representations of fruits and flowers are still unclear, it may be possible to interpret this composition as depicting four of the five senses: sight, smell, touch, and taste. E.J.S.

PEDRO RUIZ GONZALEZ
Arandilla (Cuenca) 1640–1706 Madrid

In a study of paintings recently ascribed to Ruíz González, Urrea Fernández called this artist "one of the most unfortunate painters of Madrid whose works have suffered from destruction as well as lack of interest."[1] The only monographic article on Ruíz González, by Sánchez Cantón, states that apart from his place of birth, date and place of his death, and the fact that he lived on the Calle de Juanelo in Madrid, there is no further documented information on him.[2] We must therefore rely on the biography by Palomino in his *Museo pictórico*, which tells us that Ruíz González learned the art of painting with Juan Antonio Escalante and Juan Carreño de Miranda. Among the works Palomino lists as by Ruíz González are a *Nativity*, a *St. Anthony*, and a *St. Blas* done for the Church of Sts. Justus and Pastor; portraits of four cardinals for the Colegio Imperial (San Isidro), which burned in the fire of March 16, 1720; and banners (*estandarte[s], muy caprichoso[s]*) for the churches of San Millán and the Venerable Orden Tercera. He also mentions the painting in the present exhibition, which was then in the Church of San Luis, Madrid.

Most of Ruíz González's work was done in Madrid. However, in Palomino's account there is a reference to a *Christ before Pilate* which resembles the work of Veronese and may have been painted by Ruíz González in Granada.[3]

Other known pictures by the hand of this artist are an *Assumption of the Virgin* and *Souls in Purgatory*

in the parish church in Arandilla, where Ruíz González was baptized; and *Ecstasy of St. Theresa* and *St. Pascual Bailón Accompanied by Theological Virtues* in the parish church in Magaz (Palencia).

Both Palomino and Ceán Burmúdez cite Ruíz González as a competent and prolific draftsman, and there are several of his drawings in the Biblioteca Nacional, Madrid, the Prado, and Spanish private collections.
 E.J.S.

NOTES

1. Urrea Fernández, "Obras de pintores menores madrileños: B. de Castrejón, A. Van de Pere y P. Ruíz González," *Boletín del Seminario de Arte y Arqueología*, 40–41 (1975), p. 711.

2. Sánchez Cantón, "Pedro Ruíz González: Pintor de la escuela de Madrid," *Archivo Español de Arte*, 16 (1943), pp. 399–403.

3. This is perhaps the painting in the Prado catalogued as no. 2807 (*Cristo en la noche de la pasión*).

41. *King Charles II Before the Sacrament*

Oil on canvas; 232.4 × 166.4 cm. (90 × 65½ in.)

Signed and dated at lower left: *Pº RVIZ*
 GOZLZ. F,
 1683

Provenance Church of San Luis, Madrid; Carnegie Institute, Pittsburgh.

Literature Palomino, 1724 (1947 ed.), p. 1125; Thieme-Becker, 1935, vol. 28, p. 199; Mayer, 1942, p. 484; Sánchez Cantón, 1943, p. 400; Weissberg, 1954, p. 335; Gaya Nuño, *Claudio Coello*, 1957, p. 21; Gaya Nuño, 1958, no. 2527, pl. 235; Kubler and Soria, 1959, p. 389, note 24; Held, 1965, pp. 152–153, pl. 124; Angulo, 1971, p. 294; Urrea Fernández, 1975, p. 712; Valdivieso, Otero, and Urrea, 1980, p. 321.

Museo de Arte de Ponce, Puerto Rico (60.0131).

A priest stands in the center of a group of fourteen persons, holding a monstrance with the Eucharist. To the left, King Charles kneels, looking outward, beyond the picture plane. Behind him are several ecclesiastical attendants, and at the lower left are two noblemen. The more prominent of the pair may tentatively be identified as Don Antonio de Toledo, son of the Duke of Alba, who is present in a similar pose in the *Sagrada*

Forma by Claudio Coello (fig. 17). Toledo touches the shoulder of his young son, who gives an offering to two children next to him holding a plate and incense vessel. At the left side of the composition there is a thurifer, an acolyte, another attendant holding a miniature ciborium, and two others bearing a canopy.

The retable behind the group is very ornate, recalling actual sculpted altarpieces by Churriguera. Vine-covered salomonic columns divide the altarpiece into three sections. The niche at the right contains an image of St. Dominic. St. Andrew is represented at the left. There is a tabernacle in the center with a painting of Samson and the lion on the door. It is flanked by two sculpted angels, and above there is a cartouche with the inscription: DE COMEDENTE EXIVIT CIBVS, ET DE FORTI AGRESSA EST [ULCEDO]. SAMS XIIII [*sic*] (Judges 14:14: "Out of the eater came forth meat, and out of the strong came forth sweetness"). The tabernacle is domed and standing above it is the figure of a bishop. A painted image of God the Father flanked by putti is seen in the apse of the retable. In the upper left corner of the picture are several cherubs holding a banner with another inscription: ET ADORABVNT EV̄ OMNES REGES...OMNES GENTES SERVIENT (Psalms 72:11: "Yea, all Kings shall fall down before Him; all nations shall serve Him").

This painting most likely commemorates a benediction or other religious service in which King Charles participated. The man in the lower right corner of the painting is probably the donor. As early as 1724, Palomino recorded the presence of this work in the Church of San Luis, where it hung until approximately the 1930s. Sánchez Cantón published it as having been burned in the fire that destroyed the church on March 9, 1936, although the picture had been removed before this time.[1]

This is one of the most important works by Ruíz González, given its large size, clear signature, and date, as well as its faithful portrait of the king. Equally significant is the fact that it clearly served as a partial source of visual and thematic inspiration for the famous *Sagrada Forma* altarpiece by Claudio Coello in the Escorial (fig. 17). E.J.S.

NOTE

1. The 1972 edition of Tormo's *Las iglesias del antiguo Madrid* (originally published in 1927) contains notes by María Elena Gómez Moreno documenting the further history of the churches described almost fifty years before. On p. 147 she gives the date of the fire that destroyed the Church of San Luis as March 13, 1935.

JUAN DE VALDES LEAL
Seville 1622–1690 Seville

Juan de Valdés Leal was born in Seville and received baptism in the Church of San Esteban on May 4, 1622. Little is known about his father and mother beyond that he was from Portugal and that she was Sevillian. Nothing is known either about his training as an artist or when, where, and with whom he served his apprenticeship. It has been repeatedly asserted that he trained in Córdoba under Antonio del Castillo (1616–68), since there is a relationship between the earliest works of Valdés and the style of the slightly older Cordoban, but it is more likely that he was apprenticed in Seville, before moving to Córdoba.[1] When that move took place is also unknown, but in 1647 he was a resident there and recorded as a master, so it may be assumed that he had been working in this city since the mid-1640s. In 1647 Valdés painted his first known work, the signed and dated *Saint Andrew* in San Francisco, Córdoba, and that same year he married.

In his first major commission, the cycle of stories from the history of the Order of St. Clare, done for the convent of Santa Clara in Carmona in 1652–53, Valdés Leal's personal style begins to emerge. The frenzied movement and brilliant color and light of one of the canvases (*The Retreat of the Saracens* in the Museo Provincial de Bellas Artes, Seville) indicates the direction his art would take in the future. It has been suggested that Valdés made a trip to Madrid in 1655, where he came into contact with the work of the painters of the Madrid school and was also able to absorb the lessons of Titian and Rubens, masters who were particularly well represented in the royal collection.[2] This contact would have reinforced native tendencies toward painterliness and colorism that were part of his Sevillian heritage from Roelas (ca. 1558/60–1625).

The paintings done ca. 1655–56 and in 1658 for the Shod Carmelite Church in Córdoba (still *in situ*), particularly the *Ascension of Elijah* and *Elijah and the Angel*, already show his fully developed style. The free, almost erratic brushwork and draftsmanship, and the

feverish agitation of the forms in these works present us with the most passionate and emotionally high-pitched side of his art.

Valdés remained in Córdoba until 1656, but that year he returned to work in his native city, where he would reside until his death. The two cycles commissioned from him by the monastery of San Jerónimo de Buena Vista, executed in 1656–57, may have provided the reason for this move. They immediately established Valdés as one of the leading painters in Seville. The canvases of the Life of St. Jerome clearly express his highly dramatic and energetic style, and are executed with the brio that characterizes his mature works. The rapid, sketchy execution, shrill colors, and shimmering light combine with violent gestures and swirling draperies to create works of enormous expressive intensity and visual dynamism. The series of single figures of Hieronymite personalities painted for the sacristy of the convent is done in a more restrained vein, but also has characterizations of great expressive force.

In 1660 Valdés Leal participated with Murillo in the foundation of the drawing academy in Seville. Three years later he would become its president, a post he held until 1666 (with a possible interruption in 1664 for a trip to Madrid). Palomino's reports on Valdés's character indicate that he was proud to excess, jealous of competitors, and capable of towering rages when provoked. This appraisal of his personality must be tempered by the evidence of the esteem in which he was held by his fellow artists, which was demonstrated by his election to the presidency of the drawing academy and as examiner and steward of the Guild of St. Luke.

Valdés had been attracted to the *vanitas* theme as early as the mid-1650s (see the *Vanitas* in the Uffizi), probably under the influence of Pereda (1611–78), and in 1660 he produced the pendants at Hartford (*Allegory of Vanity*, Cat. no. 44) and York (*Allegory of the Crown of Life*). When Don Miguel Mañara decided to incorporate allegorical pieces on this theme into the decoration of the chapel of the Hospital de la Caridad, the bulk of which was entrusted to Murillo, it is not strange that he should have turned to Valdés as particularly suited for interpreting his thoughts on life and death as expressed in his *Discourse on Truth* of 1671. Valdés executed the two large *Hieroglyphs of Death and Salvation* for the Caridad; *In Ictu Oculi* (fig. 31)

and *Finis Gloriae Mundi*, in 1672. These allegories, carried out with the most gruesome realism, have been since then the most consistently admired works from his brush and his main source of fame as an artist.

The works of Valdés Leal from the late 1650s through the early 1670s show his style at the peak of his career. The paintings of this period (Cat. nos. 42, 43, and 45) are characterized by a nervous, sometimes violent brushstroke, strident and boldly combined colors, an eerie, flickering light, and a lack of concern for proper drawing or formal beauty, which are always sacrificed to expressiveness and emotional intensity. Valdés is an eccentric and often uneven artist, but his best canvases, fervent and dramatic to a rare degree in Sevillian art, are highly original and fascinating works.

Valdés fell prey to a debilitating disease around 1682, and his painter son Lucas, born in 1661, began to play an increasingly larger role in his father's commissions from that point on. By 1689 it was clear that he was too weak to work. On October 9, 1690, he made his will, and he died within the week. He was buried on October 15. In spite of his steady output of paintings and substantial clientele, and of his additional work as a gilder of bronze and painter of polychromed sculpture, Valdés died leaving an even more meager estate than Murillo. N.A.M.

NOTES

1. Duncan Kinkead, *Juan de Valdés Leal (1622–1690). His Life and Work* (London and New York, 1978), pp. 3, 22–25.
2. Ibid., pp. 79–82.

42. *Annunciation to Joachim*

Oil on canvas; 146 × 209 cm. (57⅝ × 82¼ in.)

Provenance Marqués del Llano, Spain.

Private collection, New York.

The story of the parents of the Virgin, Joachim and Anna, is told in *The Golden Legend* by Jacobus de Voragine, who took it in turn from the apocryphal literature of early Christianity.

During the feast of the Purification, Joachim, a rich man, is rebuked and turned away from the Temple of Jerusalem for his childlessness after twenty years of

marriage. Ashamed of returning home, he goes instead to stay with his shepherds in the fields. While he is there, an angel appears to him and foretells that Anna shall conceive and that the child will be the mother of Jesus. As a sign, Joachim is to go to the Golden Gate, where he will meet Anna. Anna receives a similar message, the couple meet at the appointed place, and they embrace with joy. From that moment on, Anna is with child.

Our painting depicts the moment of the appearance of Gabriel to Joachim and, as a secondary episode, the meeting at the Golden Gate. Joachim sits on an outcropping under a tree, looking up with a gesture of surprise at the angel Gabriel, who hovers above him. Gabriel seems to be beckoning Joachim to rise and walk in the direction of the Golden Gate, seen in the distance to the right. Joachim, richly dressed and wearing a turban, has a shepherd's crook in his right hand; behind him, to the left, are two shepherds with their dog and a flock of sheep. Outside the Golden Gate, beyond which rise the buildings of Jerusalem, Joachim is seen again at a later point in the narrative, embracing his wife Anna.

The representation of the *Annunciation to Joachim* is rare in art after the sixteenth century, and then it is retained exclusively in Spain. This is one more indication of the Immaculist zeal in seventeenth-century Spain since, according to the doctrine of the Immaculate Conception, Anna conceived like the Virgin Mary herself, *sine macula*. The painting of a subject concerning Mary's conception by Anna "without concupiscence" is a further reaffirmation of the belief in the Virgin's freedom from taint.

This previously unpublished work is thoroughly characteristic of Valdés Leal's painting of the second half of the 1650s, comparable in quality, style, and technique to his paintings for the Shod Carmelites of Córdoba of 1655–58 and to the cycle for San Jerónimo de Buena Vista of 1656–57. A date of ca. 1656–60 is suggested here as most likely, after Valdés's return to Seville.

The *Annunciation to Joachim* shows Valdés Leal at his best, in full command of his resources as an artist. The brilliantly clad Gabriel, in pink and vivid carmine, shines joyfully against the cloudy sky, while Joachim's darker garments play up his somber mood; his understanding hasn't grasped the meaning of the angel's announcement yet and he gestures broadly with his left

hand in a questioning manner, his face still mirroring his recent distress.

The landscape here is particularly beautiful, Valdés's lively and sketchy brushwork giving a lush and soft rendering of nature that makes it as engaging visually as the figures that inhabit it. As in the paintings done for the Shod Carmelite church in Córdoba, here too the landscape plays a very significant role in the total composition, and, in this case, contributes greatly to its sensuous appeal. N. A. M.

43. *Assumption of the Virgin*

Oil on canvas; 215 × 156 cm. (84 × 61 in.)
Signed in middle foreground with interlaced letters:
BALDES LEAL

Provenance Mme L. Carcano, Paris; Galerie Georges Petit, Paris, 1912; Dr. Carvalho, Château de Villandry; Rosenberg and Stiebel, New York; Kress Collection, 1955.

Literature Gestoso, 1916, p. 208; Loga, 1923, p. 356; Trapier, 1960, p. 48; Kinkead, 1978, pp. 184–186 and Cat. no. 101.

National Gallery of Art, Washington, D.C., Samuel H. Kress Collection (1409).

There is no scriptural foundation for the belief in Mary's bodily ascension to Heaven, carried by angels, three days after her death. The story of the Assumption of the Virgin originated in the apocryphal literature of the third and fourth centuries, but it was with its retelling in *The Golden Legend*, in the thirteenth century, that it became an important devotional theme in Christian art. It was particularly popular in the Baroque period, when it assumed a form derived principally from Titian's grand statement of the subject in his Frari altarpiece of 1518, and from Correggio's dome fresco in the cathedral of Parma of 1526–28.

The Washington *Assumption* depicts the Virgin borne aloft by three angels, her arms outstretched as she looks up in rapture. Music-playing angels and cherubs accompany her in her ascent. Below, at some distance, is the empty sarcophagus surrounded by the apostles, who look down into it or up toward Heaven. In the foreground the half-length figures of Peter and John, detached from the rest of the group, look up in awe at the soaring Virgin.[1]

The work under discussion has been dated both ca. 1659[2] and the late 1660s,[3] and in all cases a connection has been made with the style of the Madrid school and of Herrera the Younger in particular. Many features of the *Assumption* are frankly related to works by Francisco Herrera the Younger (1622–85) painted in the mid-1650s, and it can be argued that it was the immediate impact of these works on Valdés that influenced him so powerfully when painting this canvas. If Valdés was in Madrid in 1655, as Kinkead himself suggests, he would then have seen Herrera's *Apotheosis of St. Hermengild* (fig. 7), installed the previous year with a literal fanfare in the Church of the Unshod Carmelites.[4] Soon after, Herrera went to Seville for a few years, before returning permanently to the court, and there he produced two important works for the cathedral, the *Holy Sacrament Adored by Fathers of the Church* (1656) and the *Apotheosis of St. Francis* (1657). The latter, at least, was prominently displayed right in the heart of Seville, and, given its novel and exuberant Baroque style, must have made a deep impression on an artist whose own tendencies also moved in that direction.

Although a dating of around 1659 seems persuasive to the present author for the reasons given above, it may be, as Kinkead argues, that the Herrerism of the *Assumption* is the effect of renewed exposure to that artist's works. Valdés Leal's visit to Madrid in 1664 and the first public display in Seville the following year of Herrera's *Holy Sacrament Adored by Fathers of the Church* may have sparked in our painter a new interest in Herrera's art.

There is little doubt, whatever the reason for it, that the Washington *Assumption* is strongly indebted to his contemporary's work. All three of Herrera's works were known to Valdés when he undertook his *Assumption*, whether around 1659 or in the late 1660s, and their imprint is clearly seen on its style, compositional devices, coloration, and technique.

There are strong links in the Washington *Assumption* to Juan del Castillo's rather insipid version of this subject of ca. 1636, in the Museo Provincial de Bellas Artes, Seville, and the direct borrowing of one specific detail — the apostle striding to the tomb to peer inside it — from Rubens's Antwerp *Assumption* of 1626 suggests that Valdés also studied the prints after the Flemish master's various compositions on this theme.[5] The main inspiration for the Washington *Assump-*

tion, nevertheless, comes from Herrera. The light and predominantly blue coloration of the picture, the pearly, cool flesh tints, the chalky tones of the musical angels, and the extremely loose facture of Valdés's painting are closely related to Herrera's works. The backlighted figures which act as *repoussoirs* in the corner of the painting, cut off by the frame, appear in all three of Herrera's canvases, the Franciscan monk in the cathedral's *Apotheosis of St. Francis* being particularly close in pose to the St. Peter in the *Assumption*. The spatial relations of the larger figures in the *Assumption*, which are somewhat odd and ambiguous, are similar to those in the *St. Hermengild*, as is the disturbing proximity of these figures (seen in a strong *di sotto in sù*) to the picture plane and the observer. These parallels are very striking and indicate a deliberate absorption of pictorial ideas from Herrera. This strong degree of influence from his fellow artist's work, however, was short-lived and represents only an isolated episode in Valdés's development.

Although Valdés Leal's *Assumption* is quite a beautiful painting, its somewhat awkward composition and the implausible spatial relationships between its three major figural groups illustrate the unevenness that often marks his work. The group of apostles gathered about the tomb are placed at such a distance behind the ascending Virgin that their upward glances can in no way connect to her. That very distance also makes her still low position with respect to the ground appear unwarranted. St. Peter and, most particularly, St. John are so arranged in front of Mary that with their heads and eyes turned in the direction shown, they cannot possibly see her. Such carelessness in establishing spatial coherence between figures is not present in his models, although in the *St. Hermengild* Herrera has resorted to painting the corner figures performing extraordinary contortions to ensure their connection to the rising saint. Valdés's composition is altogether too compressed and crowded, and this lack of spaciousness detracts to some degree from the free, soaring effect achieved by Herrera in his two *Apotheoses*. N.A.M.

NOTES

1. For a discussion of a preliminary sketch for this composition, see Kinkead, *Valdés Leal*, Cat. no. 101s and pp. 184–185.
2. Kubler and Soria, *Art and Architecture*, p. 294.
3. Kinkead, *Valdés Leal*, ca. 1666–67, Cat. no. 101 and

pp. 184–186; see Trapier, *Valdés Leal. Spanish Baroque Painter* (New York, 1960), pp. 46–48, after 1669.

4. See above, Sullivan's introduction to the Madrid school, in this catalogue.

5. Kinkead, *Valdés Leal*, p. 186.

44. *Allegory of Vanity*

Oil on canvas; 130.7 × 99.4 cm. (51⅞ × 39⅛ in.)

Provenance Mr. Wellcome (?), London; The Spanish Art Gallery, London, 1938; Durlacher Bros., New York, 1938.

Literature Borenius, 1938, pp. 146–151; Kubler and Soria, 1969, p. 293; Trapier, 1960, pp. 30–32, 54; Gállego, 1968, pp. 201–202; Kinkead, 1978, pp. 80–81 and Cat. no. 82.

The Wadsworth Atheneum, Hartford, Connecticut, the Ella Gallup Sumner and Mary Catlin Sumner Collection (1939.70).

The Wadsworth Atheneum *Vanitas* has been known to us only since 1938, but it has become since then one of Valdés's most famous works, both for its visual beauty and for the fascination exerted by the theme.

The painting presents a dense pile of objects on a table, symbolic of the vanities of life, a cherub blowing bubbles, and an angel uncovering a painting of the Last Judgment, to which he points as he looks out at us. The objects depicted are all characteristic elements of *vanitas* compositions of the seventeenth century: the soap bubbles, skull, watch, fading flowers, and smoking candle symbolize the fleeting nature of life; the playing cards and dice, the miniature portrait of a woman, the casket overflowing with jewels, the coins, the crown and scepter, cardinal's hat, bishop's miter, and papal tiara typify the temptations of pleasure, wealth, and power; the laurel wreath, the books (treatises on painting, architecture, agriculture, anatomy, geography), the dividers, triangle, ruler and armillary sphere stand for the vanity of loftier ambitions, such as artistic and intellectual achievements and fame.

Above this compendium of temporal temptations and signs of our mortality is the painting-within-a-painting of the Last Judgment, revealed to us by the pointing angel as the final destination of mankind, the event that is for all eternity. The moral lesson is brought home most vividly, and not least by the contrast between the chaotic array of objects in the foreground and the dia-

grammatic order of a Last Judgment composition such as the one painted here.

The *Vanitas* was painted as one of a pair with the *Allegory of the Crown of Life*, in the City Art Gallery, York. The York painting represents a man holding a rosary, deeply immersed in the reading of a large book. More volumes, identifiable as religious and edifying texts, cover the table on which one also sees the lilies of chastity and the knotted scourges that denote mortification of the flesh. Behind the young man stands an angel holding a triple hourglass and pointing up to a floating golden crown with the inscription QUAM REPROMISIT DEUS. On the back wall is another painting-within-a-painting, a Crucifixion. The composition is orderly and a great deal less cluttered than that of the *Vanitas*.

The *Allegory of the Crown of Life* alludes to the promise of eternal life and the road to it through faith, devotion, and sacrifice. Our *Vanitas* presents the obstacles placed on the path to salvation and reminds us of the final retribution for our sins.

The Wadsworth Atheneum painting is one of the most attractive works by Valdés Leal, both coloristically and for its refinement and liveliness of execution; it literally seems to glow with rich and delicate colors, and to sparkle with the finest brushwork to be seen in his entire production. The artist has lavished special care in the rendering of detail and in bringing out the sensuous appeal of the objects represented. In contrast, the *Allegory* is darker and colder, as if to express by painterly means the sensual deprivation entailed by the difficult path of virtue. The pendants present an intentional contrast between sensuously appealing profusion and disorder, and somber, severe starkness and order, offering the viewer the choice and consequences of each alternative. N. A. M.

45. *Annunciation*

Oil on canvas; 107.3 × 78.3 cm. (42½ × 31 in.)
Signed and dated at lower right: *Jū de baldes Leal / Faciebat A 1661*

Provenance Dr. Carvalho, Château de Villandry; Rosenberg and Stiebel, New York.

Literature Trapier, 1960, p. 28; Indianapolis, 1963, Cat. no. 77; Wethey, 1963, pp. 207–208; Ann Arbor, 1979, no. 44; Kinkead, 1978, pp. 165–166 and Cat. no. 88.

The University of Michigan Museum of Art, Ann Arbor (1962/1.99).

Valdés Leal's treatment of the *Annunciation* (Luke 1:24–38) follows a centuries-old artistic tradition in which the scriptural passage is elaborated to correspond to its description in *The Golden Legend* and in the writings of St. Bernard. The Virgin is seated at a *prie-dieu*, with the Old Testament opened to the Book of Isaiah, and she responds to Gabriel's sudden apparition and announcement with a movement of troubled surprise and modesty. Behind her, on a balustrade, rests a glass vase with the lilies of purity and in front, to her right, is a basket of needlework, a reference to her weaving the priests' vestments as a child in the Temple. God the Father, almost dissolved in the light of his own radiance, sends forth toward the Virgin's womb the dove of the Holy Spirit, flanked by banks of clouds and cherubs. Gabriel, still aloft, rushes toward the Virgin, holding in his left hand a scepter with a scroll twisting around it and pointing to the Holy Spirit with his right.[1]

The Ann Arbor *Annunciation* is an excellent example of the exuberance of Valdés Leal's mature works. The characteristic agitation of his forms can be seen here not only in the intricately foreshortened cherubs, in the extreme torque of the figure of Gabriel, and in the wild fluttering of his hair and swirling draperies, but even in an inanimate object such as the *prie-dieu*, whose twisting forms echo the contrasted movements of the Virgin's pose.

There is an explosive energy in this composition that is partially the result of the dynamic poses of all the figures and the momentary nature of their actions, but is due also to the highly dramatic treatment of the light. The dove of the Holy Spirit is the incandescent core of a glory of light that cuts through the painting from above and creates stark chiaroscuro contrasts in the darker space below. This miraculous light dances erratically over figures and objects in shimmering splashes, energizing the whole pictorial field.

The technique here is characteristic of the mature Valdés: rapid, vibrant brushstrokes are spontaneously applied with a loaded brush in the highlights, more thinly in the darker areas. The vase of lilies is masterfully suggested by a few strokes of white impasto, and the *contre-jour* effect in the balusters below is also beautifully brought off.

The coloration is vivid, with reds, pinks, mauves,

and greens shining out against the cool grays, but the over-all effect of the painting is nonetheless somewhat somber, as the dark areas predominate.

Valdés Leal's lack of concern for correct anatomical drawing can best be seen here in the figure of Gabriel. His curved right arm and enormous right hand are anatomically impossible but, as in Ottonian illuminations, the distortion and exaggeration of that pointing arm and hand function expressively wonderfully well.

The *Annunciation* represents Valdés's painting at its best: full of energy, dramatic and brilliant in its light and color effects, intense in its rendering of the narrative, and dazzling in its impetuous brushwork. It engages the viewer's sympathetic responses to the religious drama through powerful pictorial and expressive means. N. A. M.

NOTE

1. Usually, the words of Gabriel's greeting: "*Ave Maria gratia plena*," are inscribed in it.

46. *Conversion of St. Augustine by St. Ambrose*

Oil on canvas; 165.5 × 109 cm. (70 × 47½ in.)

Provenance Archbishop's Palace, Seville; probably Maréchal Soult, 1810; Rosenberg and Stiebel, New York.

Literature Ceán Bermúdez, *Diccionario*, 1800, vol. 5, p. 110; Soria, "Valdés Leal's Life of St. Ambrose," unpublished manuscript, 1960, St. Louis Art Museum files; Kinkead, 1978, pp. 236–244 and Cat. no. 112.

St. Louis Art Museum (1:1964).

According to Ceán Bermúdez, in 1673 Valdés Leal was commissioned by Ambrosio Spínola, Archbishop of Seville, to paint a series of the life of St. Ambrose for the archespiscopal palace as well as to paint and gild the oratory where the pictures were to be located.[1] Valdés received 10,000 ducats for the whole job, a sum that, although not negligible, compares poorly with Murillo's remuneration of 1,000 ducats for a large *Virgin and Child* (in the Walker Art Gallery, Liverpool) painted that year for the same oratory.[2]

The St. Ambrose series consisted of several small- and medium-sized paintings, at least seven of which have re-

cently reappeared after being considered lost since the Napoleonic invasion of Spain.[3] In the chronological order of the narrative the first and last pieces (*Bees Touch the Infant Ambrose's Mouth without Doing Harm* and *Bishop Honorius Administers the Sacraments to the Dying St. Ambrose*) are of a smaller format, whereas the remaining five—*St. Ambrose Appointed Governor of Liguria and Aemilia by Emperor Valentinianus*; *St. Ambrose Consecrated Bishop of Milan*; *The Conversion of St. Augustine by St. Ambrose*; *St. Ambrose Refuses Emperor Theodosius Admission to his Church*; and *The Penance of Emperor Theodosius before St. Ambrose*—are of medium size.

The subjects of this series are unusual in Spanish painting; their choice as decorations for the oratory seems to respond to the specific desire of the patron to promote his public image by identifying himself with his name saint. Ambrosio Ignacio Spínola y Guzmán (1632–84), grandson of the Italian general immortalized in the *Surrender of Breda*, in fact had Valdés paint St. Ambrose with his own features, recognizable from a portrait of the Archbishop engraved in 1681.[4]

All the paintings of the series show a considerable number of figures in a large setting, either indoors or outdoors, beyond which other spaces open up. The first subject is the only one that has merely a handful of actors, but shares with the rest a complex and not altogether clear sequence of spaces as the site for the action. The elaborate architectural settings and the caricaturesque, often awkward types in all the paintings of this series are typical features of Valdés Leal's late works.

Our painting depicts St. Ambrose in two separate scenes of a continuous narrative. In the foreground he is shown in animated discussion with St. Augustine, and in the middle ground, baptizing him. According to Jacobus de Voragine's *The Golden Legend*, St. Ambrose, Bishop of Milan, converted St. Augustine by preaching convincingly against the Manichean heresy. Augustine, then thirty years old, was baptized with his son in 386, six months after his arrival in Milan. St. Ambrose's conversion (and subsequent baptizing) of St. Augustine was his most important deed in terms of Church history. As befits the importance of the subject, the present painting is among the most carefully and successfully worked out of the series.

In the conversion scene Ambrose, seated at a table beneath a circular canopy crowned with a statue of Faith, argues with Augustine with evident pleasure. His facial expression and emphatic hand-gesture, as well as those of his opponent, suggest that he has just succeeded in his goal of persuasion. The clerics standing behind the saints also appear pleased by the effect of Ambrose's eloquence,[5] while the two seated men facing Augustine express with broad gestures their surprise at the outcome of the disputation. These two figures are rendered with a very spontaneous, open brushwork, with flickering, separate touches for the highlights. The figures from St. Ambrose to the left are less vividly painted, although their duller appearance seems due in part to abrasion. St. Augustine is the best preserved of this group.

The scene of the baptism, which occupies an elevated, vaulted bay directly behind the foreground space, is painted with a very light and sketchy touch and is pale in color, in contrast to the blacks and vibrant reds and purples of the foreground scene. The contiguous bay to the left opens to a two-story nave, also painted very thinly and in light tones. The architecture of this edifice, which does not conform to any possible church plan, is merely suggestive of an imposing ecclesiastical interior of classical stamp and the spatial relationships between the four areas described are also not to be taken too literally. The impression of an appropriate setting for the action, however, is more convincing than in other paintings of the series. 　　　N. A. M.

NOTES

1. Ceán Bermúdez, *Diccionario*, vol. 5, p. 110.

2. Ibid., 3, p. 62.

3. See Kinkead, *Valdés Leal*, p. 237 and nos. 109–115.

4. This was discovered by Soria and written in an unpublished ms., a copy of which is kept in the files of the St. Louis Art Museum. The engraving by Richard Collin (Brussels, 1681) of Pedro Nuñez Villavicencio's portrait of Ambrosio Spínola can be seen in the New York Public Library and the Biblioteca Nacional, Madrid.

5. These men also appear to be portraits of specific individuals. Something that strikes one immediately as belonging to a portrait is the obvious anachronism of the spectacles (*quevedos*) worn by one of the priests.

47. *Portrait of an Ecclesiastic*

Oil on canvas; 104.1 × 89 cm. (41 × 35 in.)

Provenance William R. Mead.

Literature Brown, "Valdés Leal," 1976, pp. 332, 335, fig. 3.

Mead Art Museum, Amherst College, Amherst, Massachusetts, bequest of William R. Mead, class of 1867 (P. 1936. 25).

A bishop stands before a table on which there are a miter, a staff, an inkwell, and a book. In the background a swag of drapery adds a further touch of luxury to the scene.

This painting was considered to be by an anonymous artist until it was published by Jonathan Brown, who noted the rarity of portraits in the art of Valdés Leal. He pointed out, however, that the "psychological intensity" of the sitter, is similar to the penetrating realism of the figures in many paintings by Valdés.

We know that Valdés Leal worked for Archbishop Ambrosio Spínola. The *Conversion of St. Augustine by St. Ambrose* in the present exhibition (Cat. no. 46) is an example of the product of Spínola's patronage. Nonetheless, it is probably not Spínola who is depicted in this portrait. A comparison between the man represented here and a print of Ambrosio Spínola made

several years before his death in 1684 reveals, according to Brown, a different individual.[1] The Amherst portrait may, in fact, according to Brown, depict Spínola's predecessor, Antonio Cardinal Paíno, who died in 1669 at the age of seventy. Duncan Kinkead, however, doubts the likelihood of this work as representing a Sevillian archbishop.[2]

At the bottom right and left of the painting are two small, rounded shapes. It is likely that they are vestiges of a cartouche which formerly contained certain facts pertaining to the life of the sitter. It is also possible that the portrait formed part of a series of likenesses of ecclesiastics which were often painted for bishops' residences, cathedrals, etc. The cartouche identifying the sitter may have been removed to make the painting more attractive to a potential buyer by concentrating the viewers' entire attention upon the figure himself.

E. I. S.

NOTES

1. The print, by Richard Collin (1681) in the Biblioteca Nacional, Madrid, is published by Brown in "Valdés Leal: Atribuciones y falsas atribuciones," *Archivo Español de Arte*, 49 (1976), fig. 4.

2. In correspondence with the author, Kinkead asserts that "I...can state with assurance that no Sevillian archbishop ever looked like this man."

Plates

NOTE: *Each plate number refers to the corresponding number in the catalogue.*

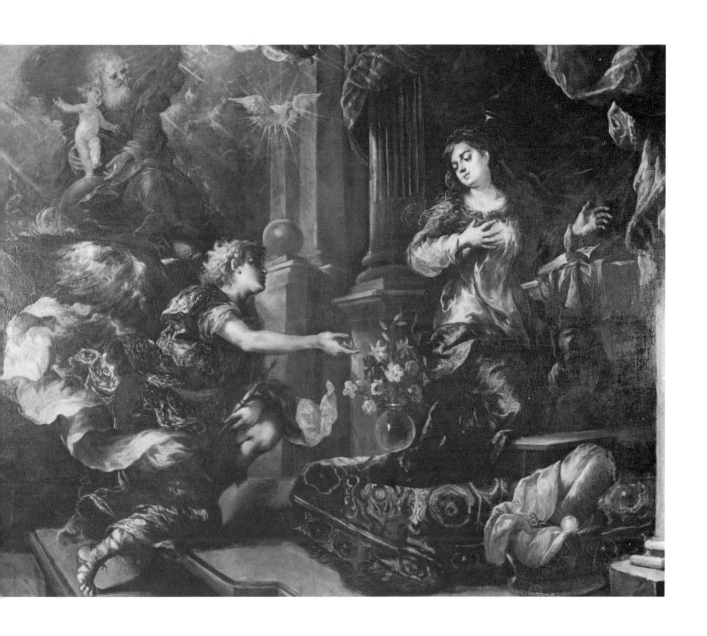

1. Anonymous, *The Annunciation*

2. Juan de Arellano, *A Basket of Flowers*

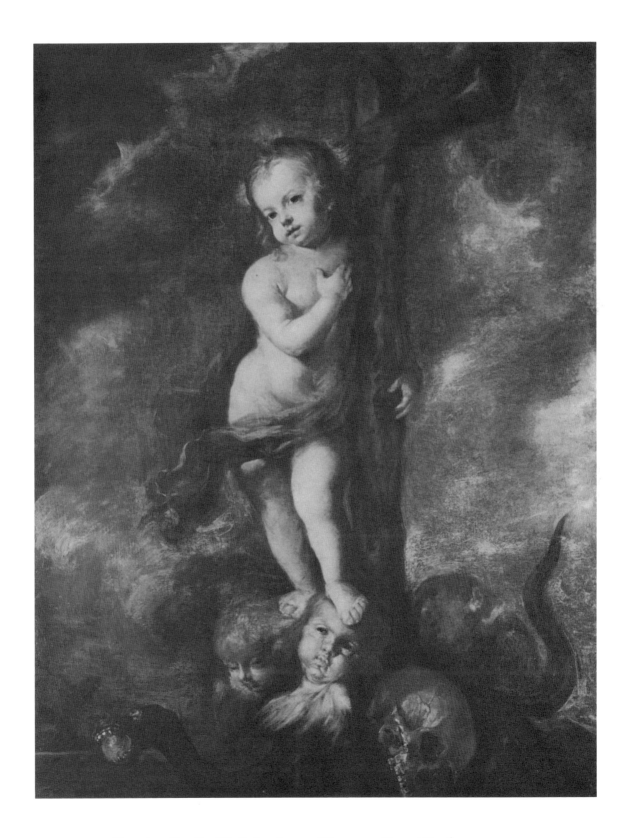

3. Francisco Camilo, *The Infant Jesus as Victor over Sin and Death* 117

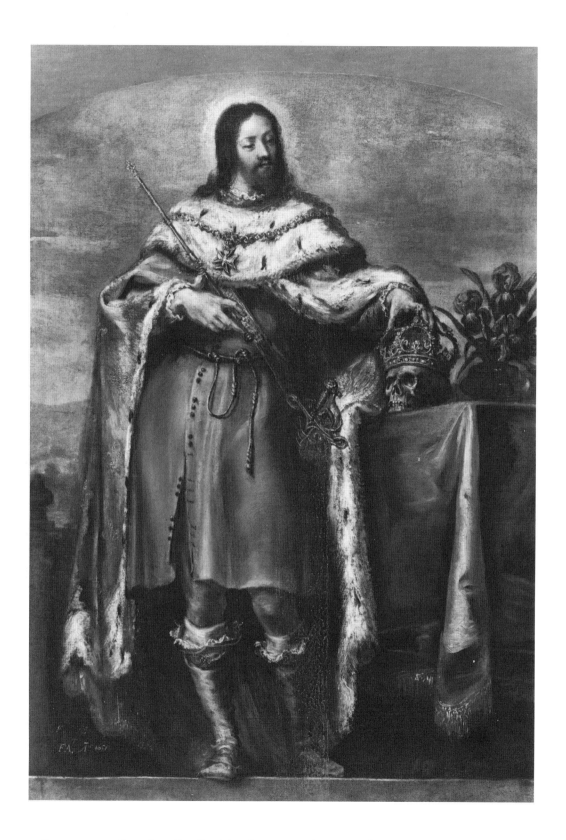

4. Francisco Camilo, *Mors Imperator (St. Louis of France Contemplating a Skull)*

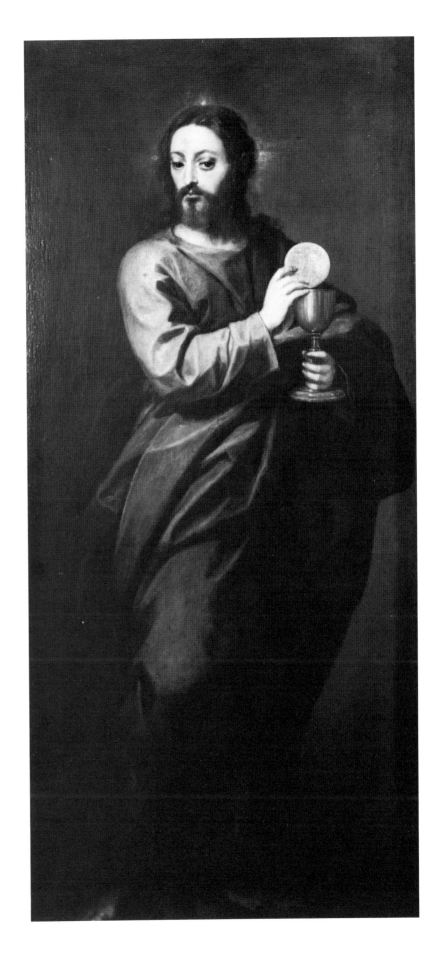

5. Alonso Cano, *Christ the Redeemer*

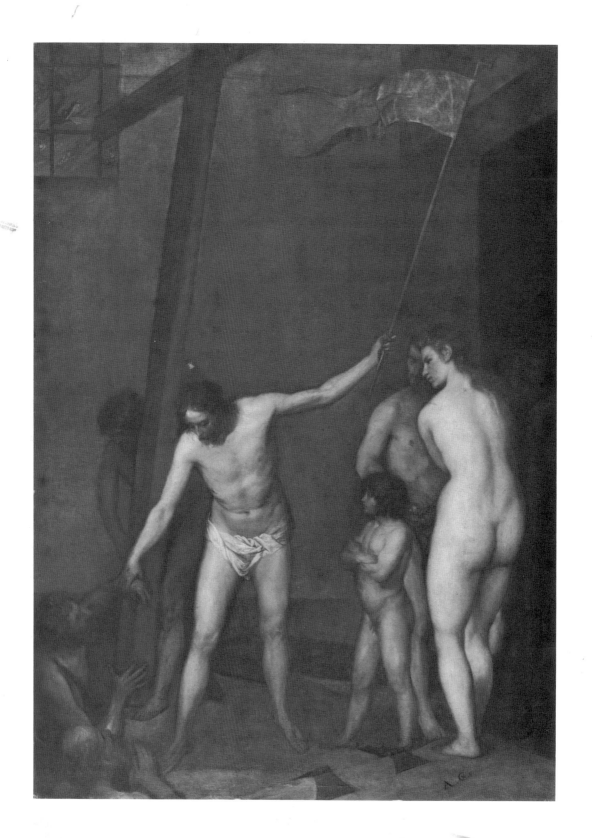

6. Alonso Cano, *Christ in Limbo*

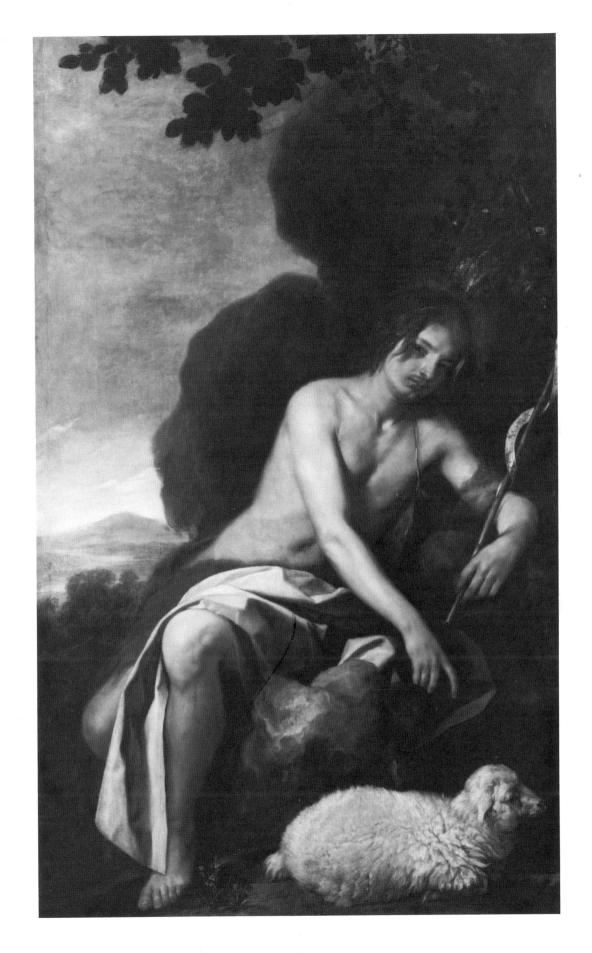

7. Alonso Cano, *St. John the Baptist*

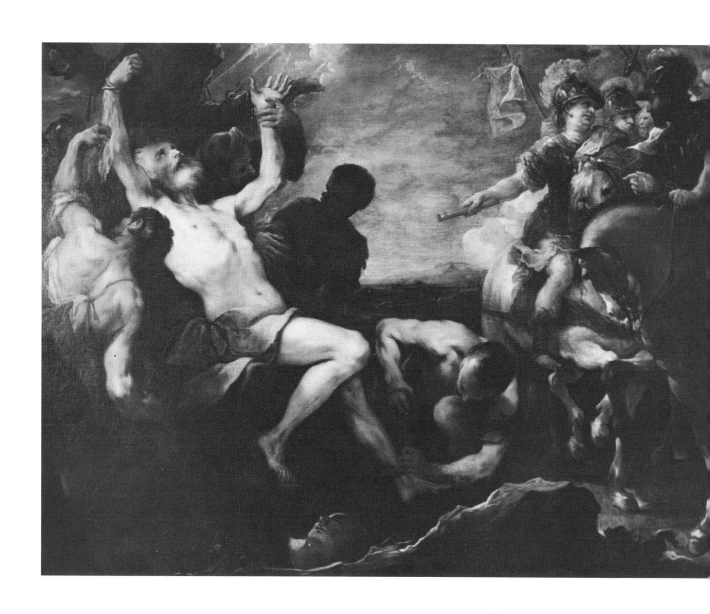

8. Juan Carreño de Miranda, *Flaying of St. Bartholomew*

9. Juan Carreño de Miranda, *Portrait of Doña Mariana de Austria, Queen of Spain* 123

10. Juan Francisco Carrión, *Vanitas*

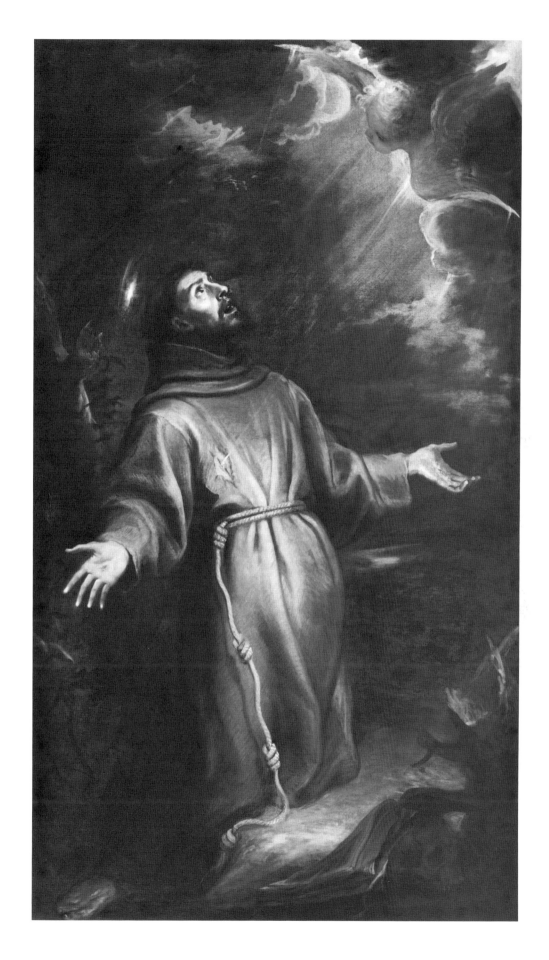

11. Mateo Cerezo, *St. Francis Receiving the Stigmata*

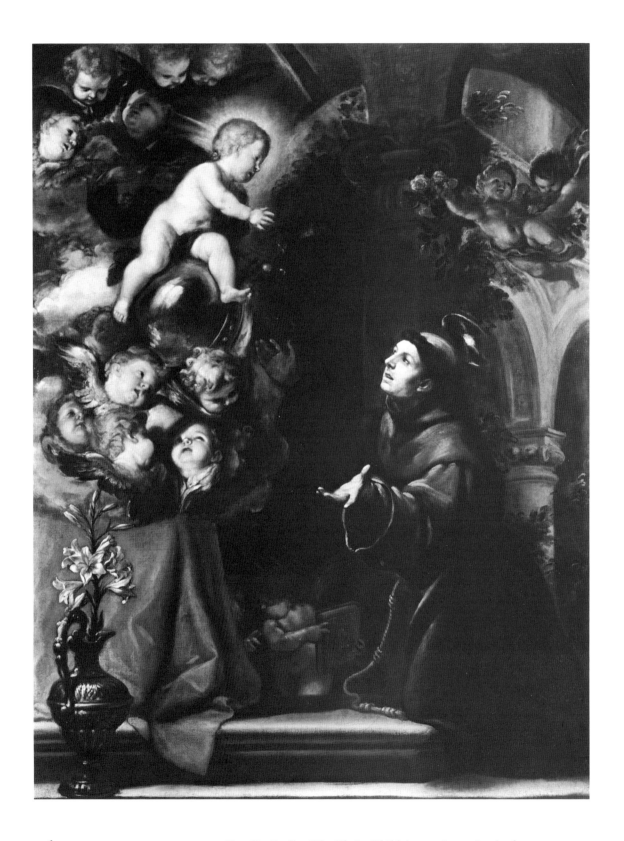

12. Claudio Coello, *The Christ Child Appearing to St. Anthony*

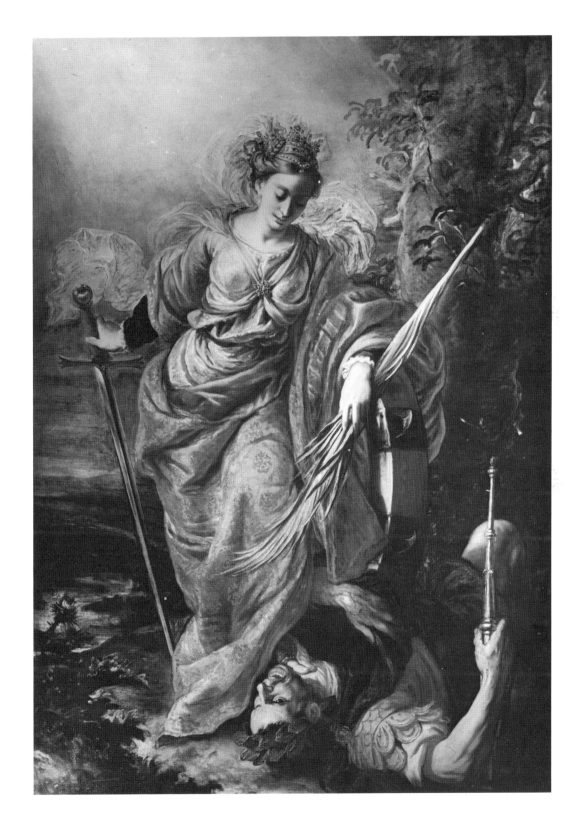

13. Claudio Coello, *St. Catherine of Alexandria Dominating the Emperor Maxentius* 127

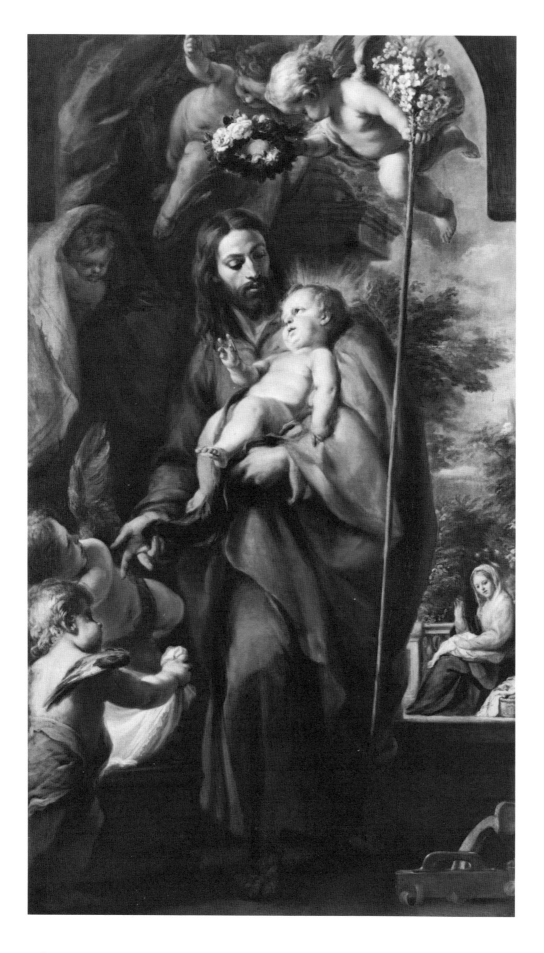

14. Claudio Coello, *St. Joseph and the Christ Child*

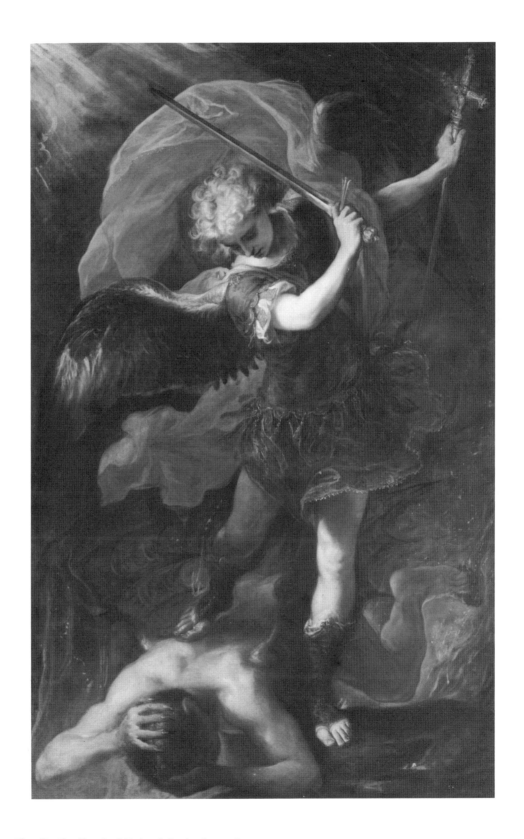

15. Claudio Coello, *St. Michael the Archangel*

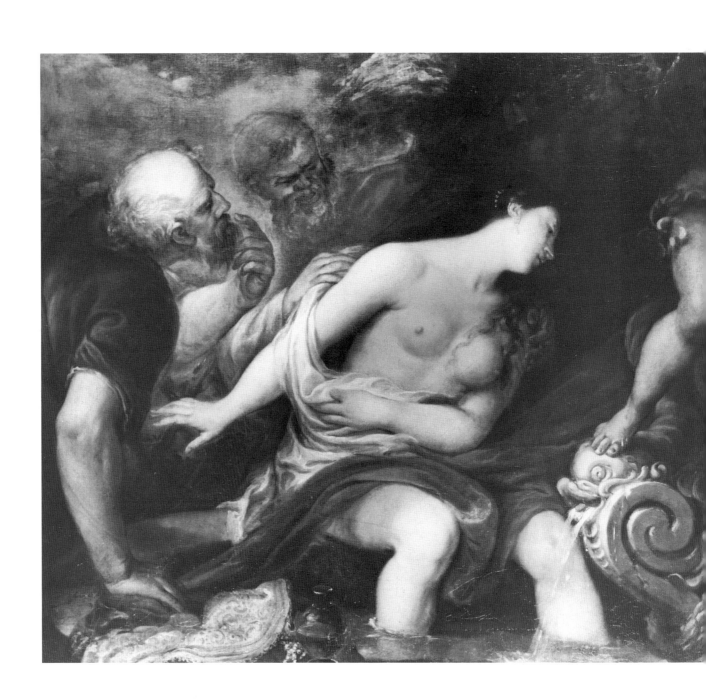

16. Claudio Coello, *Susannah and the Elders*

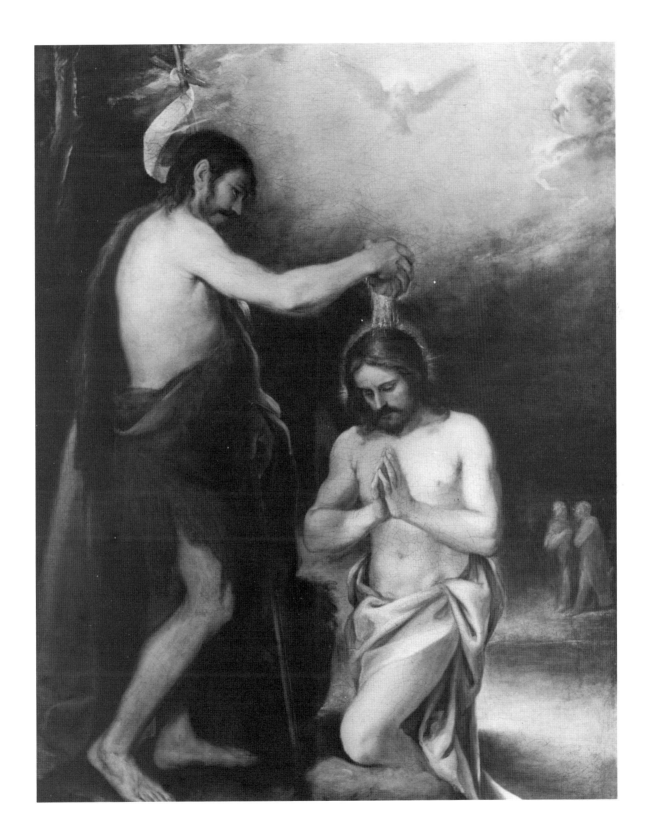

17. Juan Antonio Escalante, *The Baptism of Christ*

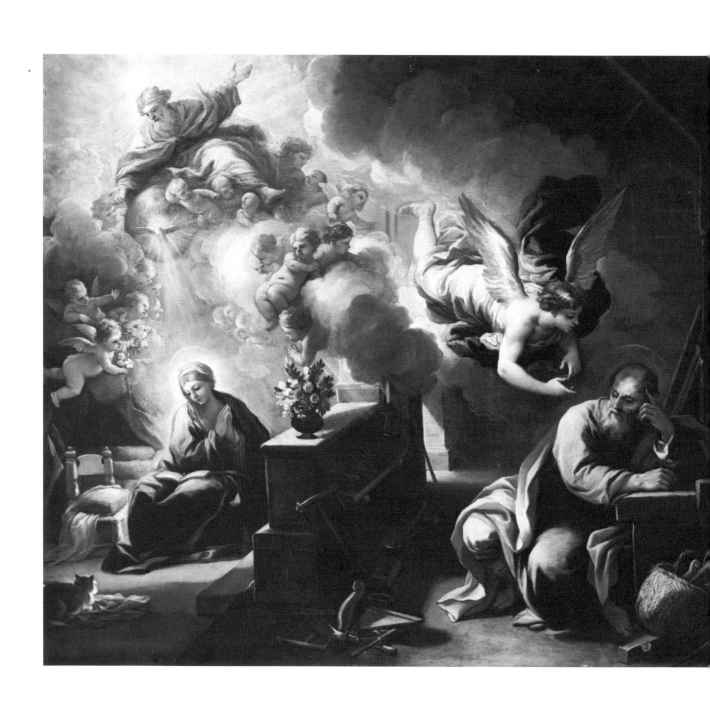

18. Luca Giordano, *The Dream of St. Joseph*

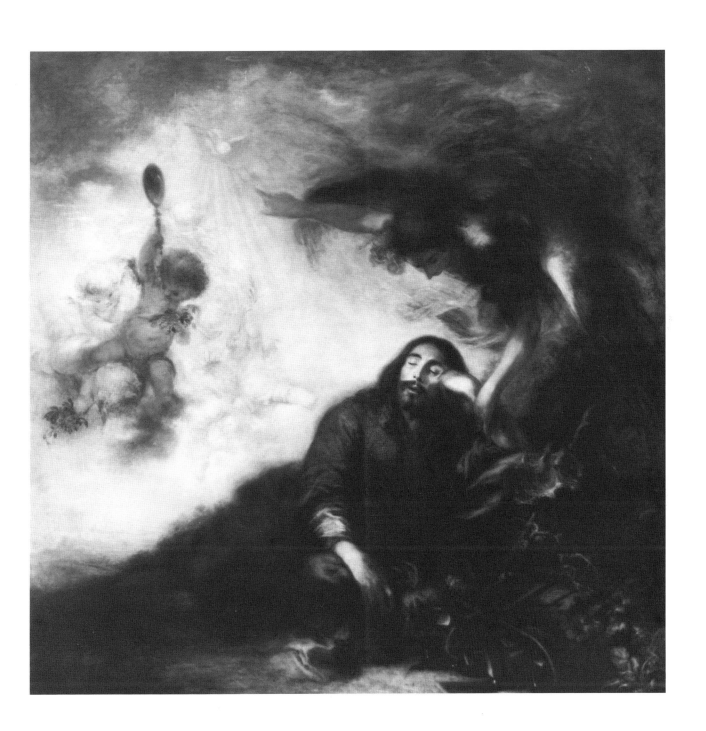

19. Francisco de Herrera the Younger, *The Dream of St. Joseph*

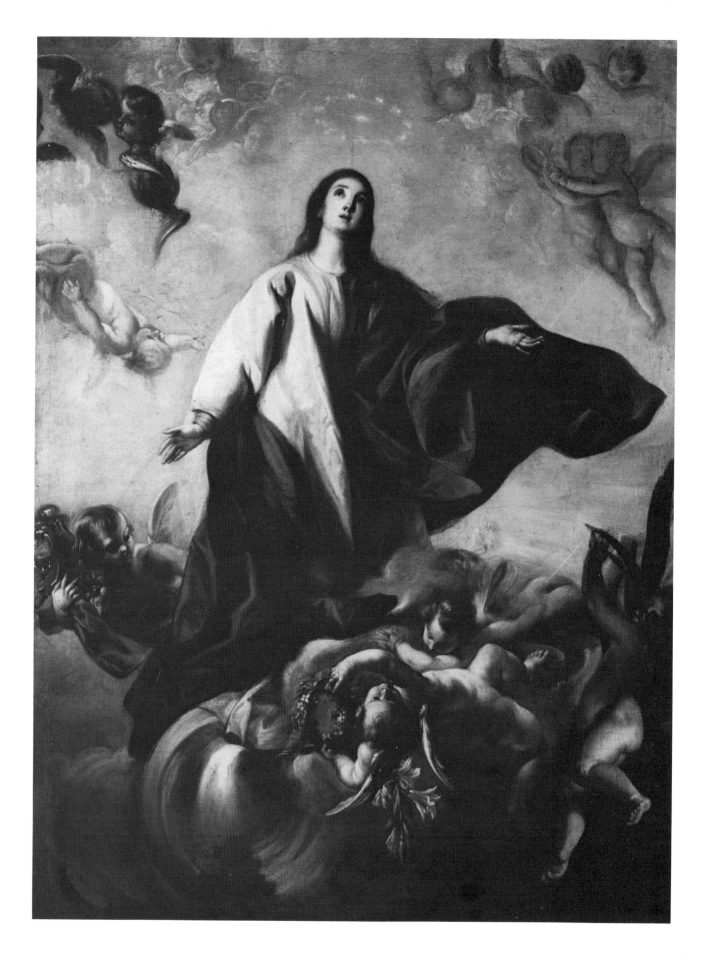

20. Attributed to José Jiménez Donoso, *The Immaculate Conception*

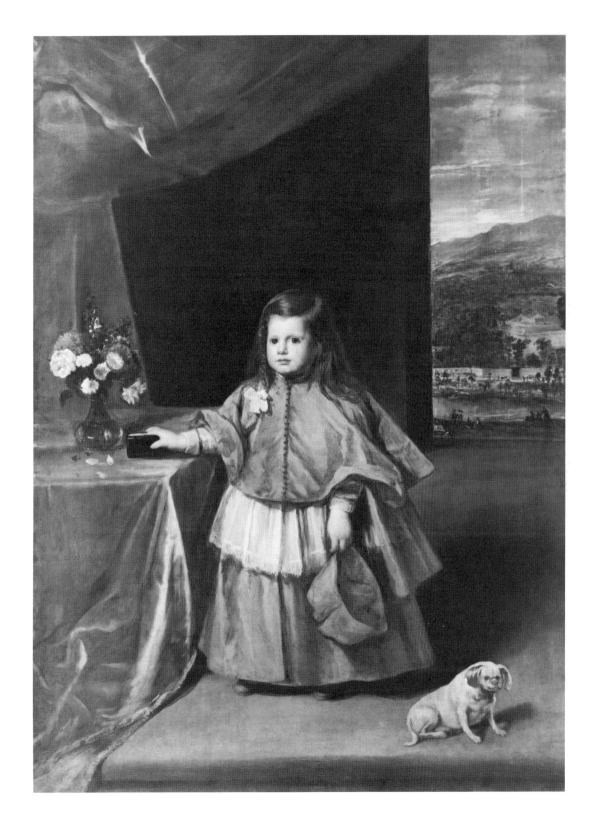

21. Juan Bautista Martínez del Mazo, *A Child in Ecclesiastical Dress* 135

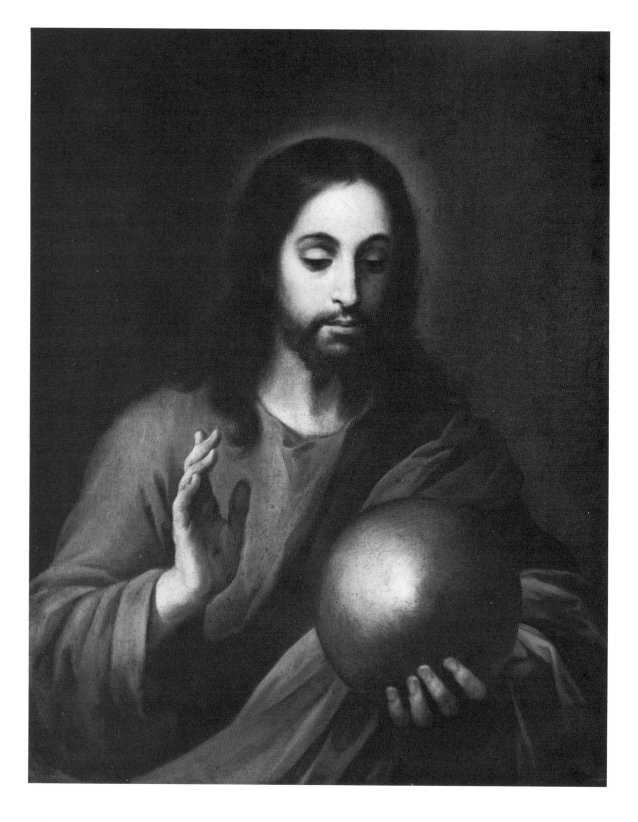

22. Francisco Meneses Osorio, *The Savior of the World*

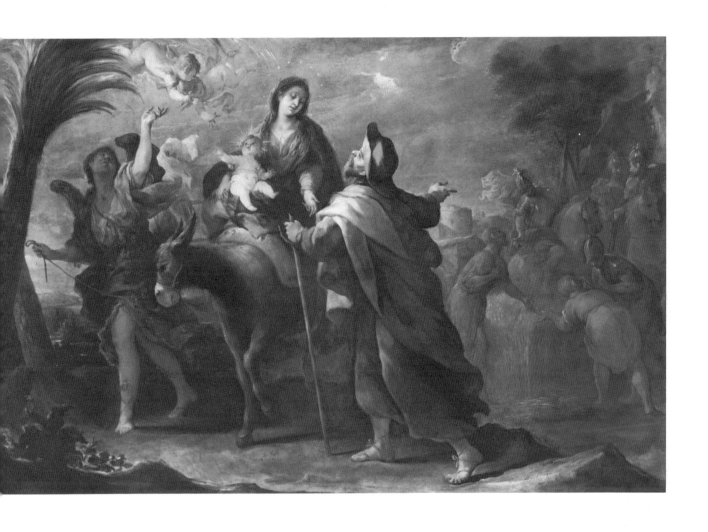

23. José Moreno, *The Flight into Egypt*

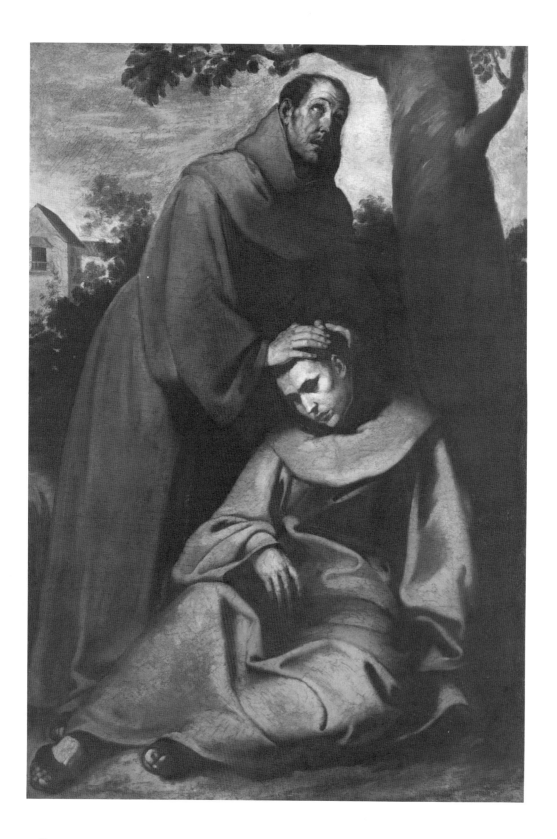

24. Bartolomé Esteban Murillo, *Two Franciscan Monks*

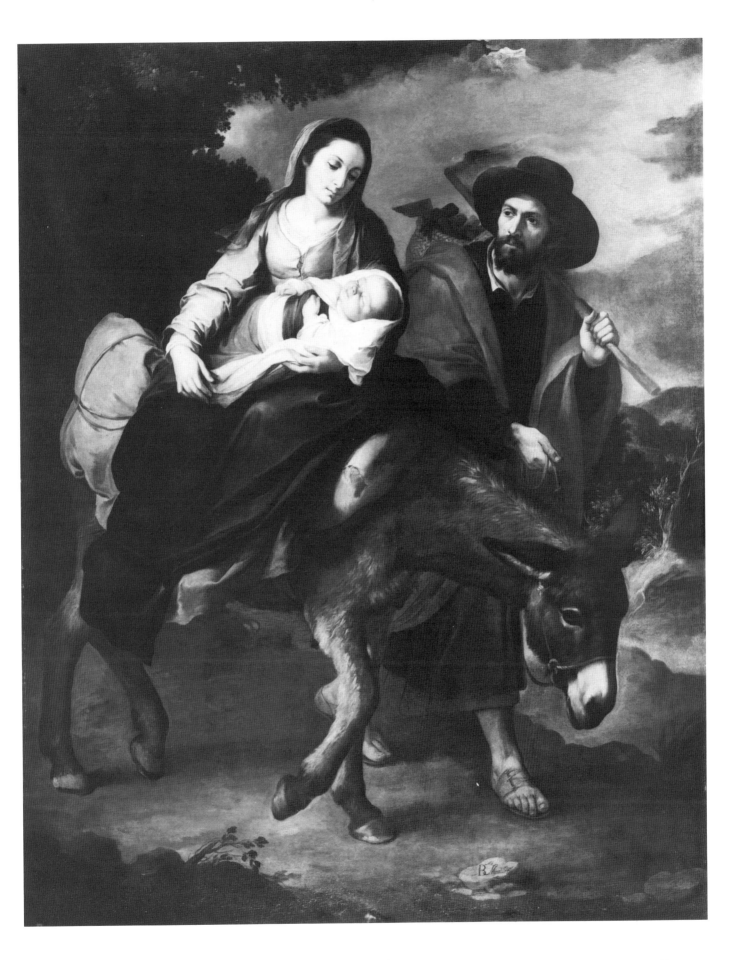

25. Bartolomé Esteban Murillo, *The Flight into Egypt*

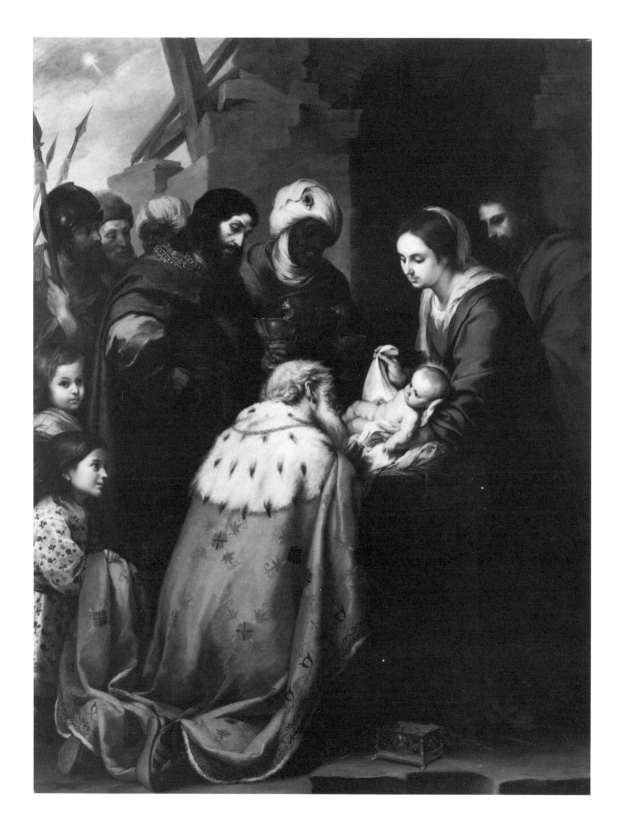

26. Bartolomé Esteban Murillo, *The Adoration of the Magi*

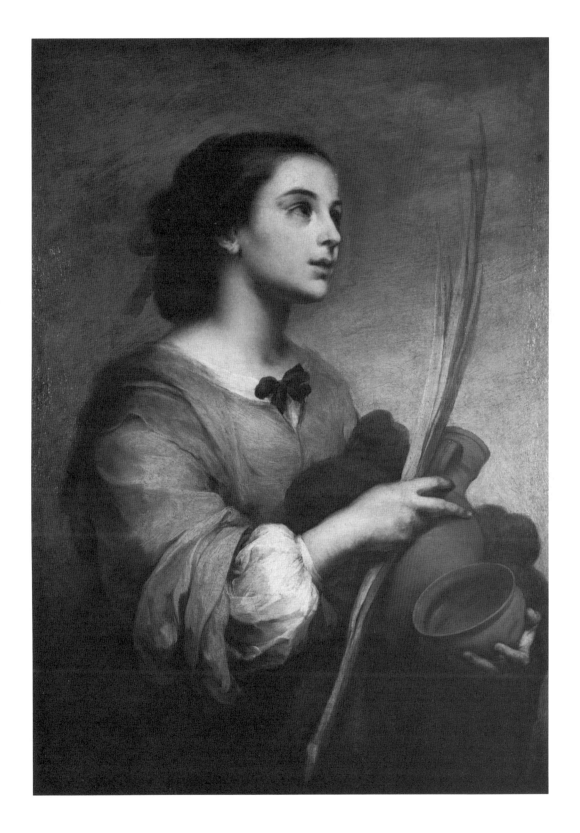

27. Bartolomé Esteban Murillo, *Saint Justa*

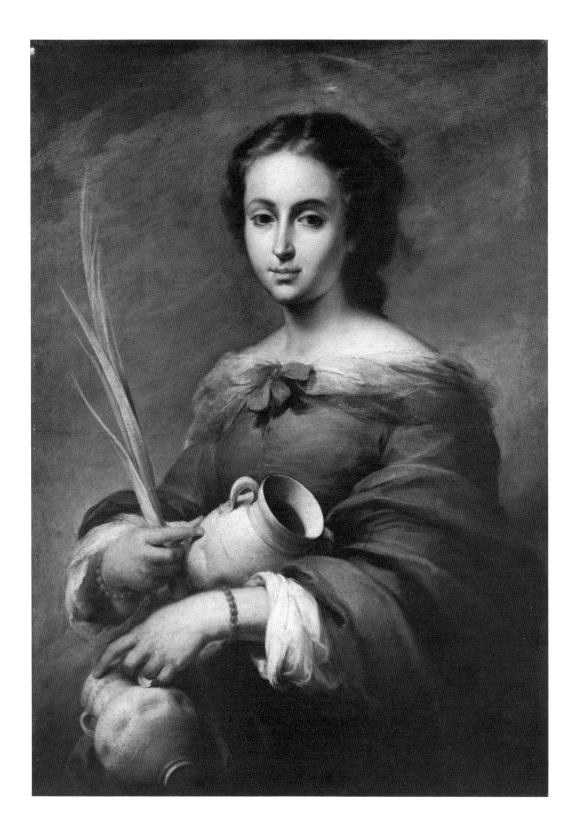

28. Bartolomé Esteban Murillo, *Saint Rufina*

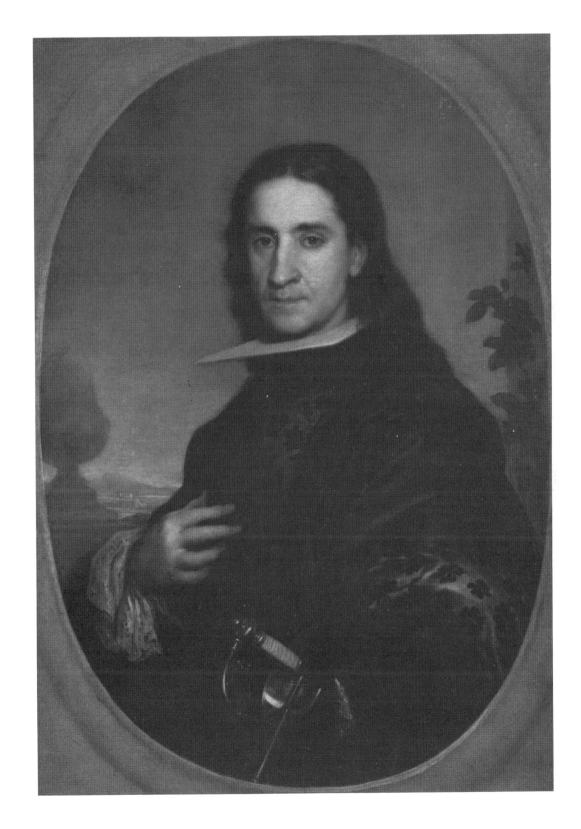

29. Bartolomé Esteban Murillo, *Portrait of a Cavalier* 143

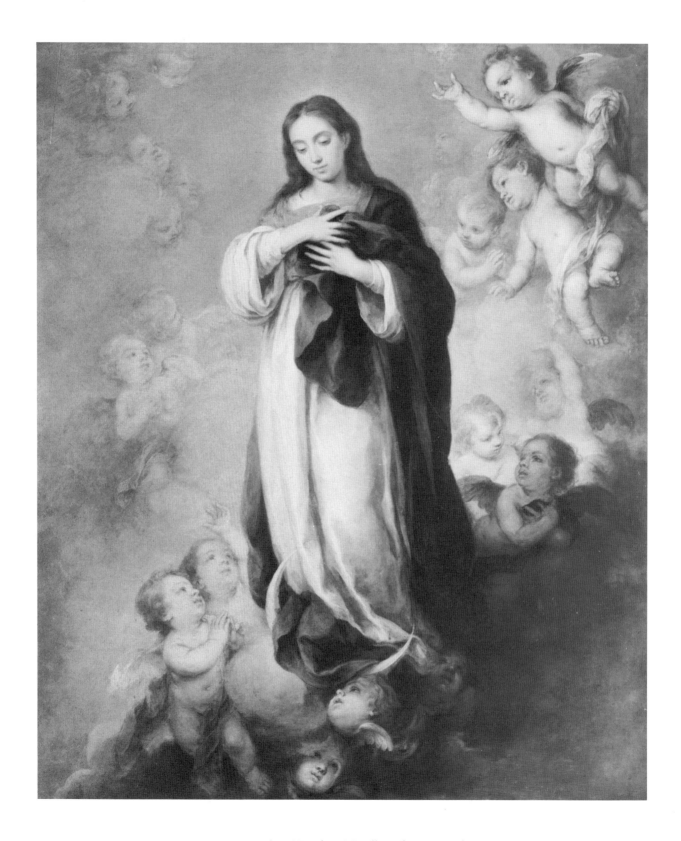

30. Bartolomé Esteban Murillo, *The Immaculate Conception*

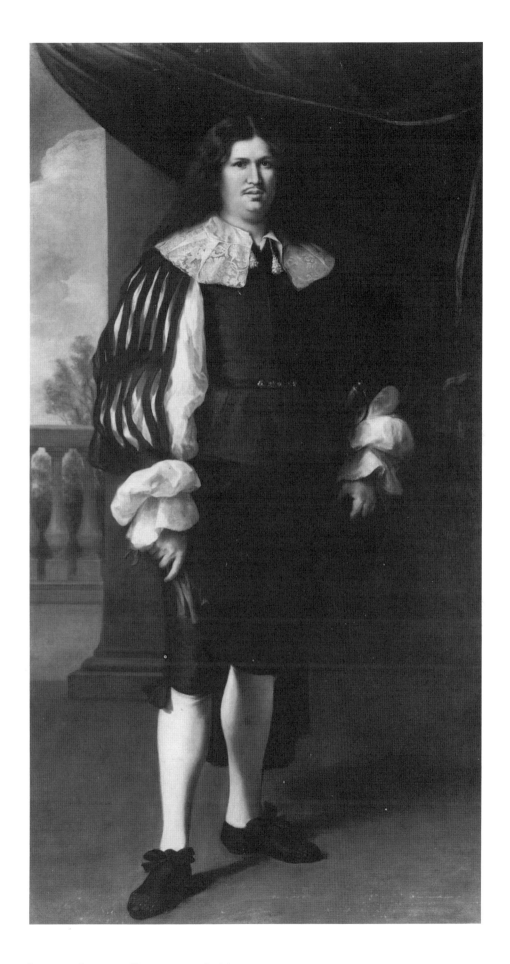

31. Bartolomé Esteban Murillo, *Portrait of a Man*

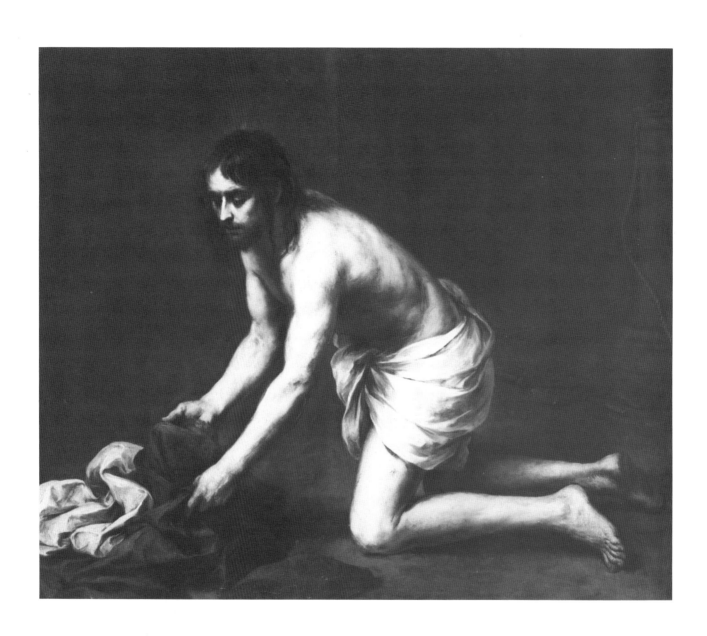

32. Bartolomé Esteban Murillo, *Christ After the Flagellation*

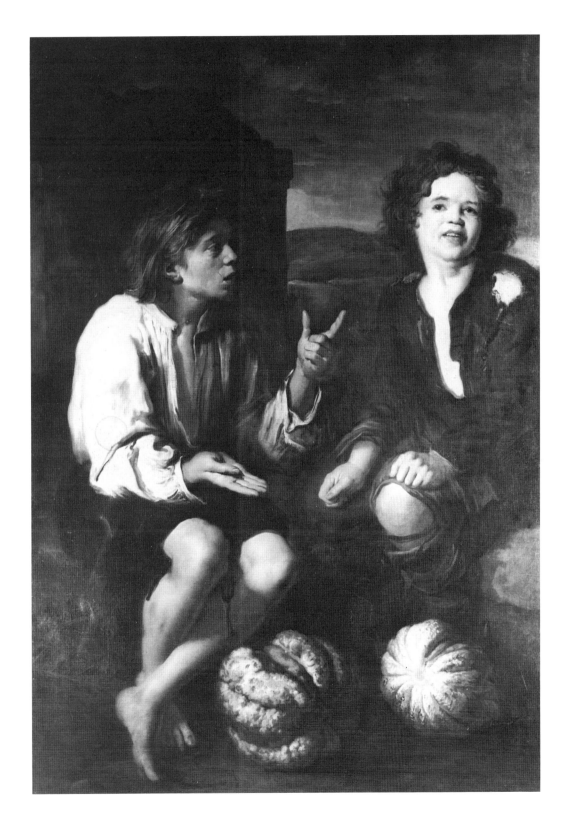

33. Pedro Nuñez de Villavicencio, *Two Boys with Pumpkins* 147

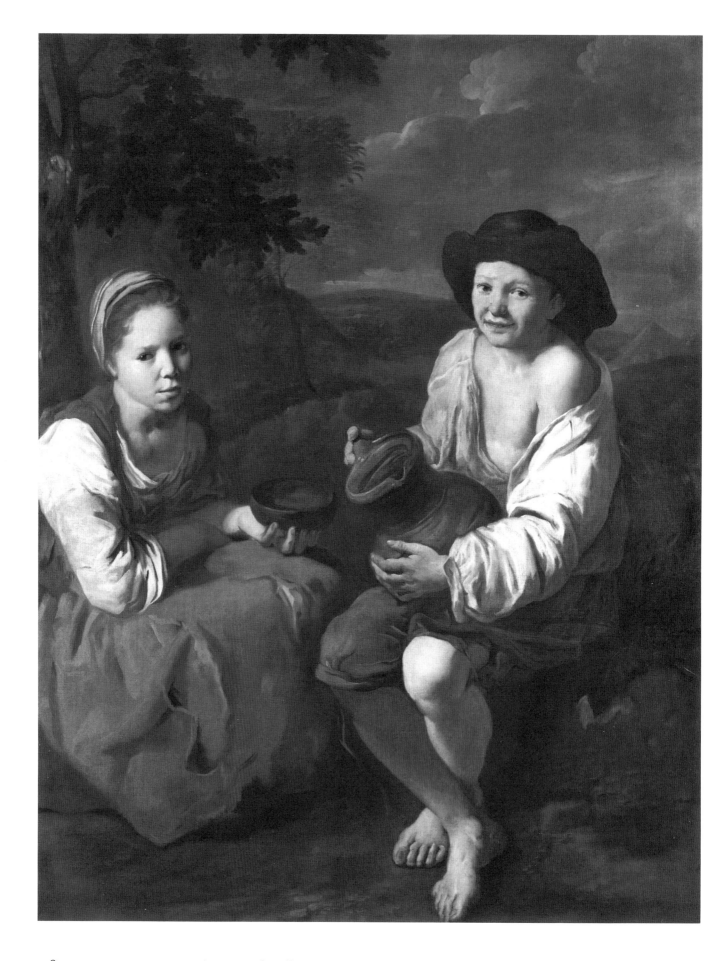

34. Pedro Nuñez de Villavicencio, *Two Peasant Children in a Landscape*

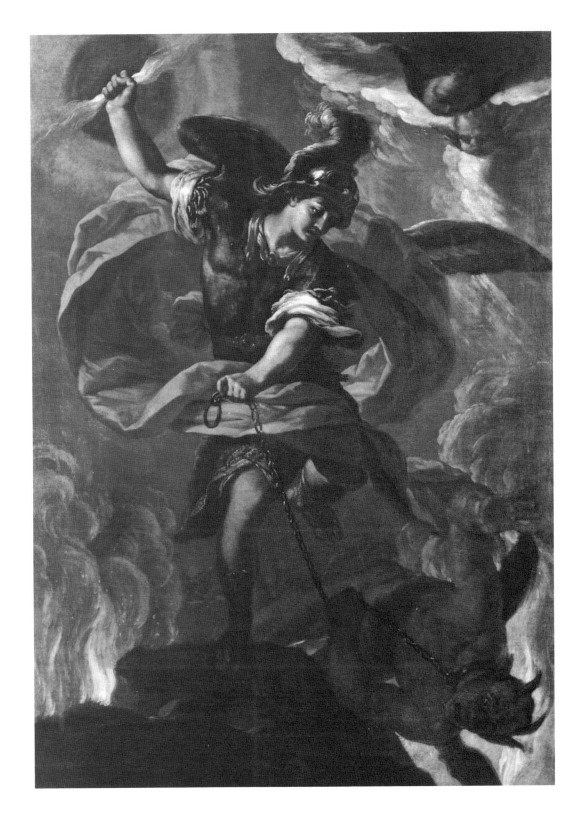

35. Antonio Palomino, *The Archangel Michael Casting Satan into Hell*

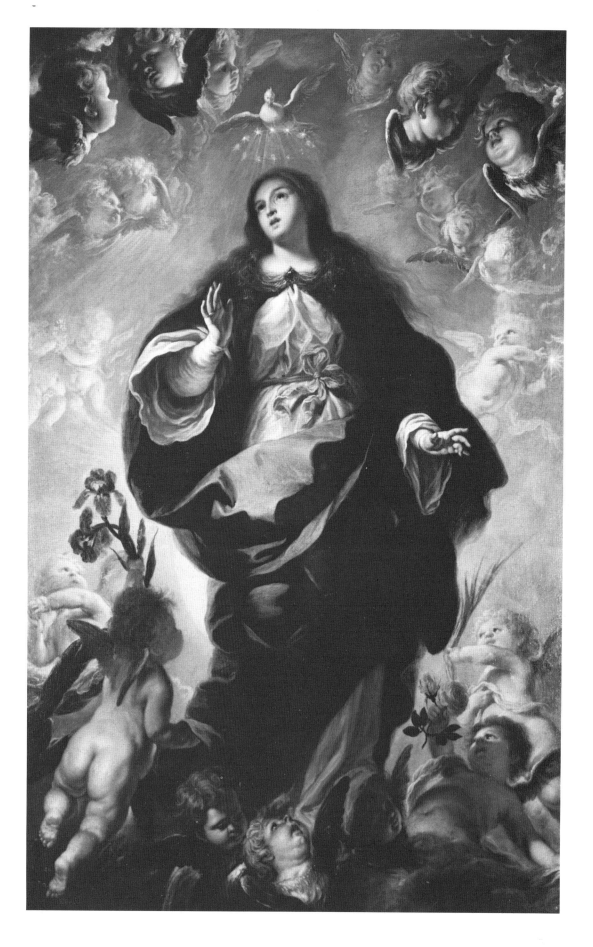

36. Antonio Palomino, *The Immaculate Conception*

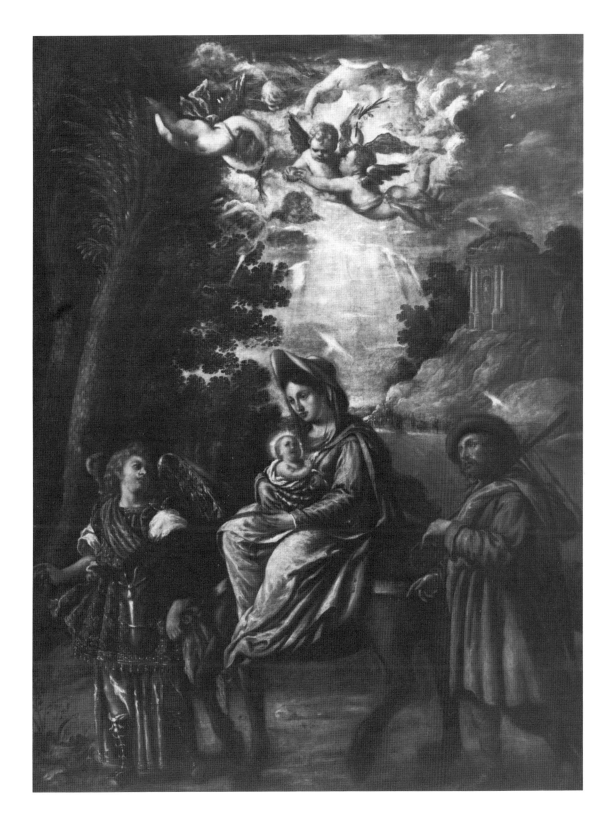

37. Juan de Pareja, *The Flight into Egypt* 151

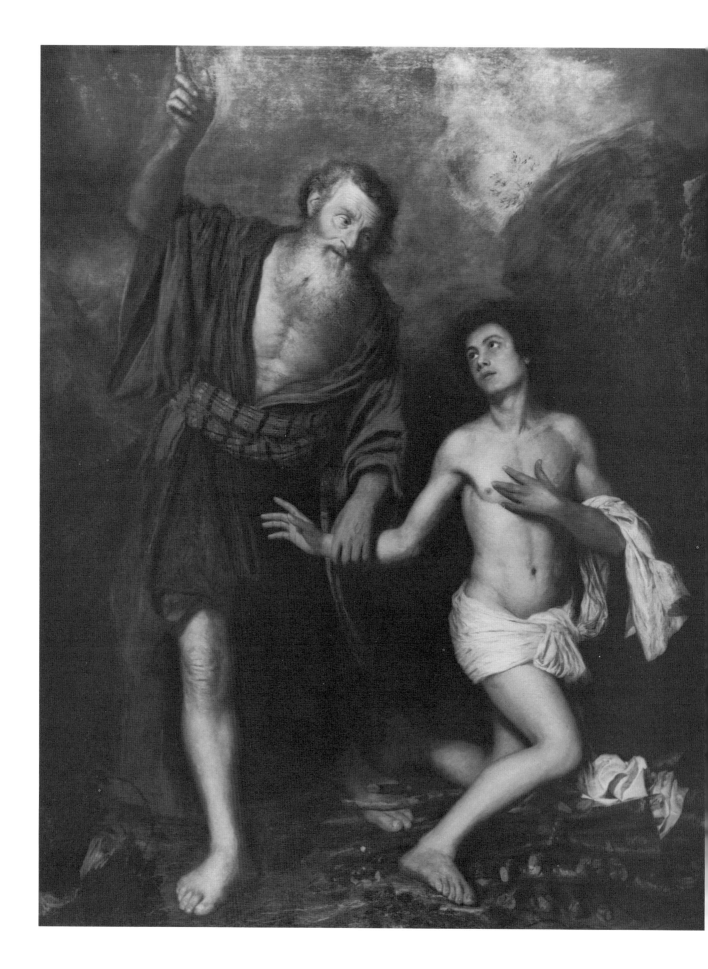

38. Antonio de Pereda, *The Sacrifice of Isaac*

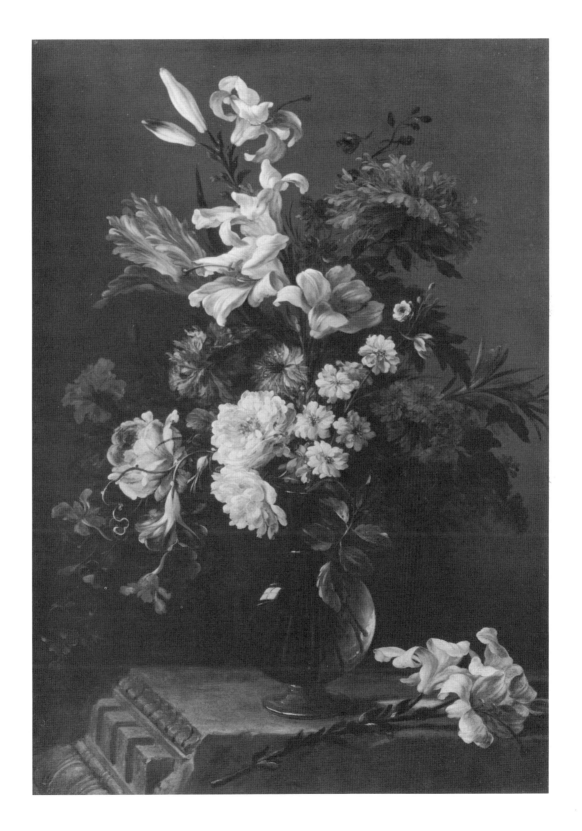

39. Bartolomé Pérez, *A Vase of Flowers on a Pedestal*

40. Bartolomé Pérez, *Still Life: Flowers and Fruit*

41. Pedro Ruíz González, *King Charles II Before the Sacrament* 155

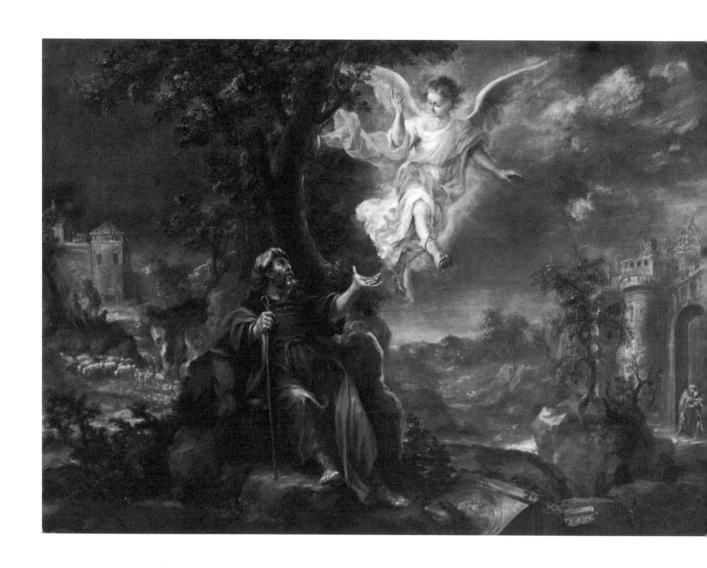

42. Juan de Valdés Leal, *Annunciation to Joachim*

43. Juan de Valdés Leal, *Assumption of the Virgin* 157

44. Juan de Valdés Leal, *Allegory of Vanity*

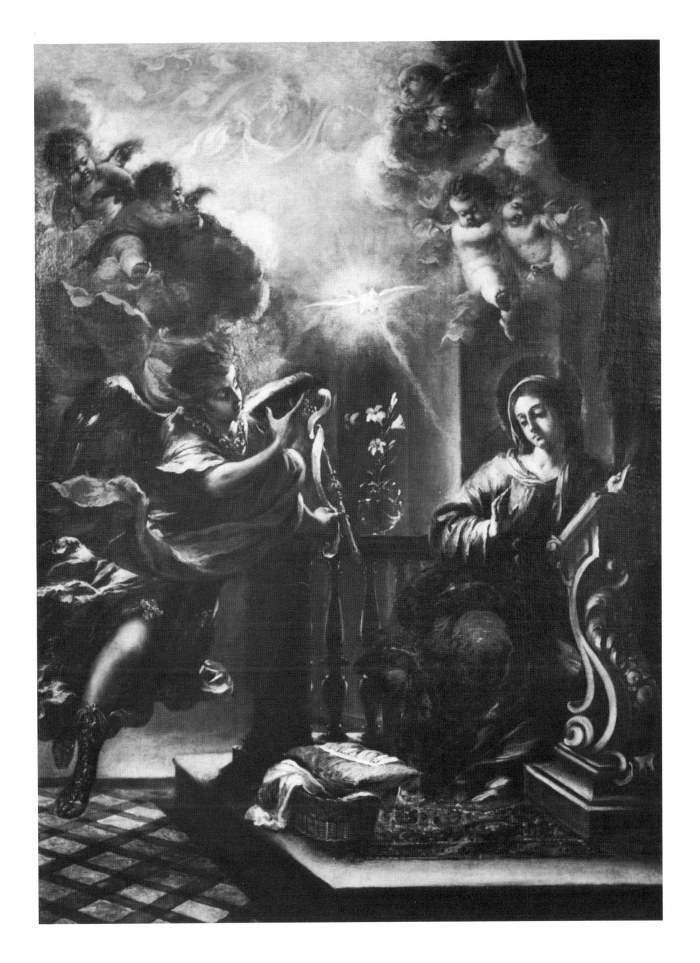

45. Juan de Valdés Leal, *Annunciation*

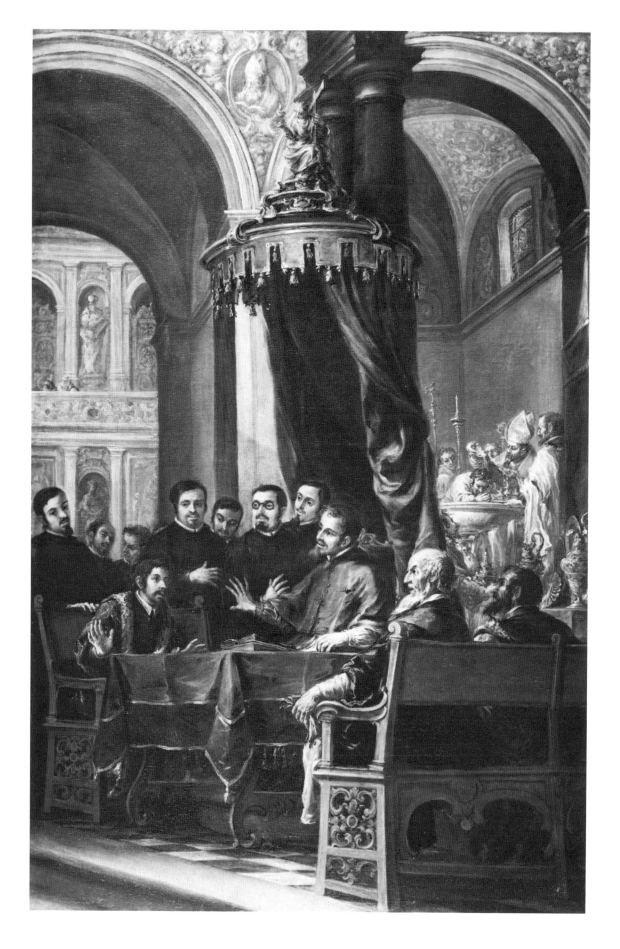

46. Juan de Valdés Leal, *Conversion of St. Augustine by St. Ambrose*

47. Juan de Valdés Leal, *Portrait of an Ecclesiastic*

Desiderata

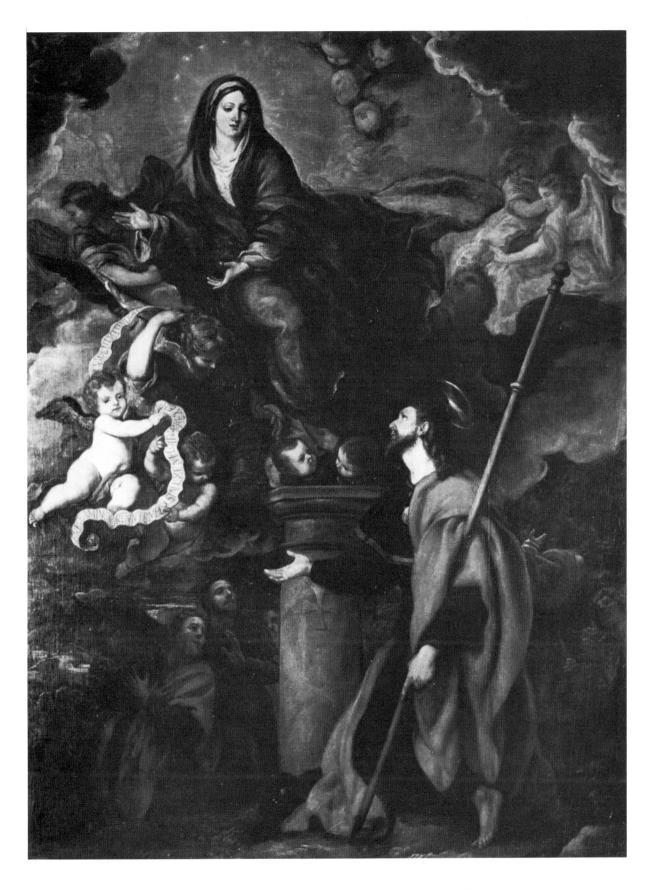

Figure 45. Claudio Coello, *The Virgin Appearing to St. James the Greater*
(The Vision of St. James the Greater of the Virgen del Pilar),
oil on canvas, 192 × 145 cm. (75 × 57 in.).
San Simeon, California, Hearst San Simeon State Historical Monument.

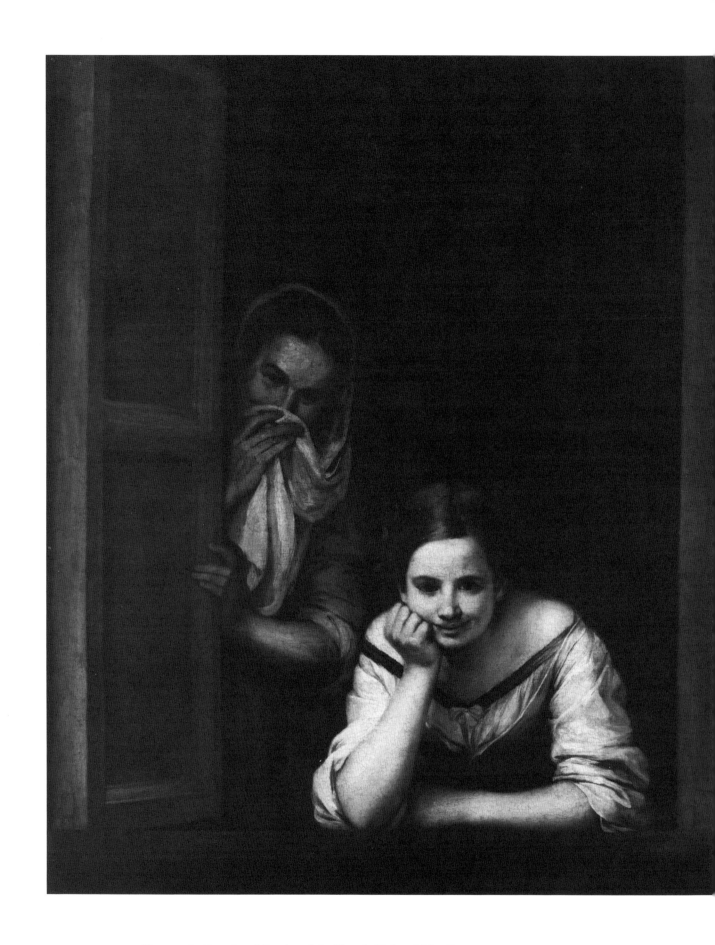

Figure 46. Bartolomé Esteban Murillo, *A Girl and Her Duenna*,
oil on canvas, 127.7 × 106.1 cm. (50¼ × 41¾ in.).
Washington, D.C., National Gallery of Art, Widener Collection, 1942 (642).

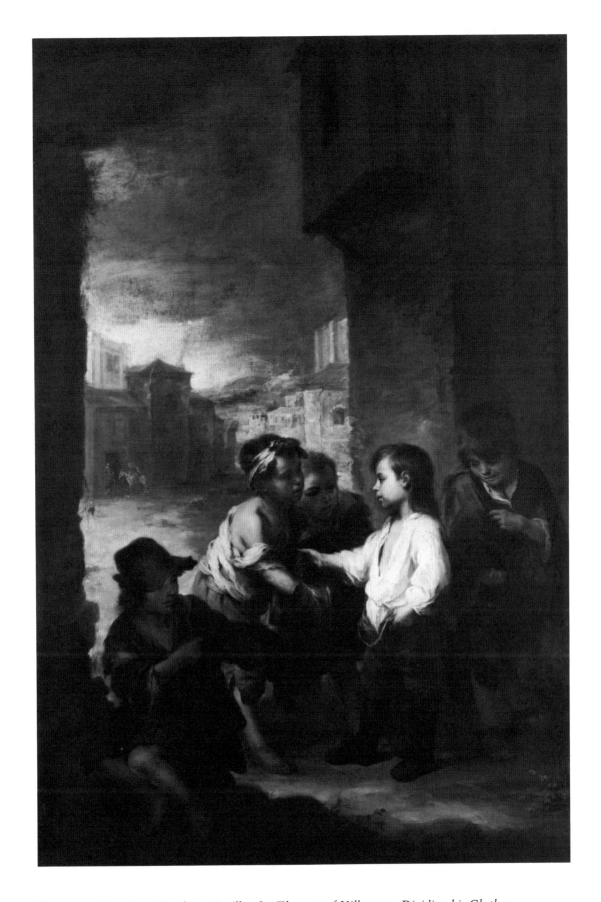

Figure 47. Bartolomé Esteban Murillo, *St. Thomas of Villanueva Dividing his Clothes Among Beggar Boys*,
oil on canvas, 219.7 × 149.2 cm. (86½ × 58¾ in.).
Cincinnati, Ohio, Cincinnati Art Museum, bequest of Mrs. Mary M. Emery (1927.412).

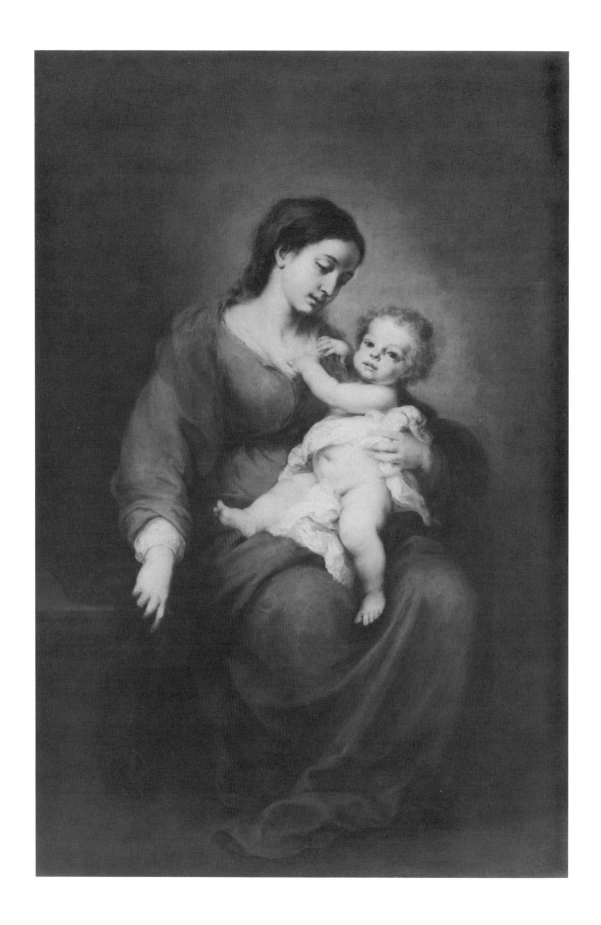

Figure 48. Bartolomé Esteban Murillo, *The Virgin and Child (The Santiago Madonna)*, oil on canvas, 163 × 109 cm. (65¼ × 43 in.).

New York, The Metropolitan Museum of Art, Rogers Fund, 1943 (43.13).

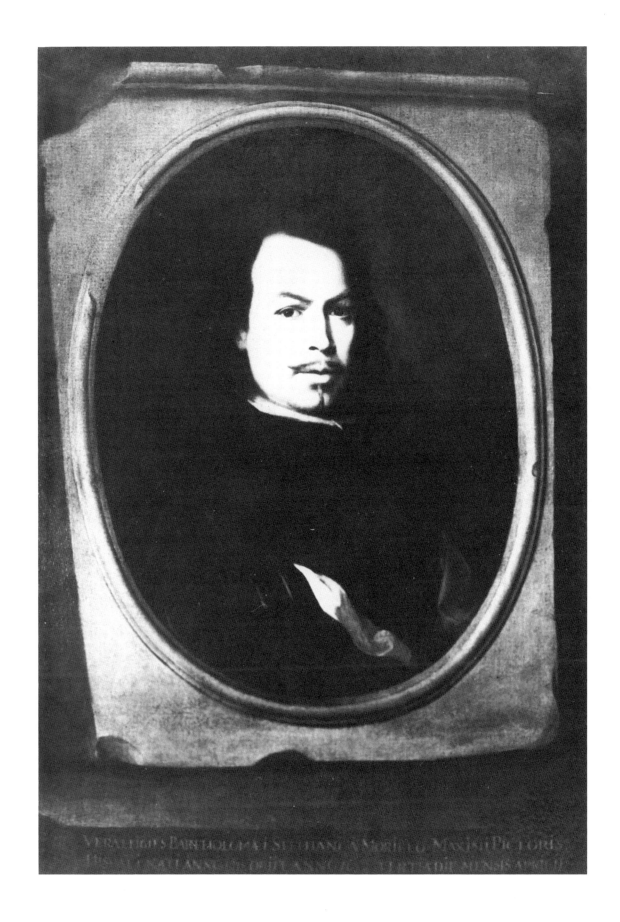

Figure 49. Bartolomé Esteban Murillo, *Self-Portrait*,
oil on canvas, 108 × 76 cm. (42½ × 30 in.).
Private collection.

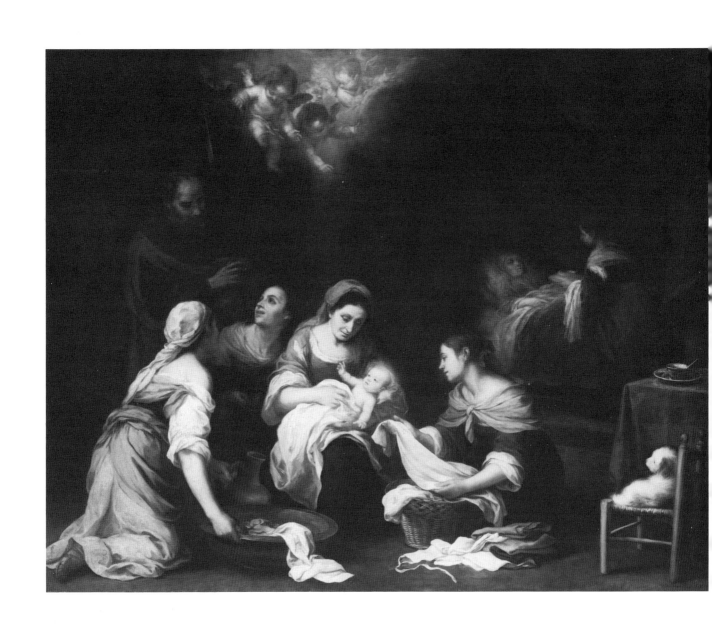

Figure 50. Bartolomé Esteban Murillo, *The Birth of St. John the Baptist,*
oil on canvas, 146.7 × 188 cm. (57³/₄ × 74 in.).

170 Pasadena, California, Norton Simon Museum of Art, the Norton Simon Foundation (F.73. 38.P).

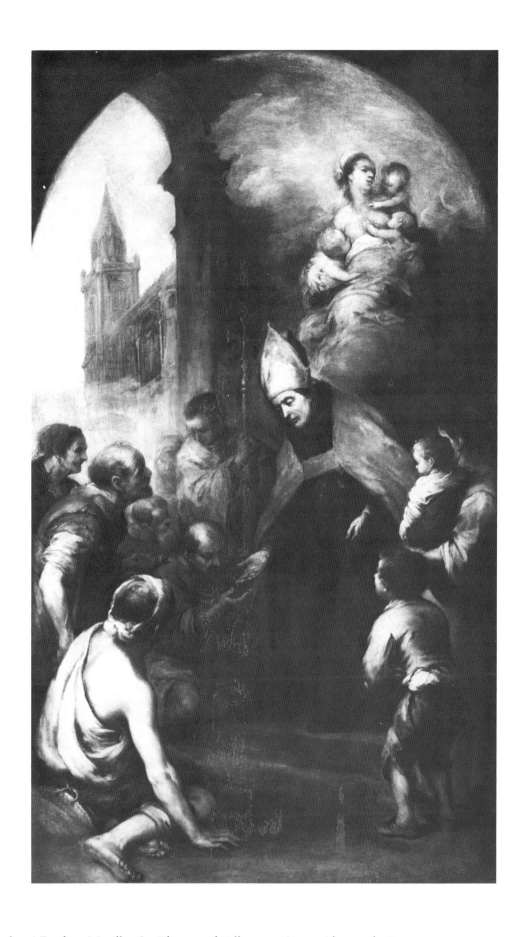

Figure 51. Bartolomé Esteban Murillo, *St. Thomas of Villanueva Giving Alms to the Poor*, oil on canvas, 130.2 × 74.9 cm. (51¼ × 29½ in.).
Pasadena, California, Norton Simon Museum of Art, the Norton Simon Foundation (F.72.42.2.P). 171

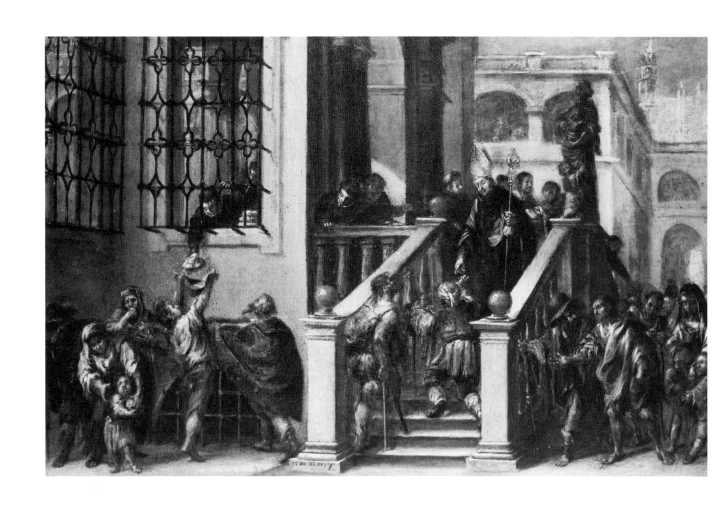

Figure 52. Juan de Valdés Leal, *St. Thomas of Villanueva Giving Alms to the Poor*,
oil on panel, 28.6 × 43.8 cm. (11 × 17¼ in.).

172 El Paso, Texas, El Paso Museum of Art, Samuel H. Kress Collection (61-1-56).

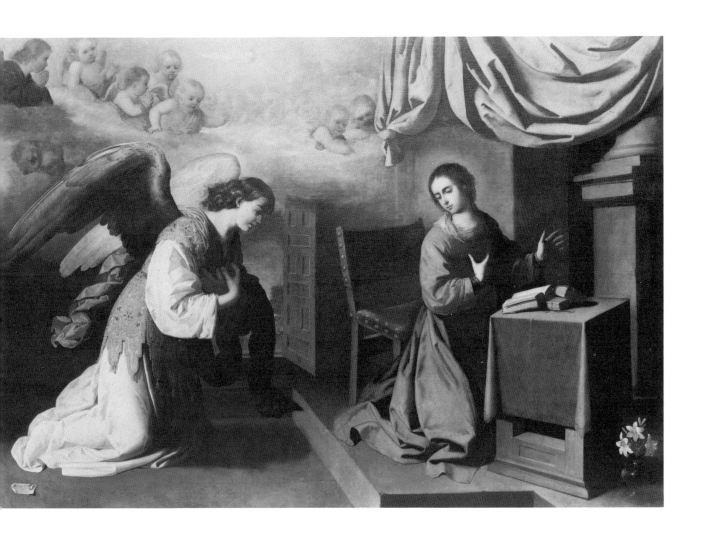

Figure 53. Francisco de Zurbarán, *Annunciation*,
oil on canvas, 223 × 310 cm. (90 × 123 in.).
Philadelphia, Pennsylvania, Philadelphia Museum of Art, the W. P. Wilstach Collection (w'00-1-16).　173

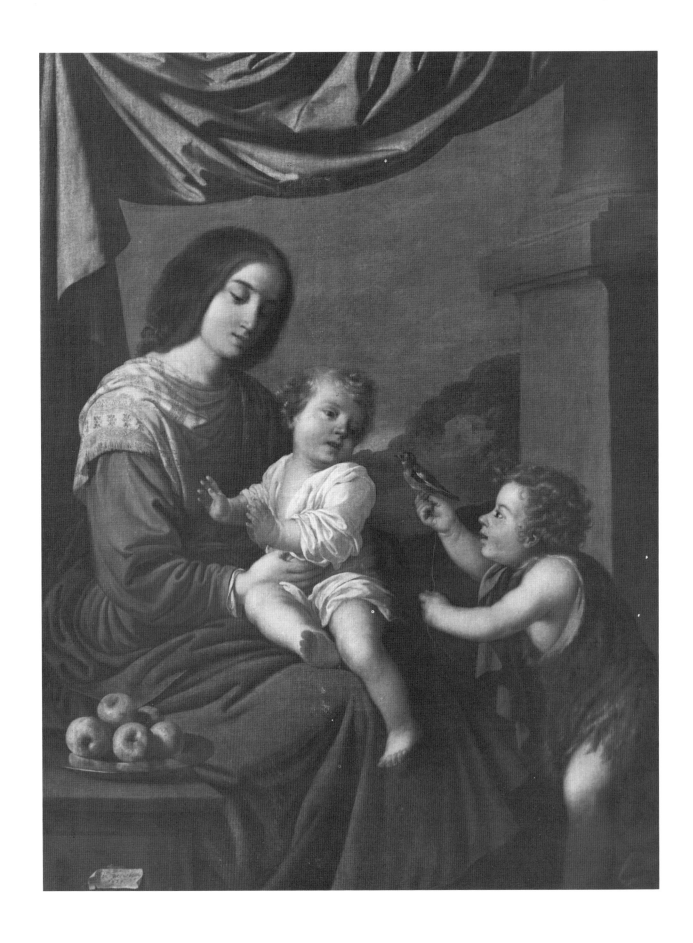

Figure 54. Francisco de Zurbarán, *Virgin and Child with St. John the Baptist*, oil on canvas, 137 × 104 cm. (57 × 41 in.). San Diego, California, San Diego Museum of Art.

Selected Bibliography

Frequently cited periodicals have been abbreviated:

AEA *Archivo Español de Arte*
AEAA *Archivo Español de Arte y Arqueología*
BSAA *Boletín del Seminario de Estudios de Arte y Arqueología*
BSEE *Boletín de la Sociedad Española de Excursiones*

Abbad Ríos, Francisco. *Las Inmaculadas de Murillo*. Barcelona, 1948.

"Accessions" 1958. "Accessions of American and Canadian Museums." *Art Quarterly* 21 (1958), pp. 321–332.

"Acquisitions" 1977. "Acquisitions." *Art Journal* 36 (1977), pp. 249–256.

Adams, Philip R. "A Panorama of Spanish Art." *Apollo* (April 1971), pp. 268–279.

Aguilar y Cuadro, Rafael. *Nuevos datos para la biografía de Palomino*. Bujalance (Córdoba), 1958.

Agulló y Cobo, Mercedes. "Noticias de arte en una información inédita de Palomino y Ruíz de la Iglesia." *AEA* 32 (1959), pp. 229–246.

———. "El Monasterio de San Plácido y su fundador, el madrileño Don Jerónimo de Villanueva, Protonotario de Aragón." *Villa de Madrid* 13 (1975), pp. 37–50.

———. *Noticias sobre pintores madrileños de los siglos XVI y XVII*. Documentos inéditos para la historia del arte. Vol. 1. Madrid, 1978.

Alvarez y Baena, José Antonio. *Hijos de Madrid ilustres en santidad, dignidades, armas, ciencias y artes*. Vol. 1. Madrid, 1789.

Alvarez Cabanas, A. *La Santa Forma: Cuadro de Claudio Coello existente en El Escorial*. Madrid, 1935.

———. "En torno a un centenario. Claudio Coello en El Escorial." *Ciudad de Dios* 154 (1942), pp. 319–332.

Amador de los Ríos, José, and Dios de la Rada y Delgado, Juan de. *Historia de la villa y corte de Madrid*. 4 vols. Madrid, 1863.

Amaya, Mario, and Zafran, Eric M. *Treasures from the Chrysler Museum at Norfolk and Walter P. Chrysler*. Nashville, 1977.

Angulo Iñiguez, Diego. "Tiziano y Lucas Jordán. La Anunciación de San Ginés de Madrid." *AEA* 15 (1940–41), pp. 148–154.

———. "José Antolínez: Obras inéditas o poco conocidas." *AEA* 27 (1954), pp. 213–232.

———. "José Moreno." *AEA* 29 (1956), pp. 67–70.

———. *José Antolínez*. Madrid, 1957.

———. "Claudio Coello." *AEA* 31 (1958), p. 339.

———. "Francisco Rizi. Su vida, cuadros religiosos fechados anteriores a 1670." *AEA* 31 (1958), pp. 89–115.

———. "Nuevas obras de José Antolínez." *AEA* 31 (1958), pp. 341–343.

———. "Francisco Camilo." *AEA* 32 (1959), pp. 89–108.

———. "Herrera Barnuevo y Antolínez." *AEA* 32 (1959), pp. 331–332.

———. "Un 'Memento Mori' de Juan Francisco Carrión." *AEA* 32 (1959), pp. 260–262.

———. "Miscelánea Murillesca." *AEA* 34 (1961), pp. 1–24.

———. "Francisco Rizi. Cuadros religiosos posteriores a 1670 y sin fechar." *AEA* 35 (1962), pp. 95–122.

———. "Nuevas obras de Francisco Camilo." *AEA* 38 (1965), pp. 59–61.

———. "Francisco Rizi: Cuadros de tema profano." *AEA* 44 (1971), pp. 357–387.

———. *Pintura del siglo XVII*. Ars Hispaniae. Vol. 15. Madrid, 1971.

———. "Herrera el mozo y el Alcázar de Madrid." *AEA* 45 (1972), pp. 401–402.

———. "Francisco Rizi: Pinturas murales." *AEA* 47 (1974), pp. 361–382.

———. *Murillo y su escuela*. Seville, 1975.

———. *Murillo*. 3 vols. Madrid, 1981.

Ann Arbor 1979. *Eighty Works in the Collection of The University of Michigan Museum of Art*. The University of Michigan Museum of Art, Ann Arbor, 1979.

Aparicio Olmos, Emilio María. *Palomino: Su arte y su tiempo*. Valencia, 1966.

Arco, Ricardo del. "La pintura en Aragón en el siglo XVII." *Seminario de Arte Aragonés* 6 (1954), pp. 51–75.

Areán González, Carlos. *Velázquez y la escuela de Madrid en el siglo XVII*. Madrid, 1976.

Art Quarterly 1957. Review of *Alonso Cano. Painter, Sculptor and Architect*, by H. Wethey. *Art Quarterly* 20 (1957), pp. 122–123.

Austin, A. Everett. "The Baroque." *Art News Annual* 19 (1950), p. 21.

Azcárate, José María de. "Algunas noticias sobre pintores cortesanos del siglo XVII." *Anales del Instituto de Estudios Madrileños* 6 (1970), pp. 43–61.

Baldry, A. *Velázquez*. London, 1905.

Bantel, Linda, and Burke, Marcus B. *Spain and New Spain. Mexican Colonial Arts in Their European Context*. Exh. cat. Corpus Christi, 1979.

Barettini Fernández, Jesús. *Juan Carreño, pintor de cámara de Carlos II*. Madrid, 1972.

Baticle, Jeannine. "La fundación de la orden Trinitaria, de Carreño de Miranda." *Goya* 63 (1964), pp. 140–153.

———, and Marinas, Cristina. *La Galerie Espagnole de Louis-Philippe au Louvre 1838–1848*. Paris, 1981.

Bergström, Ingvar. *Maestros españoles de bodegones y floreros del siglo XVII*. Madrid, 1970.

Berjano y Escobar, D. *El pintor D. Juan Carreño de Miranda*. Madrid, 1925.

Selected Bibliography

Beruete y Moret, Aureliano de. *The School of Madrid*. London, 1909.

———. *Valdés Leal*. Madrid, 1911.

———. "Los pintores de Carlos II: Claudio Coello." *Por el Arte* 1 (1913), p. 17.

Birmingham 1971. *The Art of Spain*. Exh. cat. Birmingham Museum of Art, Birmingham, Ala., 1971.

Blanc, Charles; Bürger, W.; Mantz, Paul; Viardot, Louis; and Lefort, Paul. *Histoire des peintres de toutes les écoles. Ecole Espagnole*. Paris, 1869.

Bonet Correa, Antonio. "Velázquez, arquitecto y decorador." *AEA* 33 (1960), pp. 215–249.

———. *Iglesias madrileñas del siglo XVII*. Madrid, 1961.

———. "Nuevas obras y noticias sobre Colonna." *AEA* 37 (1964), pp. 307–312.

Borenius, Tancred. "An Allegorical Portrait by Valdés Leal." *Burlington Magazine* 73 (1938), pp. 146–151.

Bosarte, Isidoro. *Viaje artístico a varios pueblos de España*. Madrid, 1804.

Bottineau, Yves. "L'Alcazar de Madrid et l'inventaire de 1686. Aspects de la cour d'Espagne au XVIIᵉ siècle." *Bulletin Hispanique* 58 (1956), pp. 421–452; 60 (1958), pp. 30–61, 145–179, 199–326, 441–483.

———. "Nouveaux regards sur la peinture espagnole du XVIᵉ et XVIIᵉ siècles." *La Revue du Louvre et des Musées de France* 5–6 (1975), pp. 10, 312–322.

Braham, Allen. "The Early Style of Murillo." *Burlington Magazine* 107 (1965), pp. 445–451.

Brown, Jonathan. "Herrera the Younger: Baroque Artist and Personality." *Apollo* (July 1966), pp. 34–43.

———. "Hieroglyphs of Death and Salvation: The Decoration of the Hermandad de la Caridad, Seville." *Art Bulletin* 52 (1970), pp. 265–277.

———. *Francisco de Zurbarán*. New York, 1975.

———. *Jusepe de Ribera: Prints and Drawings*. Exh. cat. Princeton, 1973.

———. "Pen Drawings by Herrera the Younger." In *Hortus Imaginum: Essays in Western Art*. Edited by M. Stokstad and R. Enggass. Lawrence, Kansas, 1974.

———. "Drawings by Herrera the Younger and a Follower." *Master Drawings* 13 (1975), pp. 235–240.

———. "Valdés Leal: Atribuciones y falsas atribuciones." *AEA* 49 (1976), pp. 331–336.

———. *Murillo and His Drawings*. Exh. cat. Princeton, 1976.

———. *Images and Ideas in Seventeenth-Century Spanish Painting*. Princeton, 1978.

———, and Elliott, J. H. *A Palace for a King: The Buen Retiro and the Court of Philip IV*. New Haven, 1980.

Buchanan, William. *Memoirs of Painting*. 2 vols. London, 1824.

Buendía Muñoz, José Rogelio. "Mateo Cerezo en su tercer centenario (1626–1666)." *Goya* 71 (1966), pp. 278–291.

———. "Recordatorio de Escalante en los trescientos años de su muerte." *Goya* 99 (1970), pp. 146–153.

———. "Sobre Escalante." *AEA* 43 (1970), pp. 33–50.

———. "José Antolínez, pintor de 'mitologías.'" *Boletín del Museo e Instituto Camón Aznar* 1 (1980), pp. 45–57.

Calvo Serraller, Francisco. *Teoría de la pintura del siglo de oro*. Madrid, 1981.

Camón Aznar, José. *Velázquez*. 2 vols. Madrid, 1964.

———. *La pintura española del siglo XVII*. Summa Artis. Vol. 25. Madrid, 1977.

Castañón, Luciano. *Pintores asturianos. Carreño*. Vol. 1. Oviedo, 1970.

Caturla, María Louisa. "Iglesias madrileñas desaparecidas. El retablo mayor de la antigua parroquia de Sta. Cruz." *Arte Español* 18 (1950), pp. 3–9.

———. "Sobre un viaje de Mazo a Italia hasta ahora ignorado." *AEA* 28 (1955), pp. 73–75.

———. *Catálogo de la exposición Zurbarán en el III centenario de su muerte*. Exh. cat. Madrid, 1964.

———. "La verdadera fecha del retablo madrileño de San Hermenegildo." In *Actas del XXIII Congreso Internacional de Historia del Arte*. Vol. 3. Granada, 1978, pp. 49–55.

Cavestany, Julio. "Pintores españoles de flores." *Arte Español* 6 (1922), pp. 124–135.

———. *Floreros y bodegones en la pintura española. Catálogo ilustrado de la exposición*. Exh. cat. Madrid, 1936–40.

———. "Un cuadro firmado por Mateo Cerezo." *Arte Español* 13 (1941), pp. 18–21.

Ceán Bermúdez, Juan Agustín. *Diccionario histórico de los más ilustres profesores de las bellas artes en España*. 6 vols. Madrid, 1800. Facsimile ed. Madrid, 1965.

———. *Descripción artística de la Catedral de Sevilla*. Seville, 1804.

———. *Carta…sobre el estilo…de la escuela sevillana*. Cádiz, 1806. Modern ed. Seville, 1968.

Chamoso Lamas, Manuel. "Las pinturas de las bóvedas de la Mantería de Zaragoza, obra de Claudio Coello y de Sebastián Muñoz." *AEA* 17 (1944), pp. 370–384.

Ciervo Paradell, Joaquín. *Pintores de España 1480–1874*. Barcelona, 1925.

Cincinnati 1968. *Cincinnati Art Museum Bulletin* 8 (January 1968), pp. 1–36.

Coley, Curtis G. "The Delectable Foothills of Spanish Painting." *Art News* (March 1963), pp. 22–24, 64–66.

Cook, Herbert. "Further Light on del Mazo." *Burlington Magazine* 28 (1913), p. 323.

Córdoba 1916. *Catálogo ilustrado de la exposición de Valdés Leal*. Exh. cat. Ayuntamiento. Barcelona, 1916.

Cruz y Bahamonde, Nicolás de la. *Viaje de España, Francia e Italia*. 12 vols. Cádiz, 1812.

Cruzada Villaamil, Gregorio. *Catálogo provisional, historial y razonado del Museo Nacional de Pintura*. Madrid, 1865.

Curtis, Charles B. *Velázquez and Murillo.* London and New York, 1883.

Detroit 1971. *The Detroit Institute of Arts Handbook.* Detroit, 1971.
"Detroit Given a Murillo." 1948. "Detroit Given a Murillo." *College Art Journal* 8 (1948), pp. 47–48.
Diaz Borque, J. M. *La sociedad española y los viajeros del siglo XVII.* Madrid, 1975.
Domínguez Ortiz, Antonio. "Aspectos del vivar madrileño durante el reinado de Carlos II." *Anales del Instituto de Estudios Madrileños* 7 (1971), pp. 229–252.
———. *The Golden Age of Spain 1516–1659.* New York, 1971.

E. C. B. "Lucid Spanish Interspace." *Art News* (January 1965), pp. 37, 56–57.
Elizade, J. *En torno a las Inmaculadas de Murillo.* Madrid, 1955.
Elliott, J. H. *Imperial Spain: 1469–1716.* New York, 1966.
Enggass, Robert, and Brown, Jonathan. *Italy and Spain 1600–1750.* Sources and Documents in the History of Art. Englewood Cliffs, N.J., 1970.

Fahy, Everett. "A History of the Portrait [of Juan de Pareja] and its Painter." *The Metropolitan Museum of Art Bulletin* (June 1971), pp. 453–475.
Faison, S. Lane, Jr. "A Spanish Painting of the Annunciation." *Art Quarterly* 17 (1954), pp. 204–205.
———. *A Guide to the Art Museums of New England.* New York, 1958.
———. *Williams College Museum of Art: Handbook of the Collection.* Williamstown, 1979.
Feinblatt, Ebria. *Agostino Mitelli Drawings: Loan Exhibition from the Kunstbibliothek, Berlin.* Exh. cat. Los Angeles, 1965.
———. "A 'Boceto' by Colonna-Mitelli in the Prado." *Burlington Magazine* 107 (1965), pp. 349–357.
———. "Angelo Michele Colonna: A Profile." *Burlington Magazine* 121 (1979), pp. 618–630.
Ferrari, Oreste, and Scavizzi, Giuseppe. *Luca Giordano.* Naples, 1966.
Ford, Richard. *A Handbook for Travellers in Spain.* London, 1847.
Fort Worth 1972. *Catalogue of the Collection 1972.* Kimbell Art Museum, Fort Worth, 1972.
Fort Worth 1981. *Handbook of the Collection.* Kimbell Art Museum, Fort Worth, 1981.

Gállego, Julián. *Peinture espagnole du siècle d'or.* Paris, 1964.
———. *Vision et symboles dans la peinture espagnole du siècle d'or.* Paris, 1968.

———. *Visión y símbolo en la pintura española del siglo de oro.* Madrid, 1972.
Gallego de Miguel, Amelia. *El Museo de Bellas Artes de Salamanca.* Salamanca, 1975.
García Hidalgo, José. *Principios para estudiar el nobilísimo arte de la pintura.* Madrid, 1693. Facsimile ed. Madrid, 1966.
Garín Ortiz de Tarranco, Felipe María. "Un boceto de Ribalta y un apunte de Palomino." *Arte Español* 16 (1945), pp. 139–142.
———. *Palomino, pintor mediacionista (III centenario del nacimiento en Bujalance del Regis Pictor Acisclo Antonio Palomino).* Bujalance, 1955.
Gascue Galarraga, Angel. "Las Adoraciones de Jordán del Convento de Santa Isabel de Madrid." *AEA* 42 (1969), pp. 353–356.
Gaya Nuño, Juan Antonio. *Zurbarán.* Barcelona, 1948.
———. "En el centenario de Palomino. Exequias y elogio del Barroco Nacional." *Goya* 5 (1955), pp. 265–271.
———. *Vida de Acisclo Antonio Palomino. El historiador. El pintor. Descripción y crítica de sus obras.* Córdoba, 1956. 2d ed. Córdoba, 1981.
———. "Revisiones sexcentistas, Juan de Pareja." *AEA* 30 (1957), pp. 271–285.
———. *Claudio Coello.* Madrid, 1957.
———. *La pintura española fuera de España.* Madrid, 1958.
———. "Juan Bautista del Mazo, gran discípulo de Velázquez." In *Varia Velazqueña.* Vol. 1. Madrid, 1960, pp. 471–481.
———. "La pintura española en el Museo de Ponce." *Blanco y Negro* 72 (December 8, 1962).
———. "Bibliografía crítica y antológica de Zurbarán." *Arte Español* 25 (1963–66), pp. 18–68.
———. *L'opera completa di Murillo.* Milan, 1978.
Gestoso y Pérez, José. *Ensayo de un diccionario de los artífices que florecieron en Sevilla desde el siglo XIII al XVIII inclusive.* Seville, 1899.
———. *Biografía del pintor sevillano Juan de Valdés Leal.* Seville, 1916.
Glück, Gustav. *Die Harrachsche Bildergalerie.* Vienna, 1923.
Gómez-Moreno, María Elena. "Pinturas inéditas de Alonso Cano." *AEA* 21 (1948), pp. 241–258.
———. *Catálogo de la exposición Alonso Cano.* Exh. cat. Granada, 1954.
———. *Alonso Cano. Estudio y catálogo de la exposición celebrada en Granada en junio de 1954.* Madrid, 1955.
González, Justo L. *Uno historia ilustrada del Cristianismo: La era de los mártires.* Vol 1. Miami, 1978, p. 185.
Graves, Algernon. *A Century of Loan Exhibitions 1813–1912.* Kingsmead Reprints. Bath, 1970.

Greenville 1954. *Bob Jones University Catalogue.* Bob Jones University Collection, Greenville, S.C., 1954.

Greenville 1962. *The Bob Jones University Collection of Religious Paintings.* Vol. 2. Bob Jones University Collection, Greenville, S.C., 1962.

Gregori, Mina, and Frati, Tiziana. *L'opera completa di Zurbarán.* Milan, 1973.

Griseri, Andreina. "I bozzetti di Luca Giordano per l'Escalera del Escorial." *Paragone* 7 (1956), pp. 33–39.

――――. "Luca Giordano 'alla maniera di.'" *Arte Antica e Moderna* 13–16 (1961), pp. 417–438.

Guichot y Sierra, Alejandro. *Los famosos jeroglíficos de la muerte de Juan de Valdés Leal de 1672. Análisis de sus alegorías. Estudio crítico.* Seville, 1930.

Guidol y Ricart, José. "La peinture de Valdés Leal et sa valeur picturale." *Gazette des Beaux-Arts* 50 (1957), pp. 123–136.

Guinard, Paul. *Zurbarán et les peintres espagnols de la vie monastique.* Paris, 1960.

――――. "L'influence flamande sur la peinture espagnole du 'siècle d'or.'" In *International Congress of the History of Art. Acts of the Twentieth Congress.* Budapest, 1972, pp. 33–36.

Haraszti-Takács, Marianne. *Spanish Masters.* Budapest, 1966.

――――. "Pedro Nuñez de Villavicencio, disciple de Murillo." *Bulletin des Musée Hongrois des Beaux-Arts* 48–49 (1977), pp. 129–155.

――――. *Bartolomé Esteban Murillo.* Budapest, 1978.

Harris, Enriqueta. "Velázquez en Roma." *AEA* 31 (1958), pp. 185–192.

――――. "La misión de Velázquez en Italia." *AEA* 33 (1960), pp. 109–136.

――――. "Angelo Michele Colonna y la decoración de San Antonio de los Portugueses." *AEA* 34 (1961), pp. 101–105.

――――. "Francisco Camilo: Un dibujo atribuido a Cano para un cuadro que se atribuyó a Valdés Leal." *AEA* 34 (1962), p. 330.

――――. "Velázquez and the Villa Medici." *Burlington Magazine* 123 (1981), pp. 537–541.

Helburn, Philip. "The Dream of St. Joseph by Francisco Herrera the Younger." *Chrysler Museum Bulletin* 3 (1974).

Held, Julius S. *Museo de Arte de Ponce. Catalogue I. Paintings of the European and American Schools.* Ponce, 1965.

Hernández Perera, Jesús. "Iconografía española. El Cristo de los Dolores." *AEA* 27 (1954), pp. 47–62.

――――. "Pinturas de Juan Carreño de Miranda en el Museo Lázaro Galdeano." *Goya* 19 (1957), pp. 6–10.

――――. *La pintura española y el reloj.* Madrid, 1958.

――――. "Carreño y Velázquez." In *Varia Velazqueña.* Vol. 1. Madrid, 1960, pp. 482–498.

Herrero García, Miguel. *Contribución de la literatura a la historia del arte.* Madrid, 1943.

Hubbard, Robert H., ed. *European Paintings in Canadian Collections.* Toronto, 1956.

Ibáñez, Alberto C. "Obras del pintor José Moreno en Quintadueños (Burgos)." *BSAA* 43 (1977), pp. 491–494.

Igual Ubeda, Antonio, and Subías Galter, Juan. *El siglo de oro.* Historia de la cultura española. Barcelona, 1942.

Indianapolis 1963. *El Greco to Goya.* Exh. cat. John Herron Museum of Art and Rhode Island School of Design, Indianapolis, 1963.

Jameson, Mrs. Anna. *Legends of the Madonna as Represented in the Fine Arts.* New York, 1899.

Janson, Anthony F., and Fraser, Ian A. *100 Masterpieces of Painting. Indianapolis Museum of Art.* Indianapolis, 1980.

――――. *Handbook of European and American Painting. Indianapolis Museum of Art.* Indianapolis, 1981.

Jeckel, Bernardo María. *Gran Galería de pinturas antiguas.* Lima, 1873 and 1899.

Jordan, William B. *The Meadows Museum. A Visitor's Guide to the Collection.* Dallas, 1974.

Justi, Karl. *Diego Velázquez und sein Jahrhundert.* 2d ed. Bonn, 1903. 4th ed. Bonn, 1933.

――――. *Murillo.* 2d ed. Leipzig, 1904.

Kamen, Henry. *Spain in the Later Seventeenth Century 1650–1700.* London and New York, 1980.

Kansas City 1941. *The William Rockhill Nelson Collection.* Kansas City, 1941.

Kansas City 1973. *Nelson Gallery–Atkins Museum Handbook.* Kansas City, 1973.

Kinkead, Duncan T. *Juan de Valdés Leal (1622–1690). His Life and Work.* London and New York, 1978.

Kubler, George. "El 'San Felipe de Heraclea' de Murillo y los cuadros del Claustro Chico." *AEA* 43 (1970), pp. 11–31.

――――, and Soria, Martin S. *Art and Architecture in Spain and Portugal and Their American Dominions 1500–1800.* Pelican History of Art. Harmondsworth and Baltimore, 1959, and Baltimore, 1969.

Künstle, Karl. *Ikonographie der christlichen Kunst.* Freiburg, 1928.

"La Chronique" 1971. "La Chronique des arts." *Gazette des Beaux-Arts* 77 (1971), pp. 3–180.

Lafuente Ferrari, Enrique. *Breve historia de la pintura española.* Madrid, 1934.

――――. "Cuadros de maestros menores madrileños (Pareja, Solís, Arredondo, García Hidalgo)." *Arte Español* 13 (1941), pp. 1–16, 22–31.

――――. "Escalante en Navarra y otras notas sobre el pintor." *Príncipe de Viana* 4 (1941), pp. 8–23.

――――. "Nuevas notas sobre Escalante." *Arte Español* 15 (1944), p. 29.

_____. *Historia de la pintura española.* Madrid, 1953.

_____, and Friedländer, Max. *El realismo en la pintura española del siglo XVII.* Barcelona, 1935.

Lefort, Paul. *Velázquez.* Paris, 1888.

Lipschutz, Ilse Hemple. *Spanish Painting and the French Romantics.* Cambridge, Mass., 1972.

Loga, Valerian von. "The Spanish Pictures of Sir William van Horne's Collection in Montreal." *Art in America* 1 (1913), pp. 103–104.

_____. *Die Malerei in Spanien.* Berlin, 1923.

London 1971. *Old Masters. Recent Acquisitions.* Thomas Agnew and Sons, Ltd., London, 1971.

London 1976. *The Golden Age of Spanish Painting.* Exh. cat. Royal Academy of Arts, London, 1976.

López Martínez, Celestiano. *Juan de Valdés Leal.* Seville, 1922.

López Navío, José. "El matrimonio de Mazo." *AEA* 33 (1960), pp. 387–419.

López-Rey, José. *Velázquez: A Catalogue Raisonné of His Oeuvre.* London, 1963.

_____. *Velázquez' Work and World.* London, 1968.

_____. *Velázquez. The Artist as a Maker.* Lausanne and Paris, 1979.

Lozoya, Marqués de. "Pintura española en el Museo de la Fundación Luis A. Ferré en Ponce." *Goya* 35 (1965), pp. 274–277.

_____. "Antonio de Pereda en el Patrimonio Nacional y en los Patronatos Reales." *Reales Sitios* 7 (1966), pp. 13–20.

Lynch, John. *Spain under the Habsburgs.* Vol. 2. Oxford, 1969.

Madrazo y Kuntz, Pedro de. *Viaje artístico de tres siglos por las colecciones de cuadros de los reyes de España.* Barcelona, 1884.

Madrid 1902. *Catalogue de la Collection des Tableaux de Feu Son Altesse Royale l'Infante Marie Cristine de Borbón.* Madrid, 1902.

Madrid 1966. *I esposición de anticuarios de España.* Madrid, 1966.

Madrid 1972. *Catálogo de las pinturas.* Museo del Prado, Madrid, 1972.

Madrid 1972. *San José en el arte español.* Exh. cat. Museo Español de Arte Contemporáneo, Madrid, 1972.

Madrid 1981. *Pintura española de los siglos XVI al XVIII en colecciones centroeuropeos.* Exh. cat. Museo del Prado, Madrid, 1981.

Mâle, Emile. *L'Art religieux de la fin du XVIᵉ siècle, du XVIIᵉ siècle et du XVIIIᵉ siècle.* Paris, 1951.

Manning, Bertina Suida. *1550–1650: A Century of Masterpieces from the Collection of Walter P. Chrysler.* Exh. cat. Fort Worth, 1962.

Manning, Robert. *A Loan Exhibition of Neapolitan Masters of the Seventeenth and Eighteenth Centuries.* Exh. cat. New York, 1962.

Maravall, José Antonio. *La cultura del barroco.* Barcelona, 1975.

Martín, Irene. "Juan de Arellano and Flower Painting in Madrid." M.A. thesis, Southern Methodist University, 1980.

Martín González, Juan José. "Una Asunción de Mateo Cerezo." *AEA* 28 (1955), pp. 76–77.

Marzolf, Rosemary A. "The Life and Work of Juan Carreño de Miranda (1614–1685)." Ph.D. dissertation, University of Michigan, 1961.

Maura y Gamazo, Gabriel, Duque de. *Vida y reinado de Carlos II.* 2 vols. 2d ed. Madrid, 1954.

Mayer, August L. *Die Sevillaner Malerschule.* Leipzig, 1911.

_____. *Murillo: des Meisters Gemälde.* Leipzig, 1913.

_____. *Geschichte der spanischen Malerei.* Leipzig, 1922.

_____. *Murillo.* Klassiker der Kunst. Stuttgart, 1923.

_____. *Historia de la pintura española.* Madrid, 1928 and 1942.

_____. "Zur Austellung der spanischen Gemälde des Grafen Contini in Rom." *Pantheon* 5 (1930), p. 207.

_____. *Velázquez. A Catalogue Raisonné of the Pictures and Drawings.* London, 1936.

McLaren, Neil. *The Spanish School.* National Gallery Catalogues. Revised by Allen Braham. London, 1972.

Milkovitch, Michael. *Luca Giordano in America.* Exh. cat. Memphis, 1964.

Minneapolis 1970. "Catalogue of Accessions for the Year 1970." *The Minneapolis Institute of Arts Bulletin* 59 (1970), pp. 69–97.

Mitchell, Peter. *Great Flower Painters: Four Centuries of Floral Art.* Woodstock, N.Y., 1973.

Montoto de Sedas, Santiago. *Bartolomé Esteban Murillo: Estudio bibliográfico-crítico.* Seville, 1923.

Moura Soubral, Luis de. "Juan de Valdés Leal, pintor de 'vanitas.'" *Coloquio/Artes* 31 (1977), pp. 43–57.

Moya Casales, Enrique. *Estudio crítico del pintor Antonio Palomino de Castro y Velasco.* Valencia, 1941.

_____. "El Regis Pictor Acisclo Antonio Palomino de Castro y Velasco." *Archivo de Arte Valenciano* 5 (1944), pp. 125–126.

Muller, Priscilla E. "Paintings from Spain's Past at Indianapolis and Providence." *Art Quarterly* 26 (1963), pp. 101–106.

_____. "El retablo mayor del Santuario de la Fuenciscla: Sus autores según una relación del 1662." *AEA* 41 (1968), pp. 161–164.

Nada, John. *Carlos the Bewitched. The Last Spanish Hapsburg 1661–1700.* London, 1962.

Newark 1964. *The Golden Age of Spanish Still-Life Painting.* Exh. cat. The Newark Museum, Newark, 1964.

New York 1915. *Catalogue of the Gallery of Art.* New-York Historical Society, New York, 1915.

Norfolk 1973. "The New Spanish Gallery." *Chrysler Museum Bulletin* 2 (1973).

O'Neill, A. *A Dictionary of Spanish Painters*. London, 1833–34.

Pacheco, Francisco. *Arte de la pintura*. Seville, 1649. Edited by F. J. Sánchez Cantón. Modern ed. Madrid, 1956.

Palomino de Castro y Velasco, Acisclo Antonio. *Museo pictórico y escala óptica*. 3 vols. Madrid, 1724. Modern ed. Madrid, 1947.

Pallol, Benigno. "Claudio Coello." *Estudio* 24 (1920), pp. 32–47.

Pardo Canalís, Enrique. *Pinturas de la corte de Carlos II*. Madrid, 1977.

Paris 1838. *Notices des Tableaux de la Galerie Espagnole*. Paris, 1838.

Paris 1853. *Catalogue of the Pictures Forming the Famous Spanish Gallery*. Paris, 1853.

Park, Rosemary, and Mayhew, Edgar DeN. *Complete List of American and European Drawings, Paintings and Watercolors in the Lyman Allyn Museum*. New London, 1960.

Pau 1876. *Tableaux Exposés dans le Salon de l'Ancien Asile de Pau Appartenant…à l'Infant Don Sebastien de Bourbon et Bragance*. Pau, 1876.

Pemán, César. "Un cuadro desconocido de Pedro Ruíz González." *AEA* 16 (1944), pp. 179–180.

Pérez Bustamante, Ciríaco. "Claudio Coello: Noticias biográficas." *BSEE* 26 (1918), pp. 223–227.

_____. "Claudio Coello. Algunas novedades biográficas." *Revista de Historia* 10 (1921), pp. 5–12.

Pérez Sánchez, Alfonso E. Review of "The Life and Work of Juan Carreño de Miranda (1614–1685)," by R. Marzolf. *AEA* 39 (1966), pp. 98–99.

_____. "Notas sobre Palomino, pintor." *AEA* 45 (1972), pp. 251–270.

_____. "Presencia de Tiziano en la España del siglo de oro." *Goya* 135 (1976), pp. 140–159.

_____. *Don Antonio de Pereda (1611–1678) y la pintura madrileña de su tiempo*. Exh. cat. Madrid, 1978.

Petersen, M. *Masterworks from the Collection of the Fine Arts Gallery of San Diego*. San Diego, 1968.

Petraccone, Enzo. *Luca Giordano*. Naples, 1919.

Pfandl, Ludwig. *Cultura y costumbres del pueblo español de los siglos XVI y XVII, introducción al estudio del siglo de oro*. Barcelona, 1959.

Pita Andrade, José Manuel. "Los cuadros de Velázquez y Mazo que poseyó el séptimo Marqués del Carpio." *AEA* 25 (1952), pp. 223–236.

Pla y Cargol, José. *Carreño, Coello, Pantoja y Valdés Leal*. Gerona, 1955.

Ponz, Antonio. *Viaje de España*. 18 vols. Madrid, 1772–74. Modern ed. Madrid, 1947.

Portland 1956. *Paintings from the Collection of Walter P. Chrysler Jr.*. Portland Art Museum, Portland, 1956.

Quilliet, Frederic. *Dictionnaire del peintres espagnols*. Paris, 1816.

Réau, Louis. *Iconographie de l'art chrétien*. Paris, 1957.

Rechert, Gertrude. "Juan de Valdés Leal. Murillos grosser zeitgenosse in Sevilla." *Pantheon* 11 (1936), pp. 290–294.

Richardson, E. P. "Recent Acquisitions: Murillo's Flight into Egypt." *Art Quarterly* 11 (1948), pp. 363–367.

Rodríguez de Rivas, Mariano. "Autógrafos de artistas españoles." *Revista Española de Arte* 1 (1932–33), pp. 229–238.

Rogers, Millard F., Jr. "Spanish Painting in the Museum Collection." The Toledo Museum of Art *Museum News (Summer* 1967), pp. 31–50.

_____. *Spanish Paintings in the Cincinnati Art Museum*. Cincinnati, 1978.

Rome 1930. *The Old Spanish Masters from the Contini-Bonacossi Collection*. Exh. cat. Rome, 1930.

Romero de Torres, Enrique. "Nuevas obras del pintor de 'Los Muertos.'" *Museum* 3 (1914–15), pp. 283–295.

Ruiz Alcón, María Teresa. "Lucas Jordán." *Reales Sitios* 8, no. 28 (1971), pp. 41–48; no. 29 (1971), pp. 33–40; no. 30 (1971), pp. 41–48; 9, no. 31 (1972), pp. 37–48; no. 32 (1972), pp. 37–48.

Salas, Xavier de. "Una carta del pintor Mazo." *AEAA* 3 (1931), pp. 181–182.

_____. "Rubens y Velázquez." In *Museo del Prado: Studia Rubenniana*. Vol. 2. Madrid, 1977.

Sánchez-Camargo, Manuel. *La muerte y la pintura española*. Madrid, 1954.

Sánchez Cantón, Francisco Javier. "Los pintores de cámara de los reyes de España: Los pintores de los Austrias." *BSEE* 23 (1915), pp. 132–146.

_____. "Pedro Ruíz González: Pintor de la escuela de Madrid." *AEA* 16 (1943), pp. 399–403.

_____. *Los retratos de los reyes de España*. Madrid, 1948.

_____, ed. *Fuentes literarias para la historia del arte Español*. Madrid, 1923–41.

_____, and Rodríguez Moñino, Antonio, eds. *Principios para estudiar el nobilísimo arte de la pintura*, by José García Hidalgo. Madrid, 1965.

Sánchez de Palacios, Mariano. *Murillo: Estudio biográfico y crítico*. Madrid, 1965.

_____. *Un pintor y arquitecto en la corte de Carlos II: José Ximénez Donoso*. Madrid, 1977.

San Diego 1960. *Fine Arts Gallery Catalogue*. San Diego Museum of Art, San Diego, 1960.

San Diego 1962. Fine Arts Gallery *Bulletin* (April–June 1962).

Sarthou Carreres, Carlos. *La iconografía mariana en España.* Madrid, 1929.

Schiller, Gertrude. *Iconography of Christian Art.* Greenwich, 1971.

Schubert, Otto. *Historia del barocco en España.* Madrid, 1924.

Schwartz, Sheila. "The Icongraphy of the Rest on the Flight into Egypt." Ph.D. dissertation, New York University, Institute of Fine Arts, 1975.

Shergold, N. D. *A History of the Spanish Stage from Medieval Times until the End of the Seventeenth Century.* Oxford, 1967.

Simón, José. "Francisco Rizi postergado." *AEA* 17 (1945), p. 308.

Soria, Martin S. *The Paintings of Zurbarán.* 2d ed. London, 1955.

_____. "José Antolínez, retratos y otras obras." *AEA* 29 (1956), pp. 1–8.

_____. "Notas sobre algunos bodegones españoles del siglo XVII." *AEA* 32 (1959), pp. 272–280.

Sterling, Charles. *Still Life Painting from Antiquity to the Present Time.* Paris, 1959.

Stirling-Maxwell, Sir William. *Annals of the Artists of Spain.* 4 vols. London, 1891.

Stokstad, Marilyn. "Spanish Art from the Middle Ages to the Nineteenth Century." *Apollo* (December 1972), pp. 498–503.

Suida, William E. "Spanische Gemälde der Sammlung Contini-Bonacossi." *Belvedere* 1 (1930), pp. 142–145.

_____. *Catalogue of the Paintings in the John and Mable Ringling Museum of Art.* Sarasota, 1949.

Sullivan, Edward J. "Josefa de Ayala. A Woman Painter of the Portuguese Baroque." *Journal of the Walters Art Gallery* 37 (1978), pp. 22–35.

_____. "Two Paintings by Claudio Coello in Valdemoro and His Work for the Jesuits in Madrid." In *Homenaje a Humberto Piñera. Estudios de literatura, arte e historia.* Madrid, 1979, pp. 134–144.

Tamayo, Alberto. *Las iglesias barrocas madrileñas.* Madrid, 1946.

Taylor, René. "Un Claudio Coello inédito." *AEA* 38 (1965), pp. 61–62.

Thieme, Ulrich, and Becker, Felix. *Allgemeines Lexikon der bildenden Künstler.* 37 vols. Leipzig, 1907–50.

Toledo 1976. *European Paintings.* The Toledo Museum of Art, Toledo, 1976.

Tormo y Monzó, Elías. "La Inmaculada y el arte español." *BSEE* 22 (1914), p. 55.

_____. "La galería de cuadros del incendiado Palacio de Justicia." *BSEE* 23 (1915), pp. 166–176.

_____. *Un gran pintor vallisoletano: Antonio de Pereda.* Valladolid, 1916.

_____. "Arte cristiano: Las Anunciaciones de Carreño y de Claudio Coello." *BSEE* 28 (1920), pp. 24–31.

_____. "Mateo Cerezo." *AEAA* 3 (1927), pp. 113–128, 245–274.

_____. "El centenario de Claudio Coello en El Escorial." *BSEE* 46 (1942), p. 157.

_____. *El cuadro de la Santa Forma de Claudio Coello, su obra maestra.* Discurso leído con motivo del tricentenario de su nacimiento celebrado en la sacristía del Real Monasterio de El Escorial el 29 de junio de 1942. Madrid, 1942.

_____. *Las iglesias del antiguo Madrid.* Madrid, 1972.

Torres Martín, Ramón. *La naturaleza muerta en la pintura española.* Barcelona, 1971.

Tovar Martín, Virginia. *Arquitectos madrileños de la segunda mitad del siglo XVII.* Madrid, 1975.

Trapier, Elizabeth Du Gué. *Velázquez.* New York, 1948.

_____. *Valdés Leal. Baroque Concept of Death and Suffering in His Paintings.* New York, 1956.

_____. "The School of Madrid and Van Dyck." *Burlington Magazine* 99 (1957), pp. 265–273.

_____. *Valdés Leal. Spanish Baroque Painter.* New York, 1960.

_____. "Martínez del Mazo as a Landscapist." *Gazette des Beaux-Arts* 56 (1963), pp. 293–310.

Urrea Fernández, Jesús. "Precisiones sobre Mateo Cerezo." *BSAA* 37 (1971), pp. 499–500.

_____. "Datos inéditos sobre Mateo Cerezo." *BSAA* 38 (1972), pp. 538–543.

_____. "En torno a Palomino." *BSAA* 38 (1972), pp. 556–560.

_____. "Obras de pintores menores madrileños: B. de Castrejón, A. Van de Pere y P. Ruíz González." *BSAA* 40–41 (1975), pp. 707–712.

_____. "Una pintura de Carreño y otra de Van de Pere en Valladolid." *BSAA* 43 (1977), pp. 488–490.

_____. "Una nueva obra de Francisco Rizi." *BSAA* 44 (1978), pp. 500–502.

_____, and Valdivieso González, Enrique. "Nuevas obras del pintor Mateo Cerezo." *BSAA* 39 (1973), pp. 488–491.

Valbuena Prat, Angel. "La escenografía de una comedia de Calderón de la Barca." *AEA* 6 (1930), pp. 1–16.

_____. *La vida española en la edad de oro.* Barcelona, 1943.

Valdivieso González, Enrique. "Dos pinturas inéditas de Escalante." *BSAA* 37 (1971), pp. 495–496.

_____. "Unas vanitas de Arellano y Camilo." *BSAA* 45 (1979), pp. 479–482.

_____; Otero Túñez, Ramón; and Urrea Fernández, Jesús. *El barroco, el rococó.* Historia del arte hispánico. Vol. 4. Madrid, 1980.

Valentiner, Wilhelm R. "Christ in Limbo by Alonso Cano." Los Angeles County Museum *Bulletin of the Art Division* 2 (1948).

———. "Meat, Saints, and Poetry." *Art News* (March 1950), pp. 35–37.

———. *Catalogue of Paintings, Including Three Sets of Tapestries*. Raleigh, 1956.

Valverde Madrid, José. "Dos pintores sevillanos en Córdoba: Sarabia y Valdés Leal." Archivo Hispalense 39 (1963), pp. 9–58.

Velázquez. Homenaje en el tercer centenario de su muerte. Instituto Diego Velázquez. Madrid, 1960.

Vélez de Guevara, Juan. *Los celos hacen estrellas*. Edited by J. E. Varey and N. D. Shergold. London, 1970.

Viardot, Louis. *Notices sur les principaux peintres de l'Espagne*. Paris, 1839.

Vicens Vives, Jaime, ed. *Historia social y económica de España y América*. Vol. 3. Barcelona, 1957–59.

Villars, Pierre, Marquis de. *Mémoires de la cour d'Espagne de 1679 à 1681*. Paris, 1893.

Viñaza, Conde de la. *Adiciones al diccionario histórico de los más ilustres profesores de las bellas artes en España de D. Juan Agustín Ceán Bermúdez*. 4 vols. Madrid, 1889–94.

Voragine, Jacobus de. *La Légende dorée*. Paris, 1843.

———. *The Golden Legend of Jacobus de Voragine*. Translated and adapted by G. Ryan and H. Ripperger. New York, 1969.

Voss, Hermann. *Sammlung Geheimrat Kommerzienrat Cremer*. Dortmund, 1914.

Waagen, Gustav. *Treasures of Art in Great Britain*. 3 vols. London, 1854.

———. *Der vornehmsten Kunstdenkmäler in Wien*. 2 vols. in 1. Vienna, 1866.

Waterhouse, Ellis. *Spanish Painting*. Edinburgh, 1951.

Weisbach, Werner. *El barroco, arte de la Contrarreforma*. Madrid, 1942.

Weissberg, Herbert. "Charles II at Benediction." *Carnegie Magazine* (December 1954), p. 335.

Wescher, Paul. *A Catalogue of Italian, French, and Spanish Paintings, XIV-XVIII Century*. Los Angeles, 1954.

Wethey, Harold E. "Alonso Cano's Drawings." *Art Bulletin* 34 (1952), pp. 217–234.

———. *Alonso Cano. Painter, Sculptor and Architect*. Princeton, 1955.

———. *Alonso Cano, pintor*. Madrid, 1958.

———. "Spanish Painting at Indianapolis and Providence." *Burlington Magazine* 105 (1963), pp. 207–209.

Wilenski, Reginald. "Murillo's Two Monks." *Apollo* (June 1930), pp. 475–477.

Winnipeg 1955. *El Greco to Goya*. Exh. cat. Winnipeg Art Gallery, Winnipeg, 1955.

Young, Eric. "Claudio Coello and the Immaculate Conception in the School of Madrid." *Burlington Magazine* 116 (1974), pp. 509–513.

———. "New Perspectives on Spanish Still-Life Painting of the Golden Age." *Burlington Magazine* 118 (1976), pp. 203–214.

Zarco Cuevas, Eusebio Julián. *Los pintores españoles en San Lorenzo El Real de El Escorial*. Madrid, 1931.

———. *Los pintores italianos en San Lorenzo El Real de El Escorial*. Madrid, 1932.

Zarco del Valle, Manuel. *Documentos inéditos para la historia de las bellas artes en España*. Colección de documentos inéditos para la historia de España. Vol. 55. Madrid, 1870.

———, ed. *Datos documentales para la historia del arte español: Documentos de la catedral de Toledo*. Vol. 2. Madrid, 1916.

Photographs

Alinari/Editorial Photocolor Archives, New York, fig. 21; Alte Pinakoteck, Munich, figs. 25, 26; Archivo MAS, Barcelona, figs. 24, 34, 37; Biblioteca Nacional, Madrid, fig. 19; The Bowes Museum, Barnard Castle, Co. Durham, England, fig. 12; Chrysler Museum at Norfolk, fig. 8, pl. 19; Cincinnati Museum of Art Photographic Services, fig. 47; Prudence Cumming Associates, Ltd., London, pl. 15; A. E. Dolinski Photographic, San Gabriel, California, fig. 50; El Paso Museum of Art, fig. 52; Elvehjem Museum of Art, Madison, Wisconsin, fig. 32; Frick Reference Library, fig. 49; Hearst San Simeon State Historical Monument, fig. 45; courtesy of the Hispanic Society of America, New York, fig. 10; Krannert Art Museum, University of Illinois, Champaign, pl. 32; Kunsthistorisches Museum, Vienna, fig. 1; Lyman Allyn Museum, New London, Connecticut, pl. 40; Meadows Museum, Southern Methodist University, Dallas, fig. 35; The Metropolitan Museum of Art, New York, figs. 44, 48; The Minneapolis Institute of Arts, pl. 23; M. Moreno, Fotografo de Arte, Seville, fig. 23; cliche des Musées Nationaux, Paris, fig. 27; Museo de Arte de Ponce, Puerto Rico, pl. 41; Museo del Prado, Laboratorio Fotografico, Madrid, figs. 2, 5, 6, 7, 9, 11, 13, 14, 15, 16, 28, 29, 30, 33, 36, 39, 40, 41; Museum of Fine Arts, Boston, fig. 43; courtesy of the National Gallery of Art, Washington, D.C., fig. 46, pl. 43; The National Gallery of Canada, Ottawa, pls. 24, 29; courtesy of the National Gallery of Ireland, Dublin, fig. 42; courtesy of The New-York Historical Society, pl. 20; courtesy of the North Carolina Museum of Art, pl. 39; Norton Simon Museum, Pasadena, fig. 51; courtesy of the Patrimonio Nacional, Madrid, figs. 4, 17; Philadelphia Museum of Art, fig. 53; San Diego Museum of Art, figs. 20, 54, pl. 5; Soichi Sunami, New York, pl. 12; Unusual Films, Bob Jones University, Greenville, South Carolina, fig. 38, pls. 17, 22.